# WINDSTONE

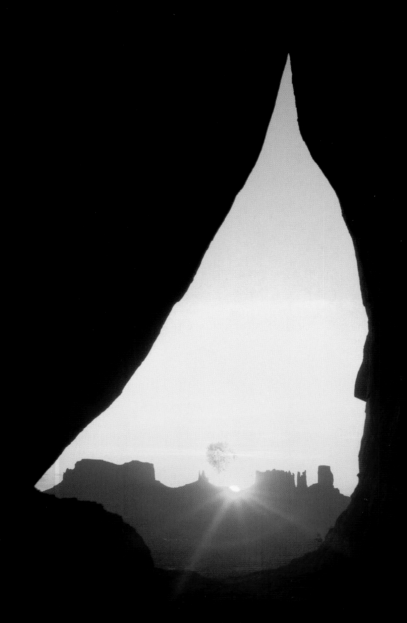

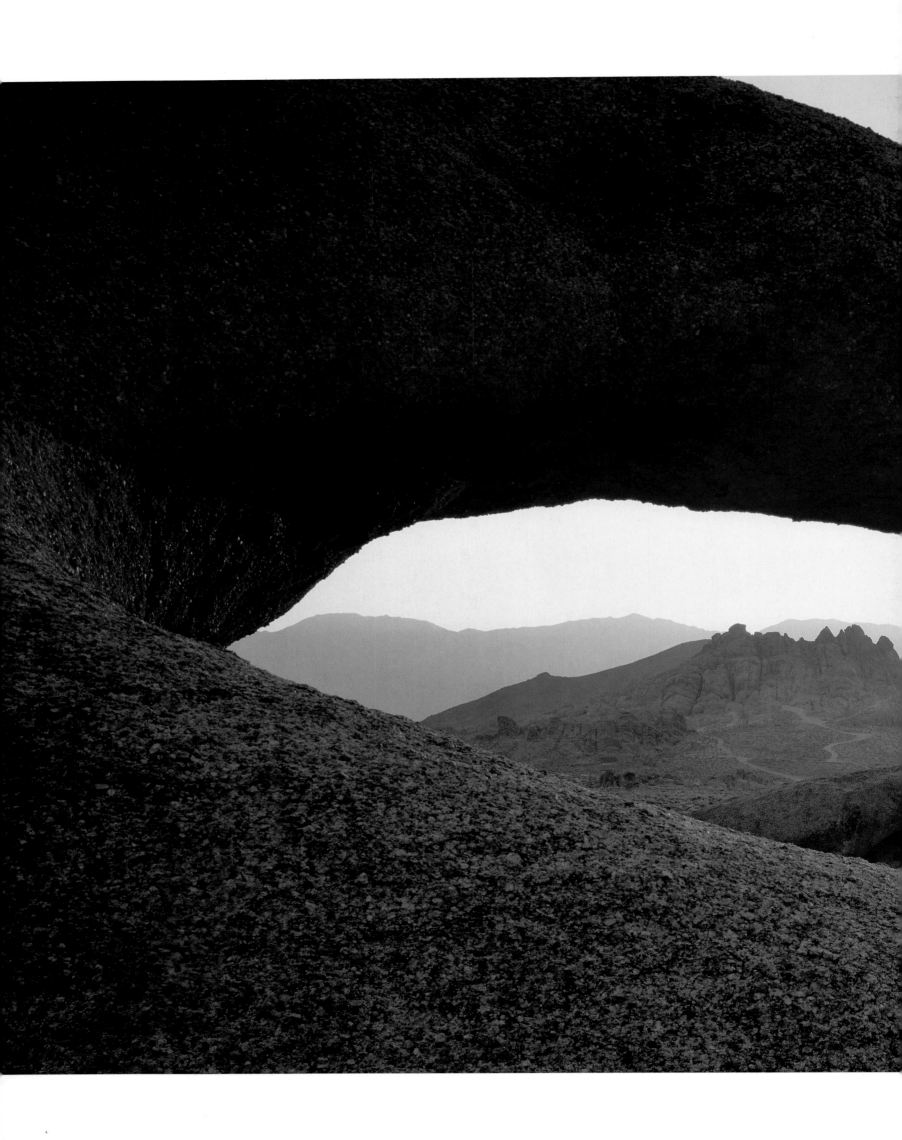

# WINDSTONE

NATURAL ARCHES, BRIDGES, AND OTHER OPENINGS

# DAVID MUENCH

ESSAY BY RUTH RUDNER

GRAPHIC ARTS CENTER PUBLISHING®

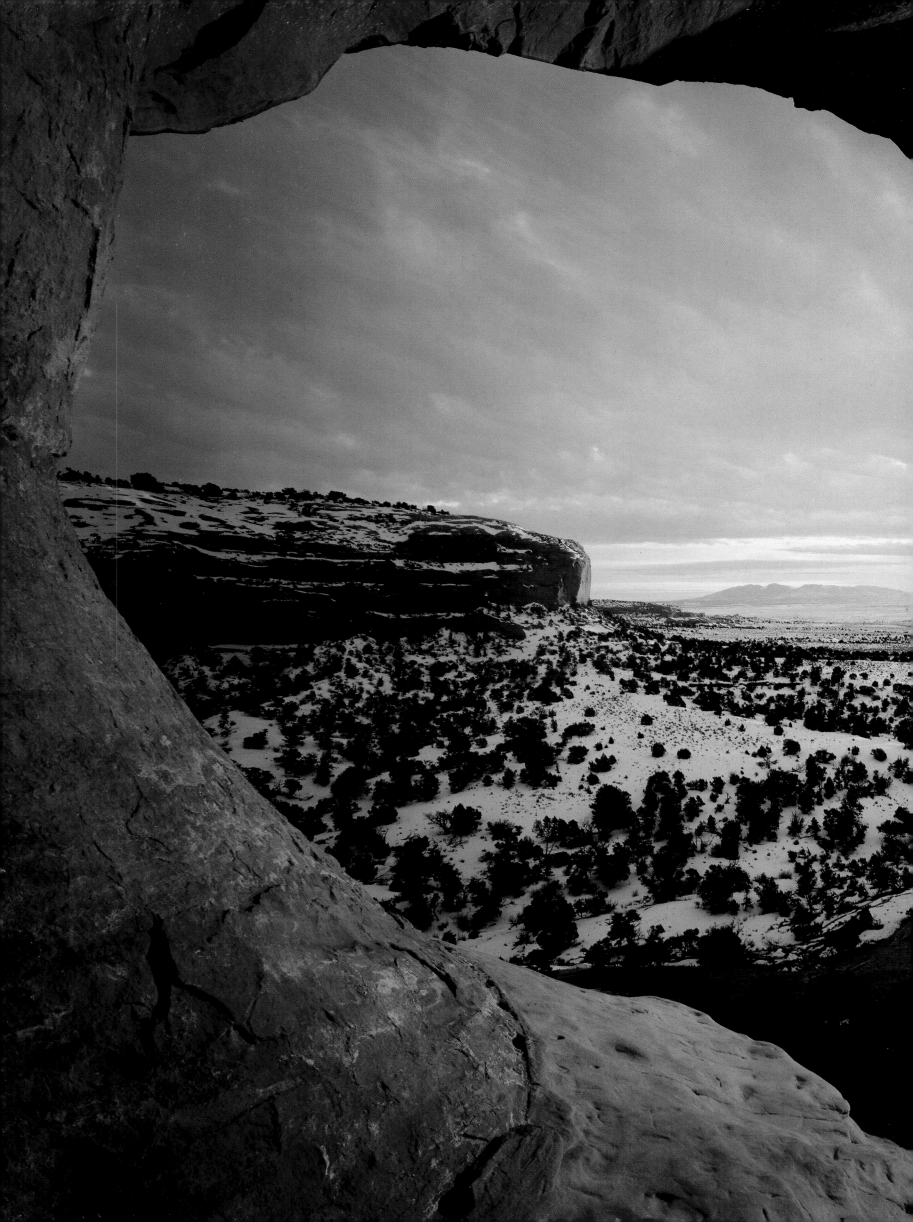

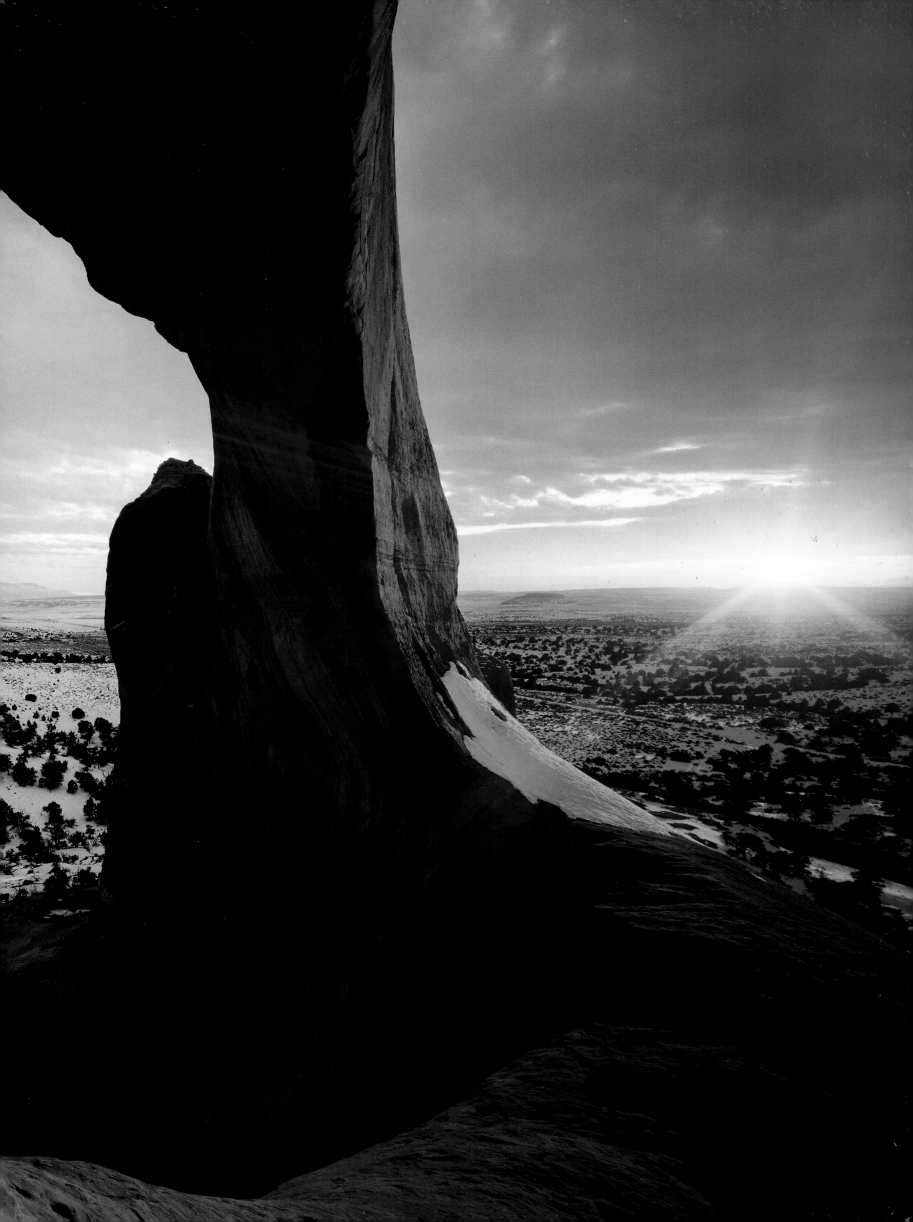

*Beauty is a summons to journey . . . a hail and a farewell of the*

*spirit, and since our deepest pattern is a round of departure and*

*return, we never recognize it more clearly than at the beginning*

*and end of our journeys. . . . When one has lived as close to*

*nature for as long as we had done, one is not tempted to*

*commit the metropolitan error of assuming that the sun rises*

*and sets, the day burns out and the night falls, in a world*

*outside oneself. These are great and reciprocal events, which*

*occur also in ourselves . . . as the evening was happening in us,*

*so were we in it, and the music of our participation in a single*

*overwhelming event was flowing through us.*

—Laurens van der Post, from *The Heart of the Hunter*

To those who celebrate the idea that there is no difference

between the earth and us, and to those who will, one day,

join the celebration, we dedicate this book.

---

David Muench                                    Ruth Rudner

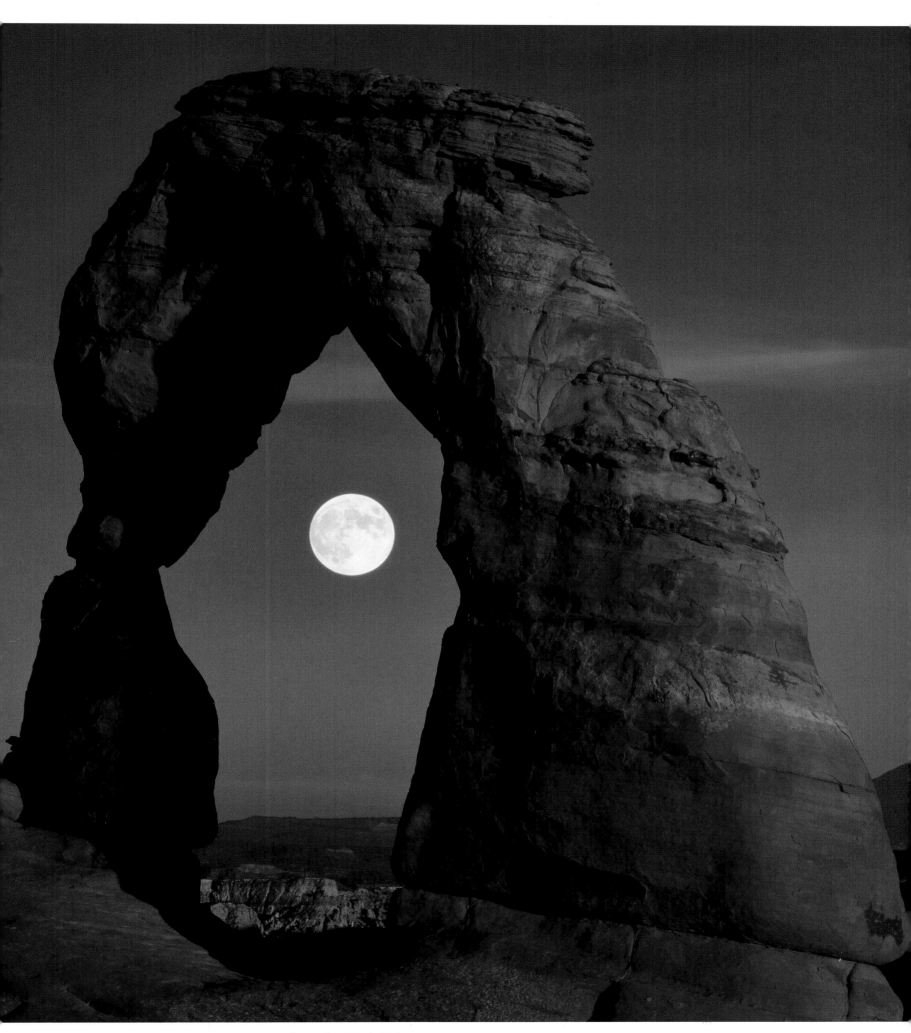

**Delicate Arch**, *Arches National Park, Utah*

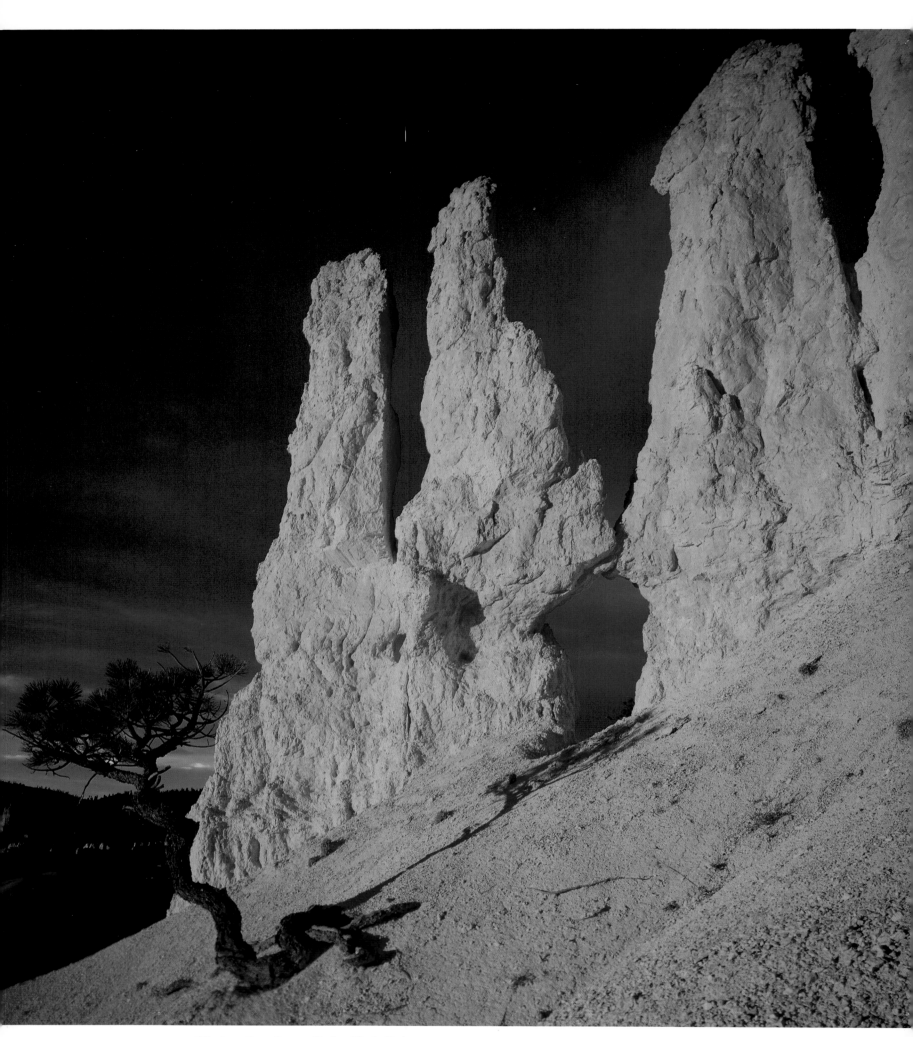

**Window,** *Bryce Canyon National Park, Utah*

# contents

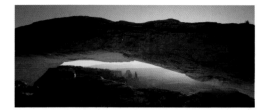

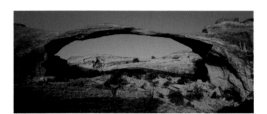

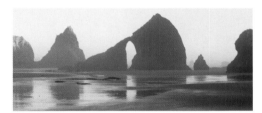

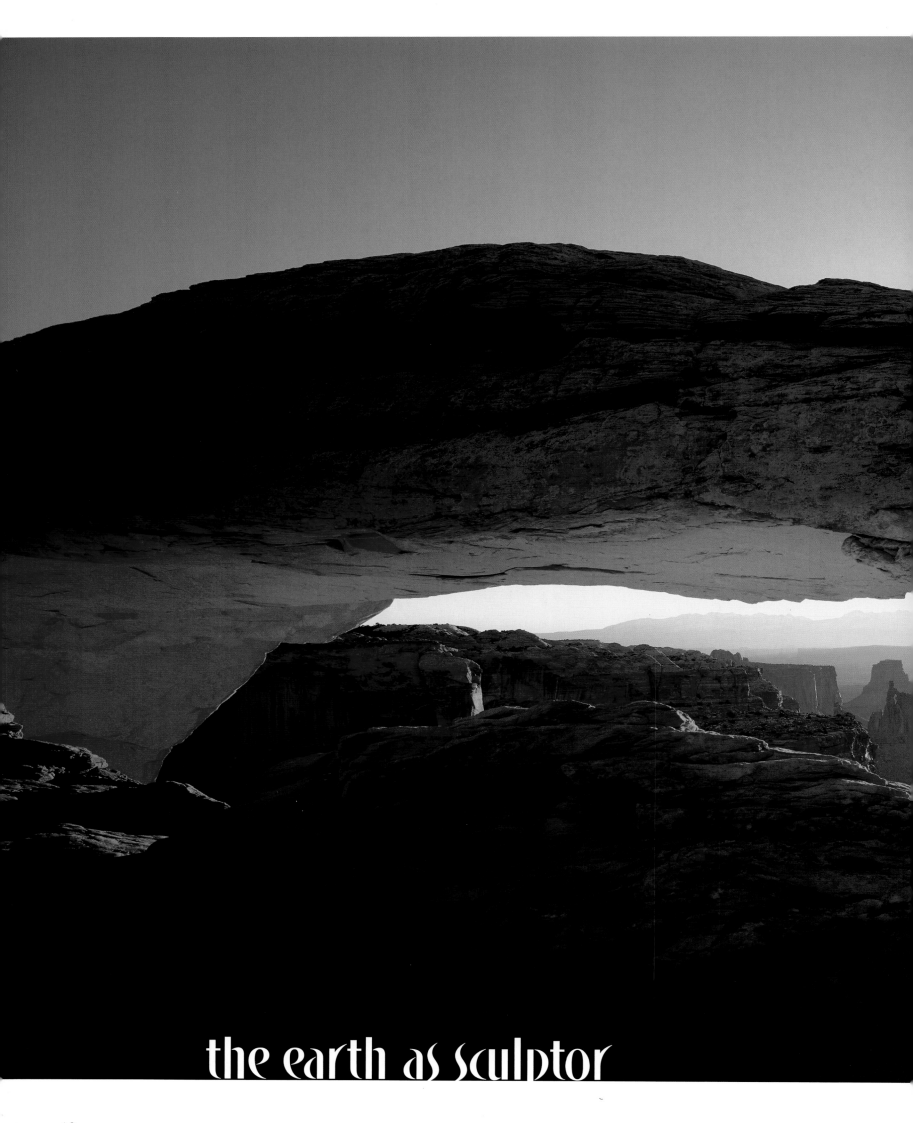

# the earth as sculptor

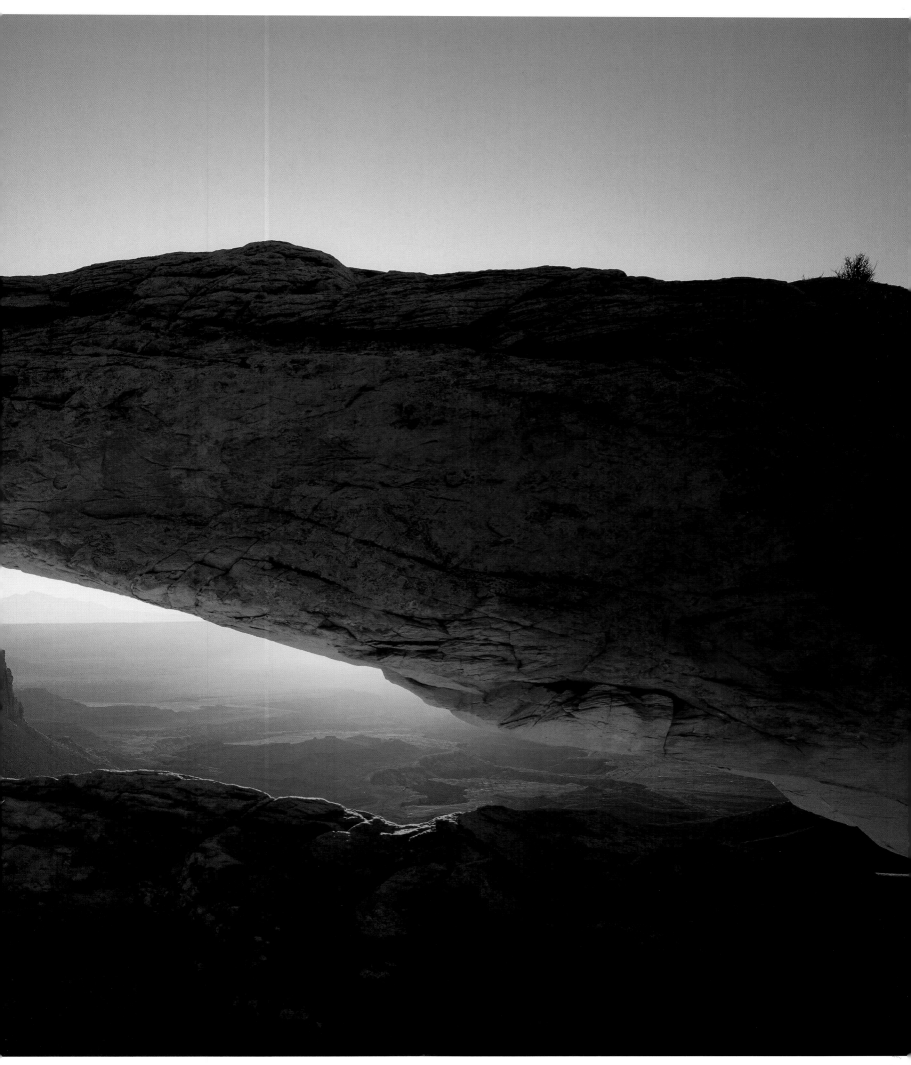

**Mesa Arch,** *Canyonlands National Park, Utah*

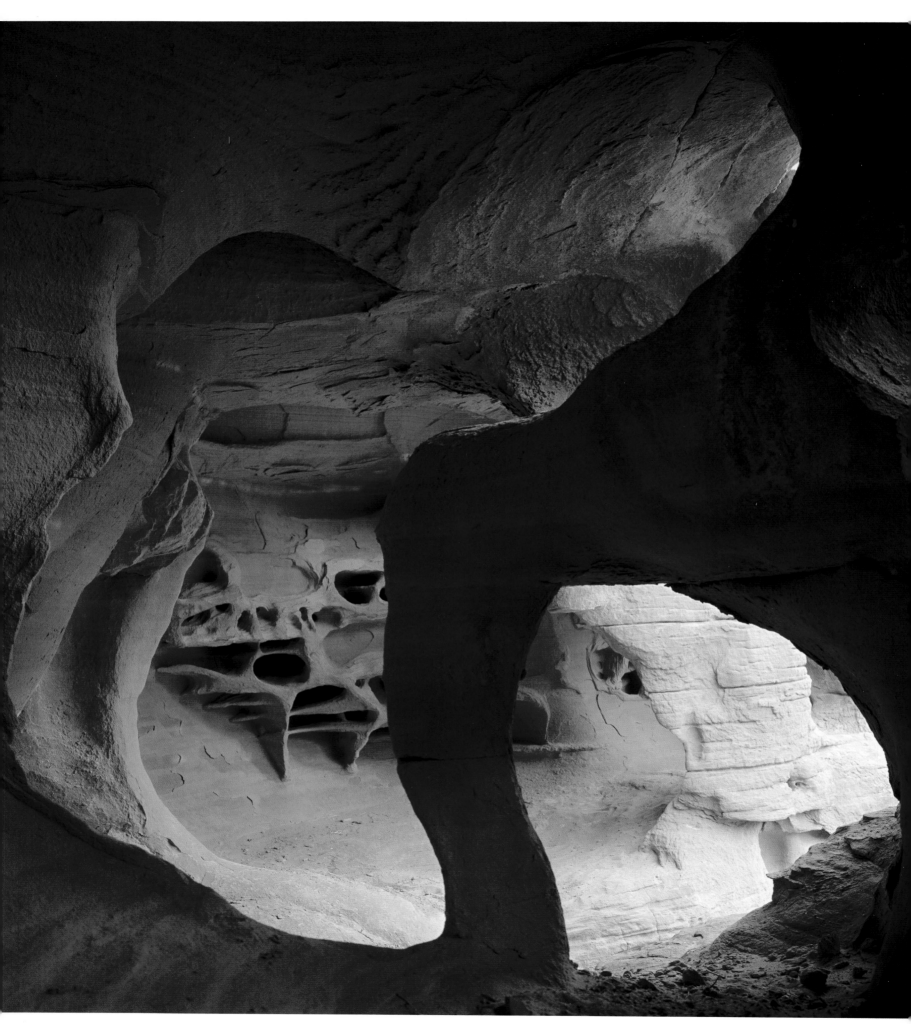

**Sandstone Cave,** *Valley of Fire State Park, Nevada*

# the earth as sculptor

The forms of rock we can crawl into, stand under, take shelter in, see through invite us in. Nature's arches, bridges, windows, and caves include us. Womblike, they protect us. They offered protection to early people, then guided them into architecture. They are indisputably architectural. They are sculptural. They are spiritual, magical, whimsical, awesome. They are geological. It is this that fascinates me most; this forming of the earth in ways that include any onlooker in the processes of the earth. You cannot look at an arch and not wonder at the power of water and wind. You cannot miss the effects and urgencies of time.

You cannot look at an arch and not wonder at the power of water and wind.

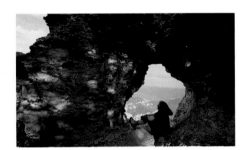

While attending to the care of four baby peregrine falcons at a Peregrine Fund release site, I camped on the edge of a meadow a thousand feet below a large window carved into a limestone rampart crowning Storm Castle. Storm Castle is a mountain in Montana's Gallatin Canyon, a major route between Yellowstone National Park and the rest of the world. From the road two thousand feet below the window, Storm Castle seems impenetrable, a solid block of crenellated rock rising out of deep forest. From camp, it is possible to see the window. A trail through the lower forest climbs up and around the southern end of the castle, then circles through the forest behind it to reach the window. You can walk into the window and sit there, looking out at miles of forest and of mountain and sky before you.

To feed the falcons and log their progress toward adulthood, my coattendant and I took turns hiking the mile-long trail from camp to the top of the cliff, then rappelling to a ledge where the box providing a nest for the falcons was tethered. The box sat exactly on the edge of the cliff so that the falcons' view was what they would have as adults—only, until they were old enough to fly, everything they saw was through the wire mesh at the front of the box.

Our rappel point was just south of the window. Sometimes, after climbing back up the cliff, I continued around to the backside of the castle to spend time in the window. Leaning back against one side of it, looking out beyond the sheer cliff dropping about forty feet directly below me, I could consider the world as the falcons saw it. I loved my window seat.

One afternoon, after the falcons had been released and were spending most of their time flying from one ledge on the cliffs to another, I was in camp, watching their activity through my spotting scope. It was late in the afternoon—tea time, cocktail time, time to wind down from any ordinary day but an active time for falcons. This day the cliff seemed oddly quiet. I searched

**Storm Castle**, *Gallatin National Forest, Montana*

Arches form in stone, in ice, in wood. The arch shape is an elemental one in nature . . . as if this is a natural way to break, as if straight lines are anathema.

the nooks and fissures on the wall. I raised my scope higher to take in the window. Suddenly a mountain lion walked into it. He walked to its very edge so that his head slightly overhung the cliff. He looked straight out, across the forest, across our camp, south to the Spanish Peaks and to Yellowstone. He turned his head to the right and looked a long time in that direction, then to the left, looking a long time in that direction too. He extended one paw, reaching out beyond the window, as if to test the air, then turned and walked out of the window, coming around to its south side. He peered out across the forest from there, then turned again and left my view.

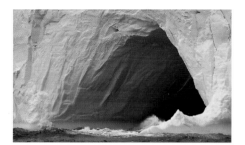

Arches form in stone, in ice, in wood. The arch shape is an elemental one in nature. Wherever you look, trees bend into arches; water arches over falls; rainbows arch over the earth. Many of the cracks and folds and fractures in rock walls are arched, as if this is a natural way to break, as if straight lines are anathema. There is an arch in the meander of a stream, the bending of grass in the wind. There is the ice arch, formed by glaciers, perhaps the most ephemeral of all the earth's forms. There is the arch of our skulls and the arch of our foot and the archness of our wit. (This is not far-fetched. To arch means to take a curved path, something a keen wit may do.) The archer, one skilled in the use of the bow (itself arch-shaped), pulls the bowstring into an arch to let an arrow fly.

There is the triumphal arch and the vaulted arch of the cathedral, which, itself, comes from the vaulted arch formed by a grove of trees. (Interesting how we are often reminded of cathedrals inside a grove of trees or a natural rock structure when, in fact, our sacred architecture is derived from just those places, regarded as sacred before Christianity.) We intuit arches as both literal and symbolic portals into a new place—a physical place indeed, but in a greater sense, a new place of the imagination and the soul. The more I see of arches, the more fascinated I become by the idea of the arch form as an instinct both of the earth and of the human mind.

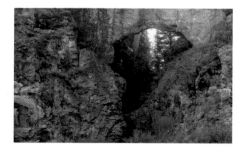

▲ **Ice Cave,** *Antarctica*

▶ **Natural Bridge,** *Yellowstone National Park, Wyoming*

When thinking of nature's arches, we usually think first of openings in stone. "Written in stone"—the words mean permanence to us, but what do they mean to the stone? The myriad forms of rock show us that nothing is permanent, nothing static. The pace of change for rocks is

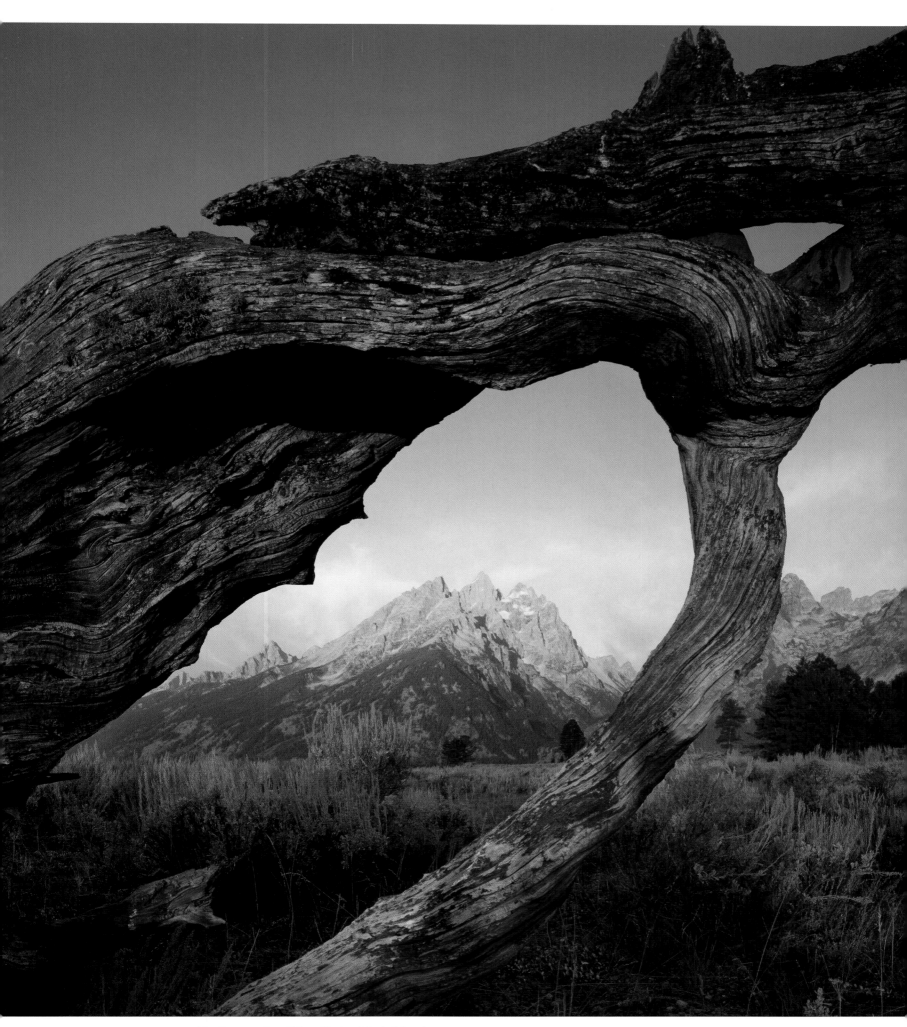

**The Tetons,** *Grand Teton National Park, Wyoming*

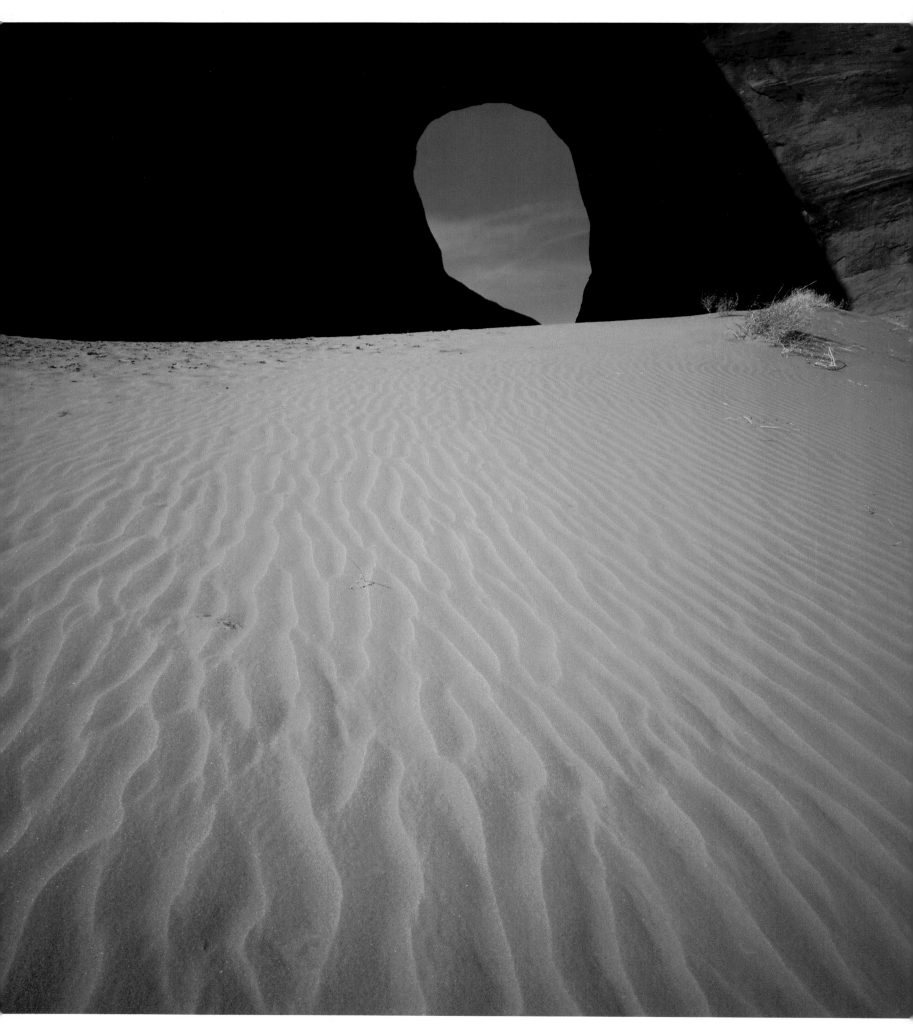

**Ear of the Wind,** *Monument Valley Navajo Tribal Park, Arizona/Utah*

different from that of trees, of beetles, of antelopes and humans, but rock lives, breathes, ages, changes like the rest of us. There are no differences between what happens to the earth and what happens to every living thing upon the earth. Some of us just do it faster.

Some geologists feel the processes that form rock arches, bridges, and windows are too superficial to matter much. They are just events on the earth's surface and have nothing to do with orogeny or plate tectonics or lithification or the other things that matter. Yet, arches represent the earth. Constructions of the earth, they serve as diagrams of the earth's processes. They provide us a tactile example of the way the earth changes; the circular use and reuse of the earth's materials; the earth's urge toward beauty and grace.

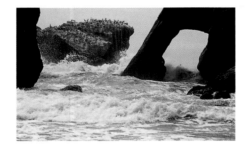

The process is simply ongoing. Time is a human artifact. The earth's sculptures are made, they mature, and die. Age and change, the old rock recycled into sand recycled into rock. Everything on earth is always in the process of becoming.

A sculptor working with rock (or wood or ice) looks for the shape inherent in the material. The earth operates the same way. Its tools are multiple. Eternally forming, re-forming, adjusting, folding, buckling, swelling, warping, quaking, toppling, scrubbing, falling, shattering—the earth is in constant motion. What shows on the surface is the result of all these processes. Recent, ancient, to the earth it's all the same. The process is simply ongoing. Time is a human artifact. The earth's sculptures are made, they mature, and die. Age and change, the old rock recycled into sand recycled into rock. Everything on earth is always in the process of becoming.

Perhaps the sculpting from rock of arches and other forms is seen most directly at the edge of the sea. The action of waves is straightforward; the inevitability of their flow clear to anyone who walks along an ocean beach. Waves rolling in and out against the shore cut away less resistant rock. They shape the more resistant rock into headlands. On headlands, they work on horizontal cracks, eating away at the rock to form caves. Inside the caves, erosion of vertical joints can form blowholes on top of the headland cliff. If a sea cave is eroded all the way through the headland, an arch is formed. If the arch or the blowhole or the sea cave collapses, sea stacks—steep-sided islands no longer connected to the headland—are formed.

Water, wind, sand, vegetation, ice, fire—all participate in this planetary sculpting. Water carves bridges quite directly, but it is the chief sculptor in arches and windows as well. Rain and snow dissolve the chemical cements binding rock particles together; they freeze into ice, then expand, fracturing the rock. Wind blows away the loosened particles, or whips the region's sand into a blasting force that scours and carves the rock. Vegetation takes hold in cracks and the growing roots widen them. The fire of volcanic events forms lava flows that channel into streams that, over many hours or days, may develop a solid crust—walls and roof that insulate the flowing lava so that it keeps moving over great distances. The walls and roof become a lava tube, or a whole system of lava tubes.

In the red rock country of the Colorado Plateau, ancient seas laid down sandstone that has been uplifted and eroded into countless whimsical shapes and beckoning arches and bridges. Lava tubes in Hawaii, Washington, California, Idaho, New Mexico, and other places speak of the volcanic beginnings of so much of the earth. In the Big Tubes Area of El Malpais National Monument in New Mexico, a seventeen-mile-long lava tube system formed when the eruptive

▲ **Tunnel Island**, *Quinault Reservation, Olympic Peninsula Coast, Washington*

▼ **Sea Arch**, *Hawaii Volcanoes National Park, Hawaii*

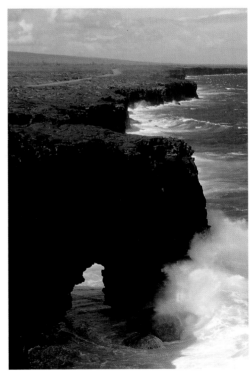

To be classified as an arch . . .

an opening must be at least

three feet wide and appear in a

continuous wall of rock.

Windows . . . are simply holes

through thin walls of rock, far

enough from the edge of the

wall that they do not influence

the shape of that edge.

A natural bridge spans a

watercourse—active river or

ancient dried streambed.

forces of magma broke through the earth's crust, creating Bandera Crater. As roofs of some lava tubes collapsed, the Seven Bridges were created. In Yellowstone National Park, volcanic rhyolite formed the park's sole natural bridge. In the granite arches of Joshua Tree National Park and Yosemite and the east side of the Sierra Nevada, fiery magma from the earth's upper mantle and lower crust rose through the crust to slowly cool and solidify into granite. In time the rock covering them eroded, revealing granites that retain the flowing look of their beginnings. In Alaska, an iceberg rent from a glacier floats onto a pebble beach, changing form constantly from the moment of calving. The opening it contains in landing changes shape by melting throughout the day, until finally the tides merge whatever is left of the berg with the sea. In Antarctica, an erstwhile piece of some vast ice shelf, now whittled by weather and time into an ice-blue arch, floats by on the open ocean.

Arches form in thin rock walls where the rock's chemical composition is particularly susceptible to erosion by rain and seeping moisture. Once in a while the opening may be the result of a rock collapsing from some internal strain. Openings are enlarged and refined by that same internal stress in combination with weathering forces. When you stand near enough to a sandstone arch, like those in the Southwest and Kentucky, you can see thin layers of rock peeling off the mother rock, a process known as exfoliation. There are some arches where exfoliation seems so immediate that you choose not to stand beneath them. This process is a continuation of the same events that formed the opening. Ultimately the sandstone, formed of sand, will crumble into sand, be transported to bodies of water to collect as sediment, become compacted into sedimentary rock, and begin the cycle over again.

Arches exist in myriad sizes and forms, but their configurations give definition to the edges of the walls from which they grew. To be classified as an arch according to Arches National Park, an opening must be at least three feet wide and appear in a continuous wall of rock.

Windows differ from arches in that they are simply holes through thin walls of rock, far enough from the edge of the wall that they do not influence the shape of that edge.

A natural bridge spans a watercourse—active river or ancient dried streambed. Bridges are formed by flowing water cutting away vertical or horizontal sections of rock. The carving water may be constant or intermittent as it sculpts and enlarges the opening. A meandering stream through the canyon it has formed often doubles back on itself so that only a thin neck of rock divides the meanders. This neck can be undercut by the stream itself, forcing an opening through the rock. While this is happening, water and ice may cause rock layers in that spot above the stream to break and fall off, enlarging the opening. If the current is strong enough to clear away the rock debris so that water can run freely through the opening, the structure becomes a bridge. If the debris, instead, diverts the course of the stream away from the opening, the structure becomes an arch.

While bridges may be any shape, many with flat spans look as if they had been built by human engineers. Early photos show people and horses and carriages crossing them. The sine

**Sandstone Detail, Grays Arch,** *Red River Gorge, Kentucky*

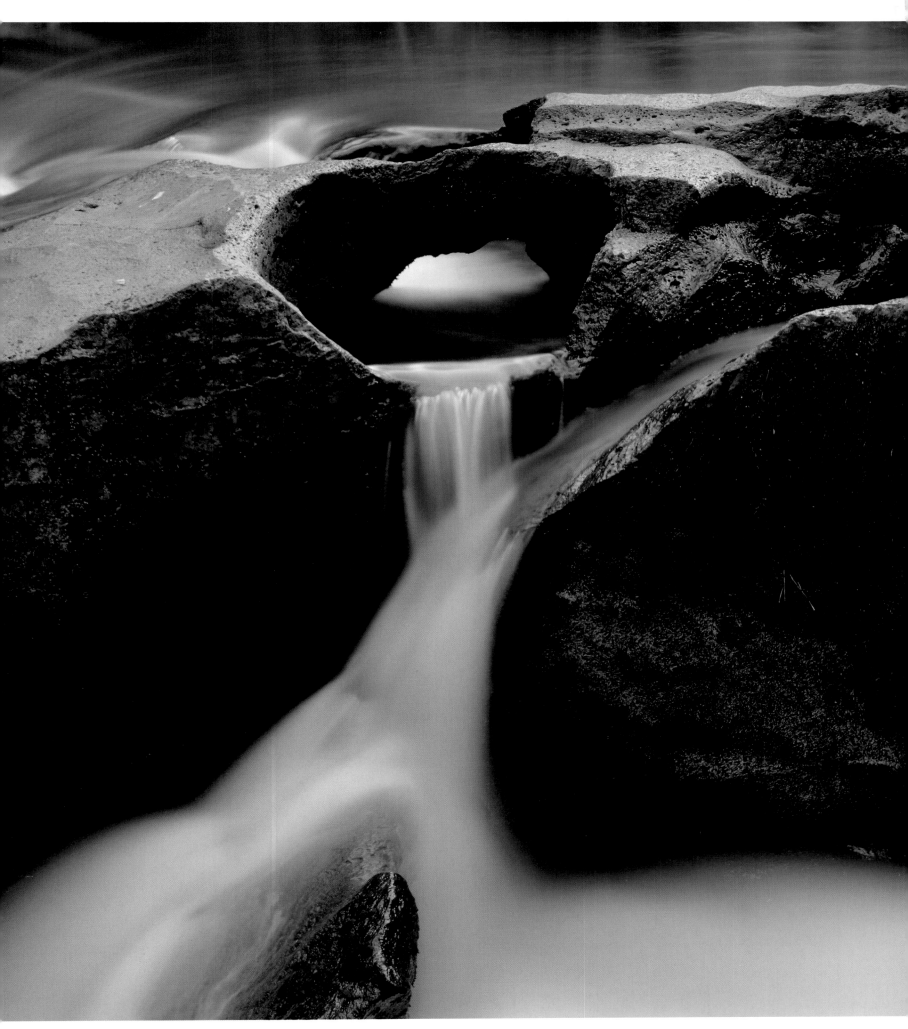

**Cascade and Bridge,** *Upper Rogue River, Oregon*

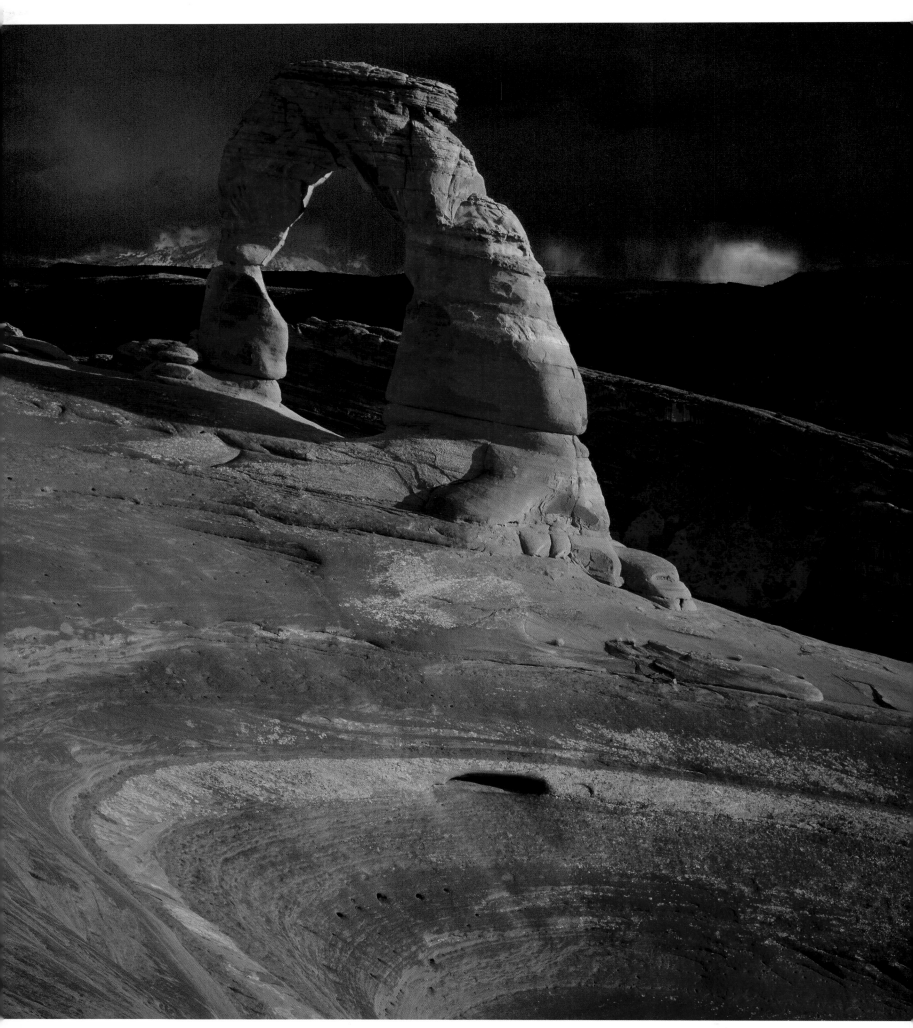

**Delicate Arch**, *Arches National Park, Utah*

qua non of natural bridges, Rainbow Bridge in Bridge Canyon, Utah, a branch of Forbidding Canyon that enters into the main channel of the Colorado River under Lake Powell, is rainbow-shaped. The name, translated as "Hole in the Rock Shaped like a Rainbow," comes from the Navajo, whose country this is. According to Navajo mythology, the rainbow is an arch of male and female beings, frozen in place. From this union come rainbows, clouds, and rain for Navajo country. The bridge is sacred to the Navajo, Utes, and Paiutes who do not walk under it. (Visitors are asked not to approach or walk under it.)

Whatever their forms and however they were formed, arches, bridges, and windows have a lifespan—a youth, a maturity, an old age.

Spectacular spans get a lot of attention. Visitors flock to whole parks named for the formations they protect: Arches National Park, Natural Bridges National Monument, and Rainbow Bridge National Monument in Utah; Tonto Natural Bridge State Park in Arizona; Natural Bridge State Resort Park in Kentucky. Other national and state parks and monuments, without arches or bridges in their names—such as Canyonlands National Park in Utah or the Big South Fork National River and Recreation Area in Tennessee—also contain extraordinary examples of natural rock openings. Still other spans, equally beautiful, are more difficult to reach; often on private land; at the farthest reaches of rough roads; at the end of difficult climbs; sunk beneath reservoirs; on sacred Indian land inaccessible to most of us.

Whatever their forms and however they were formed, arches, bridges, and windows have a lifespan—a youth, a maturity, an old age. In geologic terms, any of these rock formations we see today is relatively recent. Geologist F. A. Barnes, who has made a lifetime study of the Colorado Plateau, as well as a lifetime attempt to make its geology comprehensible to the rest of us, writes in *Canyon Country Geology* that "scientists believe most present arches have been created within the last million years."

In Arches National Park you can easily compare the mature Landscape Arch with the young Sand Dune Arch. Years of eroding, cracking, and exfoliating have left Landscape Arch with a fragility you can see from the distance you are required to stand. (The arch has been cordoned off ever since a slab about sixty feet long, eleven feet wide, and four feet thick fell in 1991. The cordoning keeps the arch safe from vandals and viewers safe from falling rock.) Not many miles away, Sand Dune Arch seems only lately to have evolved out of the thick walls containing it within a dark, cool, hidden chamber. ⌒

▲ **Rainbow Bridge,** *Rainbow Bridge National Monument, Utah*
◄ **Sand Dune Arch,** *Arches National Park, Utah*
► **Tower Arch,** *Arches National Park, Utah*

21

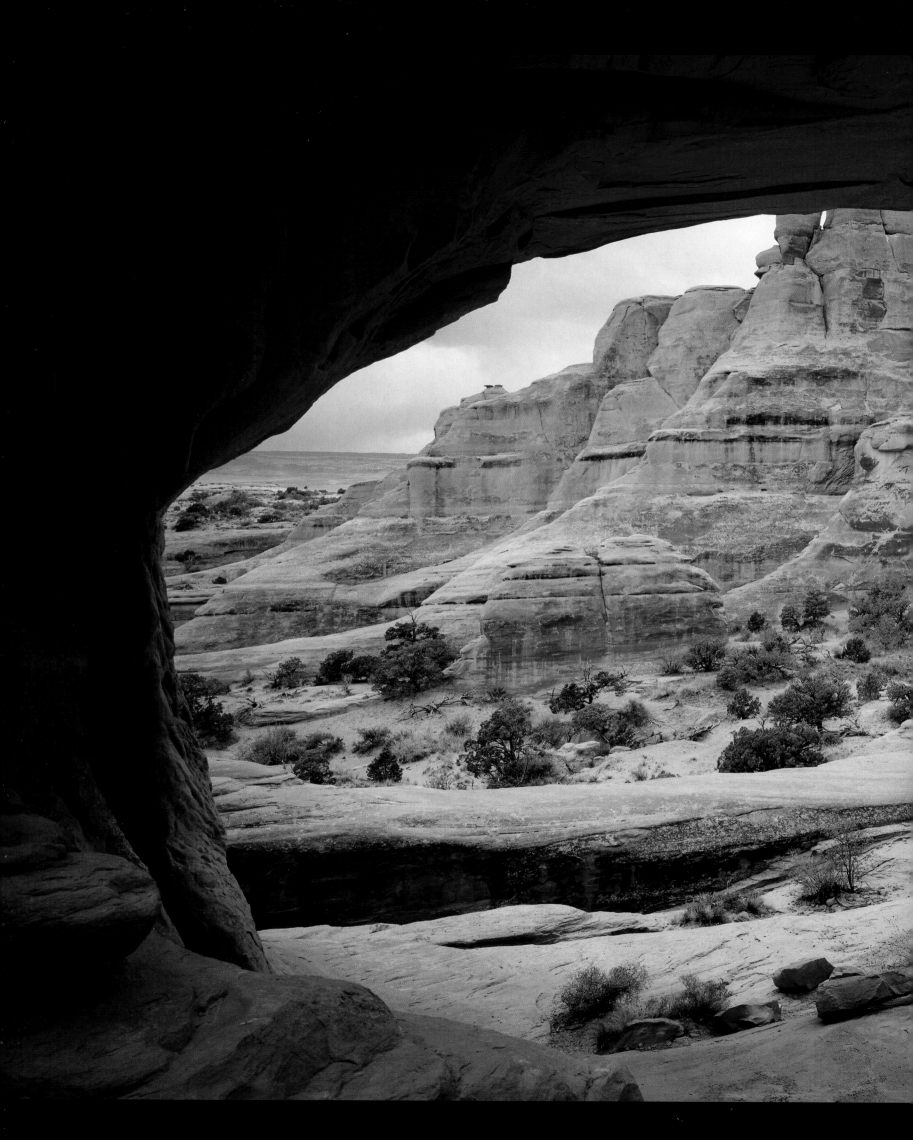

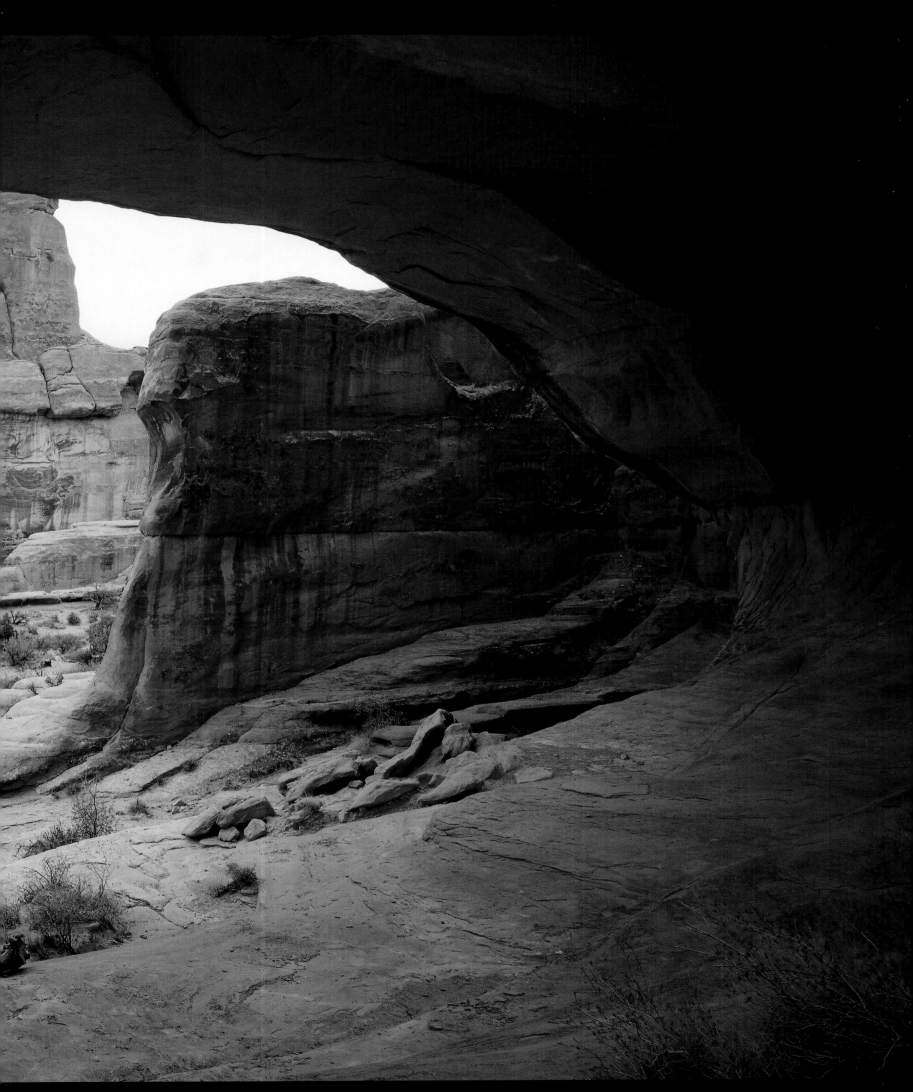

**Tower Arch**, *Arches National Park, Utah*

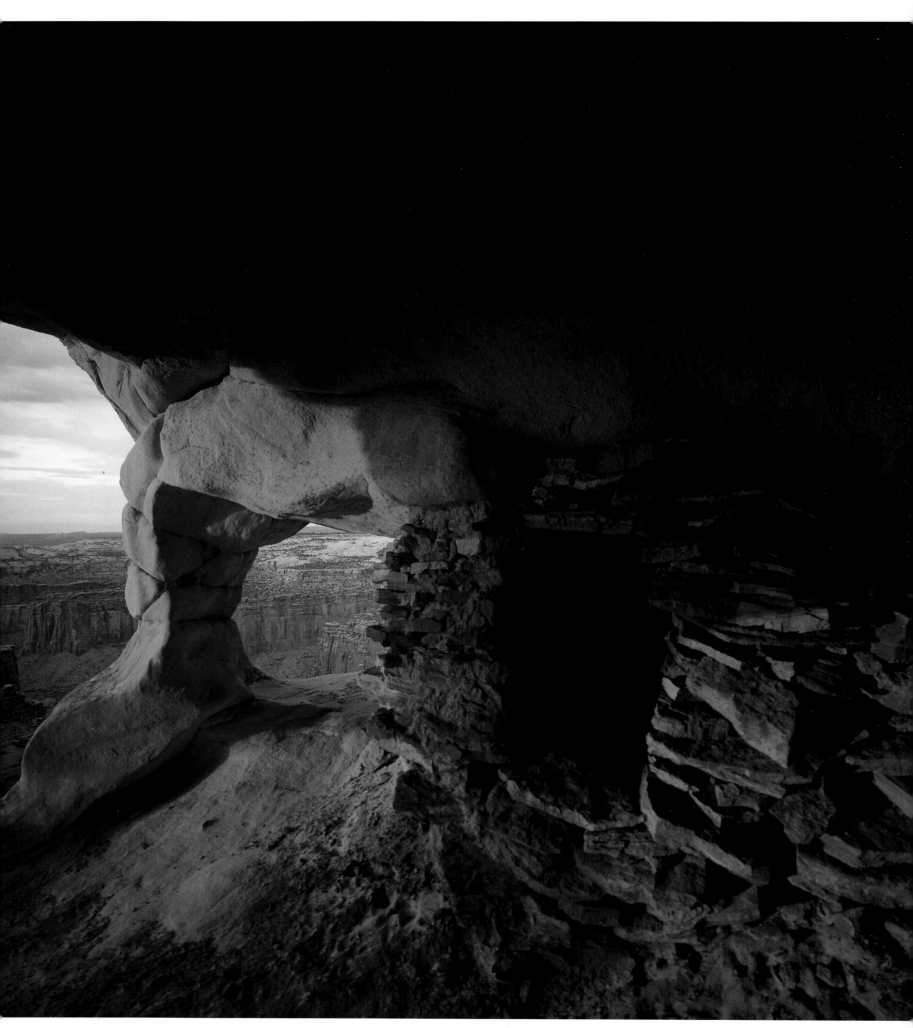

**Arch and Ancient Puebloan Granary,** *Canyonlands National Park, Utah*

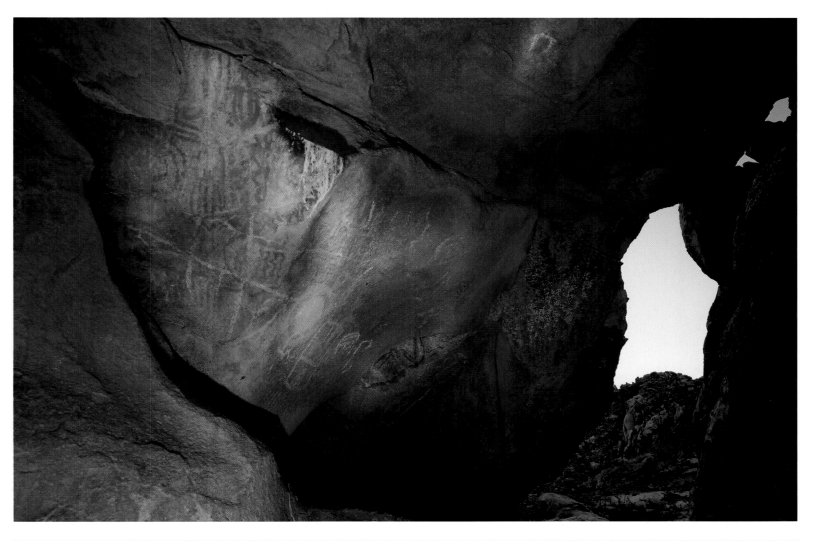

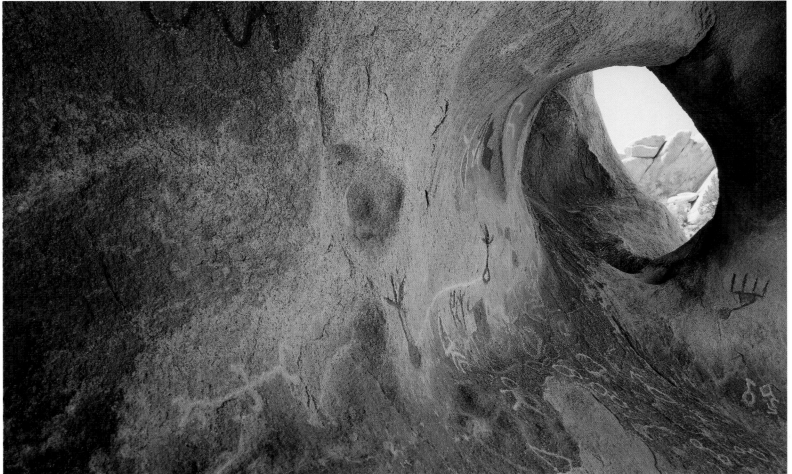

▲▲ **Cave Paintings,** *Mojave Desert, California*   ▲ **Granite Opening and Cave Paintings,** *Joshua Tree National Park, California*

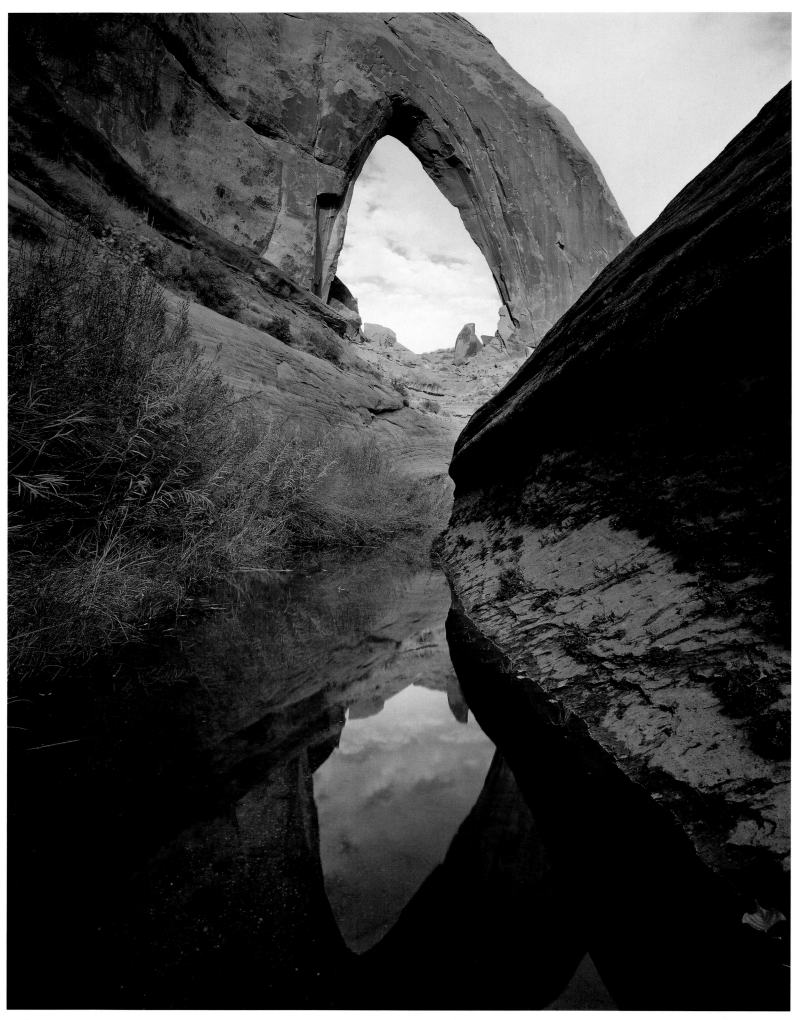

**Broken Bow Arch/Escalante,** *Glen Canyon National Recreation Area, Utah/Arizona*

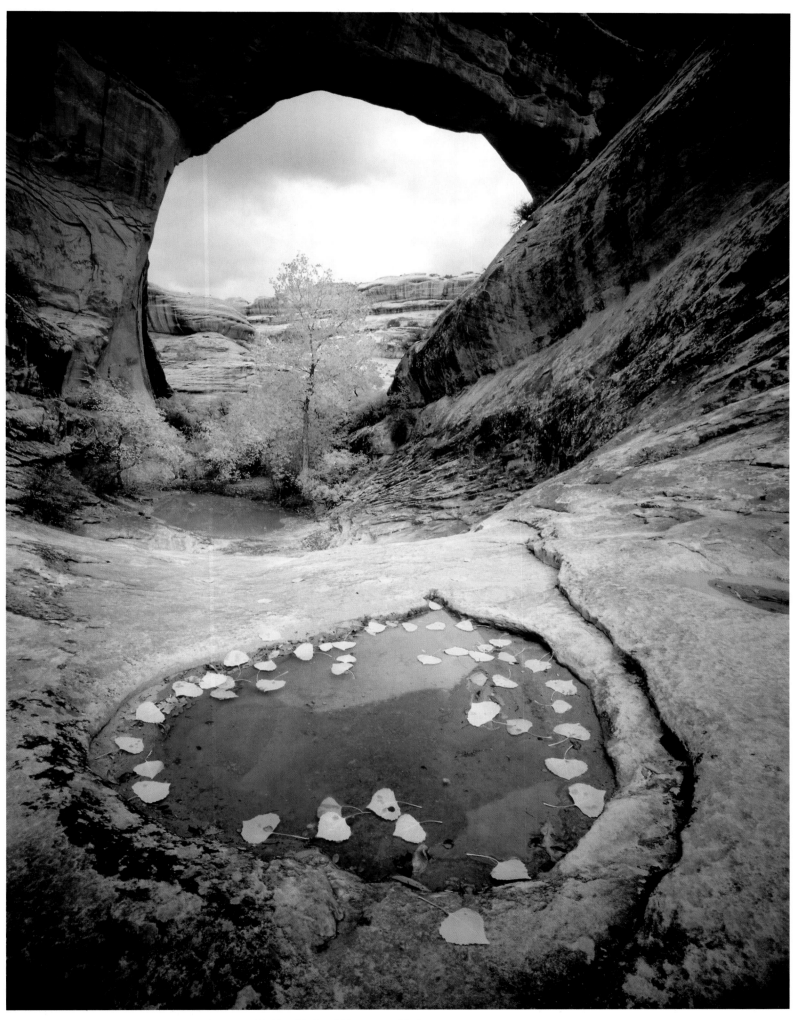

**Sipapu Bridge,** *Natural Bridges National Monument, Utah*

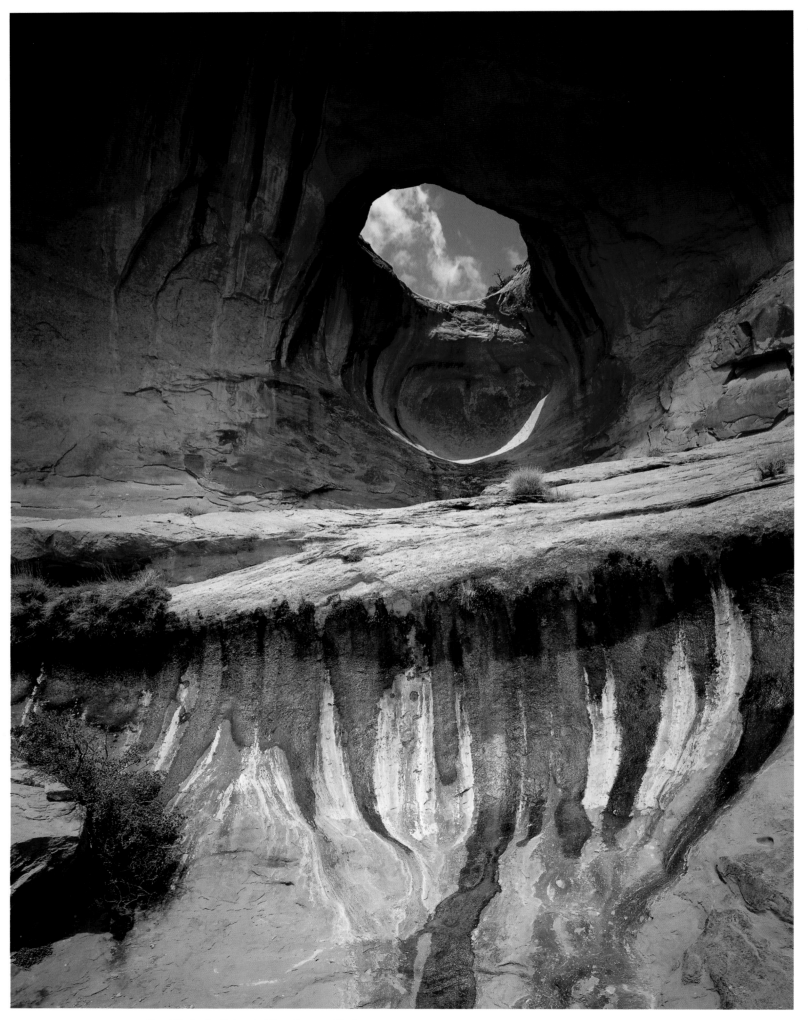

**Bow Tie Arch,** *Colorado River Canyon, Utah*

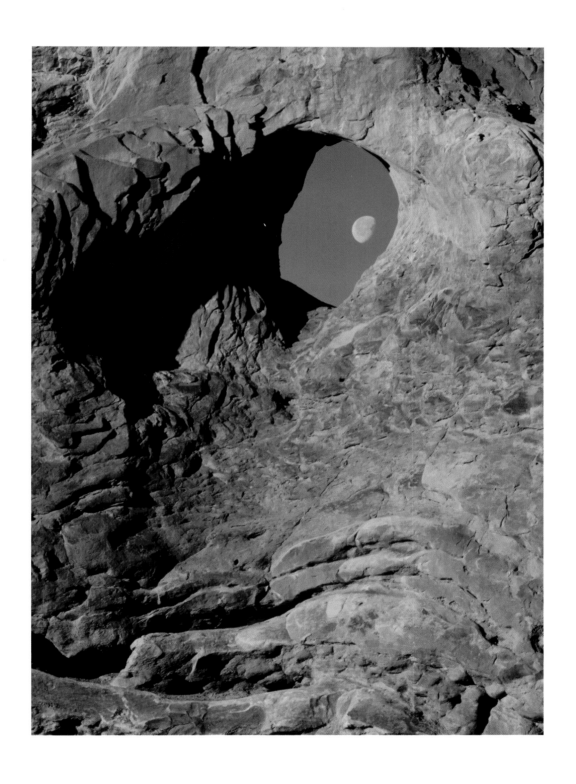

**Turret Arch**, *Arches National Park, Utah*

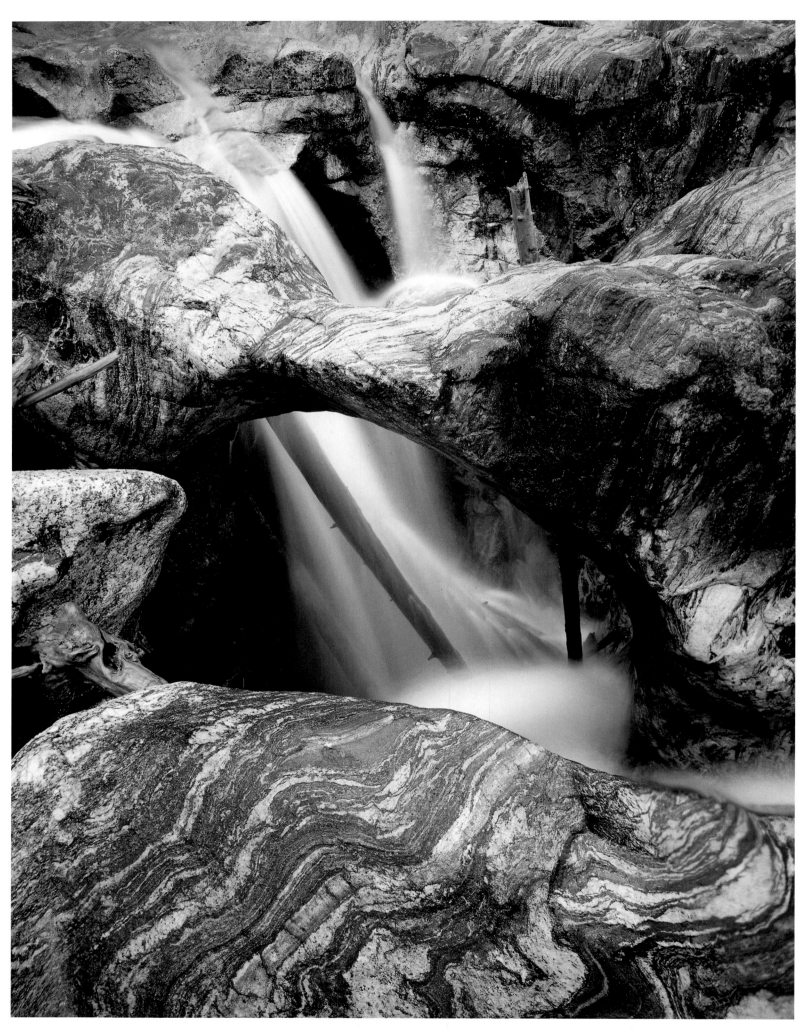

**Natural Bridge,** *Roaring Fork River, Aspen, Colorado*

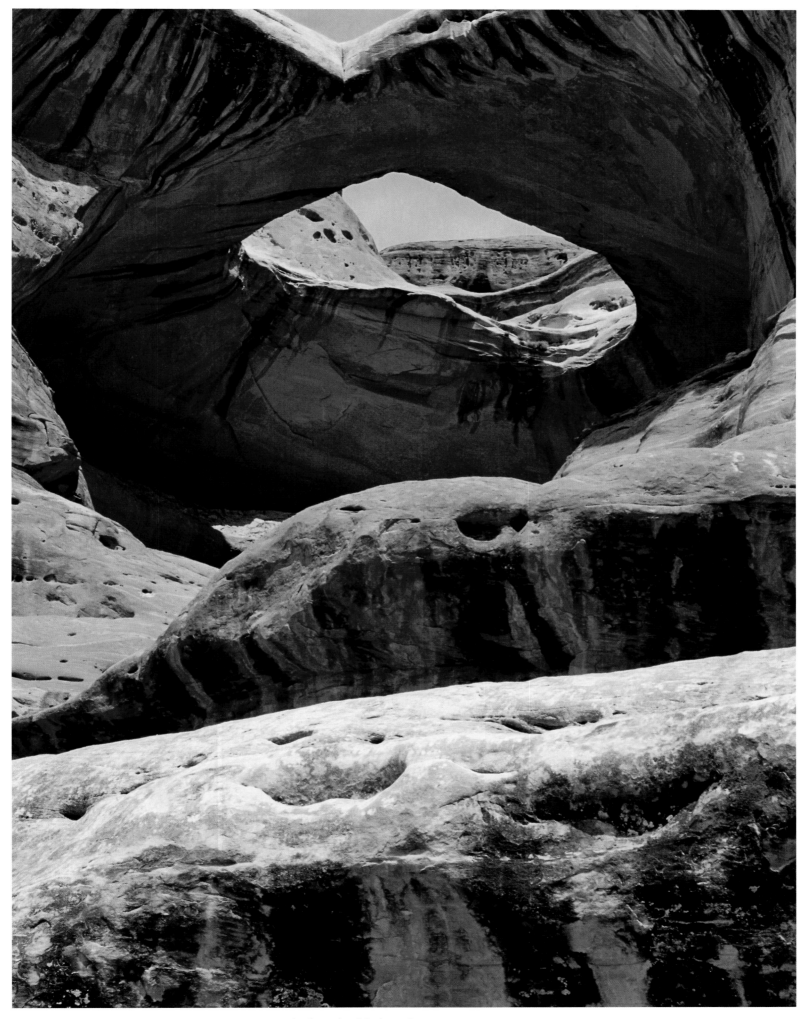

**Paul Bunyan's Potty,** *Canyonlands National Park, Utah*

**Caprock along Missouri River,** *Missouri Breaks, Montana*

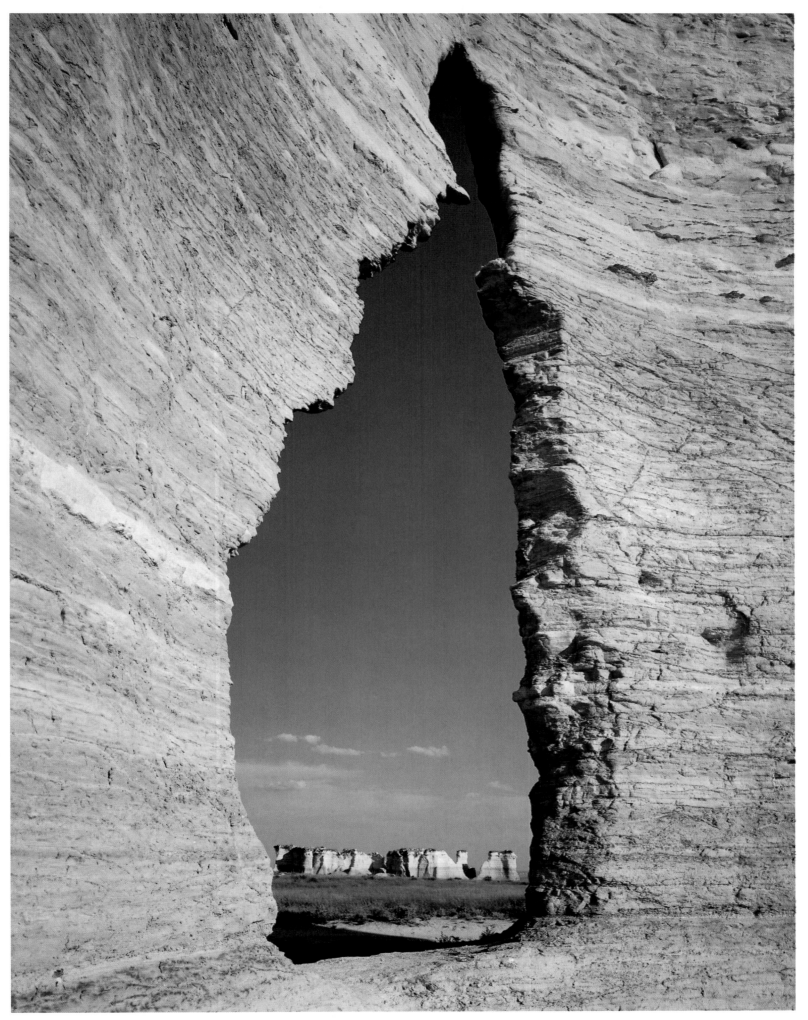

**Window at Monument Rocks,** *Monument Rocks National Landmark, Kansas*

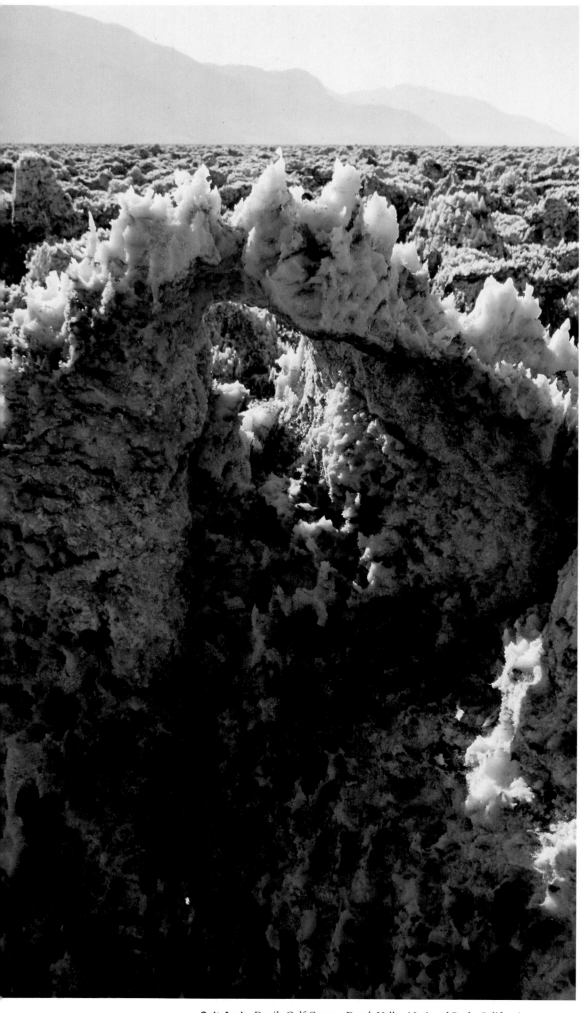

**Salt Arch,** *Devils Golf Course, Death Valley National Park, California*

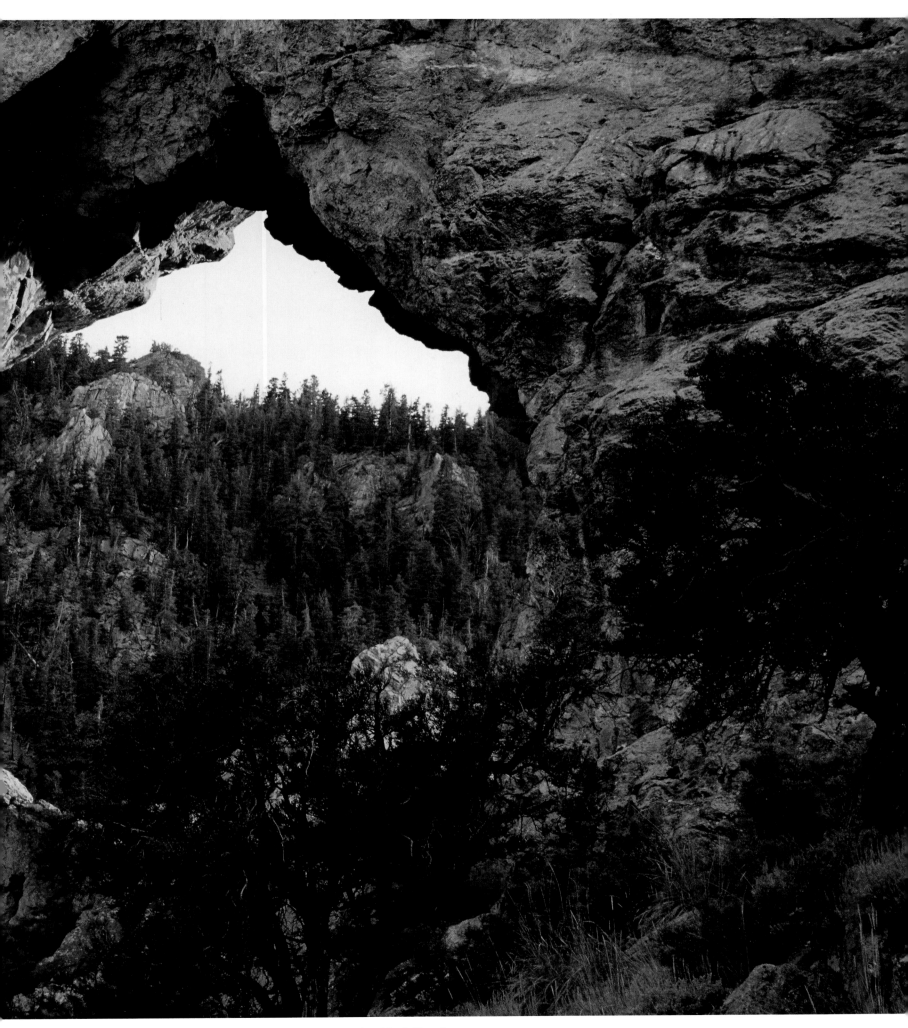

**Lexington Arch,** *Great Basin National Park, Nevada*

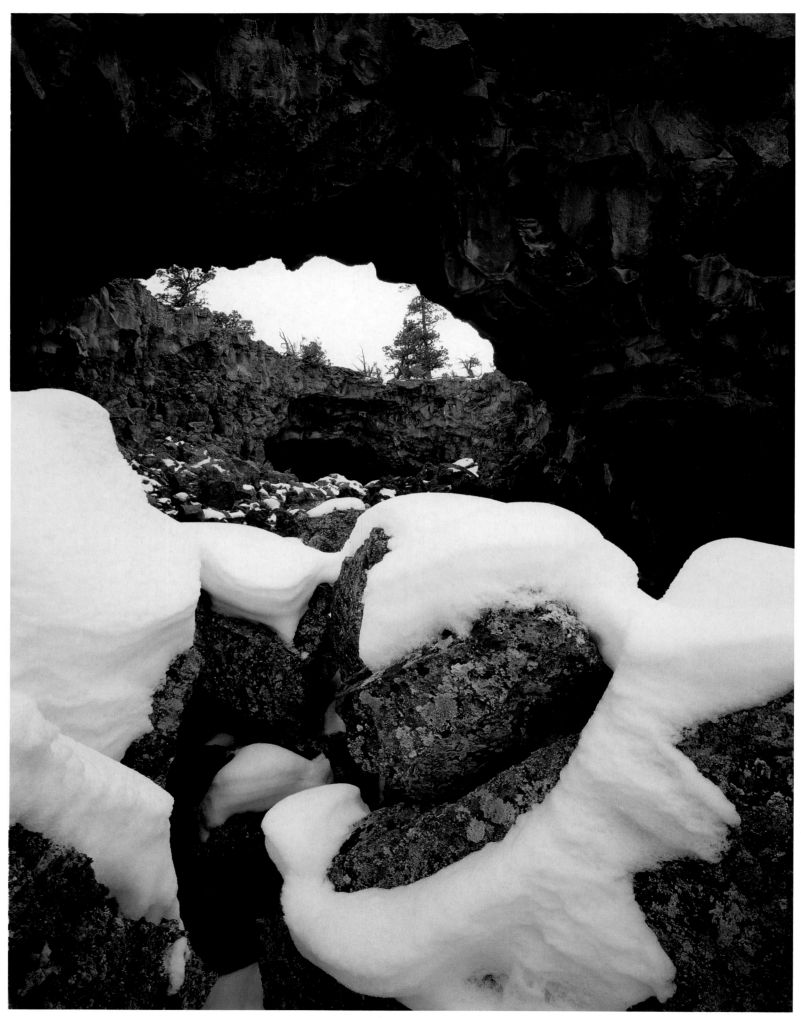

**Lava Tube,** *El Malpais National Monument and Conservation Area, New Mexico*

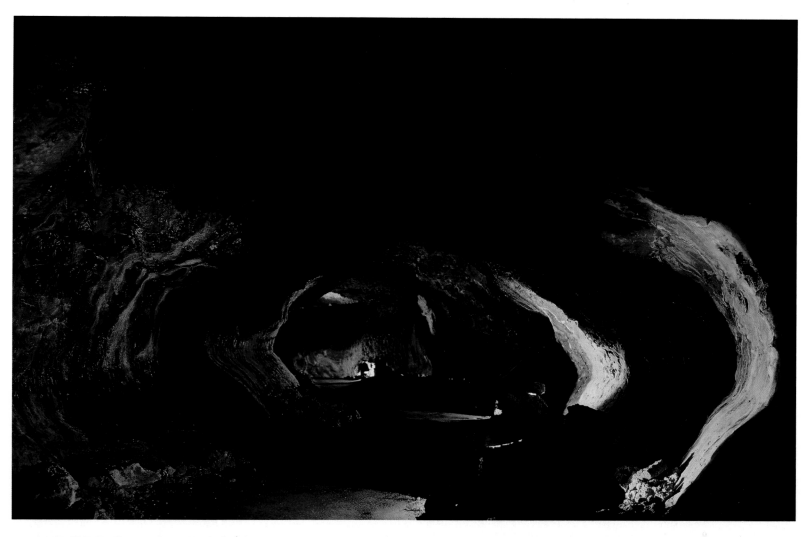

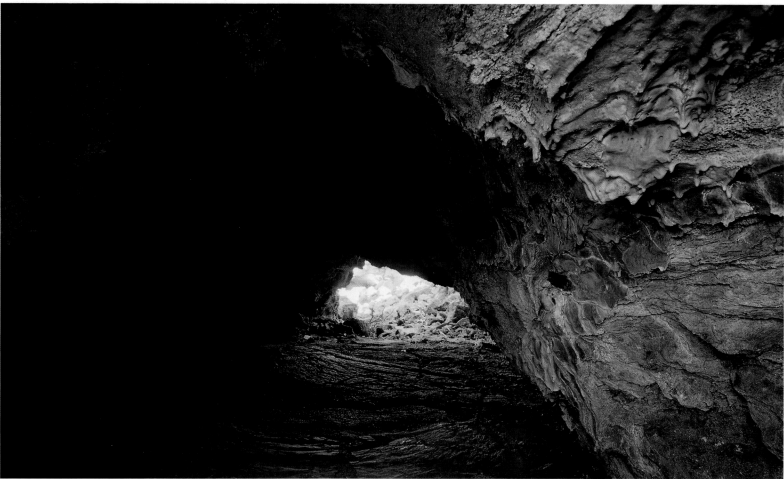

▲▲ **Lava Tube Interior and** ▲ **Lava Tube Opening,** *Lava Beds National Monument, California*

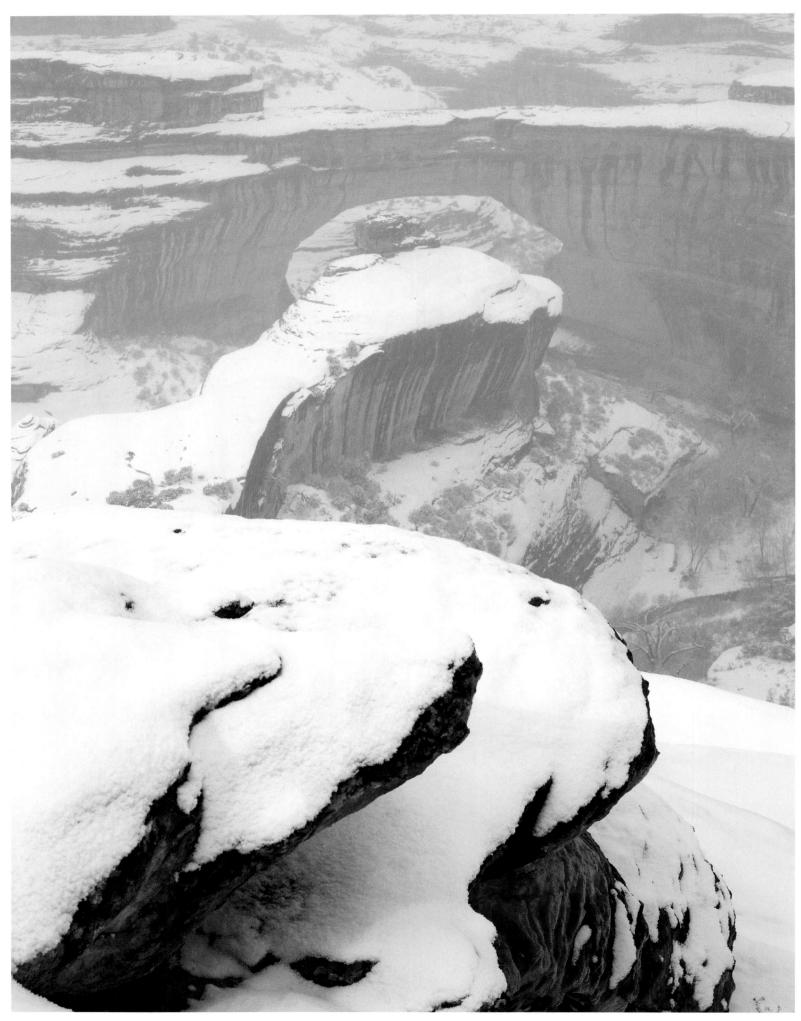

**Sipapu Bridge,** *Natural Bridges National Monument, Utah*

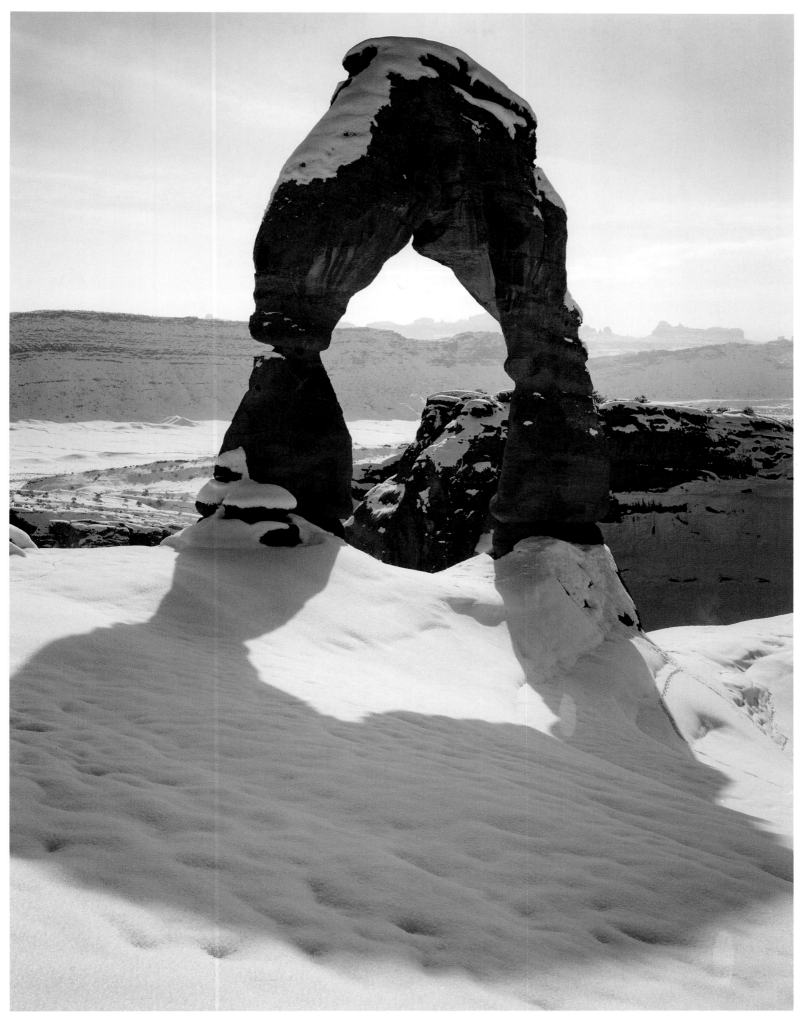

**Delicate Arch,** *Arches National Park, Utah*

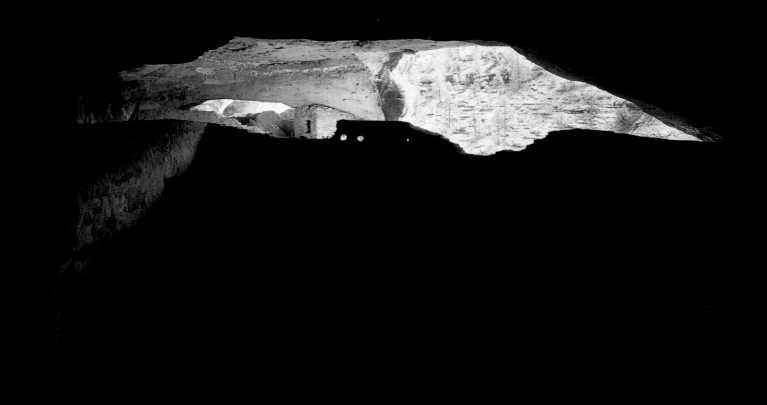

**Gila Cliff Dwellings,** *Gila Cliff Dwellings National Monument, New Mexico*

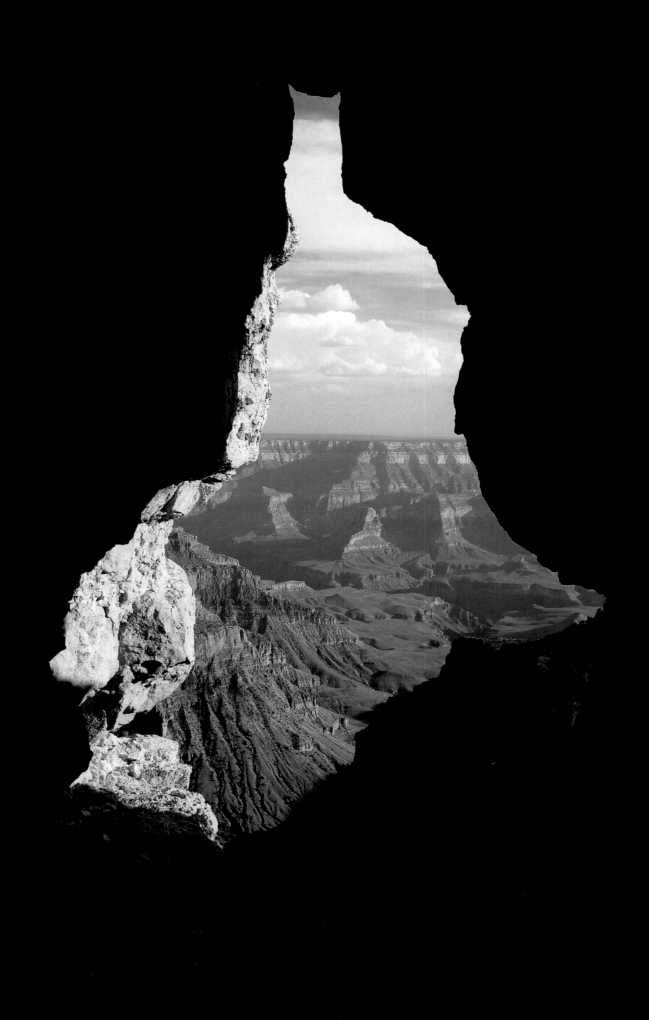

**Limestone Keyhole,** *North Rim, Grand Canyon National Park, Arizona*

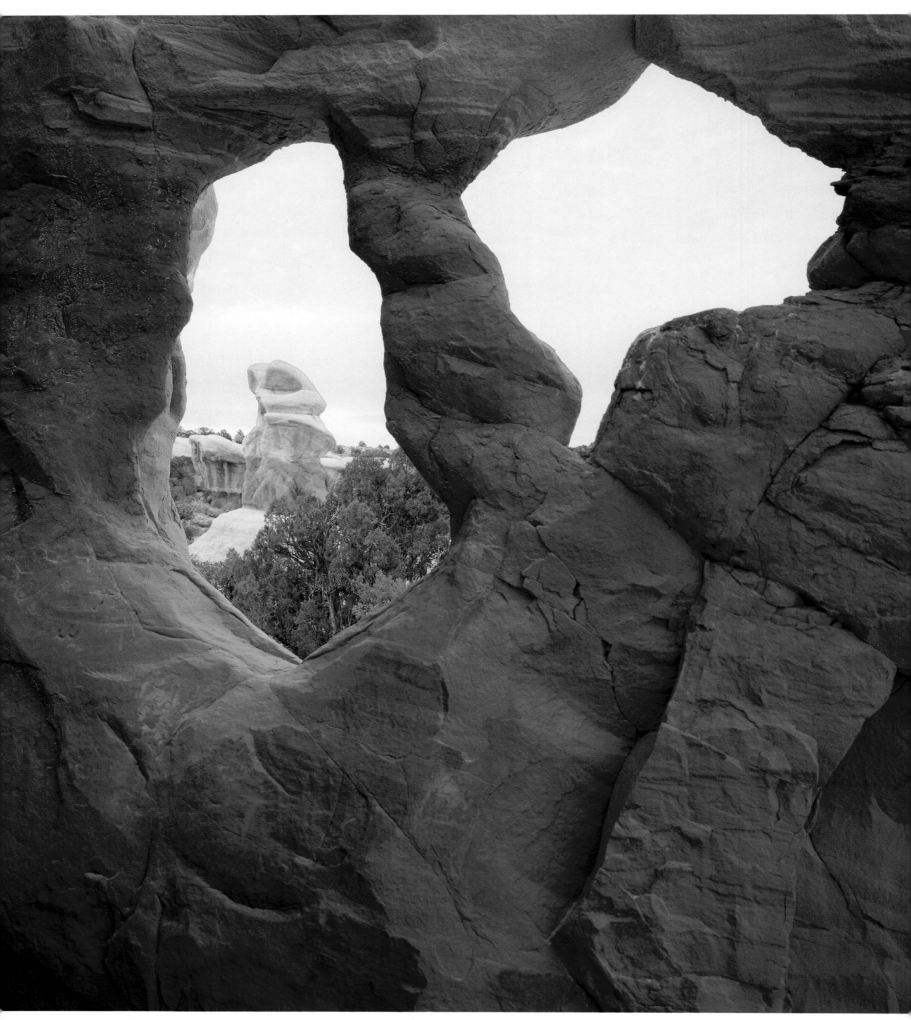

**Devils Garden,** *Grand Staircase–Escalante National Monument, Utah*

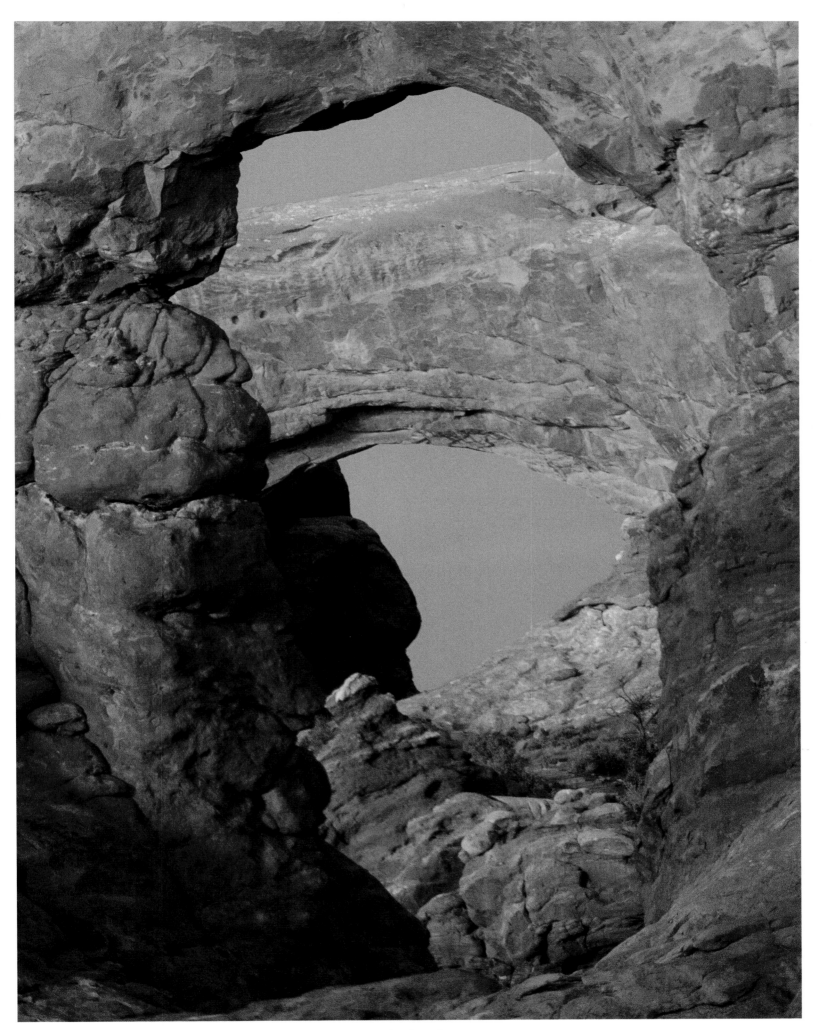

**Turret Arch and North Window,** *Arches National Park, Utah*

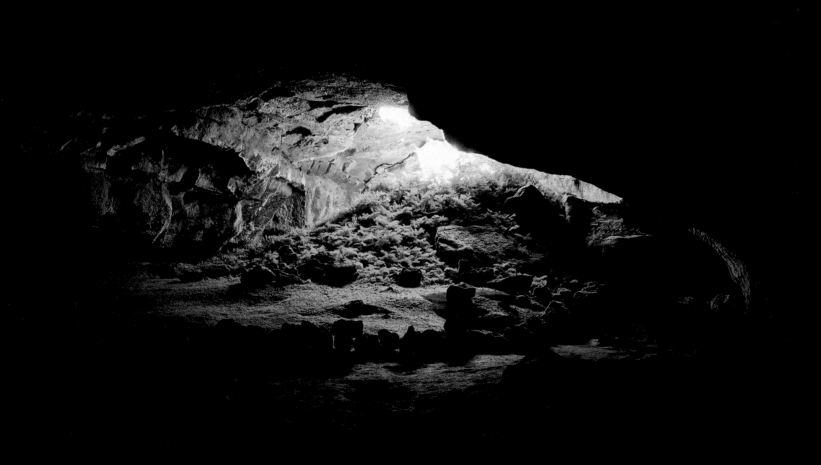

**Fern Grotto,** *Lava Beds National Monument, California*

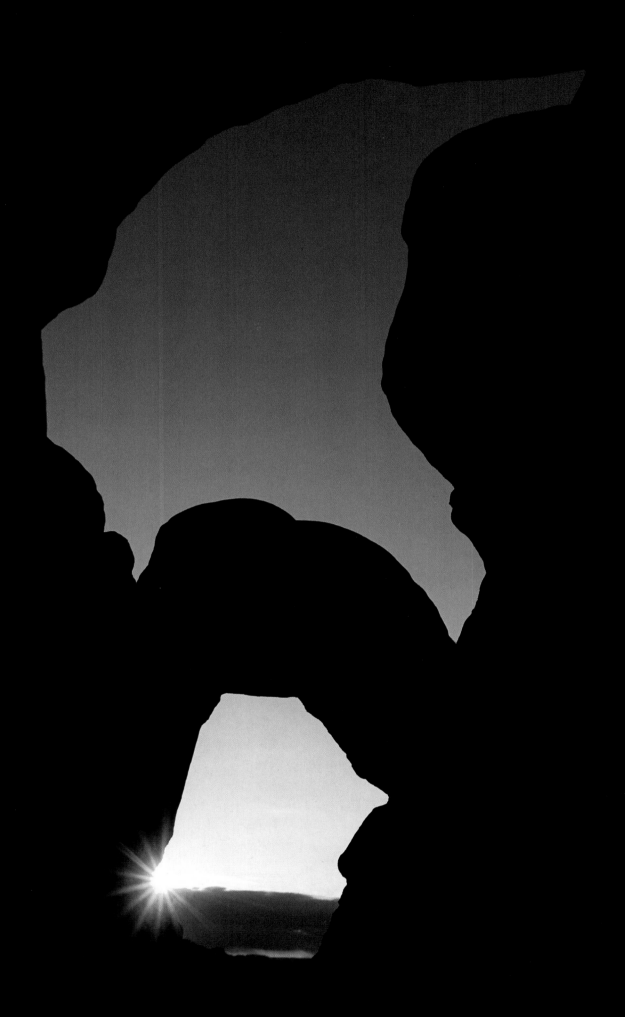

**Double Arch**, *Arches National Park, Utah*

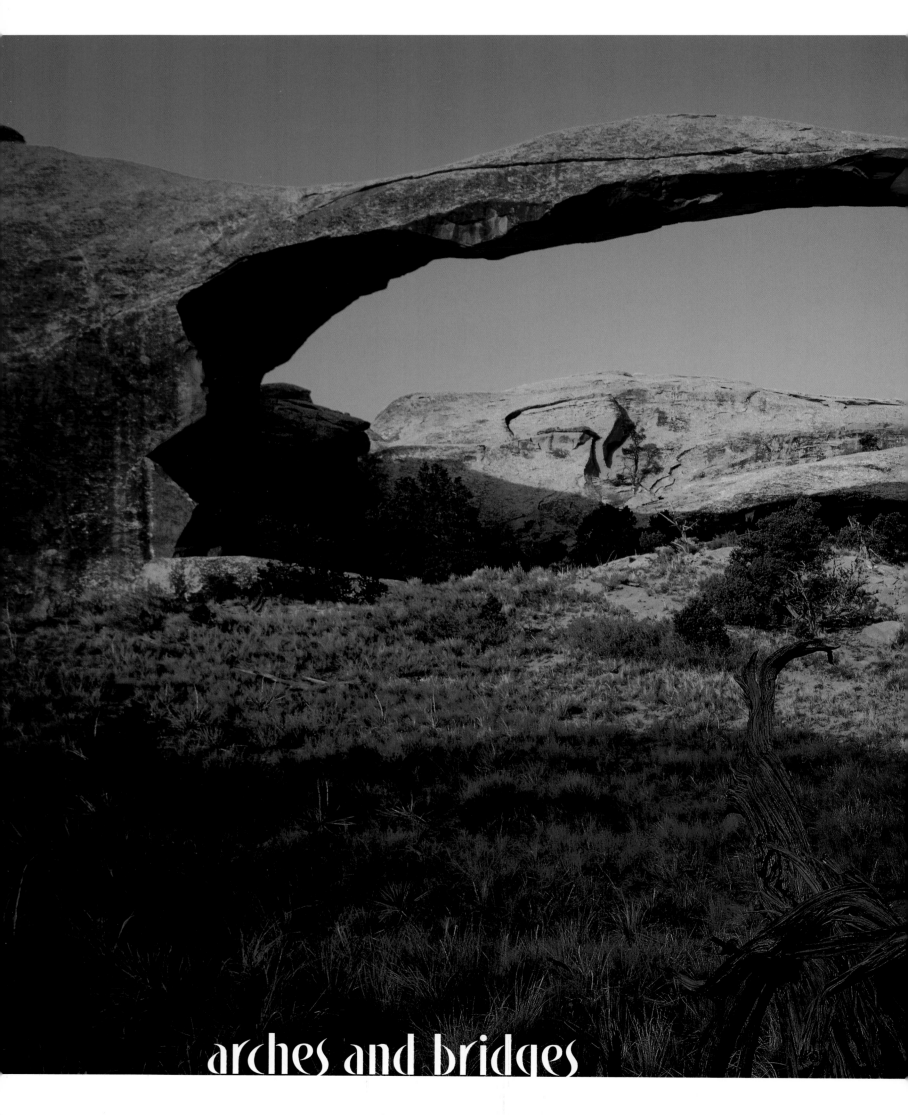

arches and bridges

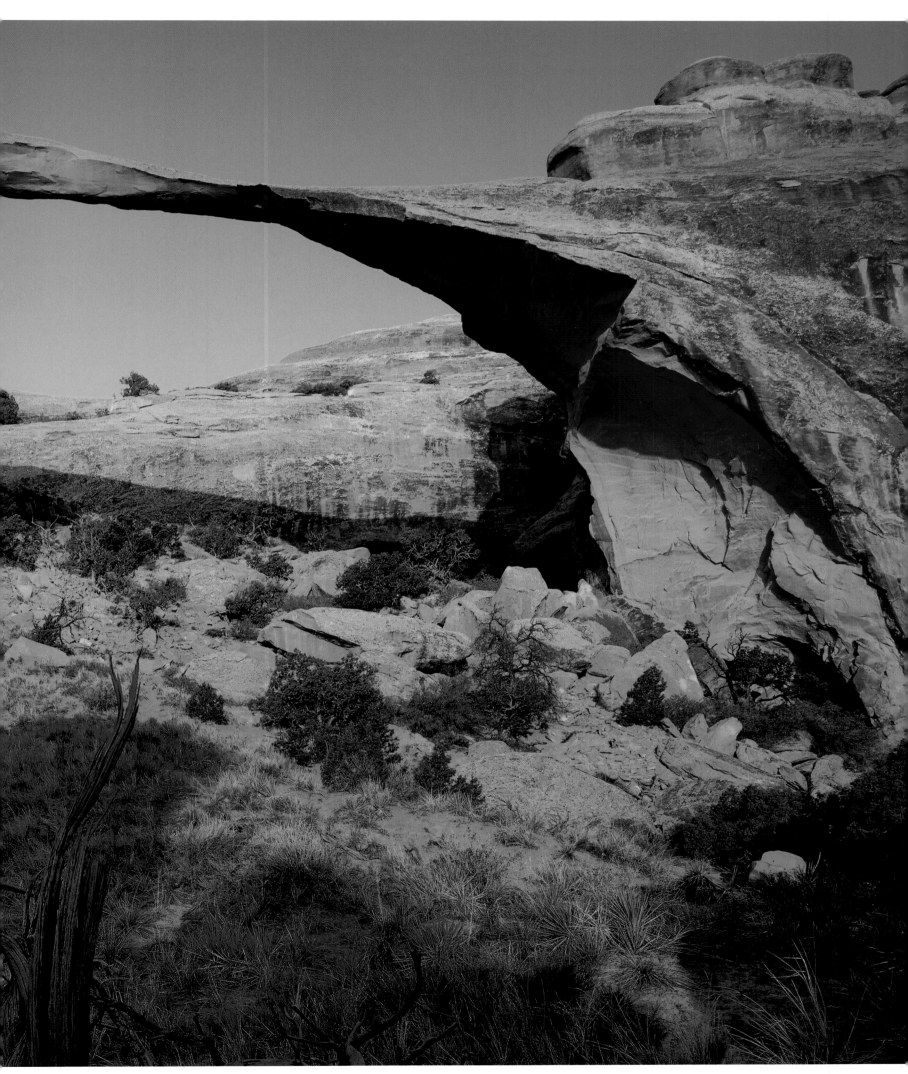

**Landscape Arch,** *Arches National Park, Utah*

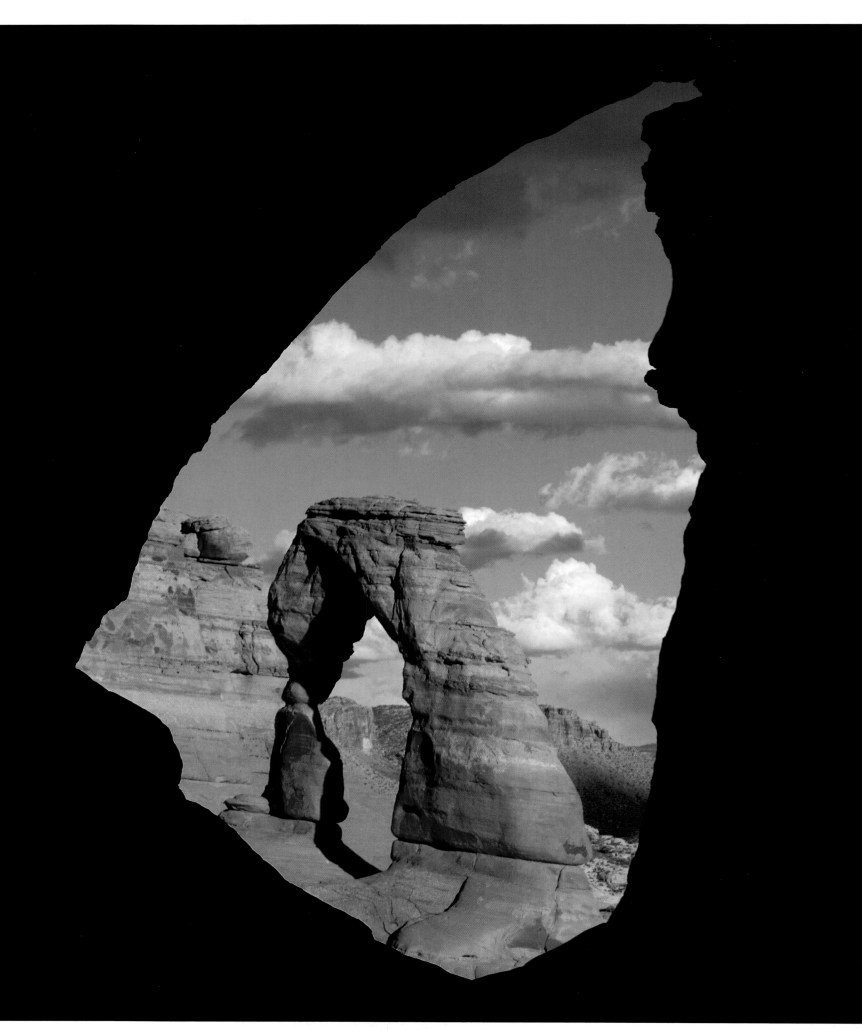

**Delicate Arch through Frame Arch,** *Arches National Park, Utah*

# arches and bridges

ARCHES NATIONAL PARK, UTAH. Containing more than five hundred arches within its boundaries, Utah's Arches National Park encompasses the greatest concentration of natural rock arches in the world. If you have one day in a lifetime to look at arches, go to the park's Devils Garden. In the view from Partition Arch, less than one and a half miles up the trail from the parking area, the geology is laid out before you in a great series of fins—long, narrow ridges of rock ideal for arch formation.

Three hundred million years ago, an ocean lay west of what is now Utah, while mountains rose to the northeast. As the mountains uplifted, a huge basin formed next to their northwest slope. Over the following eons, the ocean flooded the basin, creating an inland sea that evaporated and became inundated again twenty-nine times. Vast salt beds left behind with each evaporation grew to six thousand feet in thickness. By the time sea levels stabilized, the mountains had begun weathering so that their streams washed millions of tons of sediments onto the salt beds.

In mid-Jurassic times, the Entrada Sandstone out of which the arches and other forms in Arches National Park are carved was among those sediment layers. Under the pressure of the weight of the overlying layers, the salt moved like a glacier, flowing southwest for 200 million years. Where it passed over uneven surfaces, it was pushed up into anticlines, which are actually arch-shaped uplifts.

About ten million years ago, after the entire region had been uplifted to form the Colorado Plateau, the Colorado and Green Rivers began cutting down into the rocks. Where this cutting occurred, overlying rock and sediments were removed, exposing the salt anticlines at the surface. As streams then flowed across these anticlines, salt was dissolved and the anticlines began to collapse, widening valleys and forming deep, parallel fractures in the beds of Entrada Sandstone. As these fractures enlarged, pieces of the various beds were separated from one another, developing the rows of separate fins that form your view through Partition Arch.

Entrada Sandstone consists of three layers—the Dewey Bridge, the Slickrock, and the Moab Tongue. Each layer erodes differently. The dark, reddish brown Dewey Bridge on the bottom is less resistant than its upper layers, eroding more deeply so that it forms alcoves and hollows. It collapses altogether where it is unsupported, either forming openings or allowing them to grow larger. The red, smooth main section of Entrada Sandstone, the Slickrock layer, is more resistant. This layer is the one providing the image of red-rock country we all carry with us. The topmost layer, the yellow, pink, or beige Moab Tongue, is also a more resistant rock.

Exposed surfaces of rock are vulnerable to exfoliation, the peeling off of slabs of rock from the main rock. The exposed tops of newly developed slickrock fins round off as moisture seeps into the cracks, freezes, and expands, breaking off sharper rock fragments. The peeling usually occurs in concentric layers. Some fins are simply cut in two (or more) sections by the weathering process. Some present an arch form that does not go all the way through the fin so it may look like a shallow (or deep) amphitheater. On his epic trip down the Green and Colorado Rivers, John Wesley Powell used the word "arch" to describe arch-shaped alcoves that are not open clear through. Many of these grow into arches, then wear down and collapse.

On his epic trip down the Green and Colorado Rivers, John Wesley Powell used the word "arch" to describe arch-shaped alcoves that are not open clear through. Many of these grow into arches, then wear down and collapse.

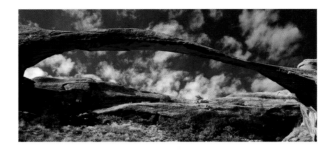

Landscape Arch . . . throwing off its raiments, approaches the end of its life as an arch. You expect it to break as you watch it; simply fall apart this one day in a million years.

Landscape Arch, which is 105 feet high and about 300 feet long, rates among the longest natural spans on earth and among the most fragile. One part of the span is only six feet wide. You can see the rock debris beneath it and, although nothing major has fallen from it since 1991, you know that it is shedding. In old age, it requires less. Throwing off its raiments, it approaches the end of its life as an arch. You expect it to break as you watch it; simply fall apart this one day in a million years. In whatever century this happens, it will be much to the dismay of photographers.

Landscape Arch, besides Delicate Arch, may be the most photographed arch in the world. On one trip there, David said—speaking of both Landscape and Delicate Arches—"Won't it be sad for the first person who sees them when they break?" I see it a different way. It is change, the constant, the tie among all that lives.

Walking the main path north through Devils Garden, Landscape Arch is the first feature I reached, about three-quarters of a mile from the parking area. For many people, it is the only arch visited in this remarkable area. From behind the railing separating visitors from the slope going up to the arch, I had a good view of the delicate span that looks to me like two elephants touching trunks.

Not far up the trail beyond Landscape Arch looms Wall Arch, so much a part of the wall I passed that it could be easily missed by someone focused on the trail. A pine tree grows straight and full and graceful almost dead center beneath the arch. Before me, a group of girls scrambled down the rocks beneath the arch, some of them frightened by the tricky footing of the terrain. "Hello, Nature!" two of them shouted.

Beyond Wall Arch, two short side trails lead to Partition and Navajo Arches. The main trail continues straight ahead to Double O Arch. The packed sand and gravel trail to Navajo Arch passes sweet-smelling spring juniper, ancient trees twisted and flowing, the forms wind takes when it chooses to be seen, and pines, dark, vibrant green against the red rock.

The approach to Navajo Arch seems more like an entrance to a cave than an arch. I entered a splendid chamber furnished with pine and juniper and old gray snags. Patinaed walls gleamed darkly. As I approached, there was sun at the entrance, cool shadow inside. The arch is thick and sturdy, abutting a sweeping wall. There are crevices along the wall, a few sloping rock mounds, a brilliantly green, full juniper for shade when sun reaches in. There is shelter under the arch from rain. This is a place I would like to stay. After my window on Storm Castle, it was the first arch I really loved.

Two months later, on a day of sand-battering wind, David and I hiked to Navajo Arch together. It was a day of hot sun, but you could not wear a hat that was not tied down. Our hats blew off and we put them in our packs. Our eyes stung with sand. When we spoke, sand filled our mouths. It stuck to the sun lotion on our arms and legs and whipped against us as we walked the short trail from the junction to the arch. Inside the arch's chamber, it whirled up into a dervish sandstorm, fiercer than the sand outside the chamber's walls. We could not linger. My love-arch spewed us out. Yet here was an opportunity to feel the carving, scouring ability of the wind. Although Navajo Arch had been denied me, I was given in its place a moment of geology.

**Landscape Arch,** *Arches National Park, Utah*

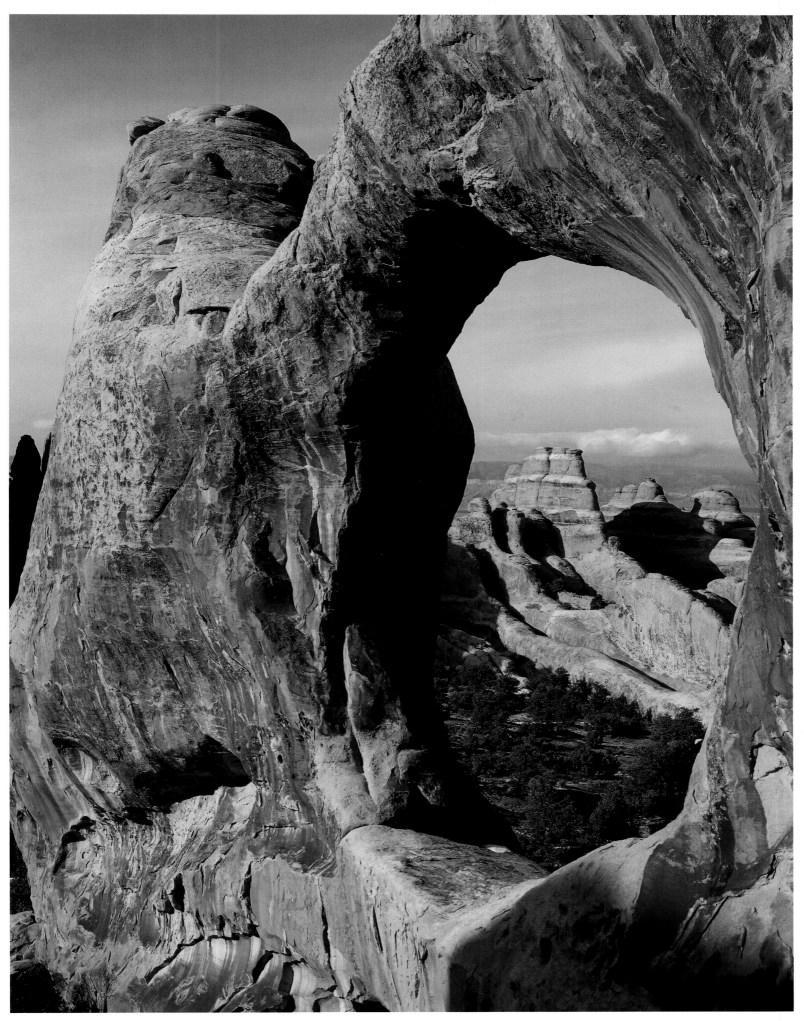

**Double O Arch and Fins,** *Arches National Park, Utah*

Through a small window of Partition Arch, I saw the La Sal Mountains to the southeast. Through this arch I saw the layers of fins, the ones that give you the kind of view of the geology you would get from a textbook. Only this is a real place, with a history you can feel. I saw the ancient seas that once covered this land. I saw eons, the colors of sand and of time. I saw rock eternally changing. Old arches. New arches forming. The half moon hanging above the wall grew full and came nearer and waned again. The juniper and pines against the arch wall grew. Their roots crumbled rock. On the sandy slope facing the arch, the yucca among the junipers bloomed.

Because Partition Arch is so easy to reach, there were many people there, even when I hiked in March. There were voices everywhere. I long for silence in such places, for some expression of awe, some moment of reverence. To hear the wind, the sound of a cricket or a bird or a dry leaf sliding across rock. Then, suddenly, everyone had left. A tiny squirrel ran into the arch from the edge between rock and sand a few feet below me. A bluebird, vibrant against the red rock, appeared from nowhere and hopped down the trail along the arch wall. I followed him as his mate flew up out of trees on my left to join him.

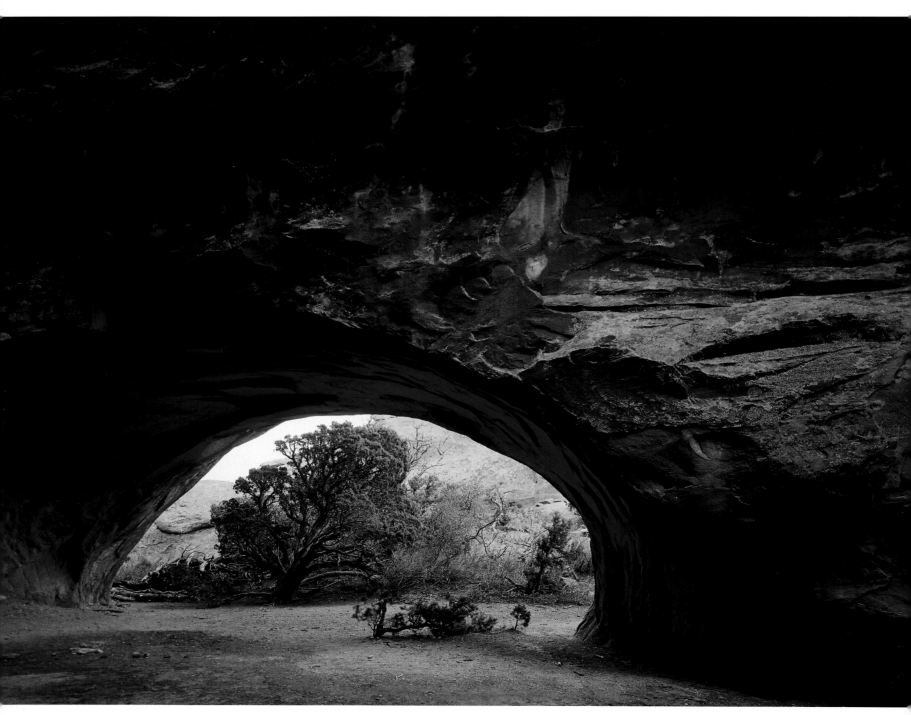

**Navajo Arch,** *Arches National Park, Utah*

The trail scrambles up a few steps carved out of the side of a fin, then follows its length a good deal of the way to Double O Arch. The higher of the two arches is more mature, the lower, smaller. Each forms a circle. It was late in the day now and the sun rimmed the inside of both arches. I was fascinated by this light and spent a long time watching it arrive, brighten, wane, and finally ease toward evening.

Sand Dune Arch is another span I love. But this one is close to the road, and advertised in park brochures as a good place to take children on a hot day, so it is often a busy place. The first time I came to it though, on a weekday in March, I had it to myself. It is hidden, in the back of a chamber concealed by a group of fins blocking views from the road. You would never imagine anything at all *inside* the high slabs of upright rock that seem to form a solid wall. A path from the parking area leads to a narrow passageway luring you into a sandy chamber. Sandstone walls of blue-gray and beige and shades of red are streaked with dark patina and late sun. Not much sun reaches so far inside this rock. You are some distance inside before you notice the arch, barely separate from the wall behind it at the back of a second chamber ballooning out from the main room. Between the wall and the arch there is just space enough to stand. The arch is perfect in its form, sturdy and young.

Less than half a mile beyond Sand Dune Arch is Broken Arch. It isn't broken, but a notch in the apex of the arch makes it look that way. The trail goes through the arch, then continues about a mile farther to the Devils Garden Campground, on its way passing through a wild, romantic landscape, winding among pines and junipers and huge boulders. To the west, high fins and boulders ease down to the trail. Open desert stretches east, north, and south.

It was late in the day, an hour for the beginning of lions. I have thought about mountain lions in country of rock ever since seeing the lion walk into the window on Storm Castle. This looked like lion country to me. There are so many places a lion can get high enough to see possible prey; so many places from which a lion could make a good leap. I wanted to dawdle because the trail was so compelling. I wanted to rush because my head was so filled with lions. I compromised by becoming doubly alert. From the campground the trail crosses open space then descends via a narrow canyon through the fins. At the trailhead there is a sign. "This is Lion Country," the sign says. "Lions can hurt you."

The deep beauty we sense in wildness is, in part, objective. But it is also the burgeoning of the primitive core of us, the core that understands that wildness can kill us. Hand to paw, we are not much match for a lion or a grizzly bear or a number of other animals. But wildness is in us, too. It exists in our own alertness to the place through which we walk. It is what allows us to survive in a wild world and what allows the wild world to survive even while we insist on taming, domesticating it. It's good to be scared sometimes. It helps us remember what formed us.

Toward the end of the canyon I lost the trail. Even returning to the last marker, I could not pick it up, but by then the canyon had opened up and the blackbrush and saltbush flats spreading around the canyon, fins, and arches allowed me a clear view of the road. I wanted to stay on a trail so as to harm the earth as little as possible. There is cryptobiotic crust here—a living amalgam of lichen, algae, fungi, mosses, cyanobacteria—that provides life needs for desert growth. When it is young, it can hardly be seen, but it can be destroyed by a single footstep, then take 250 years to grow enough to become fully functional. I walked carefully, grateful to be away from the rocks, even more grateful to have been in them.

Delicate Arch is the symbol of Arches National Park and, for many people, the symbol of the American Southwest. It is the photograph everybody wants. For nonphotographers, it is still a view devoutly sought. Reached via an uphill trek of one and a half miles over slickrock, it is one of the most popular walks in the park. So many people have followed this route that a trail has been worn into the rock. You can feel the trail with your feet as you descend from Delicate Arch after sunset. In the dark of early night, the rock holds the light of the

Hand to paw, we are not much match for a lion or a grizzly bear or a number of other animals. But wildness is in us, too. It exists in our own alertness to the place through which we walk.

In the course of eons,

falling water has dissolved

the cementing grain,

separating the arch from

the wall. Where the arch

stands free of its parent,

a thin sheet of light slides

behind it. Just below the

apex of the arch, there is

a sliver of sky.

moon or the stars, as it holds the footsteps of the thousands who have climbed to pay homage to the arch.

Photographers arrive early in the evening to find the best vantage point. Flutists and drummers play the sunset in, the sounds of their instruments drifting over rock and arch and sky as if belonging to the earth.

Unless you climb up the steep short slope to Frame Arch on the right side of the trail just before rounding the last bend in the trail to Delicate Arch, you do not see Delicate Arch until you come upon it. Frame Arch offers a spectacular view of Delicate Arch, with a sense of the surroundings you do not get from Delicate Arch itself. In the focus on reaching Delicate Arch, many people just pass by Frame Arch, making Delicate Arch a sudden, magnificent surprise. It simply appears, alone on the top edge of a deep bowl. No other rock stands in relation to it. Eighty-five feet high and sixty-five feet wide, it stands freeform against the sky. To the south, the La Sal Mountains form a distant backdrop, a kind of assurance that there are edges to the earth.

Once when we were up there, a young man, who had hiked up with his girlfriend, told us he planned to propose under the arch. (He wanted one of the many photographers to take their picture at the moment of the proposal.) The thirty or more people who gathered before sunset quickly became aware of the human drama about to take place. The couple walked around the rim of the basin curving steeply away beneath us. Ravens free-fell down the sky contained by the basin, somersaulting and diving, then pulling themselves sharply up as they neared the slickrock floor. By the time the couple reached the arch at the far end of the curved rim from where most viewers sit, they had it entirely to themselves. We watched them enter the arch. We watched him ask her. We watched her answer. Yes.

Separated from Arches National Park by the Colorado River, Morning Glory Arch hugs the side of a grotto, backing up against a solid high wall chiseled away in an echoing arch form. In the course of eons, falling water has dissolved the cementing grain, separating the arch from the wall. Where the arch stands free of its parent, a thin sheet of light slides behind it. Just below the apex of the arch, there is a sliver of sky. In a cul-de-sac at the back of the grotto, a stream runs down a narrow slot in the rock.

We hiked to the arch from Negro Bill Trailhead, a few miles north of Moab, on a hot May day. A sign at the trailhead—acknowledging that the canyon name requires an explanation in this politically correct age—explains, "Negro Bill Canyon is named after an early settler of the Moab area, William Granstaff. Granstaff came to Moab in 1877, making him one of the first non–Native American inhabitants of the region."

The trail follows a clear, rushing stream, its water cooling in the day's heat. The canyon walls are the red rock that is everywhere in this region, but the world they enclose is green and filled with wildflowers—red penstemon, pink wild roses, purple barrel cactus. We crossed the stream half a dozen times to reach the arch, imagining we approached a bridge rather than an arch—a structure as intimately connected with the stream as we were. In fact, creek and arch are separate from each other but the grotto housing them both is a paradise, a cool, green palace on a hot desert day.

CANYONLANDS NATIONAL PARK, UTAH. In Canyonlands National Park, not many miles south of Arches National Park, Mesa Arch is dawn's counterpart of Delicate Arch, the place to go for sunrise, when the inside of the low, stretching arch lights up as if made of fire. Formed at the edge of a high cliff, Mesa Arch frames Washerwoman Arch and the Pinnacles far below and beyond it and the La Sal Mountains in the distance. In the luminous light of dawn, the whimsical rock forms seen darkly through this arch seem part of a dream while Mesa Arch itself becomes a moment of our ancient memory, the visible part of silence between night and dawn, the transition moment when everything on earth changes.

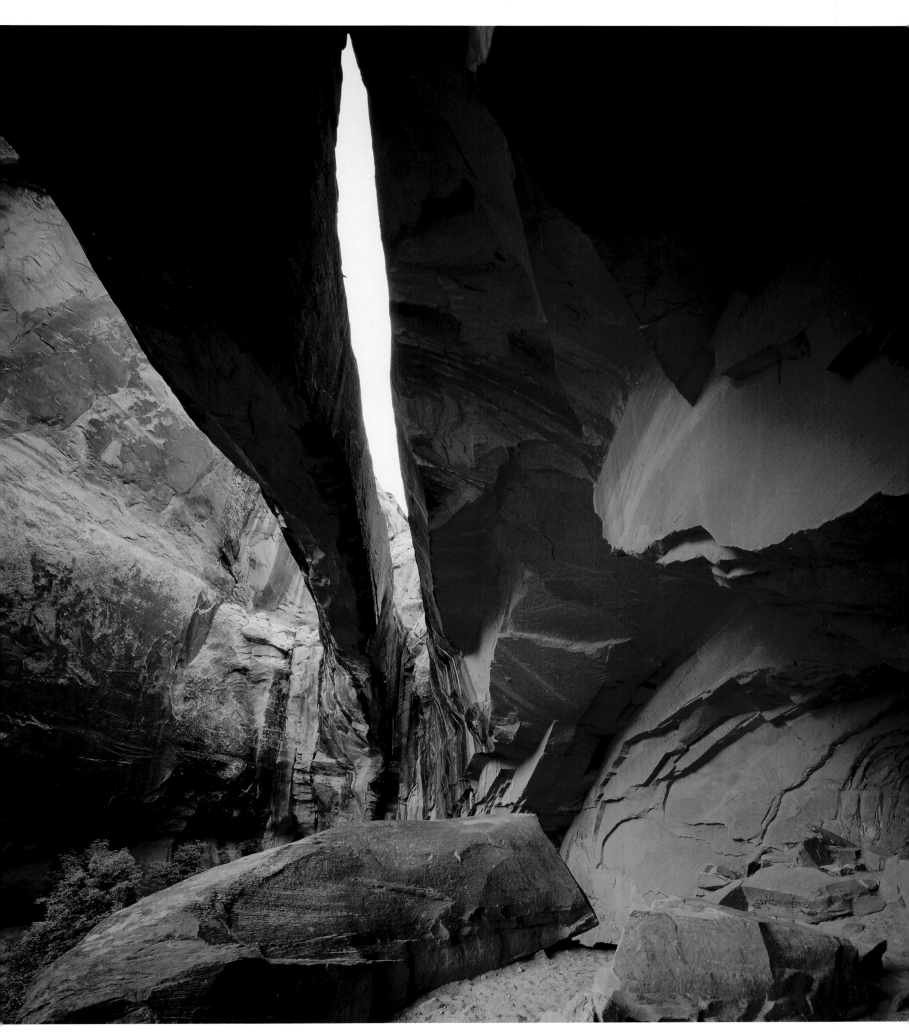

**Morning Glory Arch,** *Colorado River Canyon, Utah*

Although geologists say that, of wind and water, water is the more important sculpting force, you could have fooled us. Because the speed of wind is highest less than twenty inches above the ground, the greatest amount of erosion happens there.

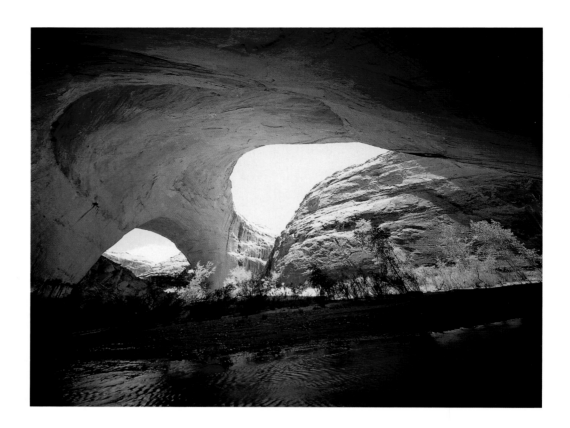

**Coyote Gulch/Escalante,** *Glen Canyon National Recreation Area, Utah*

GRAND STAIRCASE–ESCALANTE NATIONAL MONUMENT, UTAH. One quiet spring morning, we followed a sand path to the slickrock plateau edging Coyote Gulch in the Escalante country, then crossed the hills and gullies of the plateau to reach the gulch. A mile or so north of our start at the end of the Forty Mile Ridge primitive road, we arrived at a downclimb on a steep rock cliff. It is about 150 feet down from the plateau into the gulch. By the time we reached the descent, the wind had picked up on the plateau, although inside the gulch, the high, curving walls kept the wind at bay. Myriad seeps along the walls nurture maidenhair fern and columbine. Willows, cottonwoods, grasses (and lots of poison ivy) line both sides of the creek. Jacob Hamblin Arch (also called Lobo Arch) stands in an S-curve just west of the downclimb. Coyote Natural Bridge is a mile or two downstream. Stevens Arch, at the mouth of Stevens Canyon, near the stream's junction with the Escalante River is a few miles farther east.

When we retraced our steps across the plateau to reach the truck, we walked into a raging thirty- to forty-mile-per-hour headwind. Although geologists say that, of wind and water, water is the more important sculpting force, you could have fooled us. Because the speed of wind is highest less than twenty inches above the ground, the greatest amount of erosion happens there. The sand lying at the edges and cracks of the slickrock whipped against our bare legs and arms and into our faces.

"This is what it feels like to be an arch," David said.

After the harsh wind at Coyote Gulch, we were given an easy morning in Escalante. Under a clear sky, with hardly a breeze, we trudged downhill over sand to enter a quiet, gentle canyon. Maidenhair fern grows thickly in moist places along the canyon walls. Lizards are everywhere. We counted nineteen on a single rock.

Three miles from our start, Broken Bow Arch appeared as we rounded one final bend in the twisting, high-walled Willow Gulch. This perfect arch is shaped like a bow for some giant archer, except the bottom part of it seems cut off, stuck deep in the earth, missing. Perhaps it should be called Half Bow Arch. (According to Rudi Lambrechtse, author of *Hiking the Escalante,* the arch is actually named for a broken Indian bow found near its base in 1930 by local historian Edson B. Alvey.) The sturdy arch forms the end of the massive, curving canyon wall. Without the arch, the wall would define the end of the earth.

CHUSKA MOUNTAINS, NEW MEXICO. Royal Arch, also known as Gregg Arch, is an odd one. One side of it is very broad with an almost straight inner edge. The other side is much narrower, curving from the top of the arch to its waist and out again. The top appears narrow, a fragile, temporary span. The view through the arch is of forested ridges on the northern extension of the Chuska Mountains, a range the Navajo (who see life as a balance of male and female) consider a male anthropomorphic figure. To the east of Royal Arch, Shiprock (the figure's medicine pouch or bow), rises out of a vast plain. Buttes, monuments, and cliffside ledges extend in all directions from the arch. A huge rubble of boulders lies at their base. I studied the arch from a ledge backed by a red rock wall lined with caves and amphitheaters—more of the arch-shaped sculpting the earth seems so to favor.

I like the fact that Royal Arch is not a federal playground. The park and forest services do their utmost to protect the arches, natural bridges, and other rock formations in their jurisdiction, but the mere fact of a place being easily accessible to the public puts it in jeopardy. Maybe it is that we do not know how to handle awe. Maybe the unexpected in nature—a special form, a magnificent setting—calls out to certain people to perform acts ranging from disrespectful to destructive. Maybe that is a way to reduce beauty to some debased, but familiar, human perspective so it will not be necessary to deal with awe. Awe is a spiritual act and we are often uncomfortable with the truly spiritual. A photographer sets a fire under an arch to enhance his photograph, heedless of the danger smoke and fire present to the fragile sandstone. A boy peels a strip of rock from an already exfoliating arch. A show-off mars the base of an arch by incising his name. Two people climb to the top of a fragile arch, just beyond a sign saying NO CLIMBING.

These people are the minority, but no piece of land that gets the amount of visitation as our national parks do, remains untouched. Consider the footsteps worn into the slickrock route to Delicate Arch. We are hard on the earth. At least we might be respectful of her artwork. So I am glad to come to a place that is hard enough to reach that I may not return to it. My absence pays it honor.

EL MALPAIS NATIONAL CONSERVATION AREA, NEW MEXICO. Under an arch is not the smartest place to sit. The arch, forever in the process of forming, sends down rocks on the wind. We visited La Ventana Arch in New Mexico's high desert between Gallup and Albuquerque on an evening of fierce wind. Hearing what sounded like a rockslide, I thought of a rockslide in the Karwendel Mountains in Austria's Tyrol, when a chunk of mountain rolled down across the

We are hard on the earth. At least we might be respectful of her artwork. So I am glad to come to a place that is hard enough to reach that I will not return to it. My absence pays it honor.

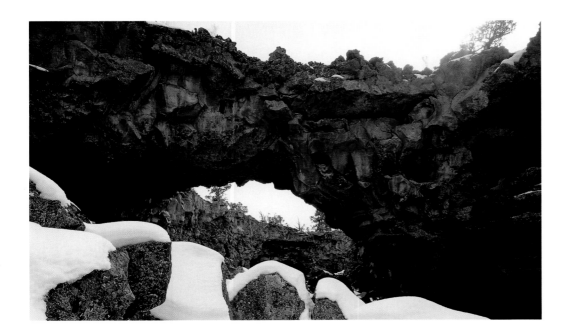

**Lava Tube,** *El Malpais National Monument and Conservation Area, New Mexico*

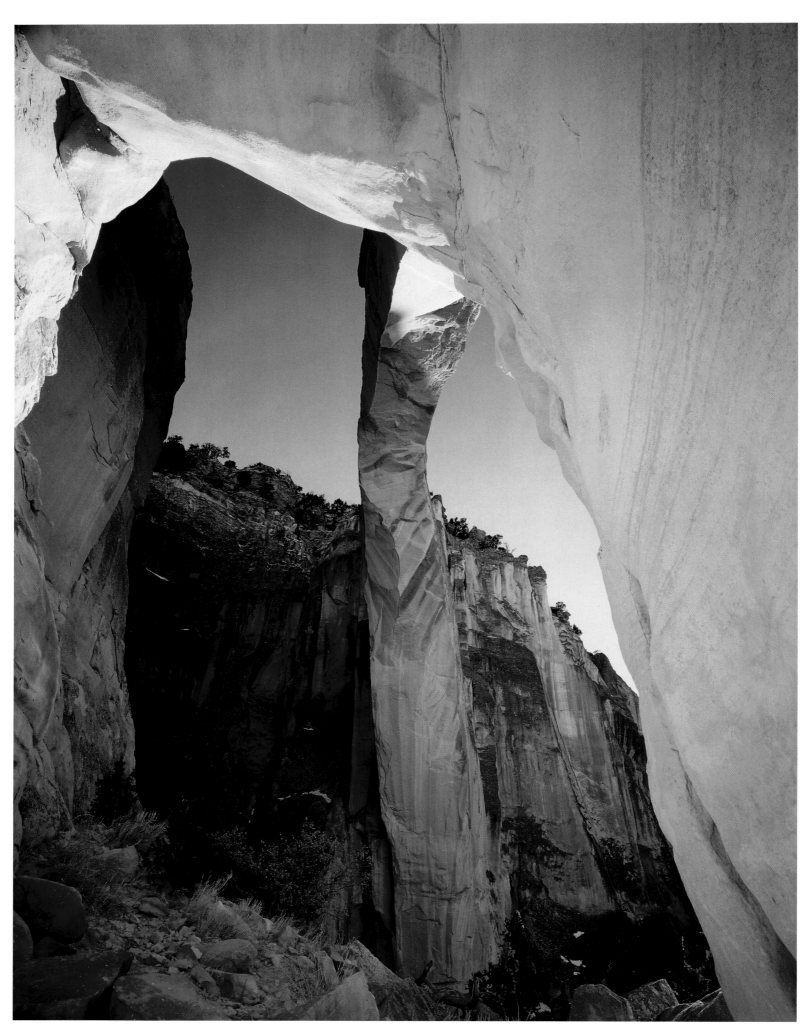

**La Ventana Arch,** *El Malpais National Monument and Conservation Area, New Mexico*

path we had walked moments before. The rock itself was preceded by a huge cloud of dust, the dust sliding down the mountain, the sound following like the roar of unimaginable wind, and then the dust cloud rising, as if it would climb the mountain to return whence it had come.

I learned then never to dawdle on trails or in meadows below the rockslides of centuries. It is no different here. And yet I sat inside La Ventana—*the window*—looking out beyond the giant boulders that have fallen from the wall to form the arch. A few hundred feet below me, the valley grass was the color of sandstone. In the greater distance I could see bare black volcanic rock, the rock of *el malpais,* "the badlands."

There are numerous levels, rooms, and walls here. A path at the bottom of the arch wall climbs steadily to the first of the rooms, a niche backing into the southern buttress of the arch, sandy floored, open to the wind. Another path winds around and over boulders into a large, darker chamber protected by lofty walls on three sides and huge boulders tumbled from the arch in front. This is a sturdy arch, clean, its sides soaring monumentally upward, its rock subtly colored sage and coral and beige, streaked with black.

CANYON DE CHELLY NATIONAL MONUMENT, ARIZONA. From the mouth of Canyon de Chelly near Thunderbird Lodge in Arizona, we drove across the flat, broad canyon floor, passing White House Ruins, other ruins, Navajo farms, and grazing sheep. There is a rural quality to this canyon, home to many Navajo people, and home to so many others before them. Carmen Hunter, our guide for our visit to the Window, told us who lives or lived in each homesite we passed and how they are related to the Hunters. She showed us the crack on the wall where her family got its name after a group of men shot arrows into the wall to see who could earn the name of Hunter. Her great-grandfather's arrow was the only one that stuck. The tip of the arrow remains imbedded in the wall, but the arrow itself is in the possession of her cousin's grandmother who keeps it under wraps.

In the morning, before joining Carmen, we hiked down to White House Ruins, the one place in the canyon visitors may go without a Navajo guide. Half a dozen Navajos had set up tables beneath the cottonwoods in front of the ruins to sell jewelry. At a table set up apart from the others, the craftsman offering his wares worked on a bracelet, completely absorbed. His work also stood apart, and we chose a bracelet of heavy silver, beautifully engraved on both sides, including a tiny coyote on the inside. His clan sign, the man said. I put the bracelet on my wrist. When we climbed out of the canyon to meet Carmen Hunter at the visitor center, she said, "My father made your bracelet." Her father descends into the canyon daily with a fifty-pound pack of his wares and another ten pounds of tools so he can work while he is there. He climbs up with it all at the end of the day although, hopefully, he has sold much of the jewelry by then.

Many homesites we passed on our way to the Window are essentially abandoned—the younger generations have little interest in so hard or isolated a life. But where there were sheep and crops, we felt the intimate connection with an old life. This is apparent even to those who only hike down to the White House Ruins. As soon as we reached the canyon floor, we came upon a large, fenced field where sheep grazed. Smoke rose from the hogan chimney.

The sandy track we drove upcanyon narrowed. It crossed the Canyon de Chelly wash, steeply angling down into the wash, then steeply coming up again. The route to the Window is not an easy one. But suddenly the land opened up and the arch appeared high up on a sheer rock wall. Driving around the end of the massive, turreted wall and through the wash again, we arrived at a grove of spring green cottonwoods, parked the truck, and began the steep climb up about five hundred feet of talused slope to the back of the arch.

Directly opposite the arch opening is a spacious cave, once home to Ancestral Puebloans. From it they had a view down into the canyon to the south and out, through the vast window of the arch, to the canyon in the west.

I learned then never to dawdle on trails or in meadows below the rockslides of centuries . . . yet I sat inside La Ventana—*the window*—looking out beyond the giant boulders that have fallen from the wall to form the arch. In the greater distance I could see bare black volcanic rock, the rock of *el malpais,* "the badlands."

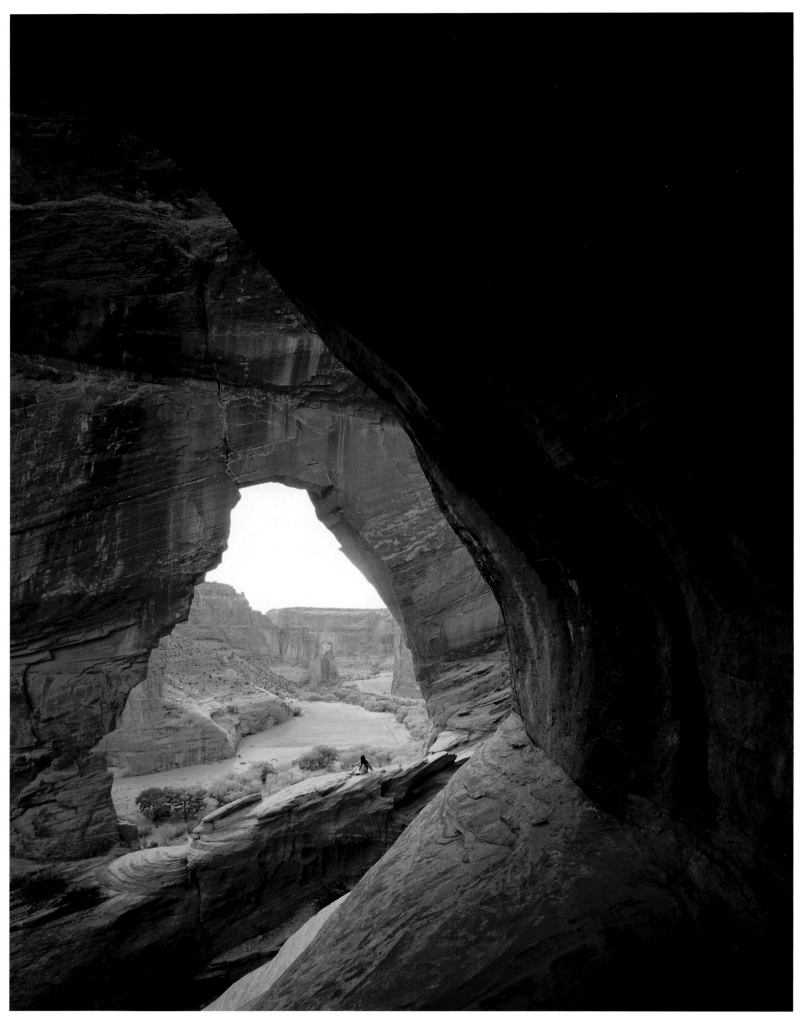

**The Window,** *Canyon de Chelly National Monument, Arizona*

In the late afternoon, after descending from the arch while David remained in the cave to photograph, I walked back along the dirt track. I crossed the wash, then sat on a rock beside the road to contemplate geology. The arch looks so much smaller from the western side. If I had not climbed up to it on the other side, I would have no sense of its size or the massive quality of its structure. You could pass any geological structure on the road, marvel at it, and never have a true sense of what it is. To understand geology, you do not need to know the names of things, but you must have seen and touched and been present to the structure itself. Things half seen can have a sacred quality. Things unknown can as well. But the utter wonder that comes from having experienced all the facets of a thing is the fullest expression of the sacred.

At the arch I experienced a world of rock sculpted into nature's forms—the arch and the cave behind it. From the road, I saw the sun, brilliant on the spring green of trees under a deep gray sky and the wash gurgling over rock and pebbles, its water so clear I could see the red-brown bottom mud of its course. Studying the wall I had thought solid and sheer, I realized the arch is cut out of a separate fin, joined to the wall but separate. The entire wall is a series of separate fins, all molded together. Why does an arch form in one fin, but not the fin next to it?

YOSEMITE NATIONAL PARK, CALIFORNIA. On the north rim of Yosemite Valley, an unusual granite arch on 8,200-foot Indian Rock is accessible via a turn off the trail to North Dome, then a brief, steep climb up a granite slope. You cannot see the arch as you climb. There seems to be nothing up there but a huge pile of rocks spiraling up to a point, a giant cairn built by giant gods. Not until you are actually on top can you see the arch, a thin slab of granite covered with black lichen, stretching across an opening that looks out on Half Dome and southeast to the Sierra Nevada crest.

> Things half seen can have a sacred quality. Things unknown can as well. But the utter wonder that comes from having experienced all the facets of a thing is the fullest expression of the sacred.

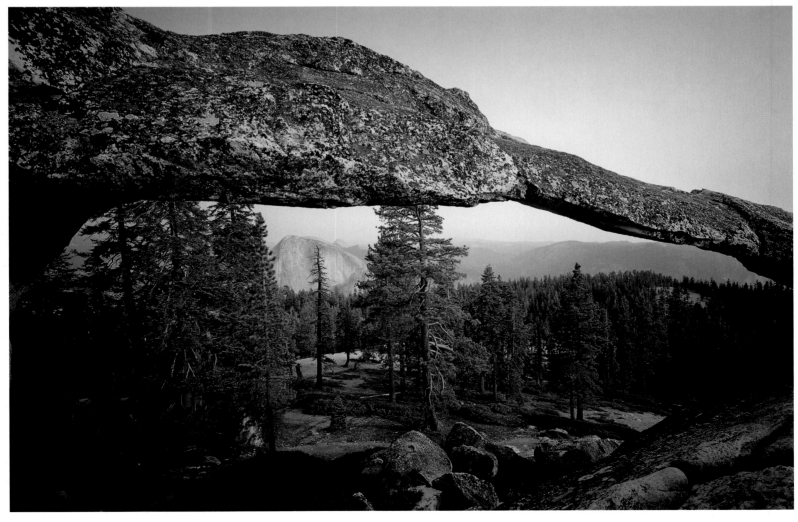

**Indian Rock,** *Yosemite National Park, California*

In a land of huge, glacier-rounded domes, the sharp-edged arch is an oddity. So is a second arch, or window, that reveals itself once you are on top. This one, which looks like an aperture in a small castle, is made of six or seven huge boulders leaning against one another with a jagged opening below the top boulders, all of it perched on the end of the rock area that is home to the larger arch.

To photograph the main arch, David climbed onto a huge boulder, balancing his camera on a smaller boulder on top. With about fifteen inches of standing room, one wrong step backward and he would be over the steep cliff side of the boulder. It is better not to watch a photographer work.

Late light streaked the rock ledge where I sat and the granite walls extending from the arch. There is black lichen at the top of the wall, ochre, chartreuse, and green lichen farther down.

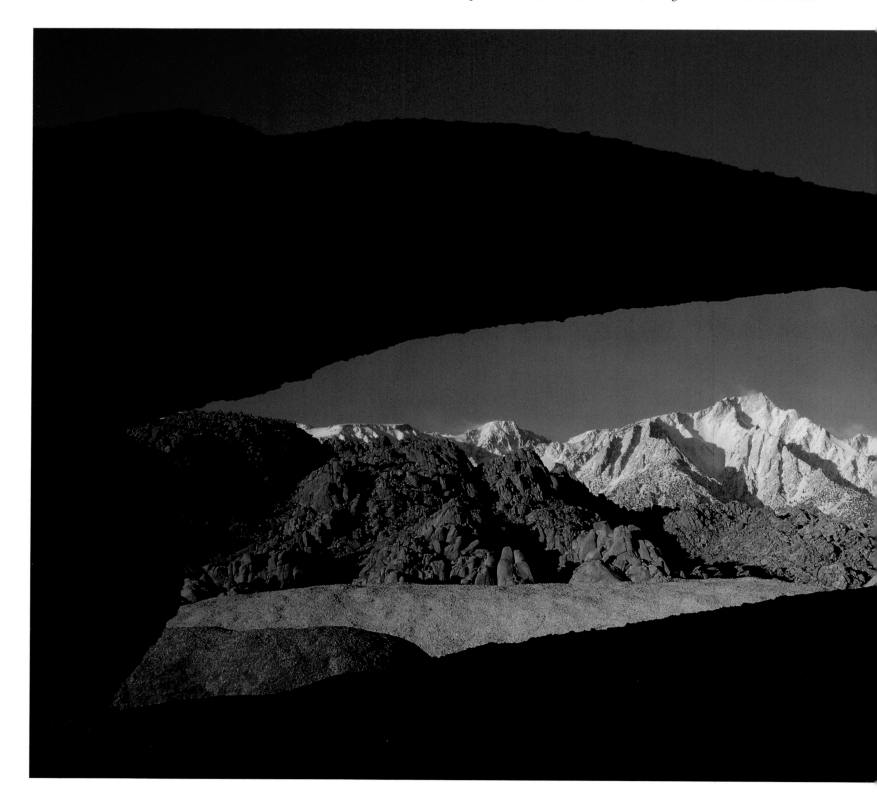

The granite is full of cracks, so you can see how water found its way to breaking off all the rock that had to fall away to form this arch. I watched the light change. We would use the last light to come off this granite. In the few miles of forest between us and the road, the Jeffrey pines, ponderosa, red firs, and huge lodgepoles lining the trail keeping it cool in the afternoon would make it dark even before full night. And it would be full night before we reached the Tioga Road.

SIERRA NEVADA, EAST SIDE, CALIFORNIA. Not far from Lone Pine, California, we walked from Movie Road to a hoodoo garden in the Alabama Hills. Crossing hot sand, we kept our eyes peeled for rattlesnakes. It was past 6:30 in the evening and the temperature was 103 degrees. I thought it too hot for rattlesnakes.

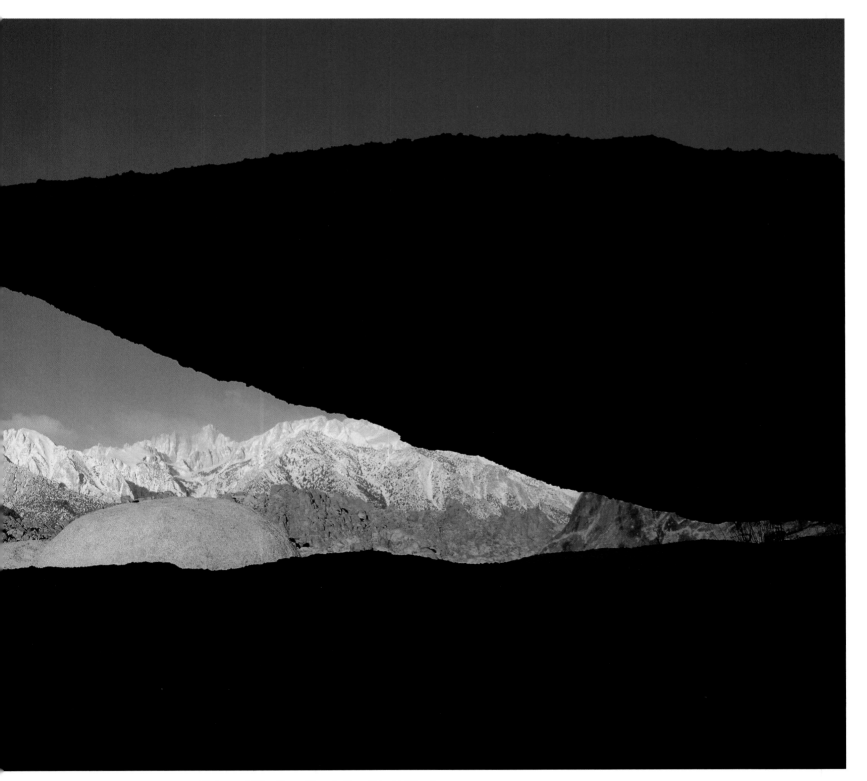

**Alabama Hills,** *Sierra Nevada East Side, California*

We had become used to the cave world and, in that time, were no longer prepared for the world above. . . . He wanted to prepare us for what life on earth offered. It is the same when you have sat for hours with an arch. The world beyond it is different. When you engage with arches, you engage in the eons of their forming.

Hoodoos are natural rock forms in fantastical shapes, like beings from the core of the earth. Formed by rain and weathering, these huge boulders rise in silent, solid testament to the life, whimsy, grace, and insistence of rock. Many of them sport arches or windows in their organic, flowing forms. We had come to look at two; the smaller of which is shaped like a miniature Landscape Arch, but chiseled out of the granite this region has produced. The larger is a dancer reaching beyond the confines of the body, reaching out of the earth and back into the earth. Its arch frames a world of hoodoos, level upon level of them, all rose-tinged in this rose-lit sky. The dreamlike quality created by the afternoon haze enhanced the mystery of this place.

Granite is my favorite rock; the most serious, real rock. Beginning as hot magma rising from inside the earth to cool into the rock of choice for climbers and sculptors, this rock of subtle colors—white and gentle gray, mottled black and beige and rose—appears on the earth's surface as if it were fluid and solid at once. When it is less than vertical, it usually offers some comfortable place to sit or lounge. What I saw in these rocks of the Alabama Hills is granite's immense grace, as it forms itself into amazing postures, flowing and alive.

GREAT BASIN NATIONAL PARK, NEVADA. Great Basin National Park is a classic example of the basin-and-range landscape covering most of Nevada and parts of Utah, Oregon, and California—a wild, lonesome country of mountain ranges divided by river basins whose waters do not flow to the sea. This park, with the Snake Range at its core, is a land of extravagant contrasts: high, green mountains where bristlecone pine forests boast some of the oldest trees on earth; hot, sagebrush desert; subterranean caves; and Lexington Arch, a six-story-tall limestone anomaly rising out of a jumble of juniper and pine. To reach the arch, you must leave the national park, cross the Nevada border into Utah, and then drive a twelve-mile dirt road to a parking area in the Humboldt-Toiyabe National Forest.

Our first view of the arch was near the end of the dirt road. It was also the last view for most of the one-and-three-quarter-mile walk to it. The trail switchbacks up a steep hillside, climbing 830 feet on the way. When it enters the park about a quarter mile from the arch, we could see the arch again. High on the skyline, it is quite grand against the sky.

Although this is a popular trail, in mid-August there was no one else there. The arch was entirely ours—the arch and the world surrounding it, the gravel hillside and the trees and the limestone cliffs east of the arch.

Great Basin National Park literature says that Lexington Arch may have begun underground, a passage in a cave system. It also says the arch may, in fact, be a bridge; that in the distant past Lexington Creek flowed through a cave in the canyon wall, enlarging the tunnel that became the arch. We walked through Lehman Caves, where water has carved the limestone into a vast series of magical rooms, archways, niches, and tunnels. It was hard, looking at Lexington Arch, to see it as ever having been underground—it seems so triumphal an announcement of cliff and ridge and sky. There are two soaring points—a pinnacle to one side of the arch and the peak formed by the apex of the arch—which make it seem regal, some sort of entranceway to Valhalla. I would not be surprised to find Valkyries along the path. But the arch buttresses are pocked with holes and tiny caves and cracks inside of which there are folds and miniature structures similar to those we saw in Lehman Caves. Flowstone at the base of the arch is a deposit that forms in caves.

Clouds covered more and more of the sky. David waited for the perfect moment of light. Life is easier for writers than for photographers. The mystery, the silence, the centuries, the grandeur of the arch are there whether the light is good or not.

When we were about to exit Lehman Caves in the early afternoon, the ranger guiding the tour stopped us and said, "You are about to enter a different world. It will be very bright out there. And warm. If you have sunglasses, you might want to put them on."

We had become used to the cave world and, in that time, were no longer prepared for the world above. We had become like blind cave fish sensitive to the tiniest vibrations in the water, or cave crickets, feeling their way through eternal night with long, slender antennae. He wanted to prepare us for what life on earth offered. It is the same when you have sat for hours with an arch. The world beyond it is different. When you engage with arches, you engage in the eons of their forming.

The sun lowered through clouds to the notch between the two peaks. It lowered into the arch itself, edging the back of the arch's north side with gold, moving in blinding gold across the arch until, directly centered, it erased the arch and there was only sun.

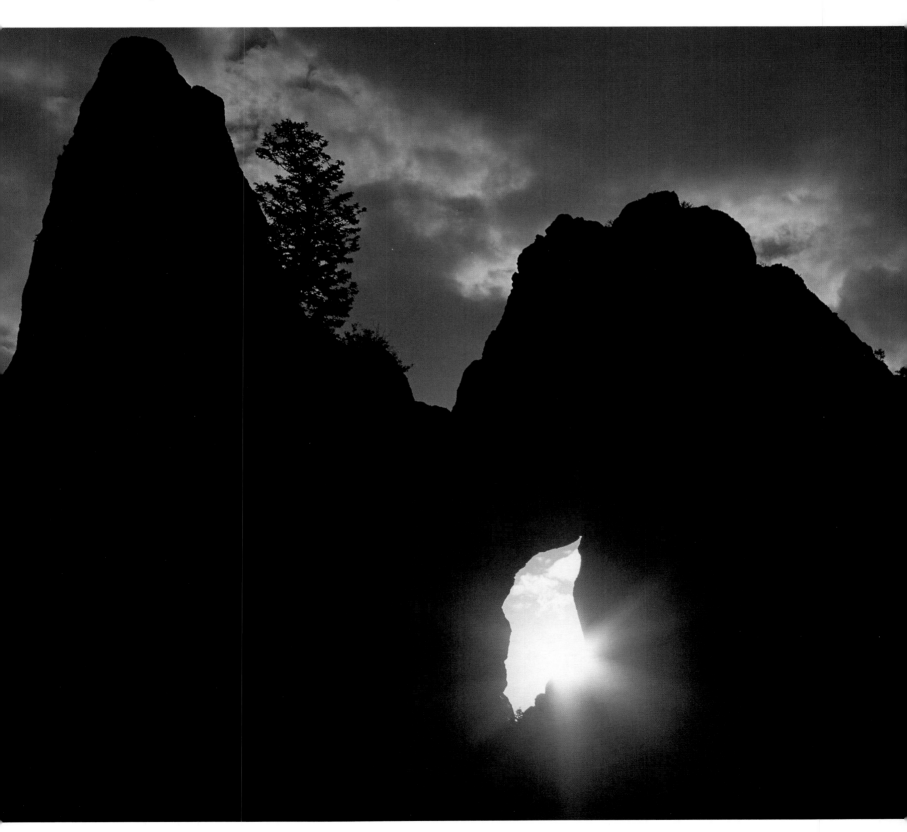

**Lexington Arch,** *Great Basin National Park, Nevada*

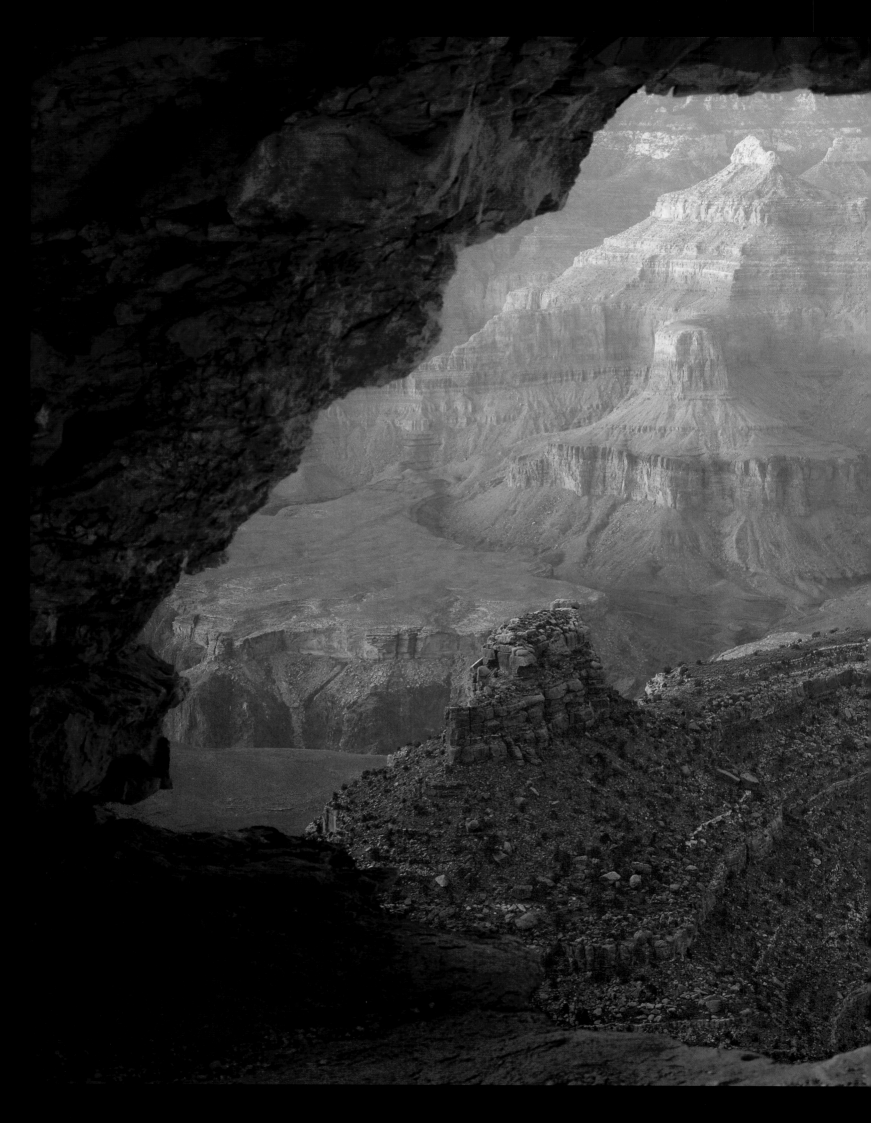

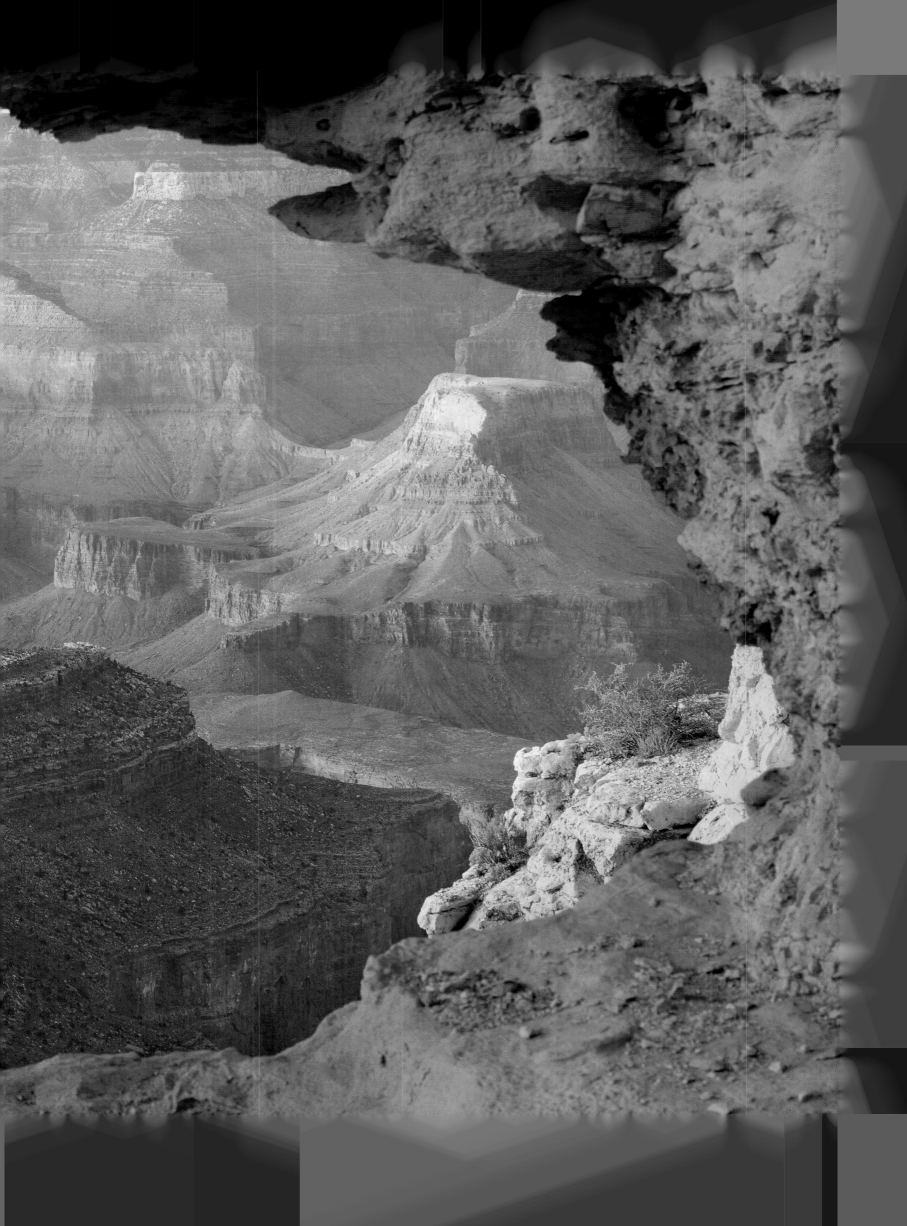

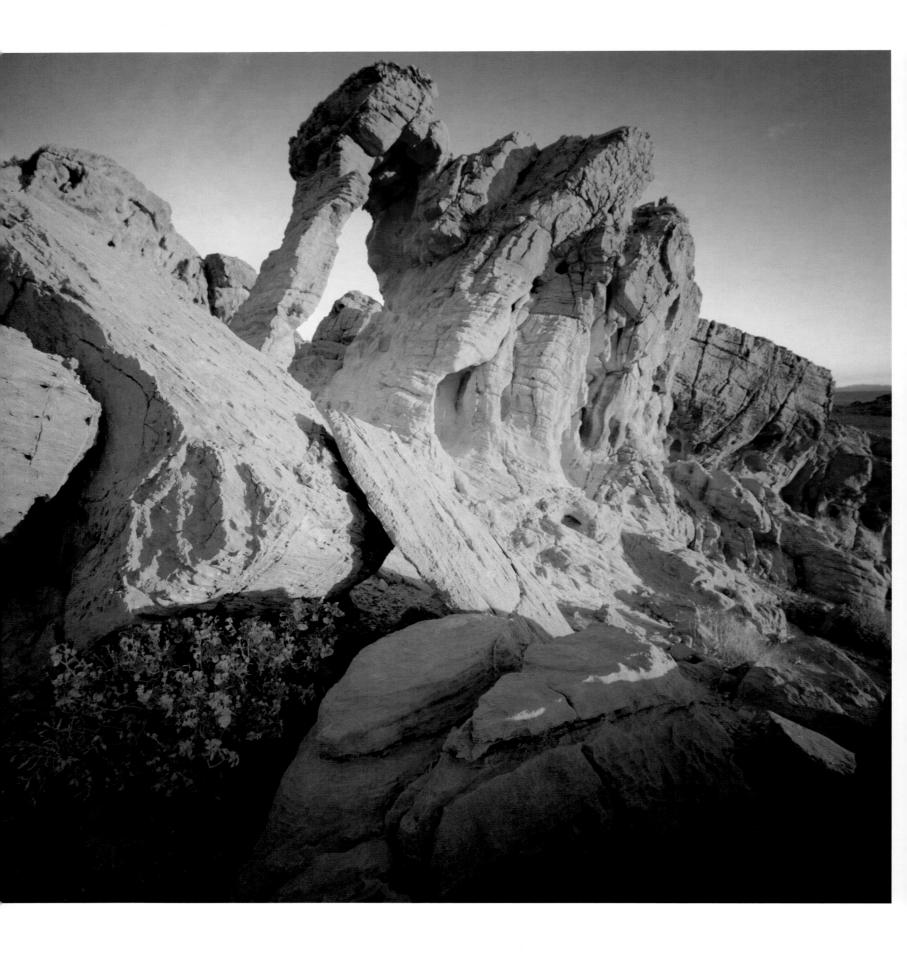

**Elephant Rock,** *Valley of Fire State Park, Nevada*

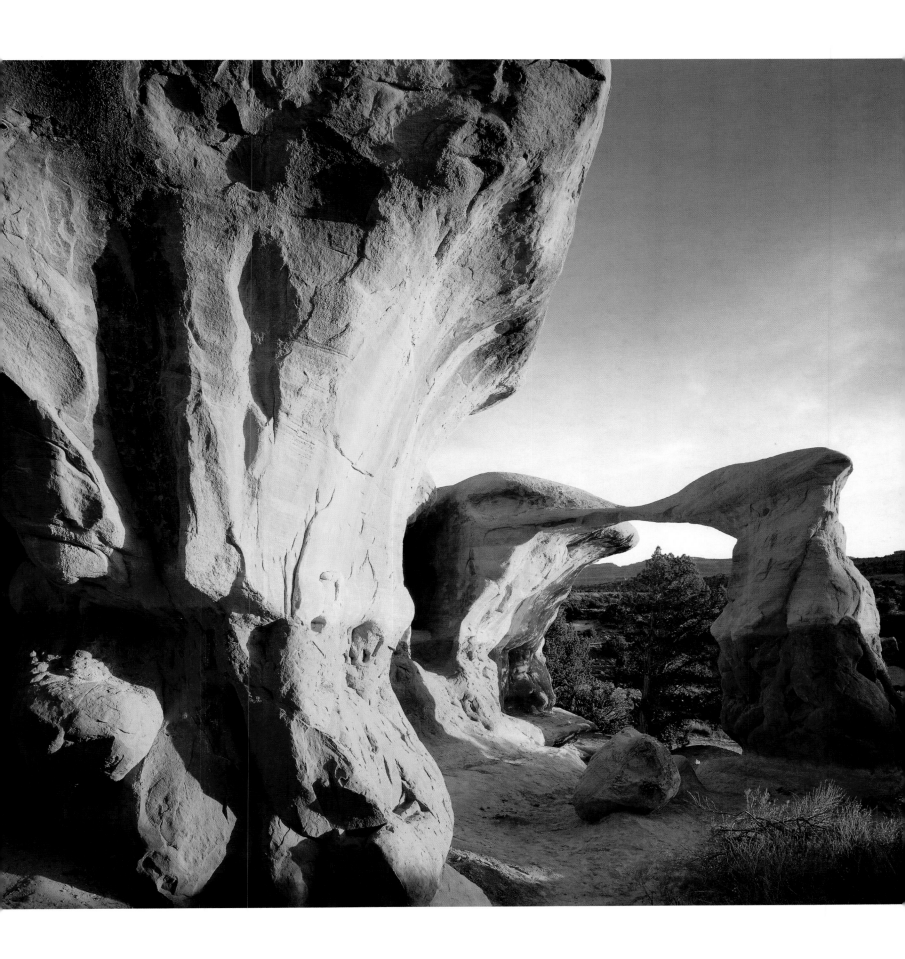

**Metate Arch,** *Grand Staircase–Escalante National Monument, Utah*

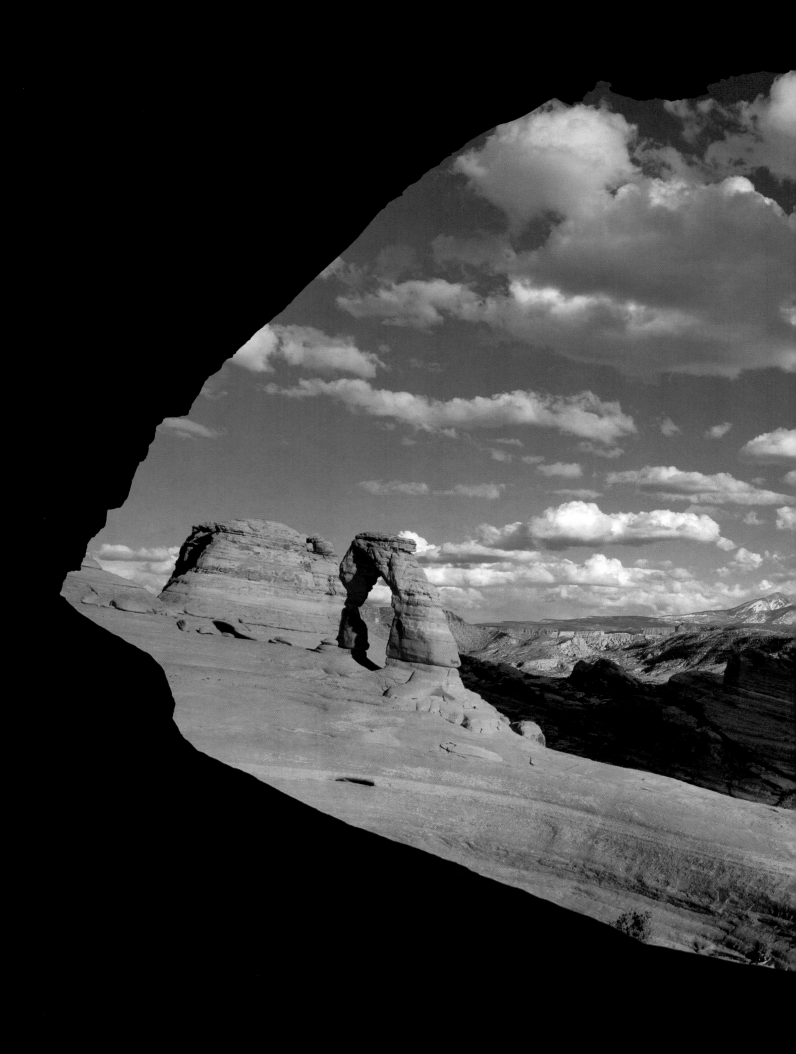

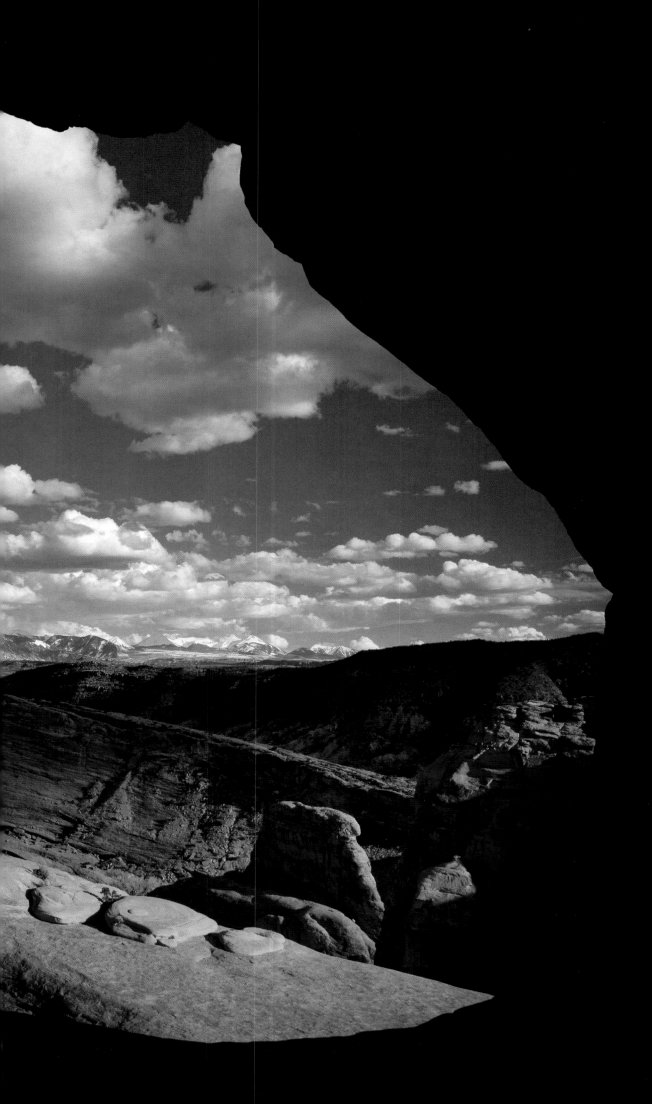

**Delicate Arch and Sierra La Sal**, *Arches National Park, Utah*

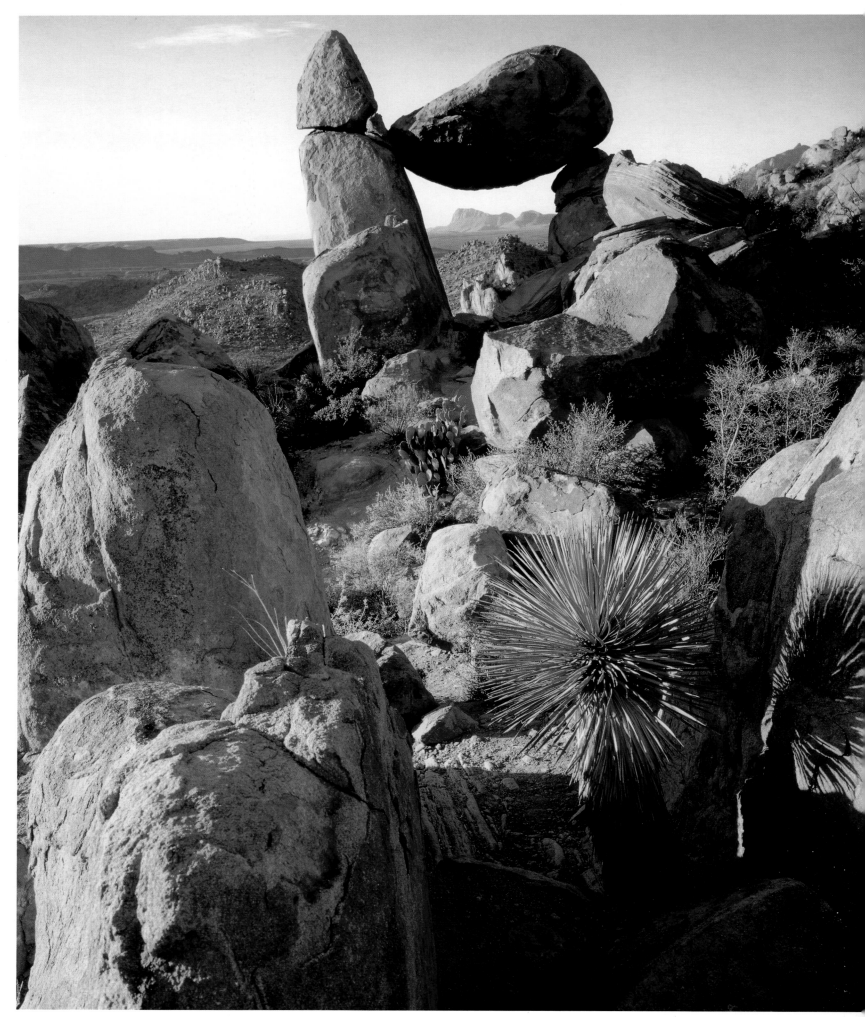

**Boulder Window,** *Big Bend National Park, Texas*

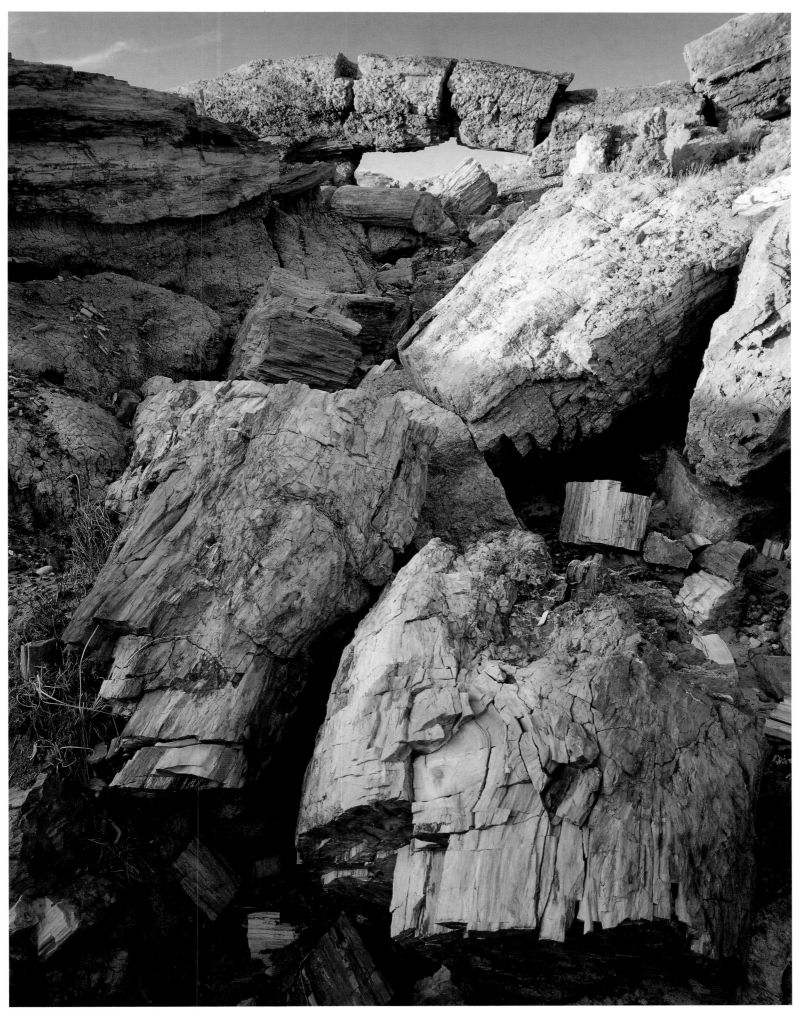

**Blue Mesa Bridge,** *Petrified Forest National Park, Arizona*

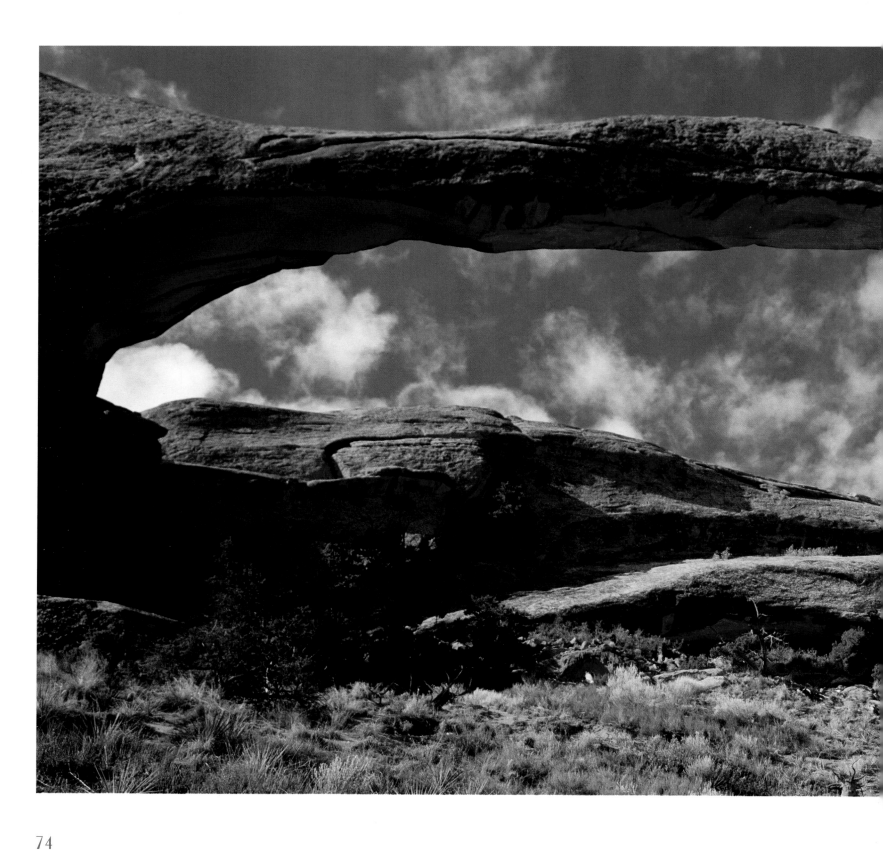

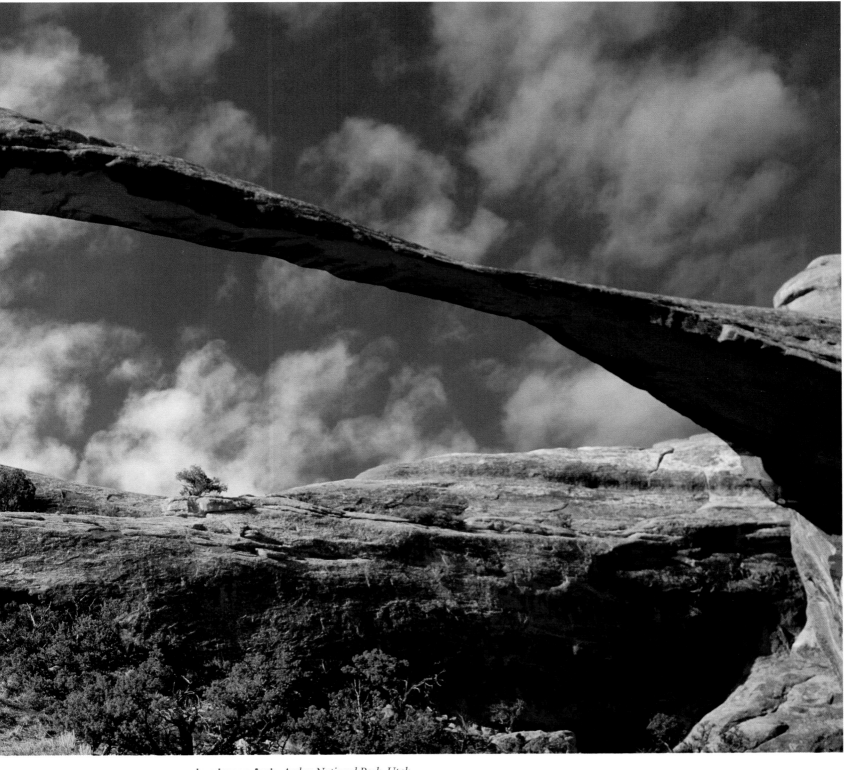

**Landscape Arch,** *Arches National Park, Utah*

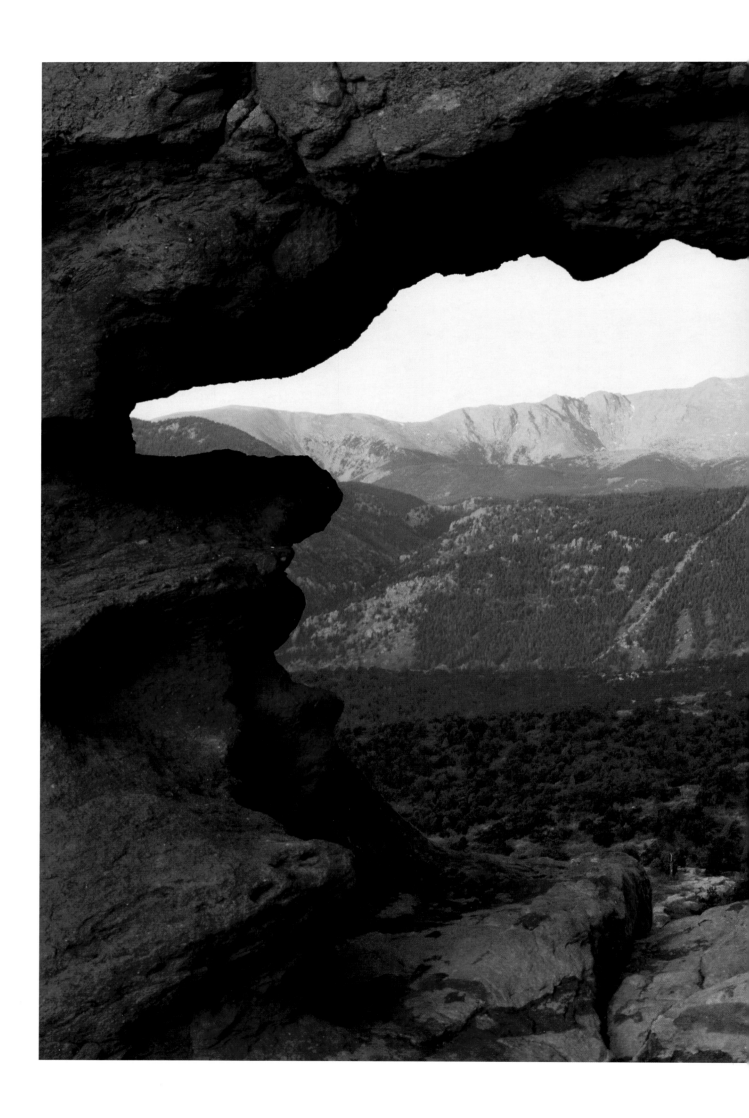

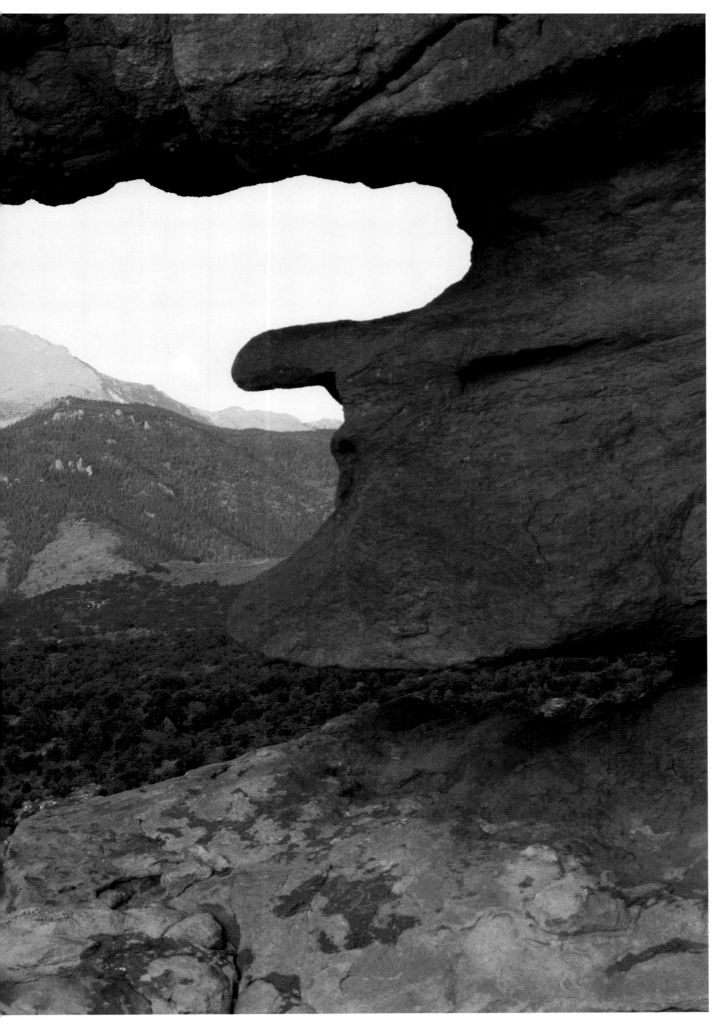

**Pikes Peak through Window,** *Garden of the Gods, Colorado*

**Saguaro and Hewitt Canyon Arch**, *Sonoran Desert, Arizona*

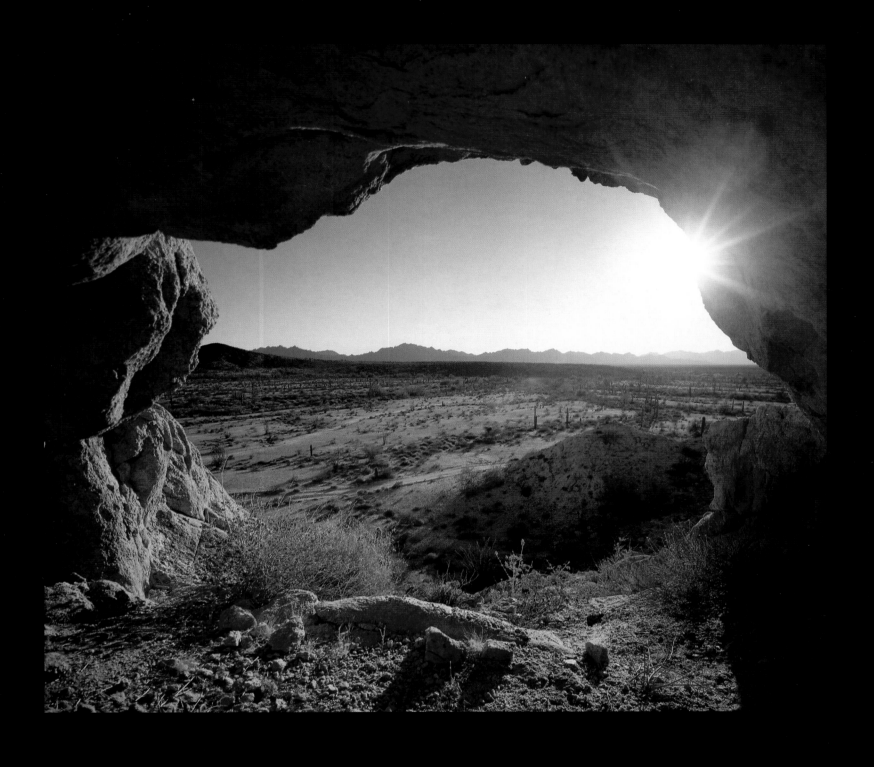

**El Camino del Diablo,** *Cabeza Prieta National Wildlife Refuge, Arizona*

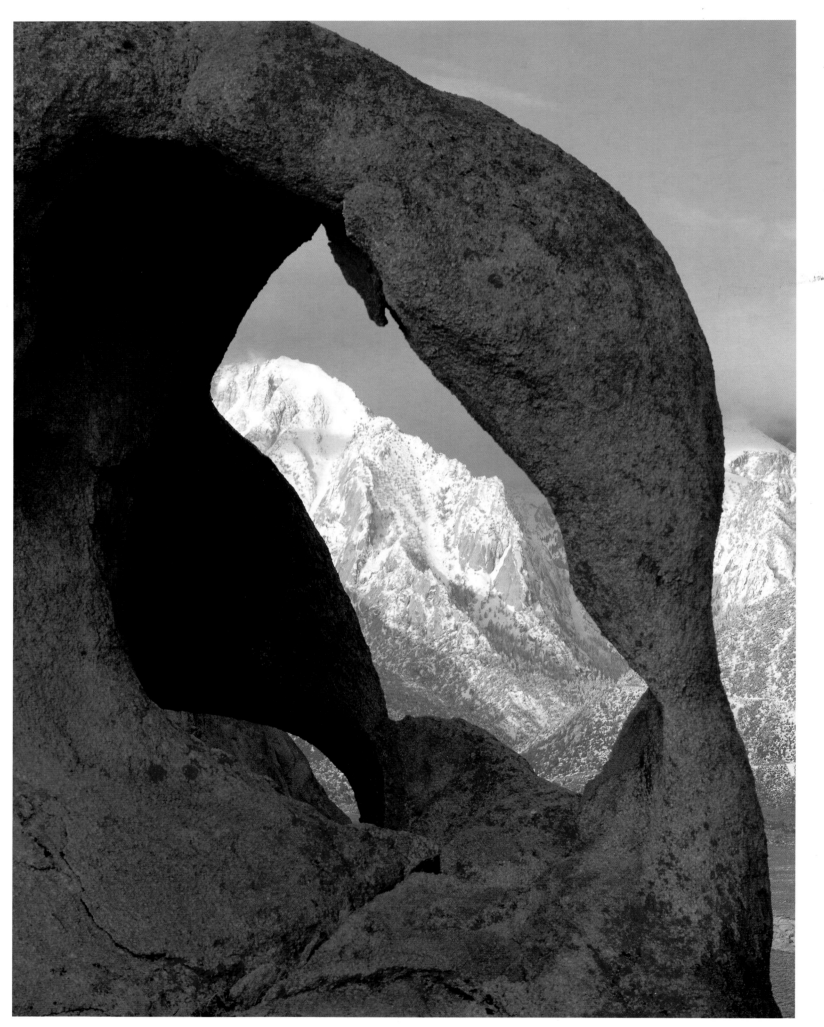

**Triple Arches,** *Sierra Nevada East Side, California*

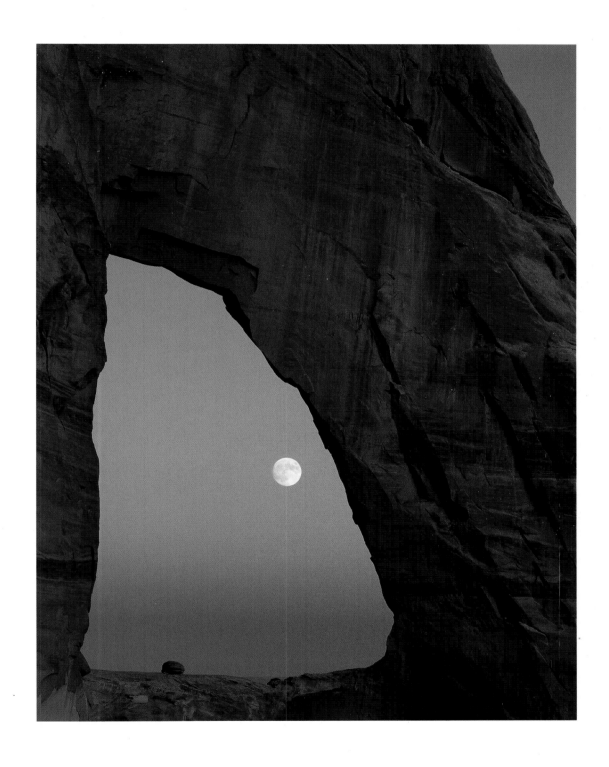

**White Mesa Arch,** *White Mesa, Arizona*

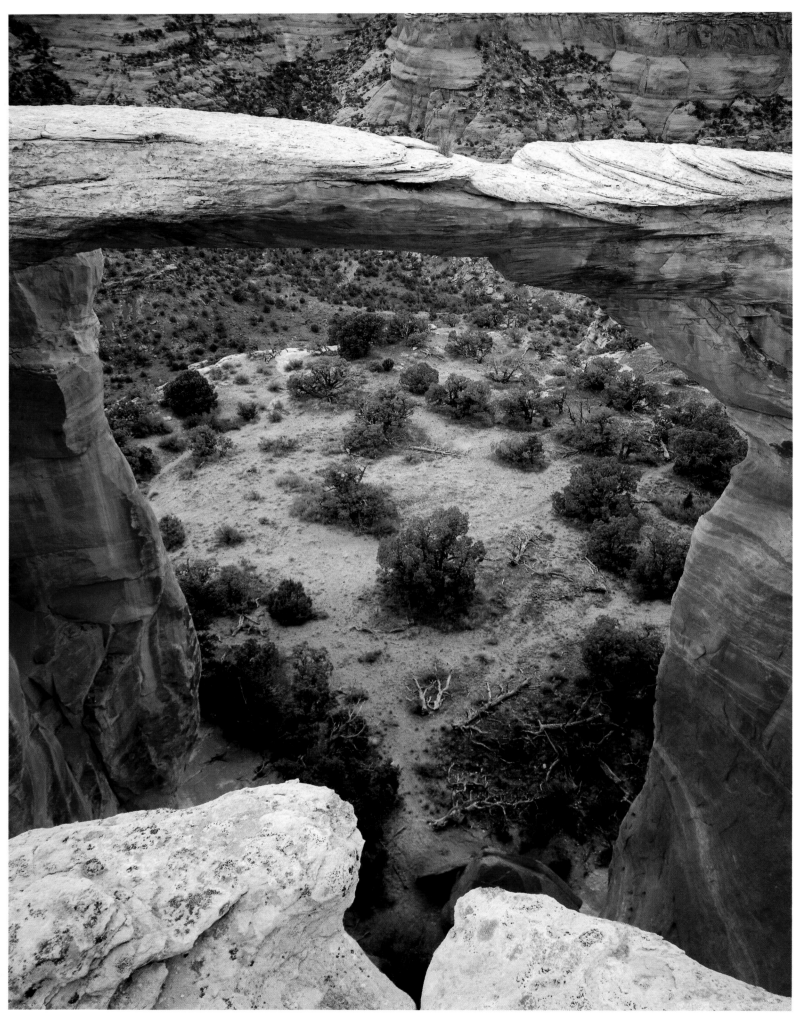

**Sandstone Span,** *Rattlesnake Canyon, Colorado*

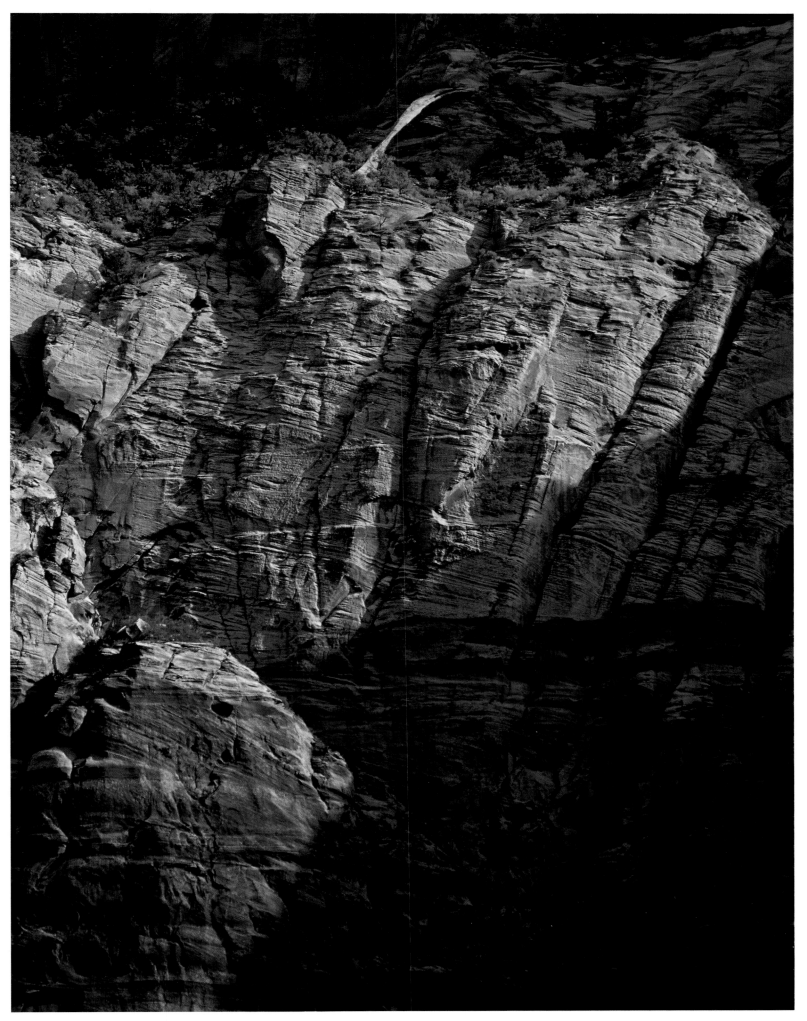

**Bridge Mountain Arch,** *Zion National Park, Utah*

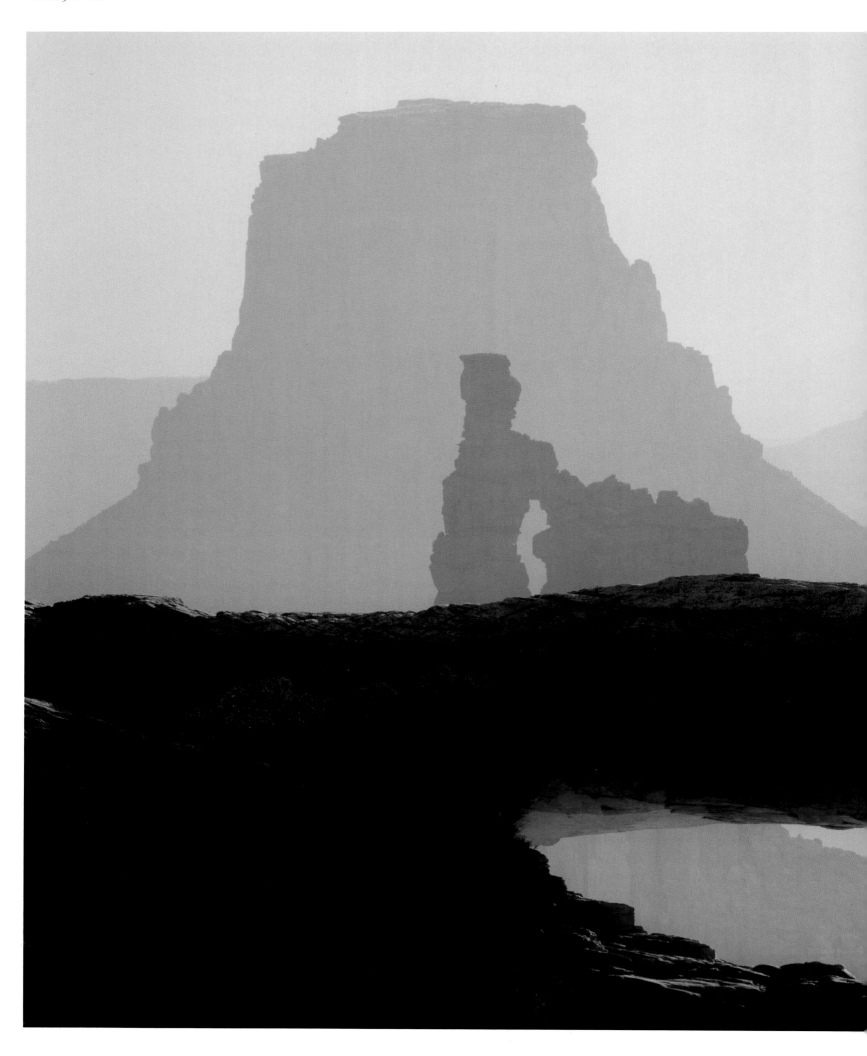

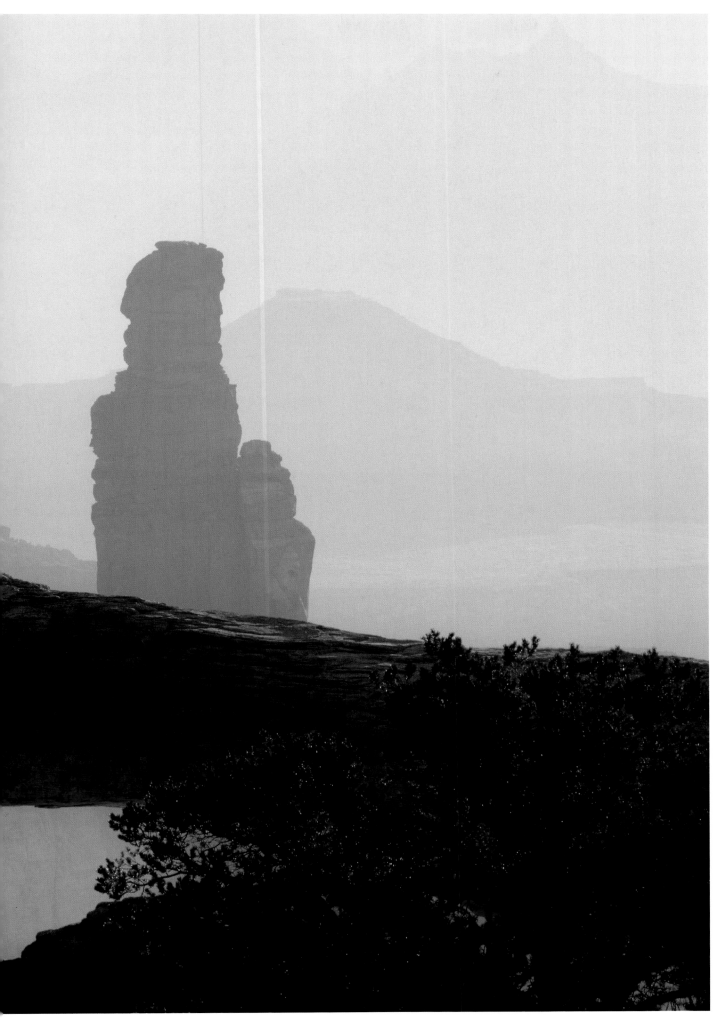

**Mesa and Washerwoman Arches,** *Canyonlands National Park, Utah*

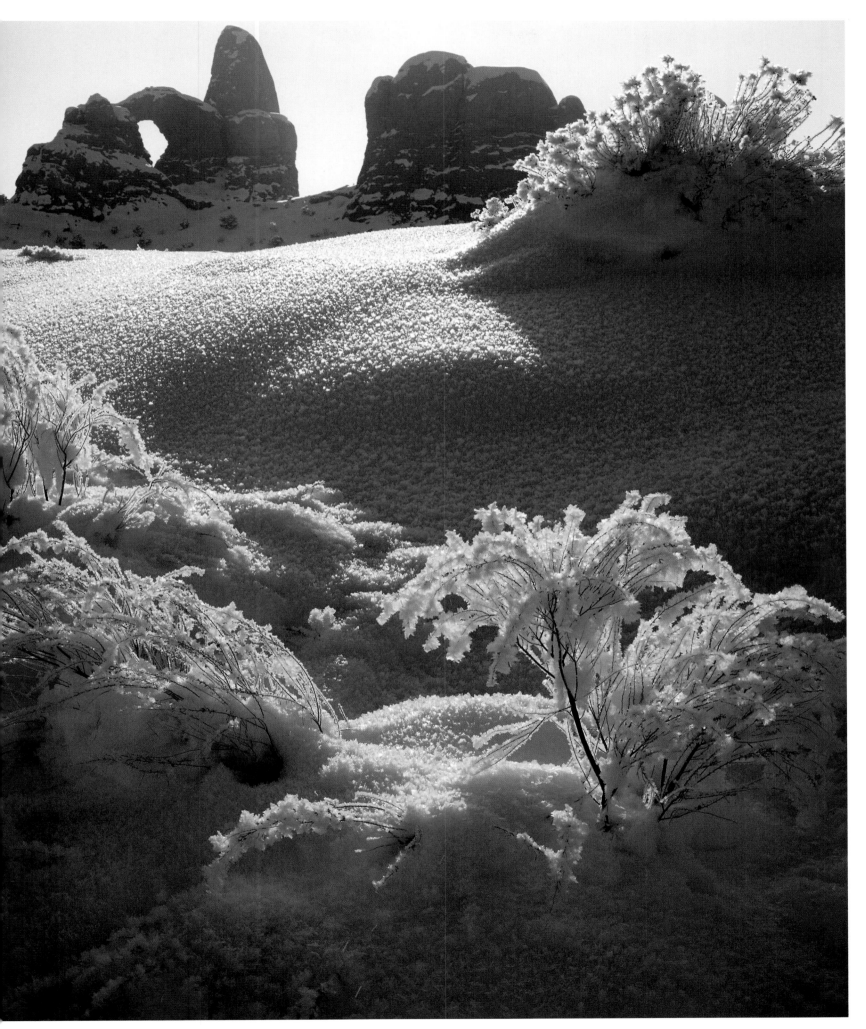

**Turret Arch,** *Arches National Park, Utah*

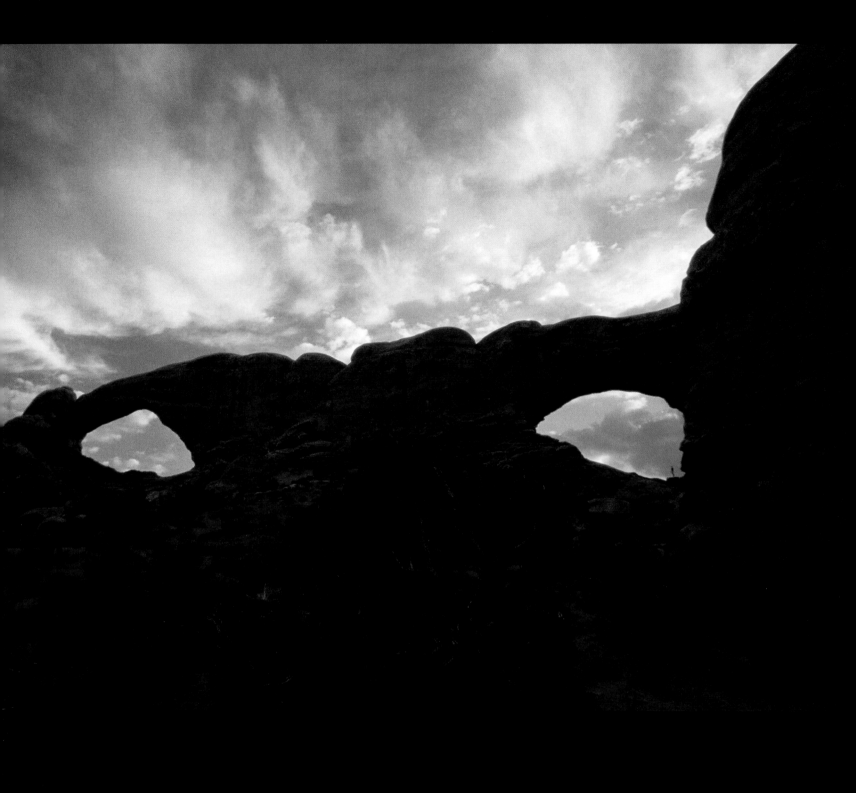

**The North and South Windows,** *Arches National Park, Utah*

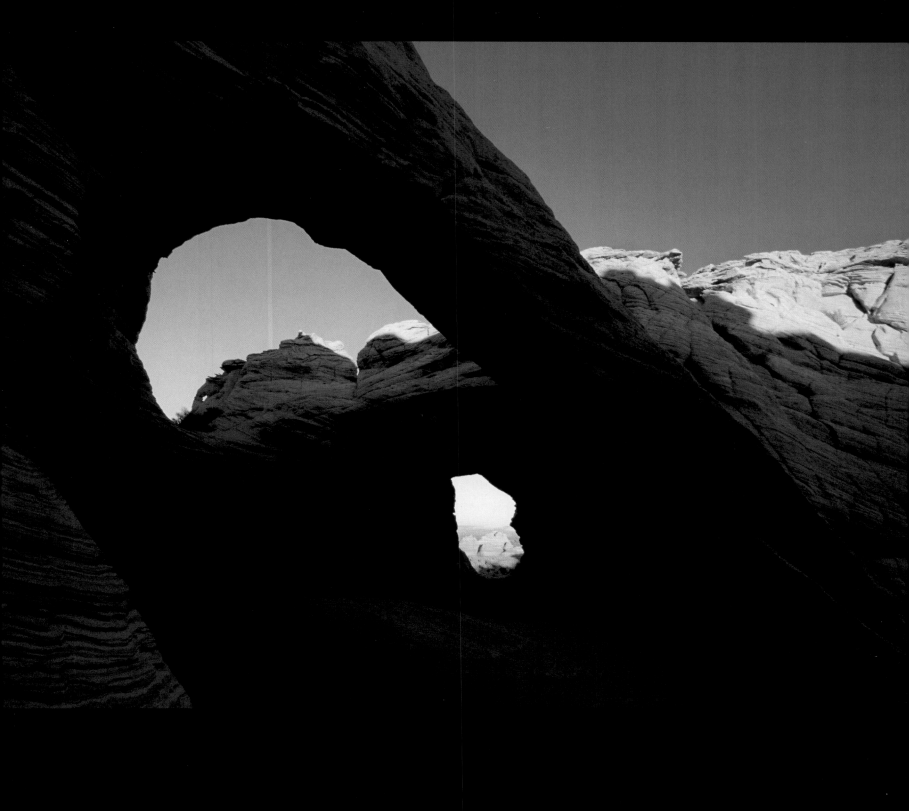

**Triple Arch**, *Paria–Vermilion Cliffs Wilderness, Utah*

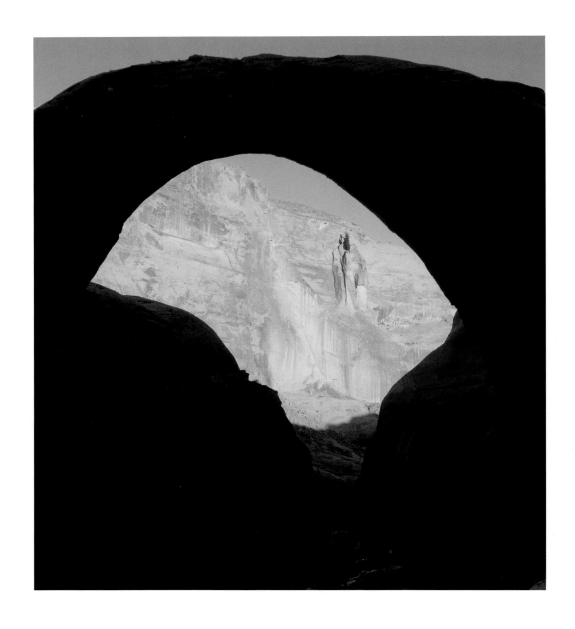

**Rainbow Bridge,** *Rainbow Bridge National Monument, Utah*

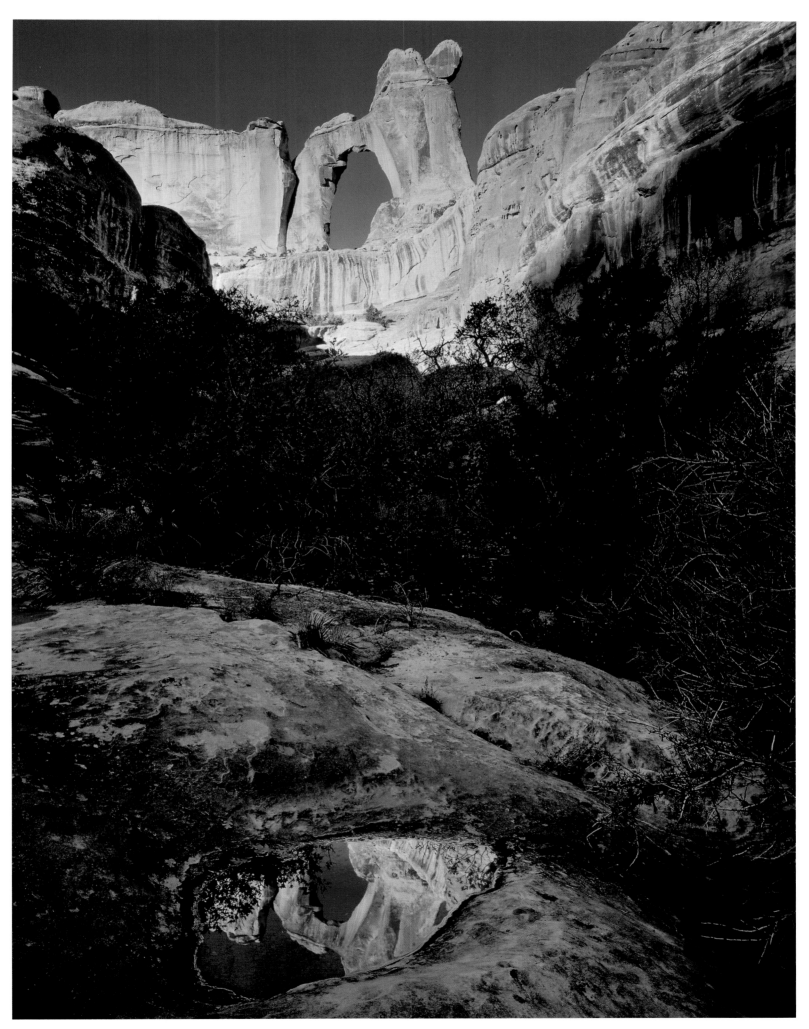

**Angel Arch**, *Canyonlands National Park, Utah*

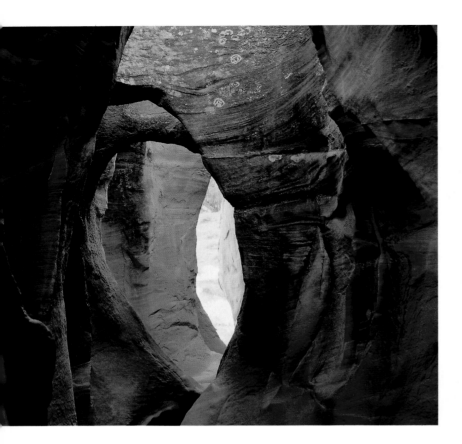

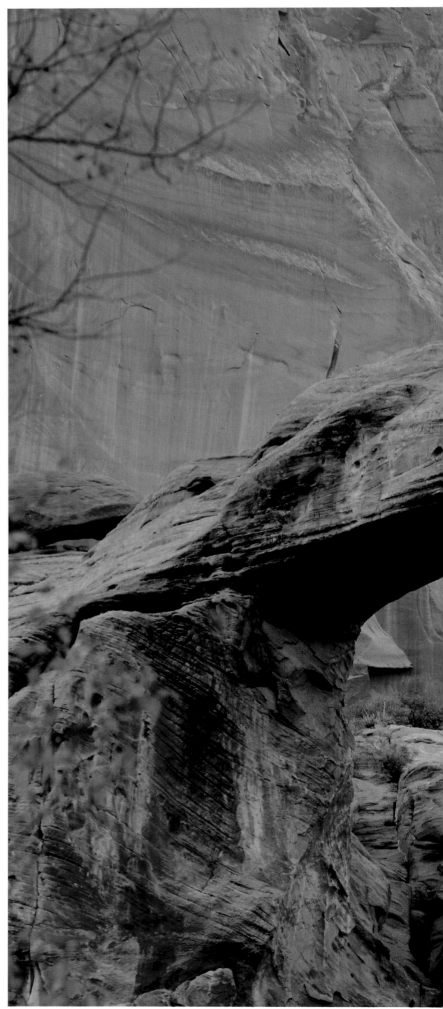

**Peekaboo Windows,** *Grand Staircase–Escalante National Monument, Utah*

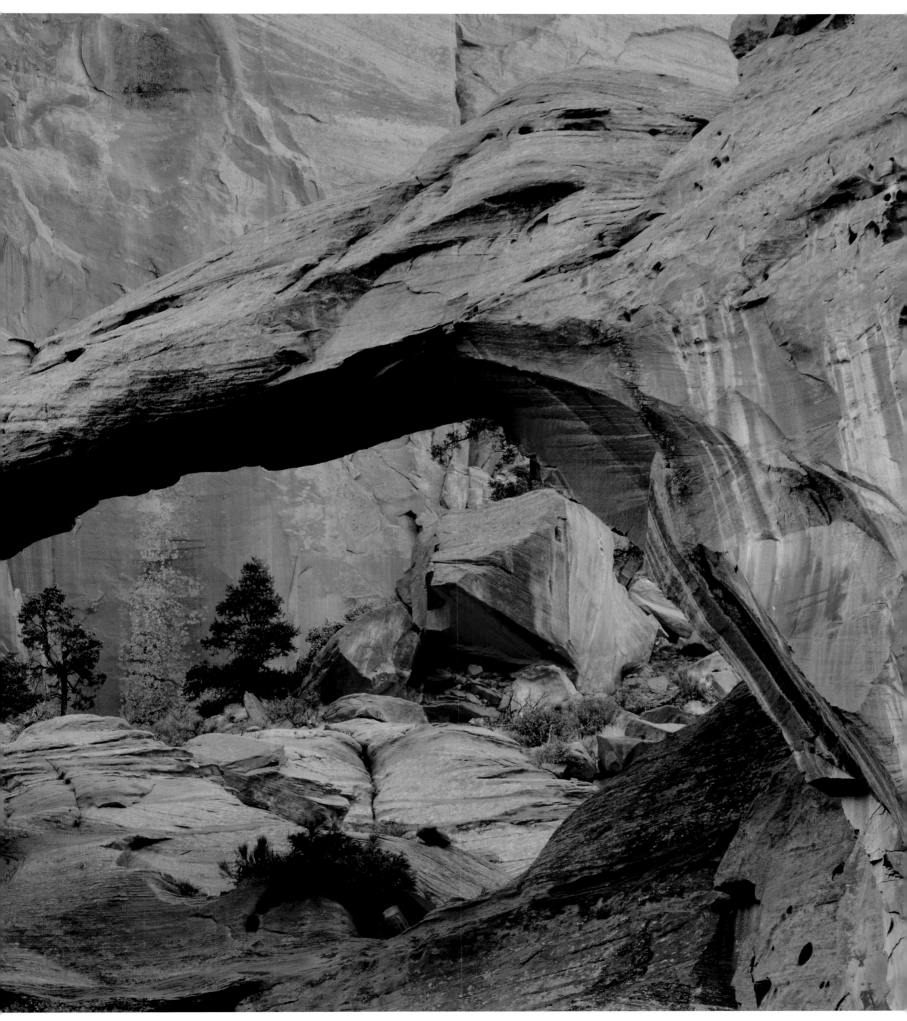

**Lamanite Arch,** *Grand Staircase–Escalante National Monument, Utah*

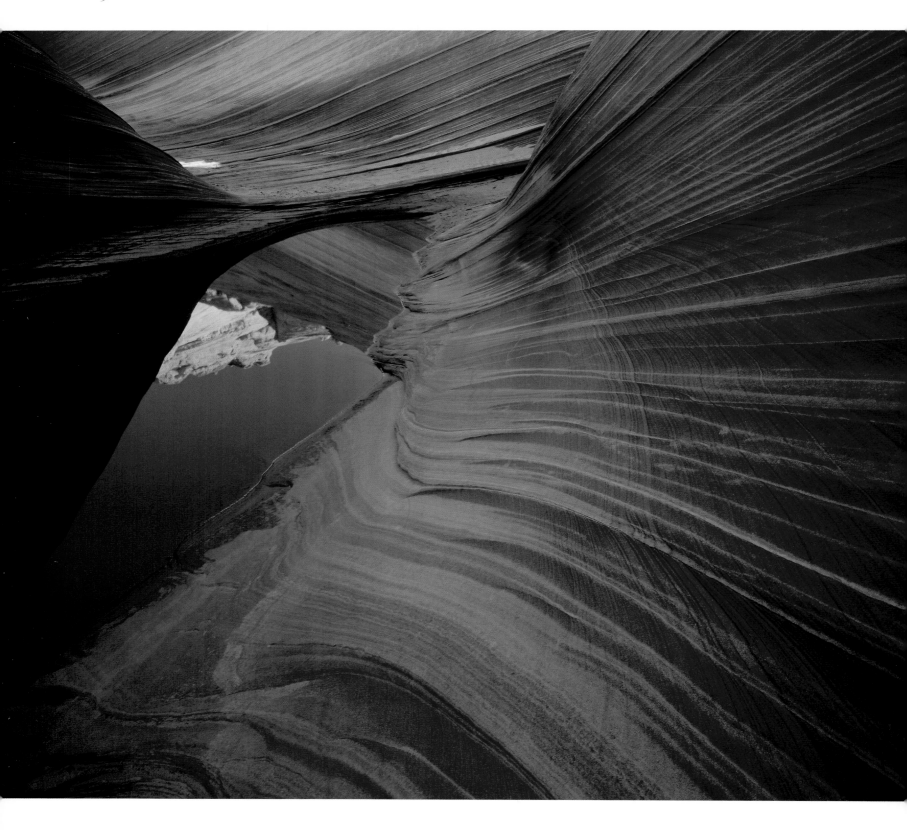

**The Wave,** *Paria–Vermilion Cliffs Wilderness, Utah*

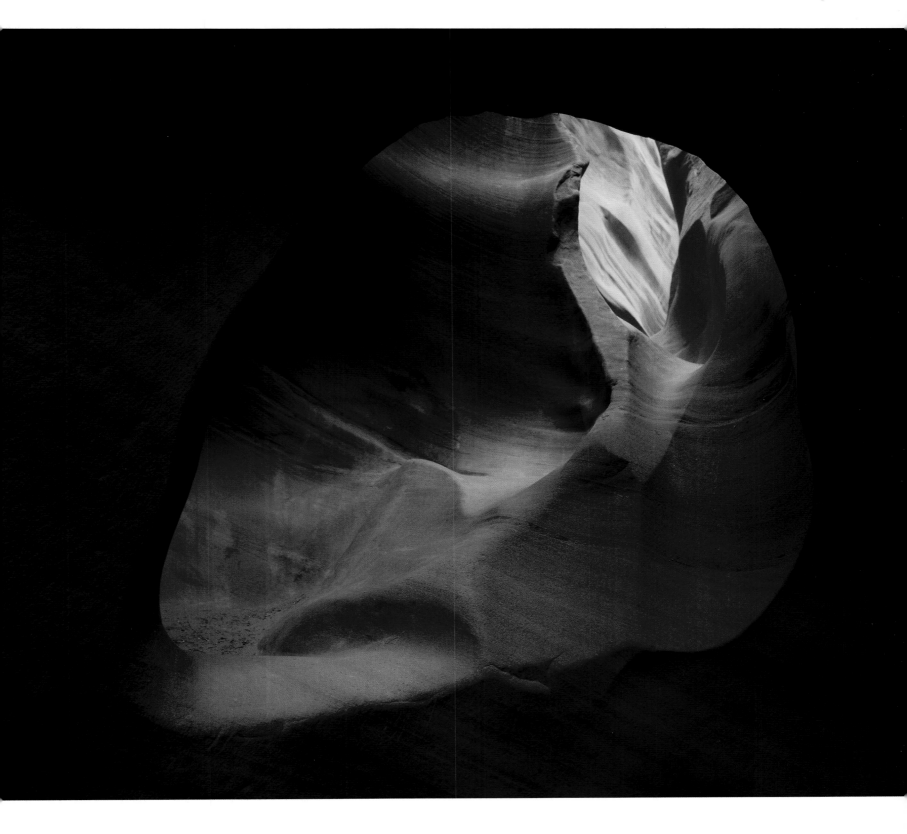

**Peekaboo Window,** *Grand Staircase–Escalante National Monument, Utah*

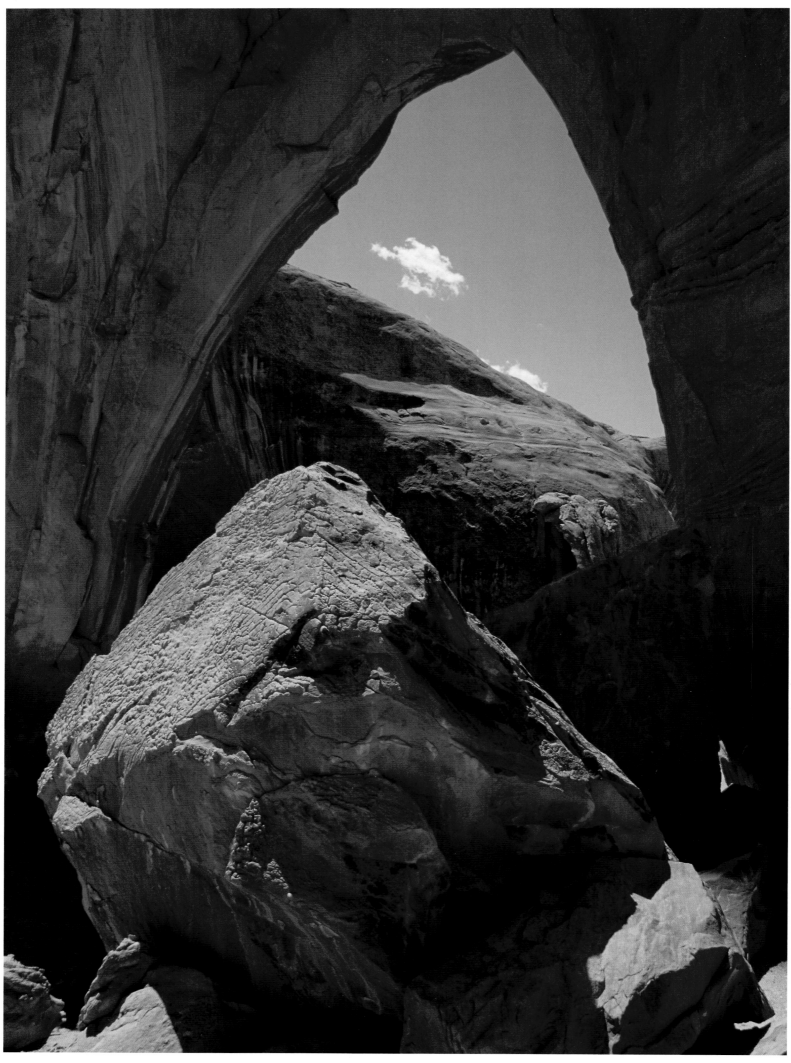

**Broken Bow Arch/Escalante,** *Glen Canyon National Recreation Area, Utah/Arizona*

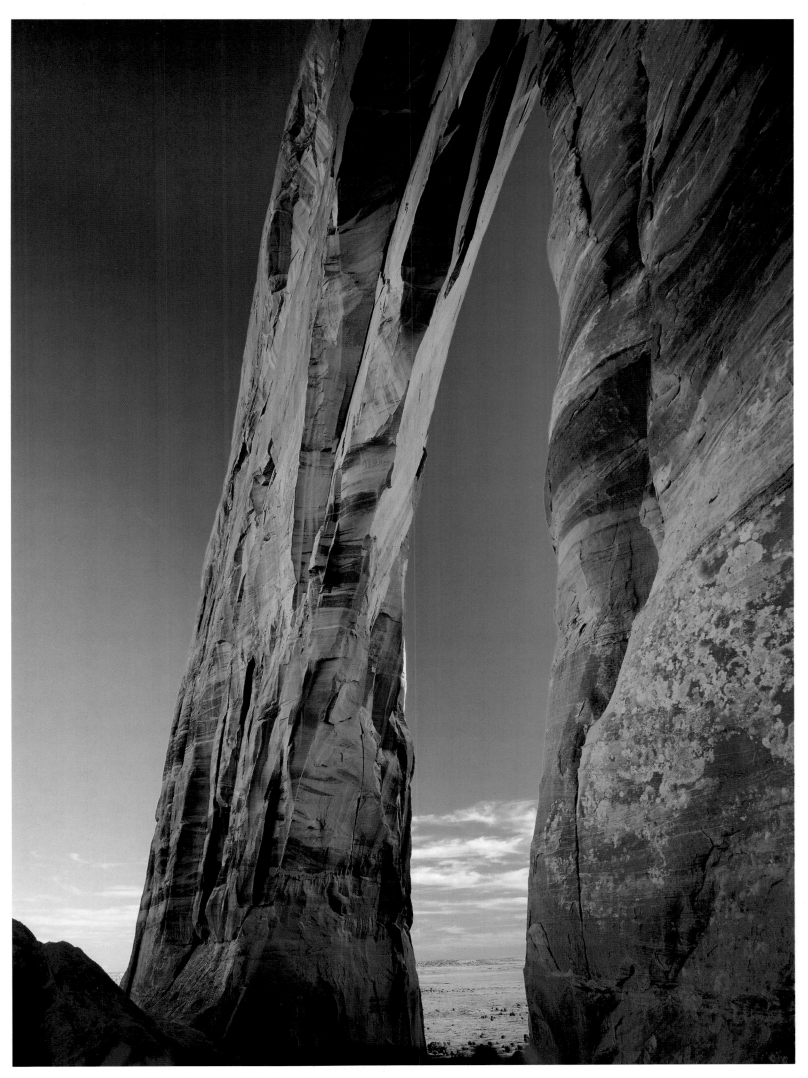

**White Mesa Arch,** *White Mesa, Arizona*

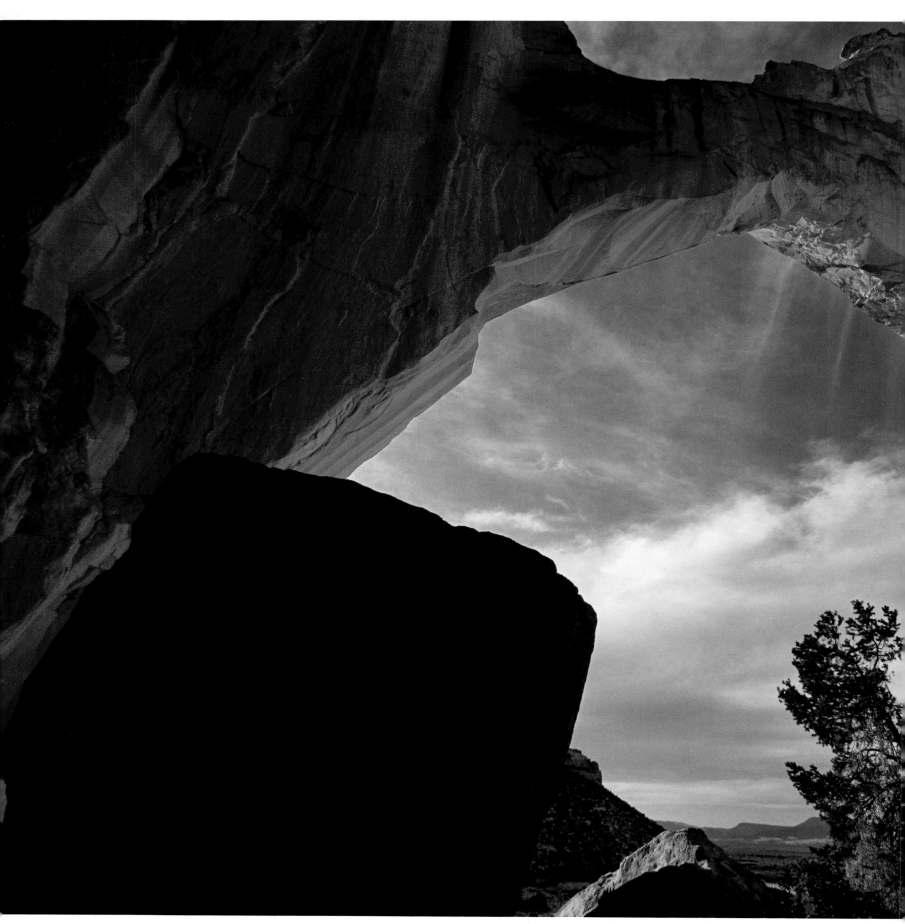

**La Ventana Arch,** *El Malpais National Monument and Conservation Area, New Mexico*

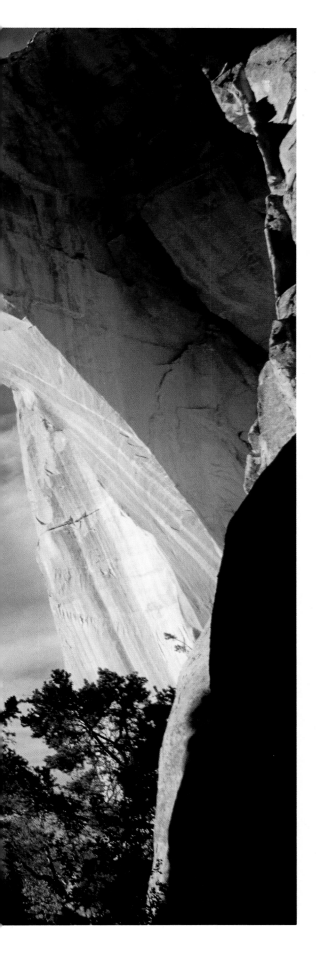

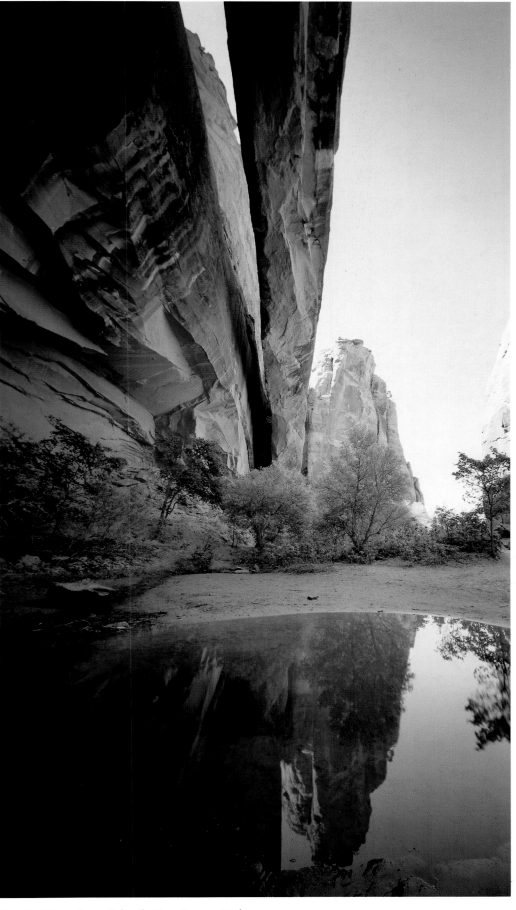

**Morning Glory Arch,** *Colorado River Canyon, Utah*

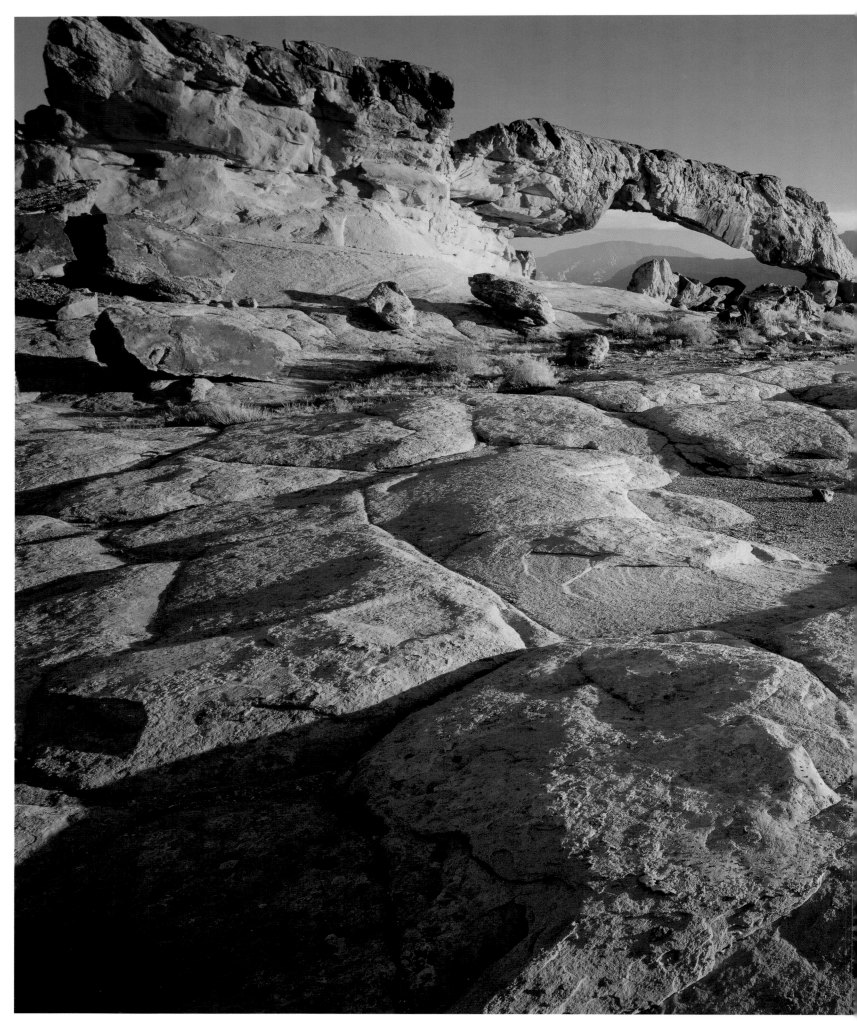

**Sunset Arch/Escalante,** *Glen Canyon National Recreation Area, Utah*

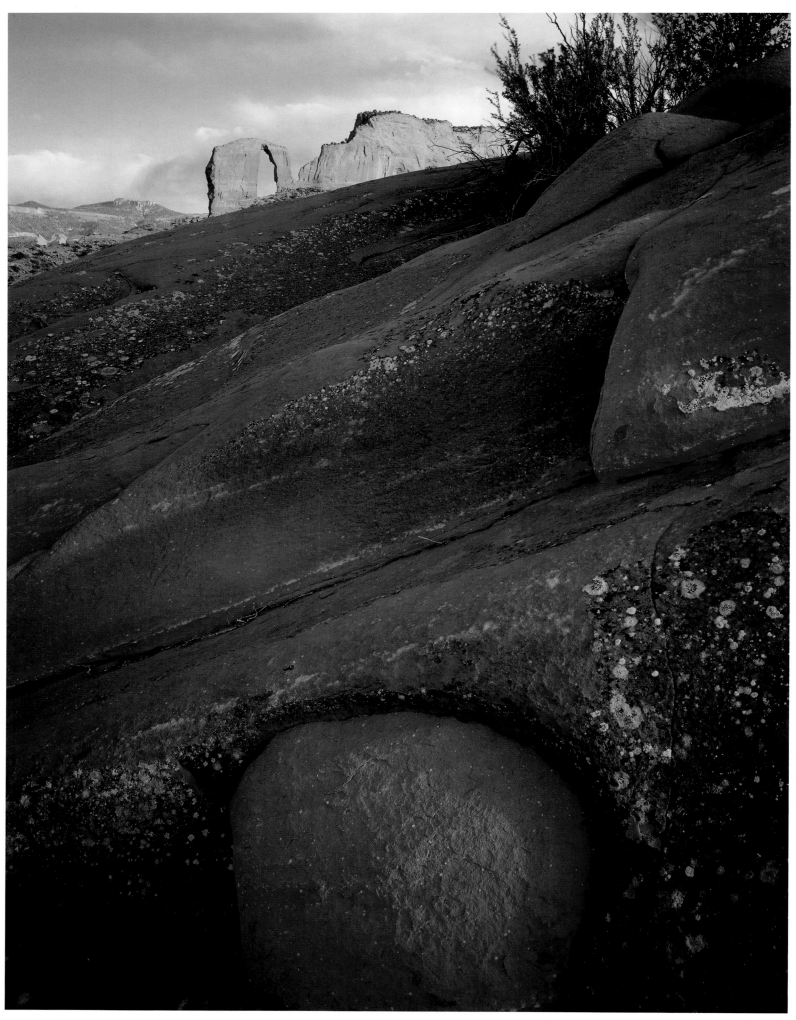

**Royal Arch,** *Lukachukai Country, Arizona*

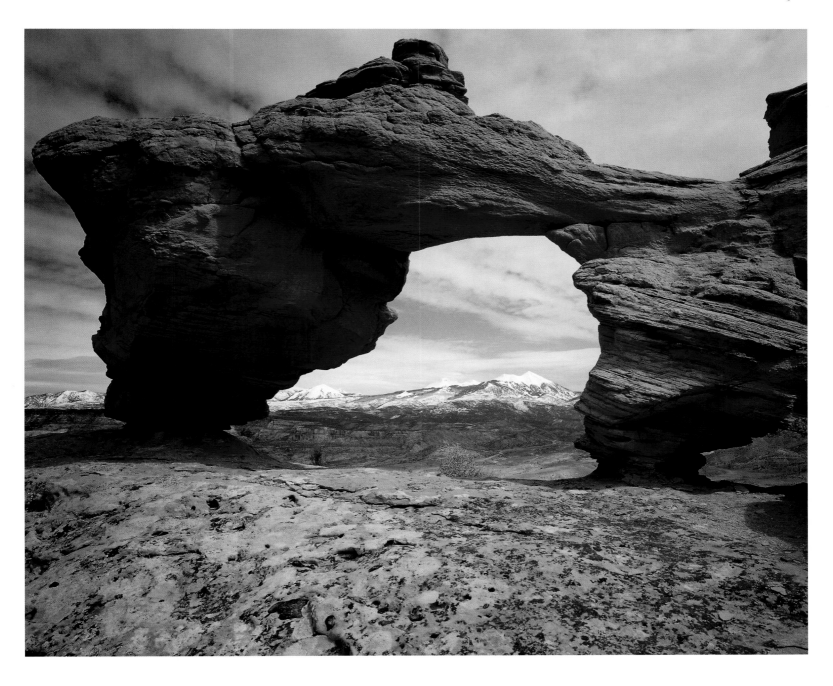

**Tukanikavista Arch,** *Canyonlands Country, Utah*

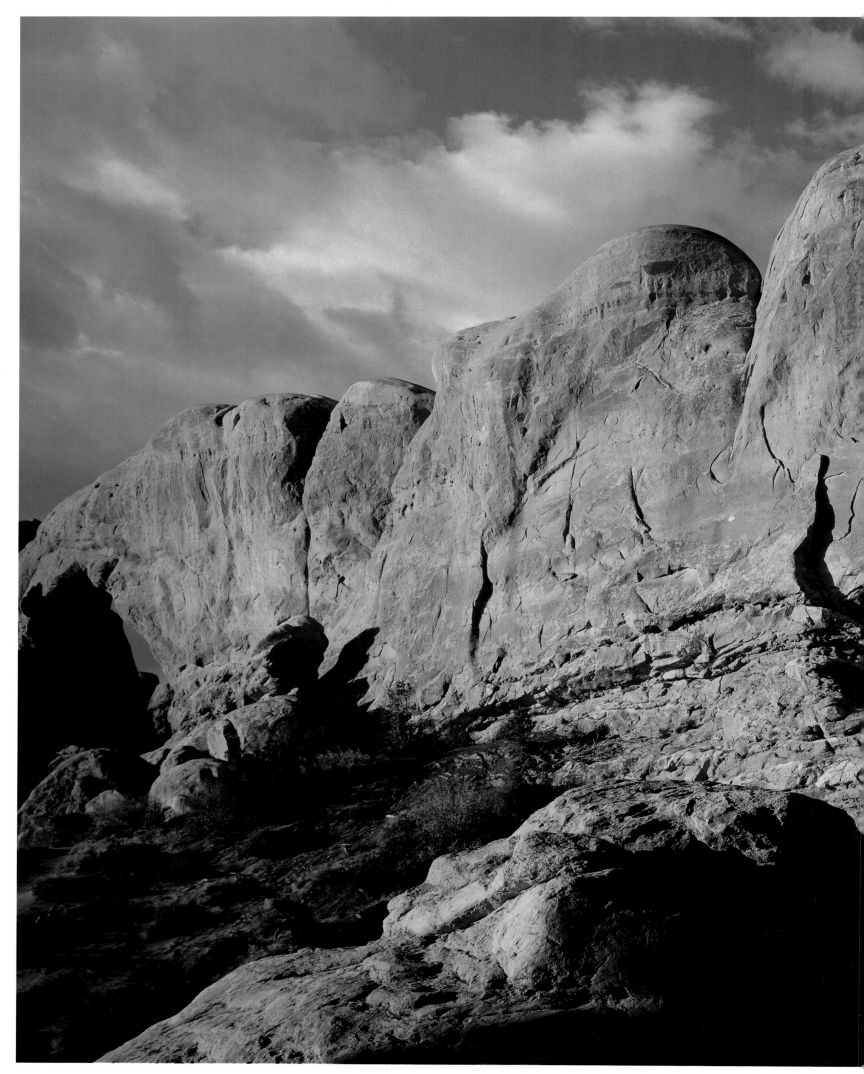

**The Windows and Turret Arch,** *Arches National Park, Utah*

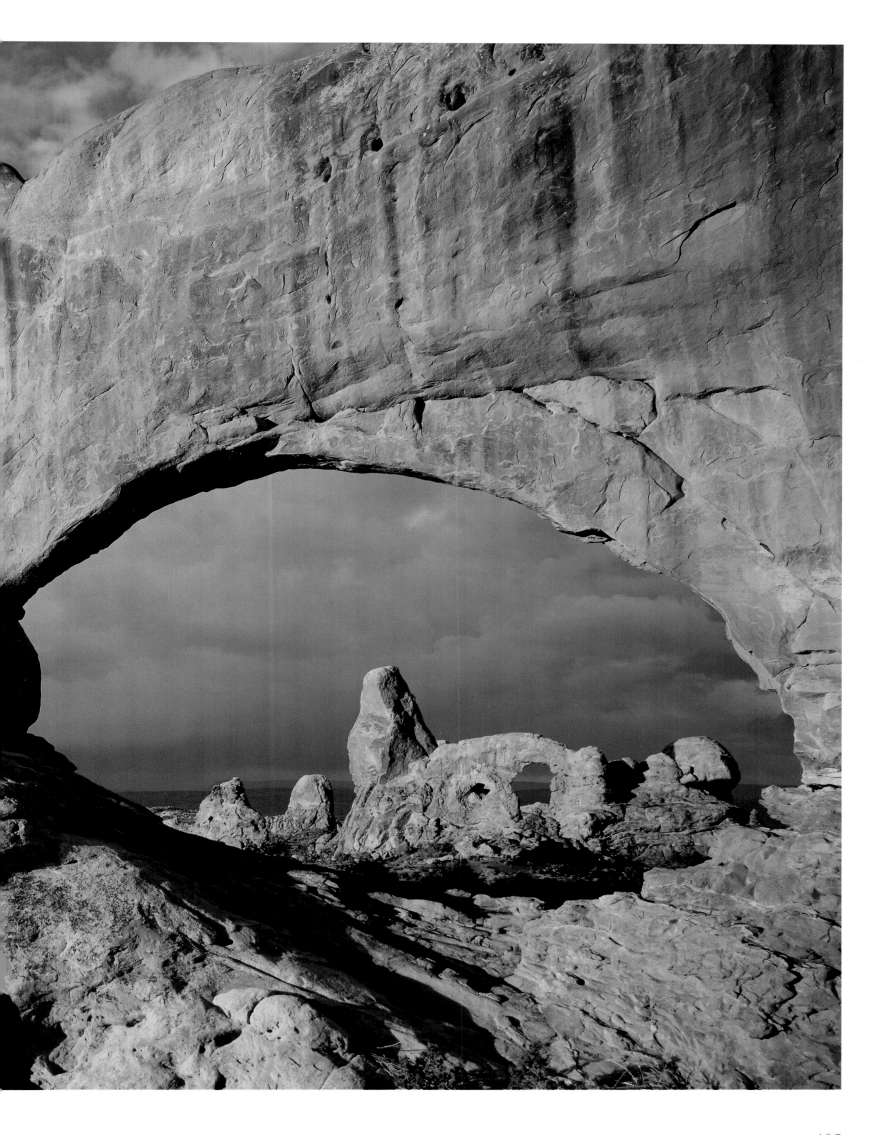

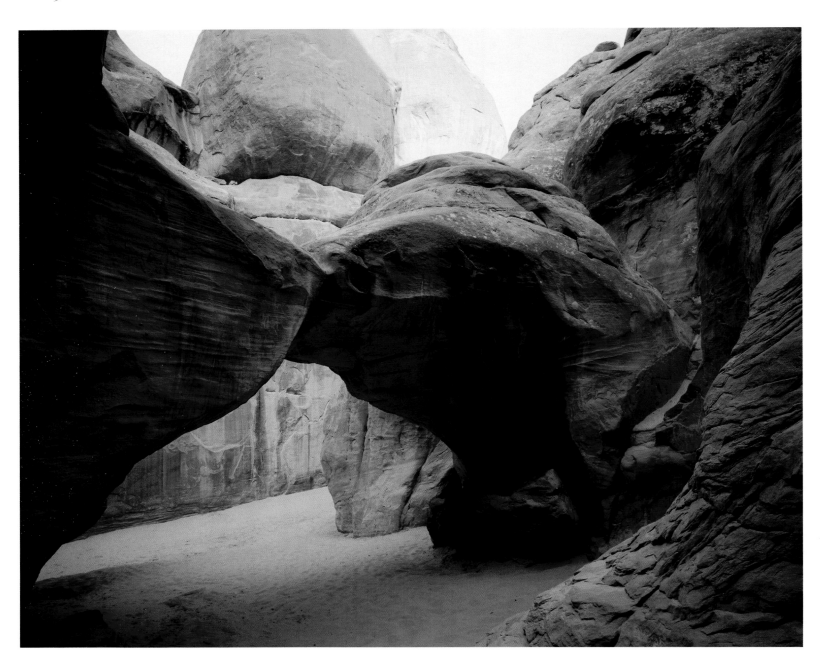

**Sand Dune Arch,** *Arches National Park, Utah*

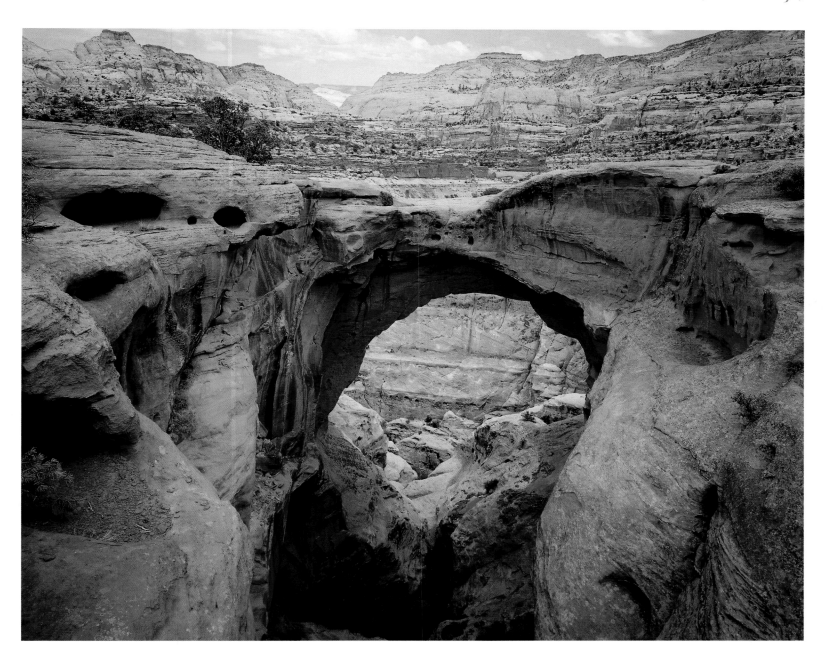

**Cassidy Arch,** *Capitol Reef National Park, Utah*

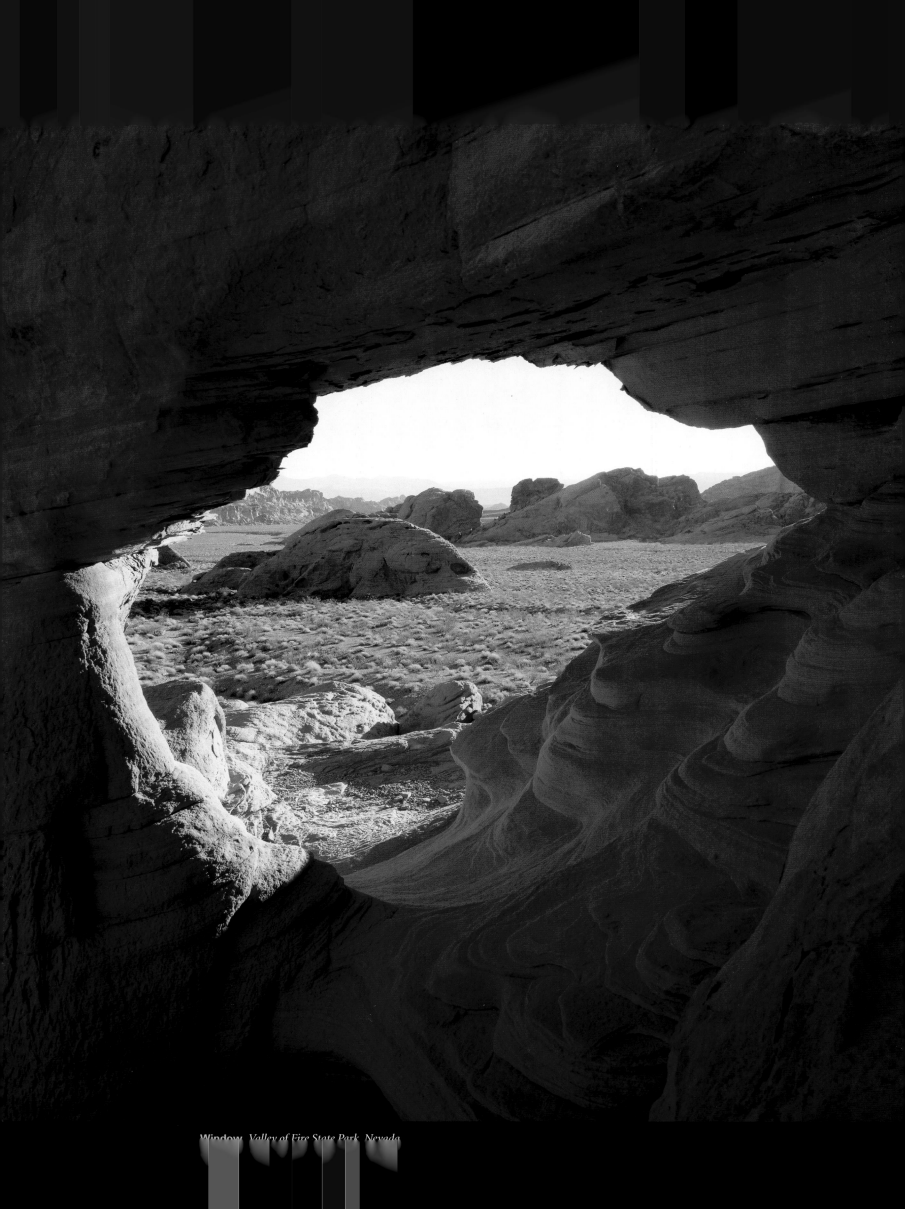

**Window** *Valley of Fire State Park, Nevada*

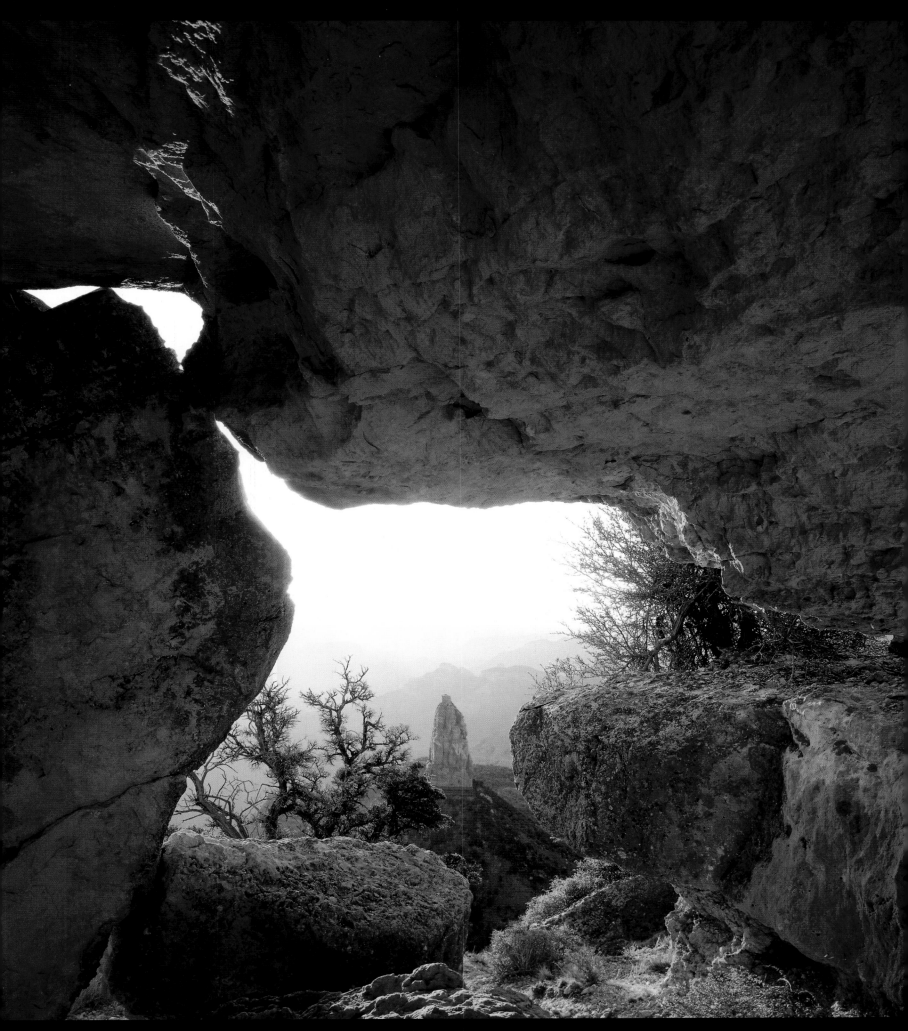

**Window,** *North Rim, Grand Canyon National Park, Arizona*

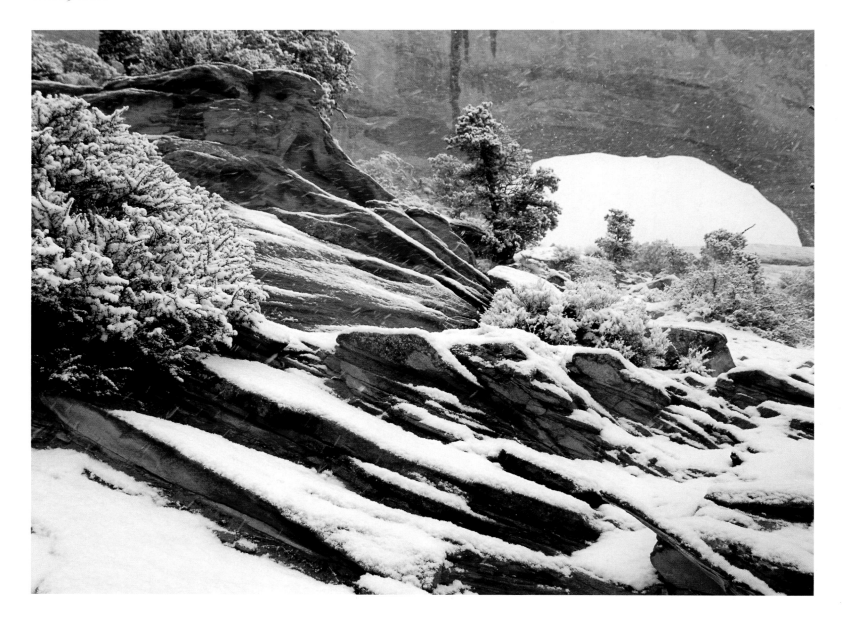

**Wilson Arch,** *Canyonlands National Park, Utah*

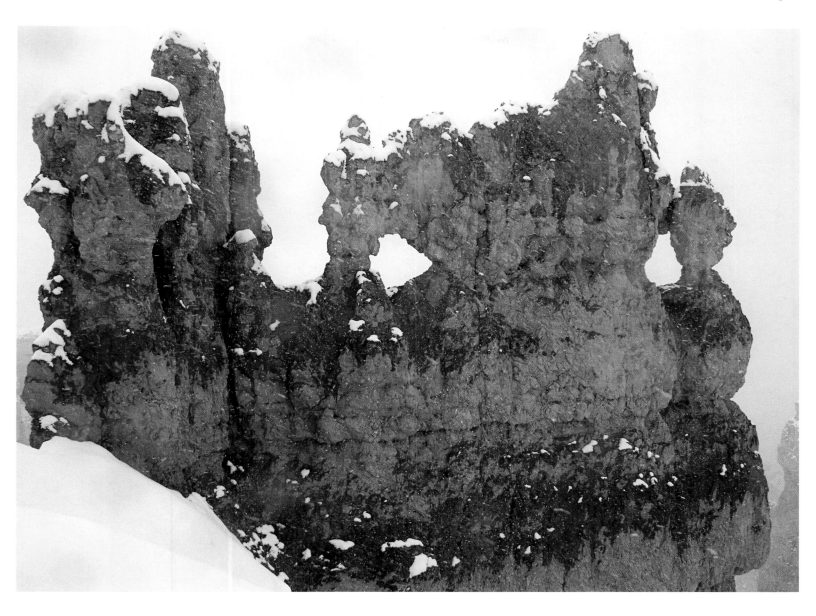

**Hoodoos,** *Bryce Canyon National Park, Utah*

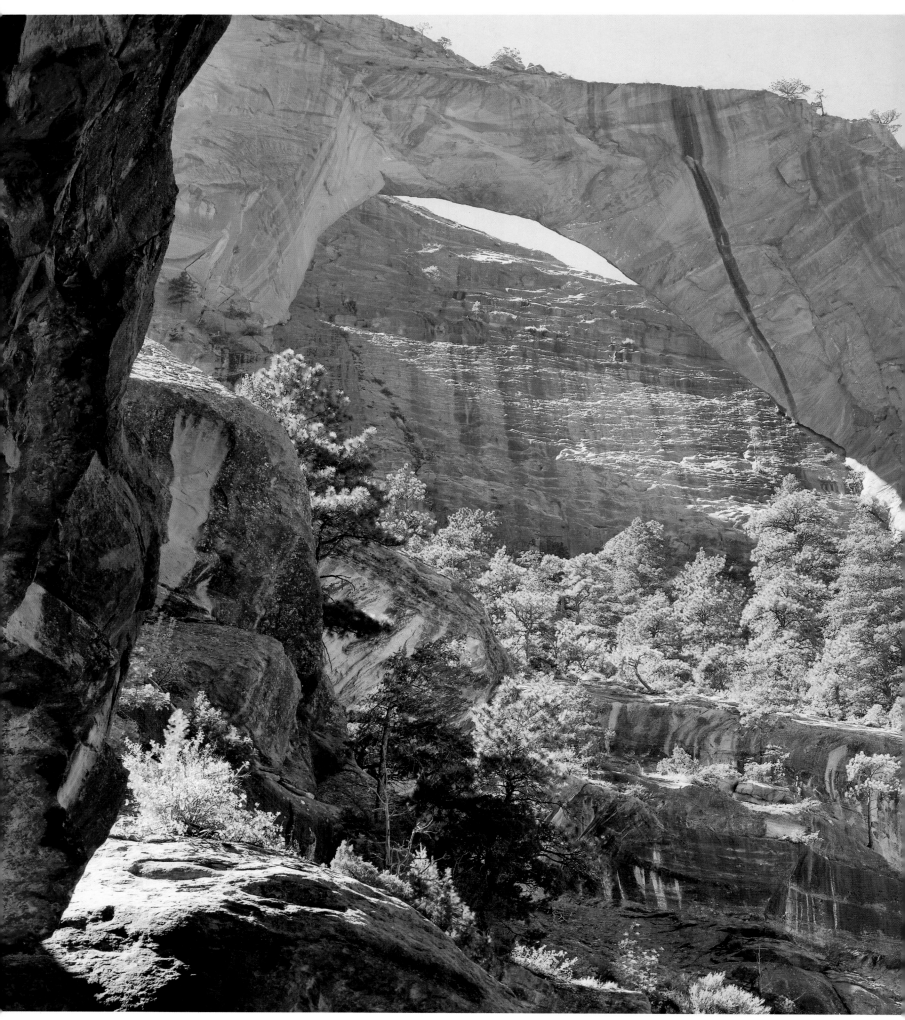

**Kolob Arch,** *Zion National Park, Utah*

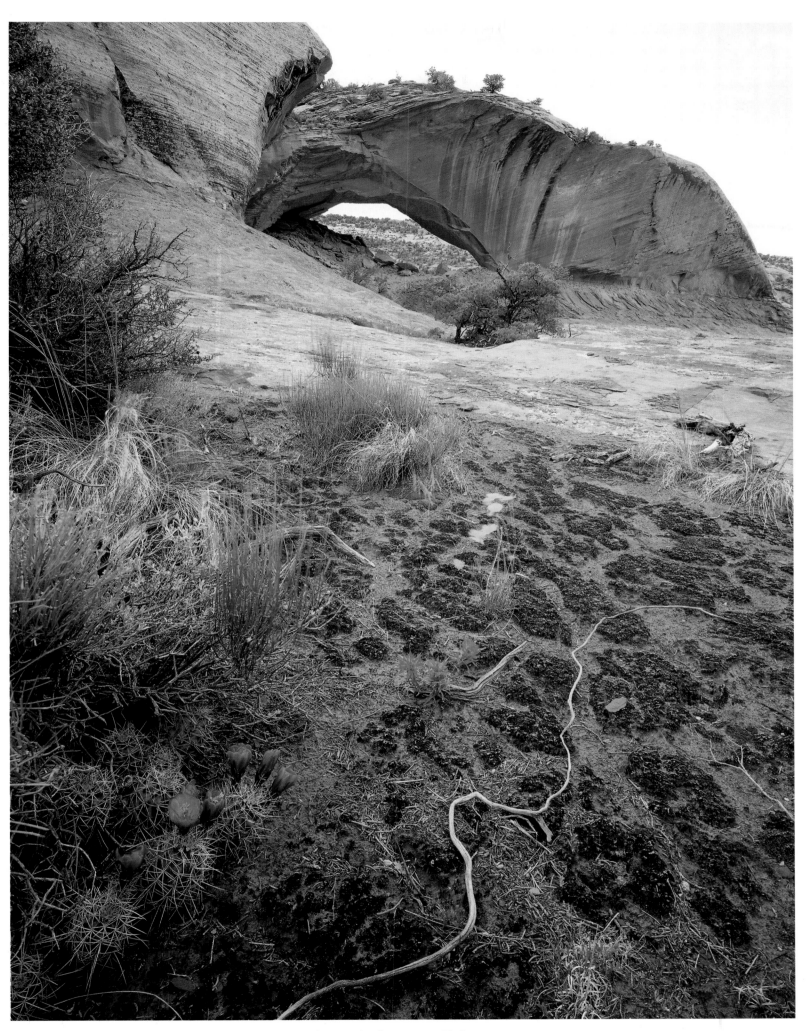

**Phipps Arch,** *Grand Staircase–Escalante National Monument, Utah*

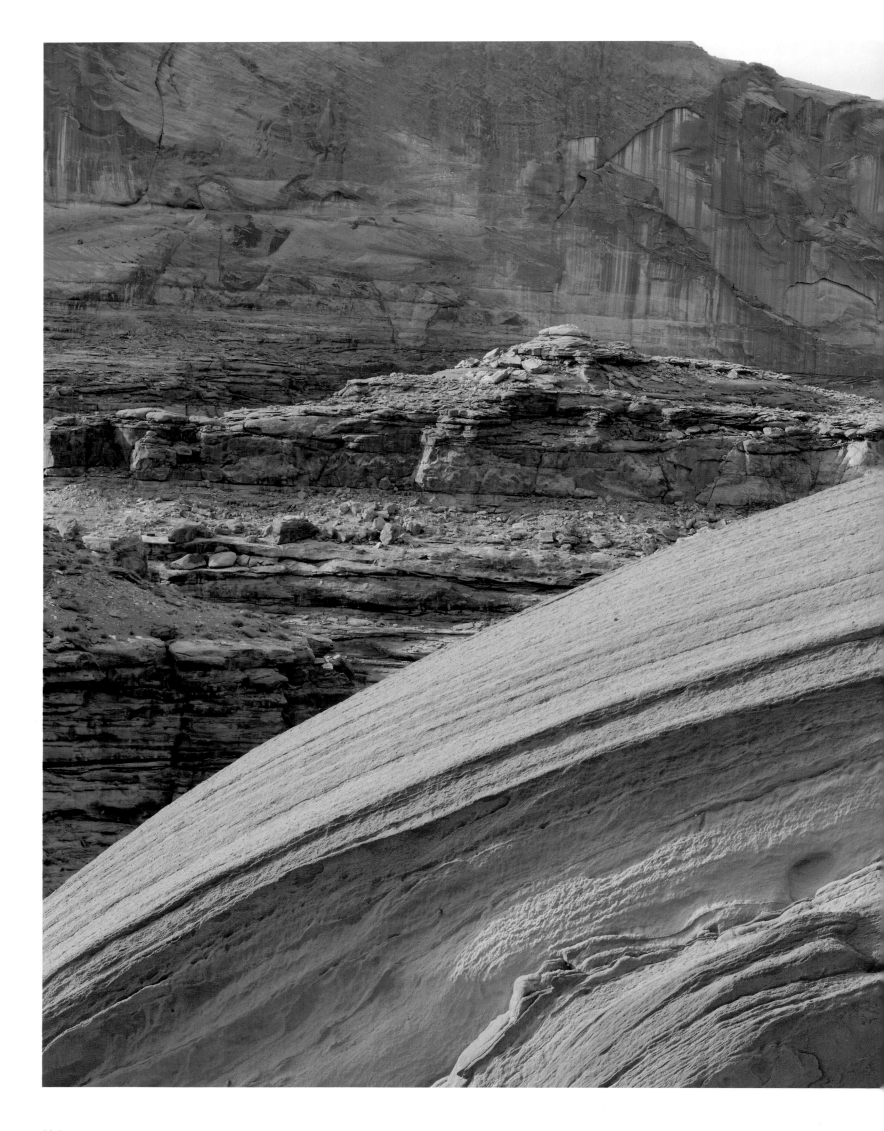

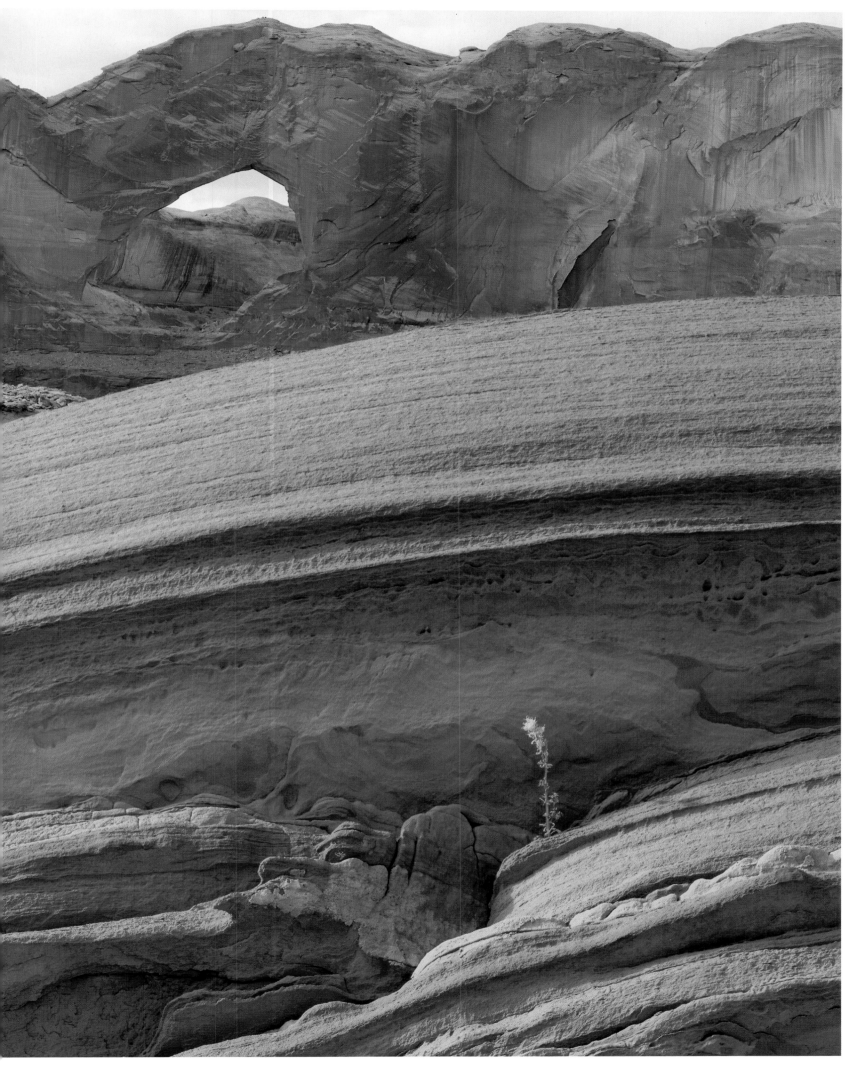

**Stevens Arch/Escalante,** *Glen Canyon National Recreation Area, Utah*

115

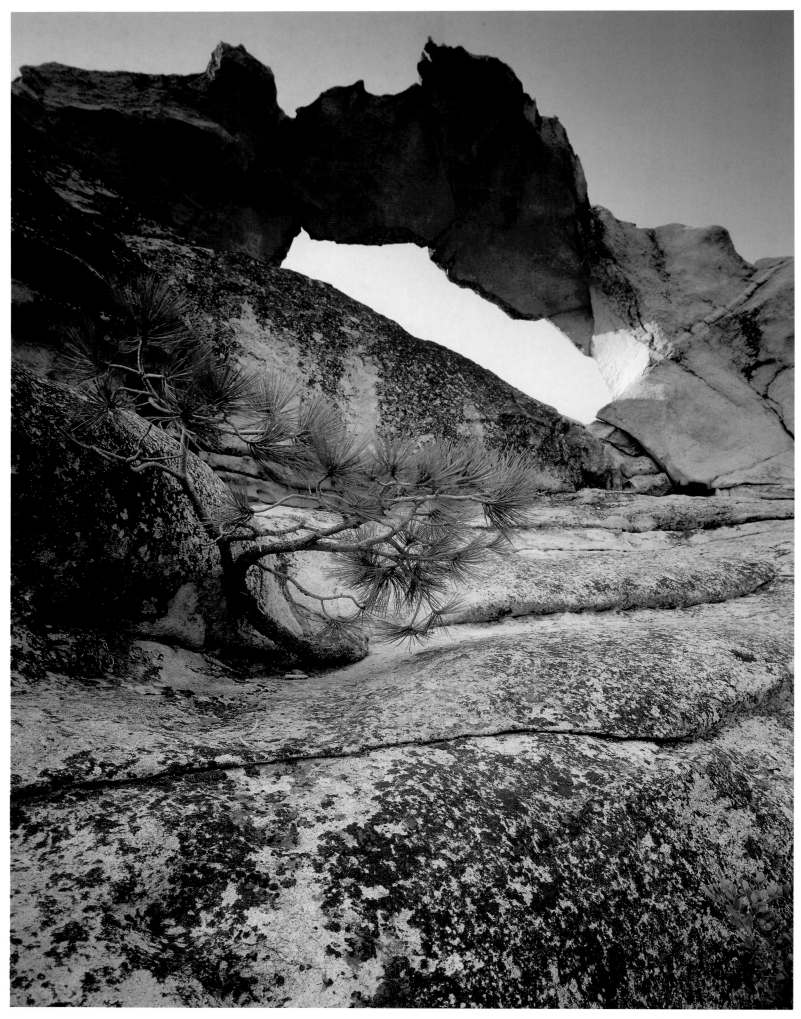

**Granite Arch,** *Yosemite National Park, California*

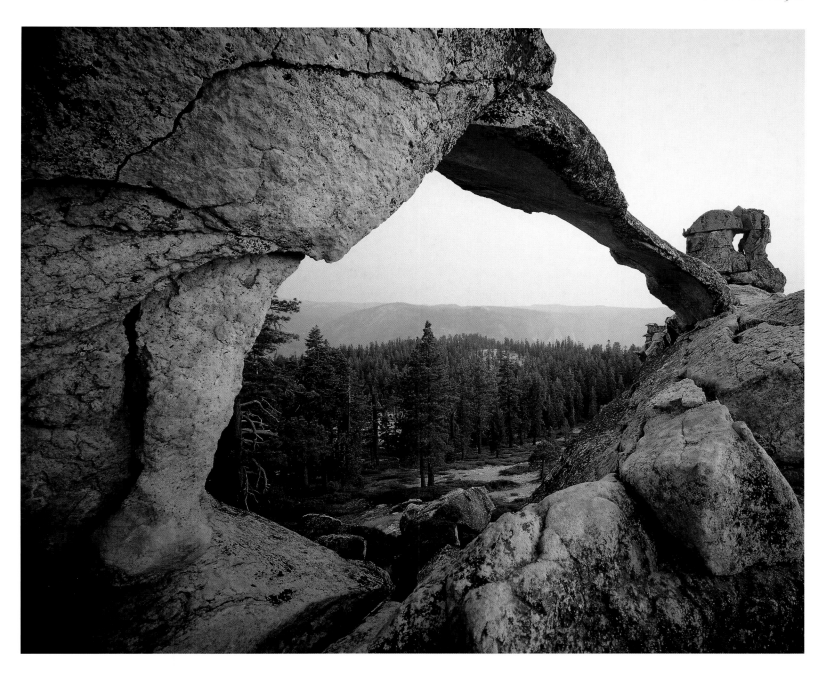

**Indian Rock,** *Yosemite National Park, California*

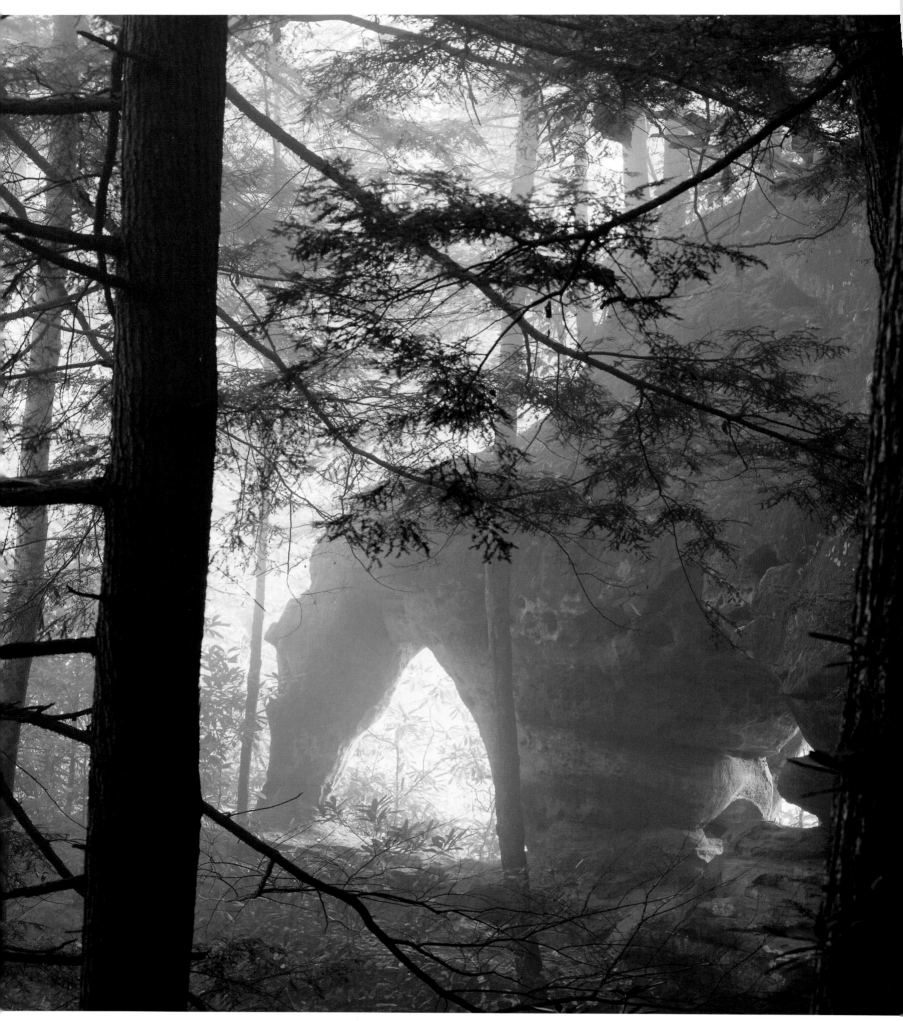

**Angels Windows,** *Red River Gorge, Kentucky*

Deep gorges carved into the ancient sandstone of the East's vast Appalachian Plateau conceal arcane openings. Ridges and cliffs in which arches and bridges form reach like fingers through thick hardwood forests where few forms are easily visible. The dark sandstone of these arches, windows, and bridges is a universe away from the flamboyant colors of the Southwest's sandstone. Language is used differently here, where the words "arch" and "bridge" are interchangeable. An arch shaped like a man-made bridge is called a bridge, whether or not it was formed by flowing water. A structure actually formed by flowing water but shaped like an arch is called an arch. Cavelike openings in cliffs are called rockhouses, places that often provided shelter for early Indians. Once an opening is naturally cut, a rockhouse becomes a lighthouse. Enlarged, the lighthouse opening becomes an arch.

It was autumn when we traveled east, raining when we arrived. In the forest, the year's leaves lie atop the soft detritus of centuries of leaves. Tree limbs grow twined against rockhouse walls, intimately and forever connected in the sinewy shapes of their accommodation. Spiderwebs glisten in low sun, fairy wings woven of fog and shimmering light. Streamlets flow through dark hollows. Birds call across the afternoon. Weak sun lingers on a single fern. A leaf falls, turning, twisting, lying on the air, slowly yielding to the silence of the earth.

DANIEL BOONE NATIONAL FOREST, RED RIVER GORGE AREA, KENTUCKY. In the richly green Daniel Boone National Forest, the quarter-mile trail from the road to Angel Windows is lined with thick clumps of rhododendron and towering umbrella magnolias. I imagined the huge, prehistoric looking leaves of these strange magnolias shading dinosaurs. (They didn't.) Fallen, the leaves lie silver white on the forest floor, like tossed-out paper—not litter, but entirely natural. We passed deep sandstone caves to reach two small arches framing the forested gorge below them, the fanciful end (or beginning) of a high, curving rock wall, punctuated by caves. Some people report seeing halos through the arches, which is how they got their name, but I think the name must come from the sheer magic of the forms' diminutive, powerful presence in this deep forest.

When you spend days hiking in an area, its wonders or its curiosities or its subtleties increase. Although we were deliberately searching out arches, each one surprised us, as if, in the mystery of the forest, we had forgotten why we had set out. The trail to Gray's Arch winds through sassafras and rhododendron, ferns and umbrella magnolia, bright red maples, oak trees and tulip poplars, then steeply descends (via fifty-nine steps) as it circles around the cliff that forms the arch. At first view, it appeared unreachably high above us, but a brief, steep trail brought us to its base. The arch is magnificent, extending out of a massive, curving wall full of caves, alcoves, and ledges. Only the sound of water falling in droplets over the wall interrupts the silence in this place.

The backside of this arch is a work of art. A cliffside of swirled and layered rock rolls into waves and circles; forms mazes, labyrinths, eyes, manes blowing in the wind, rose petals and cabbages, fins, scallops, and furls of pure motion like contour lines on a natural map defining a topography no one can imagine. Orange, green, black, and yellow, the wall is a sculpture etched and hollowed and molded.

At Sky Bridge, the only way we knew that the broad, flat walkway we had just passed over was an arch and not simply a rock ridge, was to descend and view it from below. Like most other trails in this region of Kentucky and Tennessee, there are many steps here—some carved into the cliff rock, others built of rock or wood or formed as ladders. We got to walk up seventy-seven of them on our return from Sky Bridge, which is, in fact, an arch.

Rock Bridge Arch—here's a name that takes care of everything. In addition, the arch looks man-made, its huge blocks of stone laid by skilled masons so long ago that lichen and moss have

covered the moist, dark rock. Trees and mountain laurel have found purchase here, and autumn's leaves lie yellow and orange and brown atop it. Sunlight stipples its sides and stripes the stream below. Ferns line the path to the stream from the hemlock grove we passed through to reach the arch. After days of rain and mist and fog, the cloudless blue sky was interrupted only by the gold and green heights of trees.

NATURAL BRIDGE STATE RESORT PARK, KENTUCKY. Natural Bridge State Resort Park is a playground, a busy place accessible via several trails and by chairlift. The trail to the Natural Bridge itself is one of the few hikes in this region that go uphill at the beginning. The Original Trail (that's its name), which starts just behind Hemlock Lodge, the park's hotel facility, was built in the 1890s by the Lexington and Eastern Railroad to encourage tourism in the area. It climbs over five hundred feet in half a mile through a forest of hemlock, yellow poplar, white pine, and rhododendron, to end just beneath the span of Natural Bridge, really an arch. This is a civilized walk, with gazebos every so often, places to sit and consider the forest.

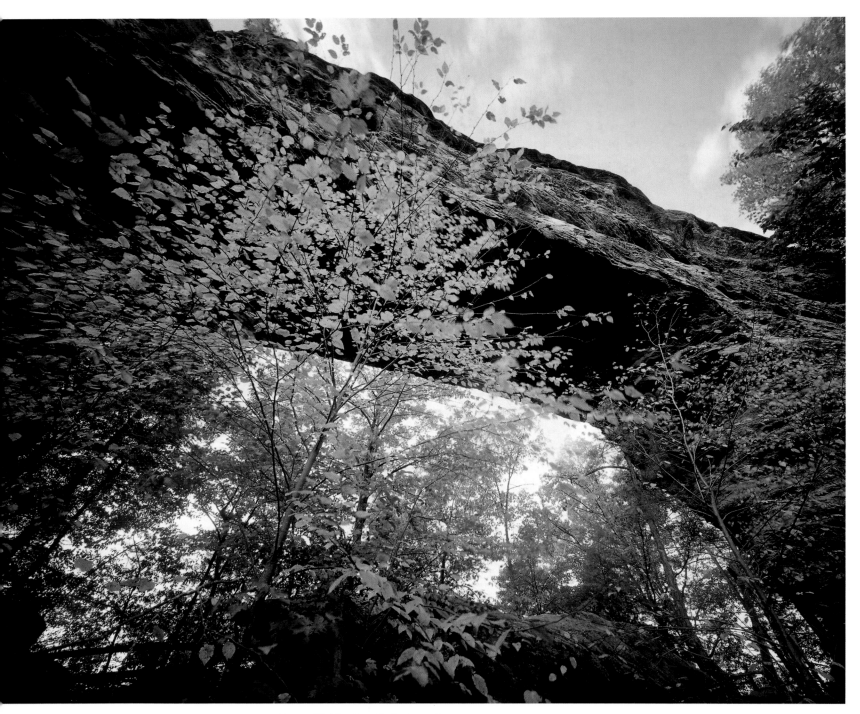

**Natural Bridge,** *Natural Bridge State Park, Kentucky*

As my friend Gena and I walked up the path one foggy morning, three spelunkers crawled out of a cave along the route, muddy but pleased with their exploration. The bridge appeared suddenly. Narrow steps lead up through a natural, shoulder-width fracture on the far side of the bridge from the trail's end to its top, a broad, flat walkway that allows visitors to cross from one trail to another. Early mornings are quiet. We felt a sense of true emergence as we climbed up through fog-shrouded forest into sun on top of the bridge.

BIG SOUTH FORK NATIONAL RIVER AND RECREATION AREA, TENNESSEE. Big South Fork is a rugged gorge area of the Cumberland Plateau, the southern part of the Appalachian Plateau. Rockhouses and arches carved from cliffs deep in the forest and along the edges of gorges are everywhere, throughout the recreation area and adjacent Pickett State Park and on private land. Local people say there are more here than anywhere in the East. They also boast the largest natural arch complex in the world is in Tennessee. It is true that few natural arches in the world can beat Twin Arches when both are taken as a single landscape feature. Evolving out of the same ridge, South Arch is 70 feet high with a span of over 135 feet and North Arch is 51 feet high with a 93-foot span. All that stands between them is a resistant part of the ridge, but we could not figure out a way, given the terrain and vegetation, to view the two together.

North Arch is a graceful, sturdy span. South Arch, full of alcoves, caves, and recesses, is far more massive and complex. A row of ferns lines one wall of South Arch; a tangle of dark, lichen-covered roots extends down one slope; huge boulders, fallen from the arch in the process of its forming, lie scattered on the sand floor. A dark, deep cave against the south buttress is beguiling and forbidding at once. We entered the cave. What seems pitch blackness from this side offers, once you step far enough inside, a tiny strip of light at its far end. We walked toward it, feeling our way along the walls and on the rock overhead, then arrived at a narrow opening that freed us into the forest where the Twin Arches' ridge ends.

NATURAL BRIDGES NATIONAL MONUMENT, UTAH. The three bridges in this national monument all developed in Cedar Mesa Sandstone deposited about 270 million years ago when America's western shoreline ran through what is now central Utah. Dating back less than thirty thousand years, the bridges are much younger. When, sometime during the last 6 million years, the long-buried Cedar Mesa Sandstone became exposed again, streams flowing through White and Armstrong Canyons began the process of cutting down into it. Owachomo, Kachina, and Sipapu Bridges are among the world's ten-largest natural bridges. Only Utah's Rainbow Bridge is larger than Sipapu.

Owachomo Bridge is now isolated from the stream channel that formed it. We walked down the dry channel—a broad, slickrock slope—to the edge of Armstrong Canyon one early May evening. There were no other people below the bridge; no wind; nothing but an occasional mosquito, a flitting bird, feathery greening shrubs, evergreen trees, brown water in the pools of the stream bed, brown mud at their edges. The stream below Owachomo Bridge bends sharply around rock ledges descending from the walls of Armstrong Canyon. One day the three bridges in the two canyons will collapse, but these walls will produce new bridges.

Owachomo Bridge spans 180 feet. It is 106 feet high, but only 9 feet thick at the span's apex. Nine feet is not much, and this bridge—the oldest in Natural Bridges National Monument—is fragile.

Kachina, the next bridge downstream, is the youngest. This one, near the confluence of Armstrong and White Canyons, is still growing. Two hundred ten feet high, Kachina Bridge has a 204-foot span that is 93 feet thick. In 1992 about four thousand tons of sandstone peeled off the underside of the bridge. A solid, massive structure formed, and essentially surrounded by overhanging walls, Kachina Bridge offered a cool respite on a hot afternoon. After descending

When . . . the long-buried Cedar Mesa Sandstone became exposed again, streams flowing through White and Armstrong Canyons began the process of cutting down into it. Owachomo, Kachina, and Sipapu Bridges are among the world's ten largest natural bridges.

Kachina Bridge is named for rock art symbols on the bridge that are symbols commonly used by Kachina dancers.

four hundred feet in a mile and a half, we arrived at a canyon shaded by oak and ash trees. Entering into the protected world of the bridge from the exposed slickrock was a revelation. Huge boulders cast shade upon pools of water gathered at their edges. There were deer tracks in the thick mud rimming the pools; the summer sound of flies; the shimmer of light in the flickering leaves. This must be a place of enormous power when storms send water pouring down the two canyons.

The ruin on the ledge to the southwest is roped off in a belated attempt to keep vandals from adding their imprint to the rock art on the walls. The Ancestral Puebloans who lived here two thousand to seven hundred years ago were considered by William B. Douglas, leader of a 1908 government survey party to the bridges, to be ancestors of the Hopi. It was he who gave Hopi names to the bridges. (They had earlier been called Edwin, Caroline, and Augusta respectively. It is hard to walk beneath Owachomo Bridge and think of it as Edwin.) Kachina Bridge is named for rock art symbols on the bridge that are symbols commonly used by Kachina dancers. Owachomo means "rock mound," a feature on top of the bridge's east abutment.

Sipapu Bridge, in White Canyon, is the largest of the three. Two hundred twenty feet high, with a span of 268 feet, this one is the easiest to see from the road and the hardest to reach. It requires a hike that descends (and then, of course ascends) 500 feet in 1.2 miles. The trail,

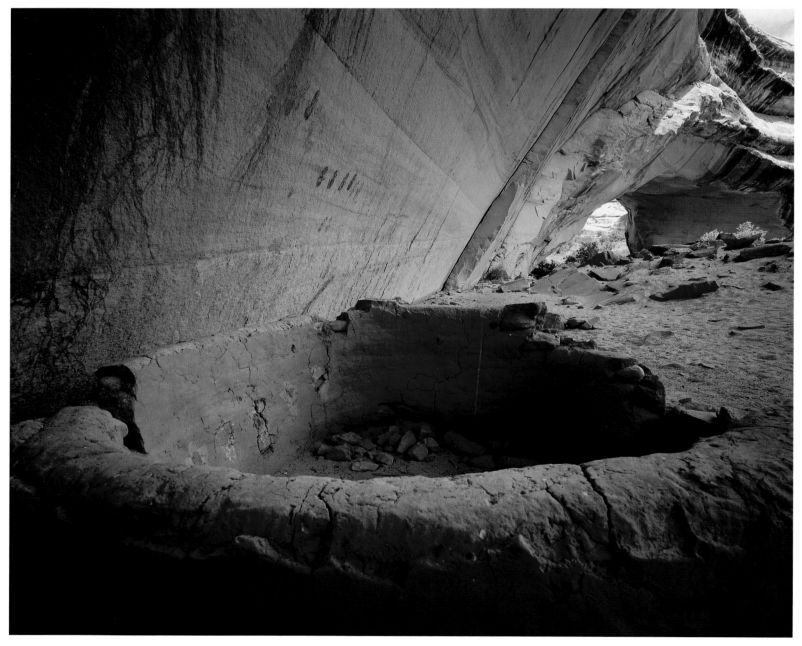

**Kachina Bridge and Kiva,** *Natural Bridges National Monument, Utah*

especially as we were climbing out, gave personal meaning to the definition of Sipapu as "the place of emergence." In his wonderful book, *Of Wind, Water & Sand,* David Petersen quotes from Douglas's field notes, writing that Sipapu Bridge formed a "great portal across the canyon through which all who follow the canyon trail must pass . . . [suggesting that] the Sipapu, which according to the cosmogonic mythology of the Hopi . . . is the gateway through which man comes to life from the underworld, and through which he must finally depart."

CAPITOL REEF NATIONAL PARK, UTAH. A harsh white light lies on the white domes of Navajo Sandstone we saw through Hickman Bridge. The huge array of domes is the source of Capitol Reef National Park's name because early visitors thought they looked like the white-domed buildings in our nation's capital. "Reef" refers to rocky barriers that once made traveling difficult here. Far beyond the park, Utah's Henry Mountains stand dark gray and blue against a pale sky. It is not an interesting light, but it is a spectacular place. The bridge, carved from Kayenta sandstone, is 133 feet wide and 125 feet high. In shadow, it is a brooding, sturdy monument to time and the movement of water. Along a crack running from the top almost to the bottom of the base, you can see the route for winter's ice, the loosening of more sand grains, the pushing apart of this rock.

Walking up the trail to Hickman Bridge, we passed two low, small bridges, one after the other spanning the intermittent creek bed. The sandstone of these little bridges seems so friable you could chip it with a fingernail. Perhaps in 180 million years they will be bridges people come to see. The bridges—the little ones and Hickman—are part of a world of cliffs, domes, canyons, and arches sculpted out of the Waterpocket Fold, an almost one-hundred-mile-long monoclinal fold created 65 million years ago.

All natural forms are always in a state of change, but Capitol Reef National Park's literature emphasizes the changing nature of nature. Maybe this is because much of the sandstone here seems so fragile, ready to erode again into the sand that formed it. Or it may be because there is so much evidence of early inhabitants here, all of whom turned out to be as transitory as the landscape itself. Years ago I took an Outward Bound course in Capitol Reef. One night we camped beneath petroglyphs incised into a wall by people of the Fremont Culture who lived here in A.D. 700. We ground meal for dinner in the rounded-out hollow of an ancient metate, a stone worked for centuries by women who must have been so different from us, and so like us. More recently, Utes and Paiutes hunted this land. There was plentiful game, and respite in the green and hidden grottoes of secluded side canyons. Explorers, miners, and Mormon pioneers followed the Indian people.

Early in that Outward Bound trip we stopped in the Fruita orchard planted by Mormons in the nineteenth century. Several buildings of their community still stand. (When Capitol Reef became a national monument in 1937, Mormon families began moving away.) Now, of course, there are the park employees and visitors like us, all of us the same—here for a while and gone; no more permanent than the rocks, the streams, the arches, the bridges, the mountains. The Capitol Reef Natural History Association ends its guide to the Hickman Bridge Trail with the words, "century after century, age after age, the canyons, domes and cliffs ebb slowly away. Even Capitol Reef is not forever."

YELLOWSTONE NATIONAL PARK, WYOMING. In Yellowstone National Park there is a bridge very different from these others. Not visible until you are almost below it, it appears suddenly, like the rare gem it is. This is not an ordinary structure here and it seems improbable in this huge landscape of meadow and stream and forest. But then, Yellowstone is full of oddities— bubbling mud, boiling springs, geysers exploding hot out of an earth in the process of forming, obsidian mountains, and sinter landscapes. Yellowstone's Natural Bridge is an opening in a

There are the park employees and visitors like us, all of us the same—here for a while and gone; no more permanent than the rocks, the streams, the arches, the bridges, the mountains.

sudden rock wall where there is otherwise nothing but forest. A graceful span made of black, sharp rhyolite, the volcanic rock underlying much of Yellowstone, it formed when what we now call Bridge Creek found an underground route through cracks in the rhyolite. In freezing, it broke away pieces of the rock, then carried the rubble away with the force of its flow.

In 1871 Ferdinand V. Hayden wrote the first description of the bridge: "We found a most singular natural bridge. . . ." Hayden named the stream Bridge Creek, but referred to the bridge simply as a natural bridge until those words had been used so long they became the bridge's proper name. Natural Bridge was made accessible to a public already flocking to Yellowstone ten years later when the park's second superintendent, Philetus W. Norris, built a trail across it. Norris, who constructed the first actual roads in the park, wanted a road across the bridge too, but that didn't happen. A present-day sign posted at the top of the trail calls the bridge a "fragile geologic structure" and asks people not to walk across it, proving that we have come a certain distance from those days when we thought everything on earth begged for use.

By walking up a 300-foot switchback trail, you reach the top of the bridge. From here the bridge looks like curtains of rock decorated with orange and black lichen, dark moss and whitewash left by roosting birds. Ferns nestle into crevices in the shadowed walls of the bridge and the steeply falling creek. From this higher side you can see light falling through a slit on top of the curtains so that the structure appears to be two bridges. The roots of a single Engelmann spruce growing on top spread out along the deck of the bridge and are slowly pushing the rock farther and farther apart. If the tree falls before the roots complete their work, the fall will tear the rock apart. Either way, the rock that gave support to the tree will, one day, be destroyed by the tree. This place is visibly in its own process of life.

On an interpretive sign below the bridge a large drawing compares it with Utah's Landscape Arch and Rainbow Bridge. Juxtaposed on top of the 300-foot-high Rainbow Bridge and 291-foot-wide Landscape Arch is Yellowstone's Natural Bridge—51 feet high and 29 feet wide. Size has nothing to do with beauty or with wonder. ✍

A presentday sign posted at the top of the trail calls the bridge a "fragile geologic structure" and asks people not to walk across it, proving that we have come a certain distance from those days when we thought everything on earth begged for use.

**Natural Bridge,** *Yellowstone National Park, Wyoming*

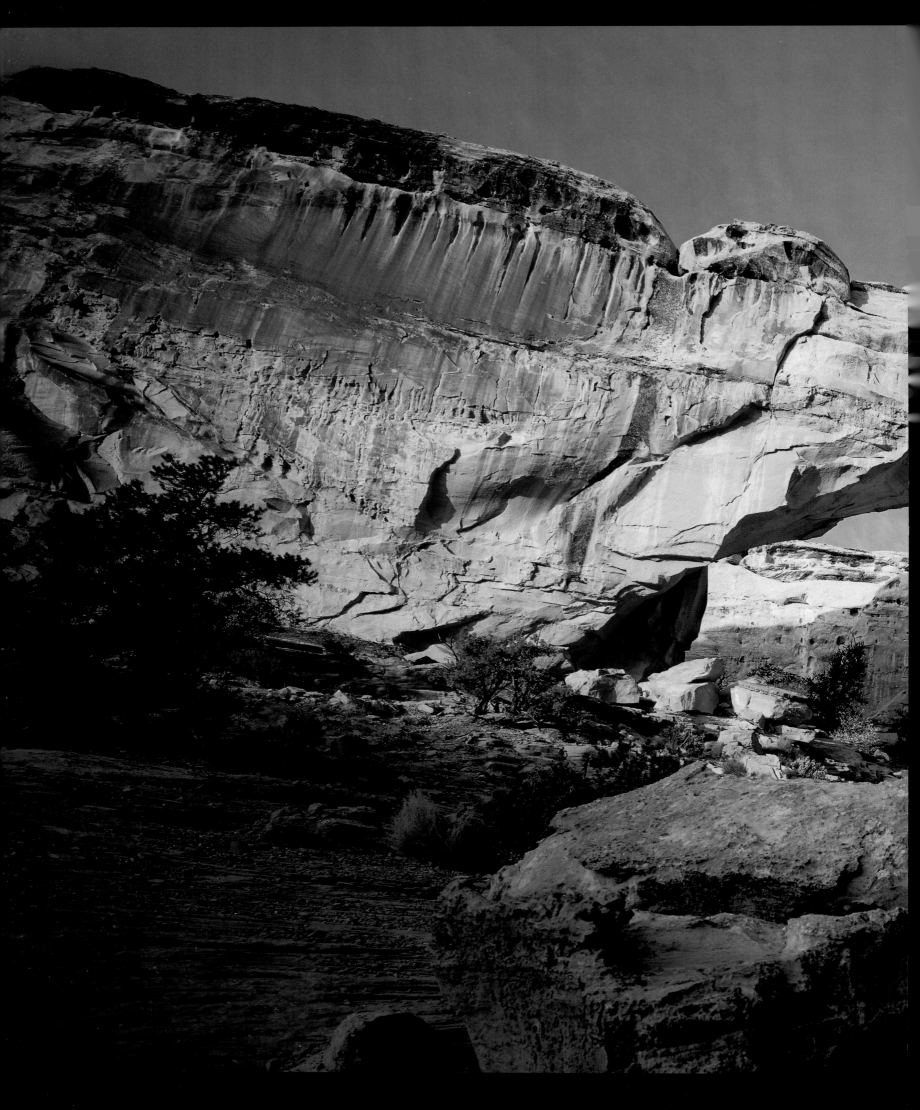

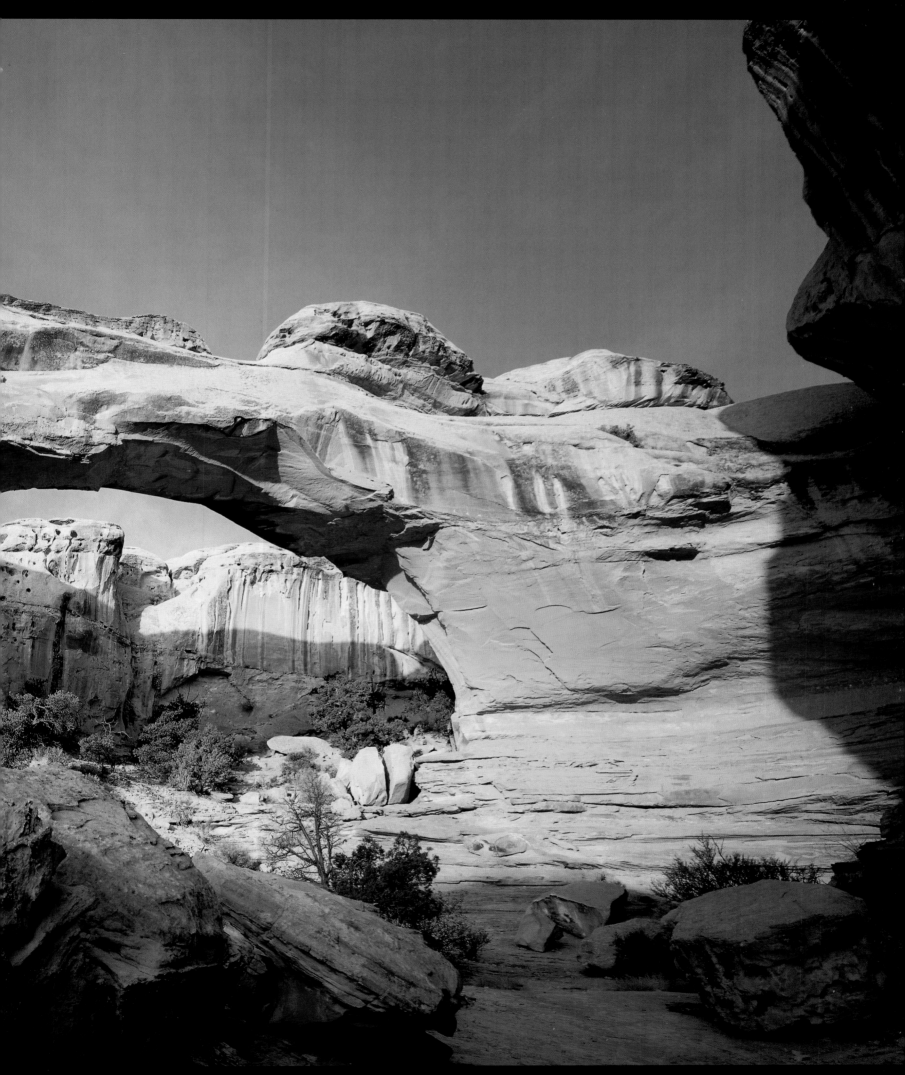

**Hickman Bridge,** *Capitol Reef National Park, Utah*

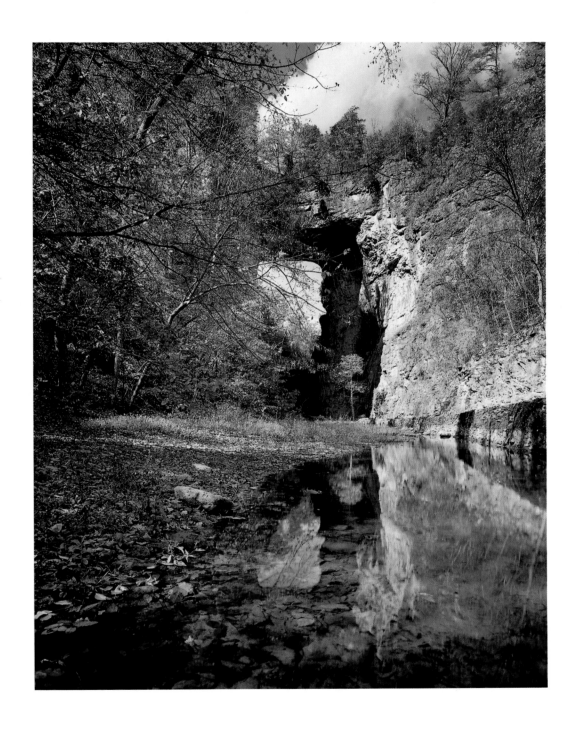

◄ **Natural Bridge,** *Natural Bridge State Park, Kentucky* ▲ **Natural Bridge,** *Natural Bridge, Virginia*

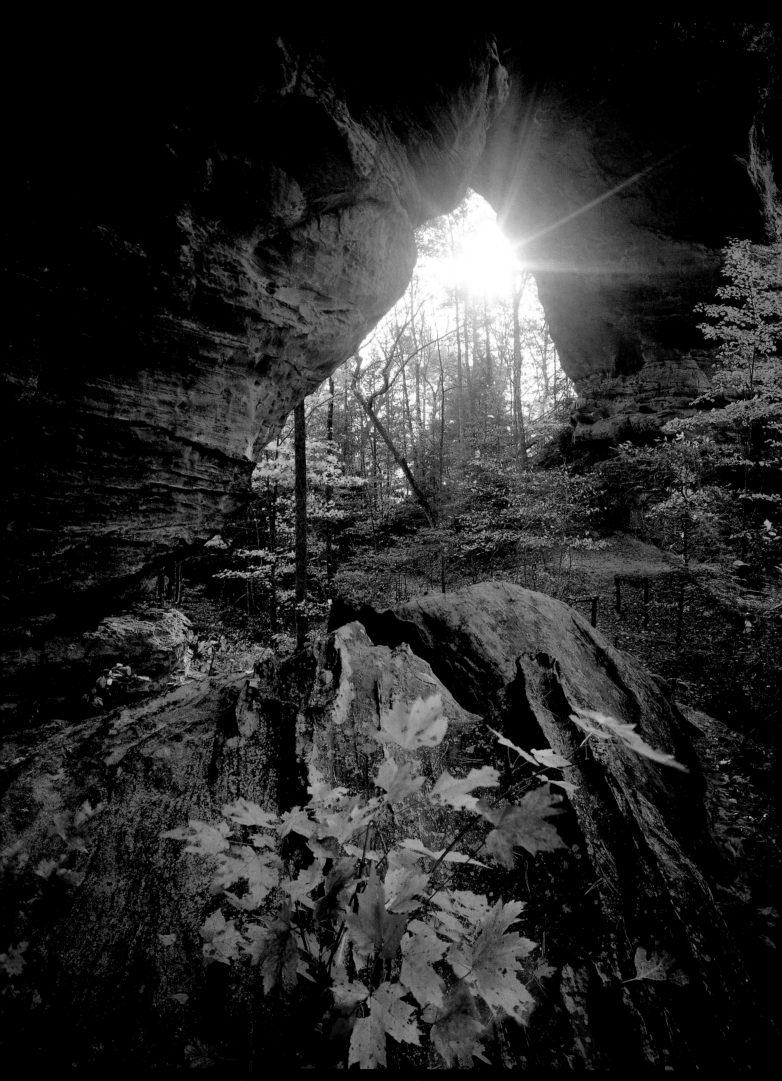

*North Arch, Twin Arches, Big South Fork National River and Recreation Area, Tennessee*

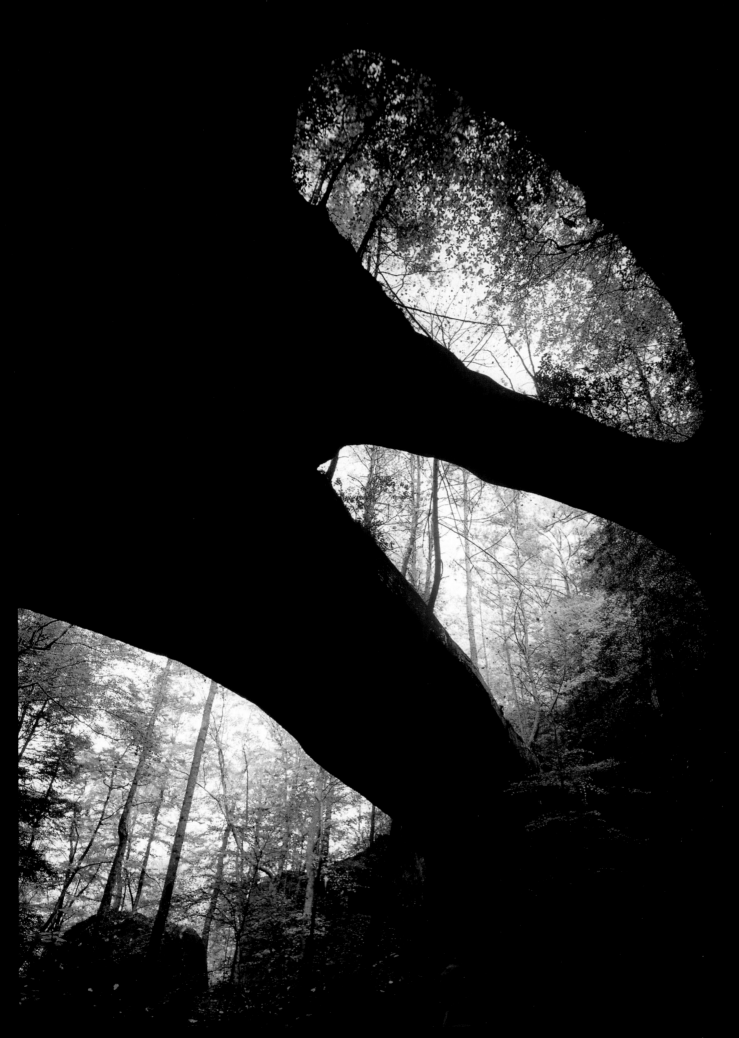

**Natural Bridge,** *Natural Bridge Park, Alabama* ▶ **Rock Bridge,** *Red River Gorge, Kentucky*

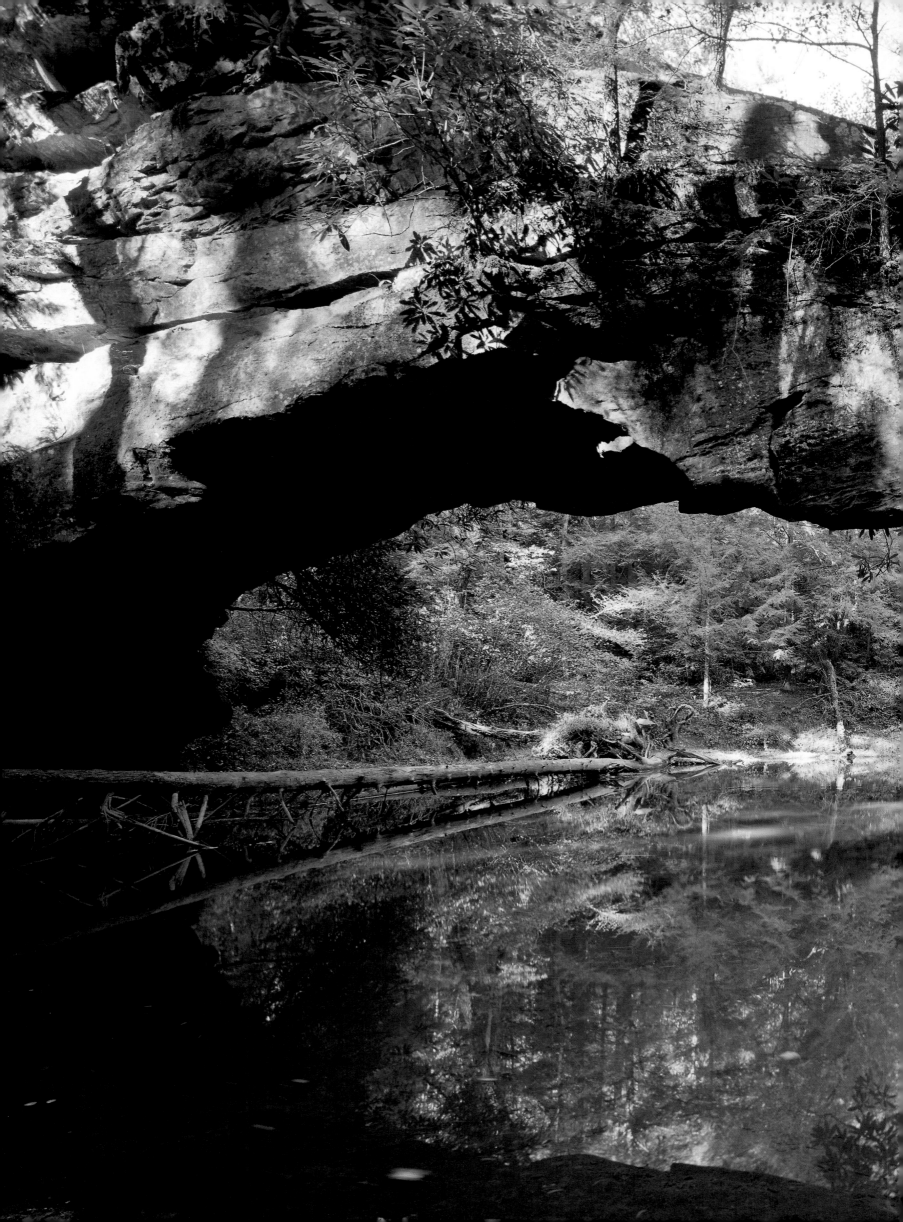

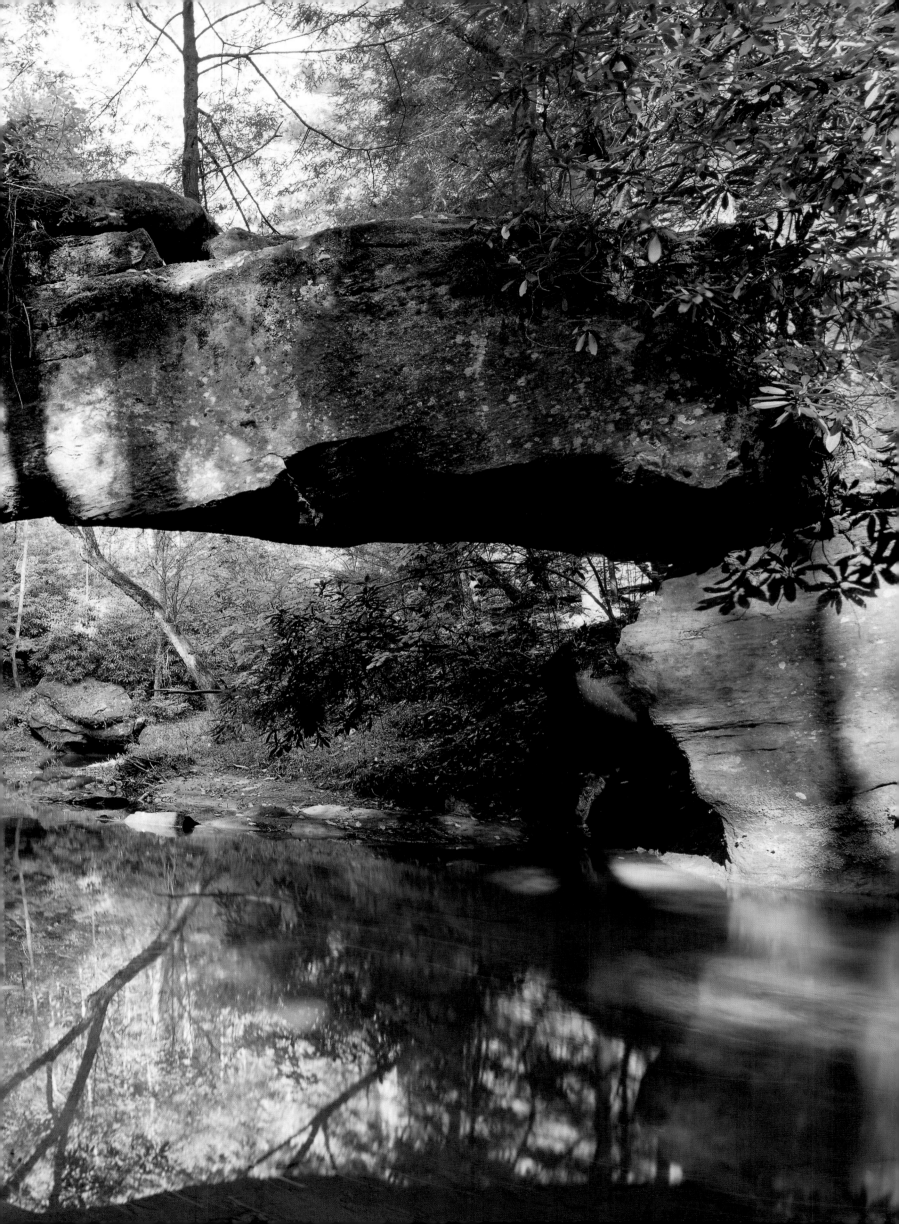

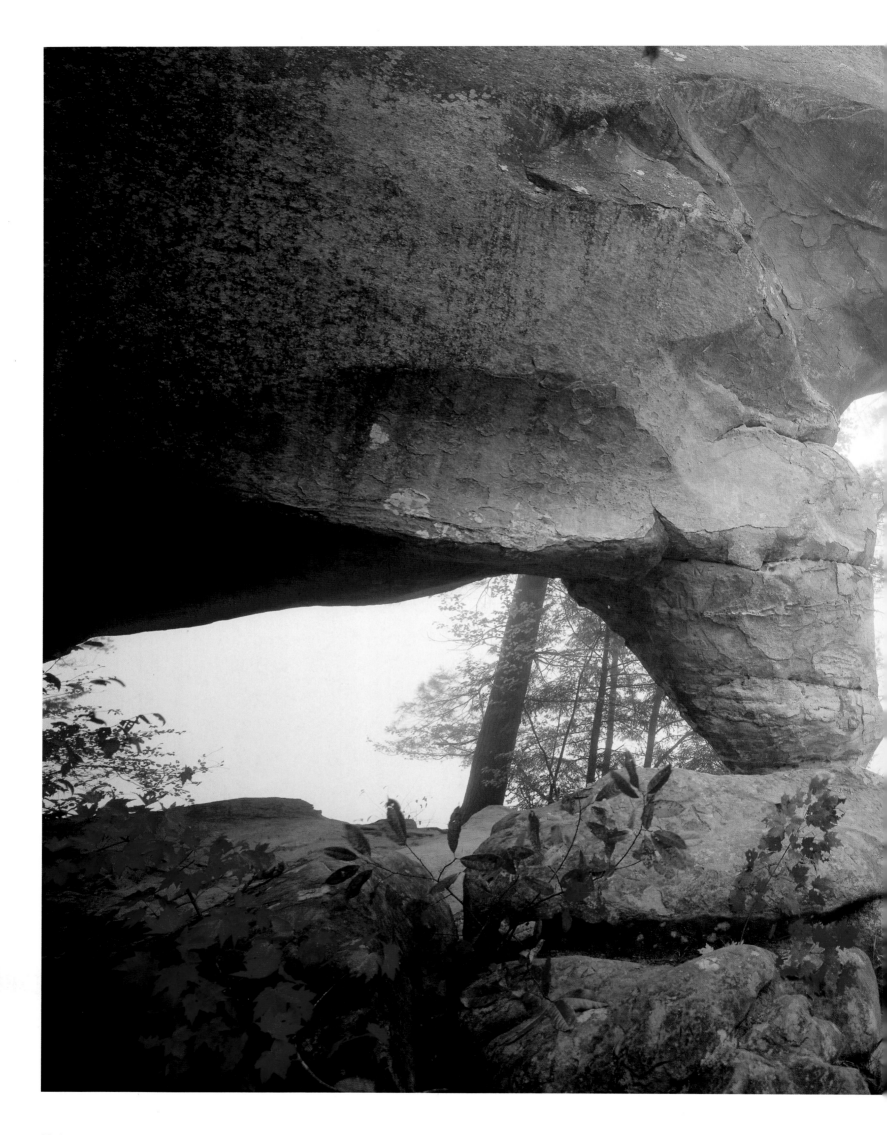

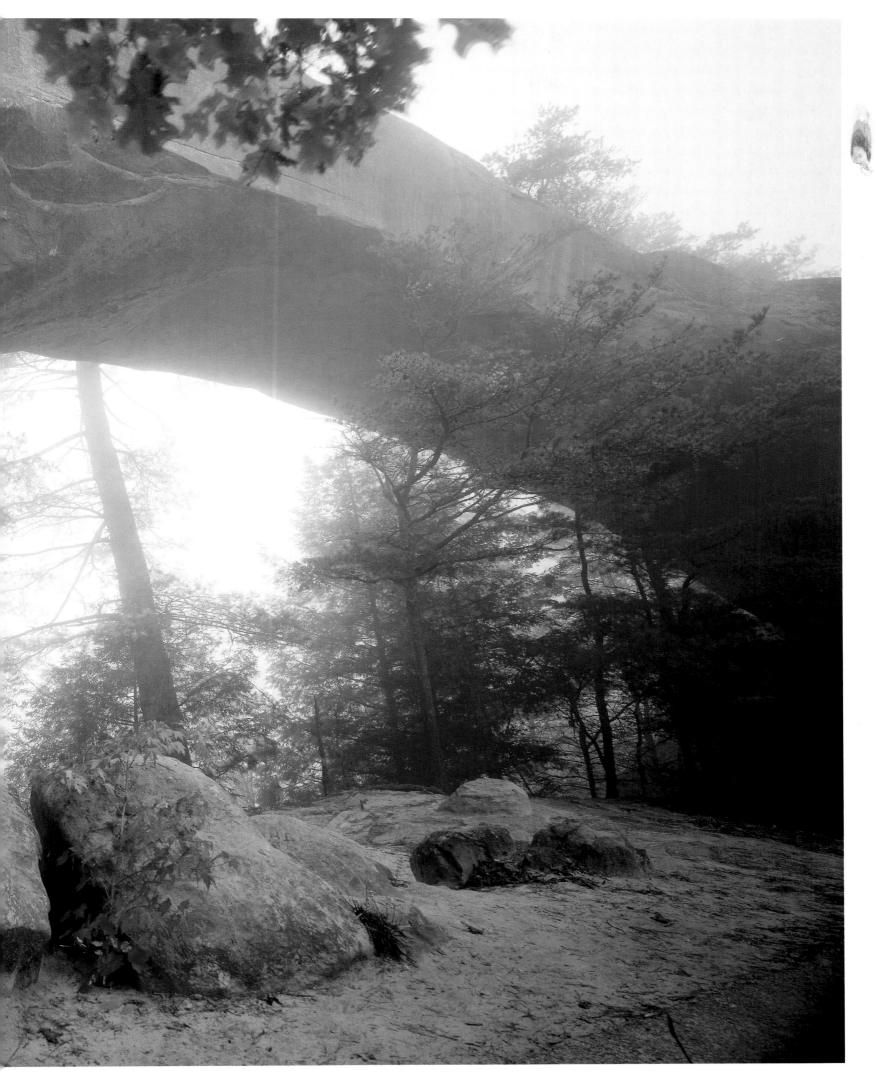

**Sky Bridge,** *Red River Gorge, Kentucky*

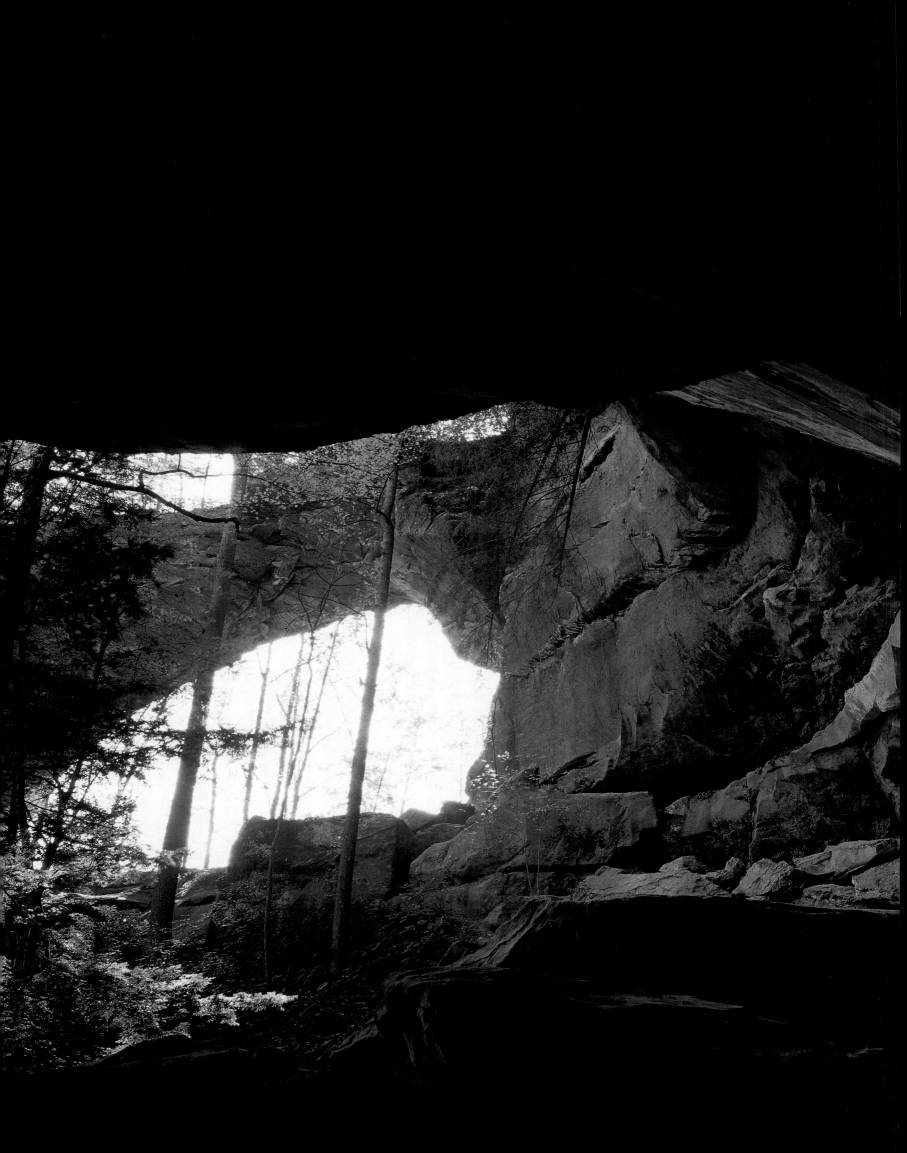

**Grays Arch**, *Red River Gorge, Kentucky*

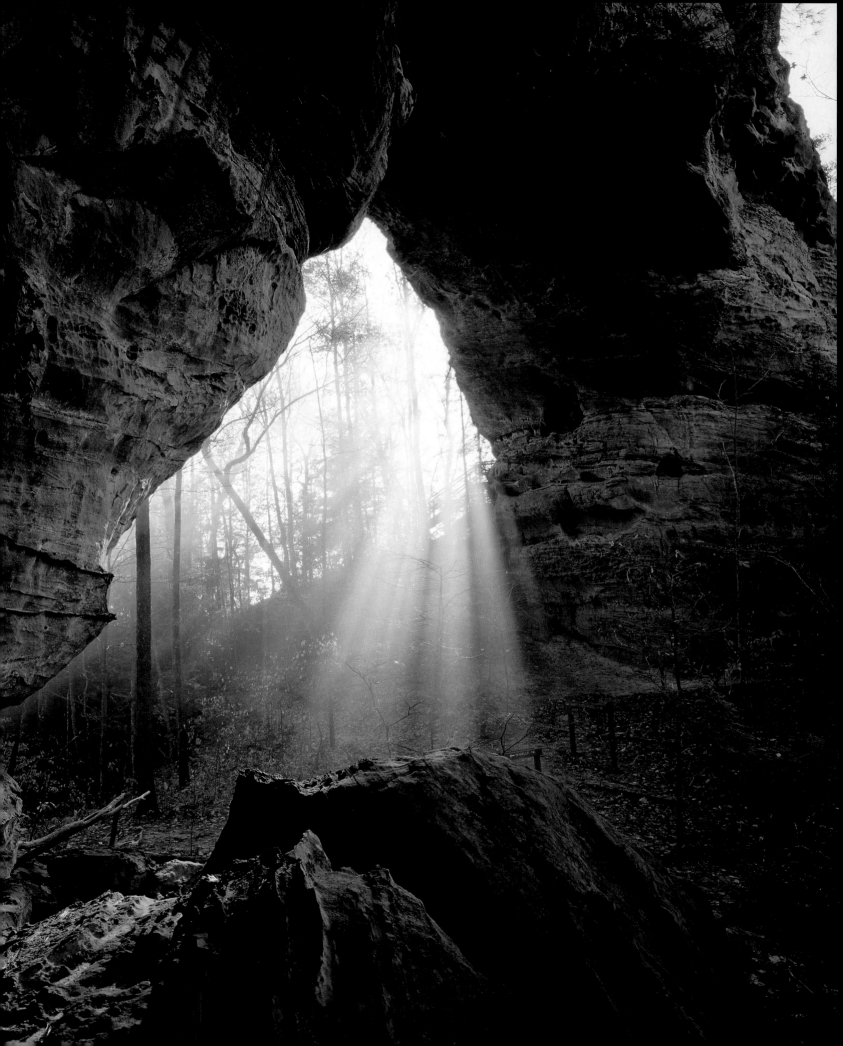

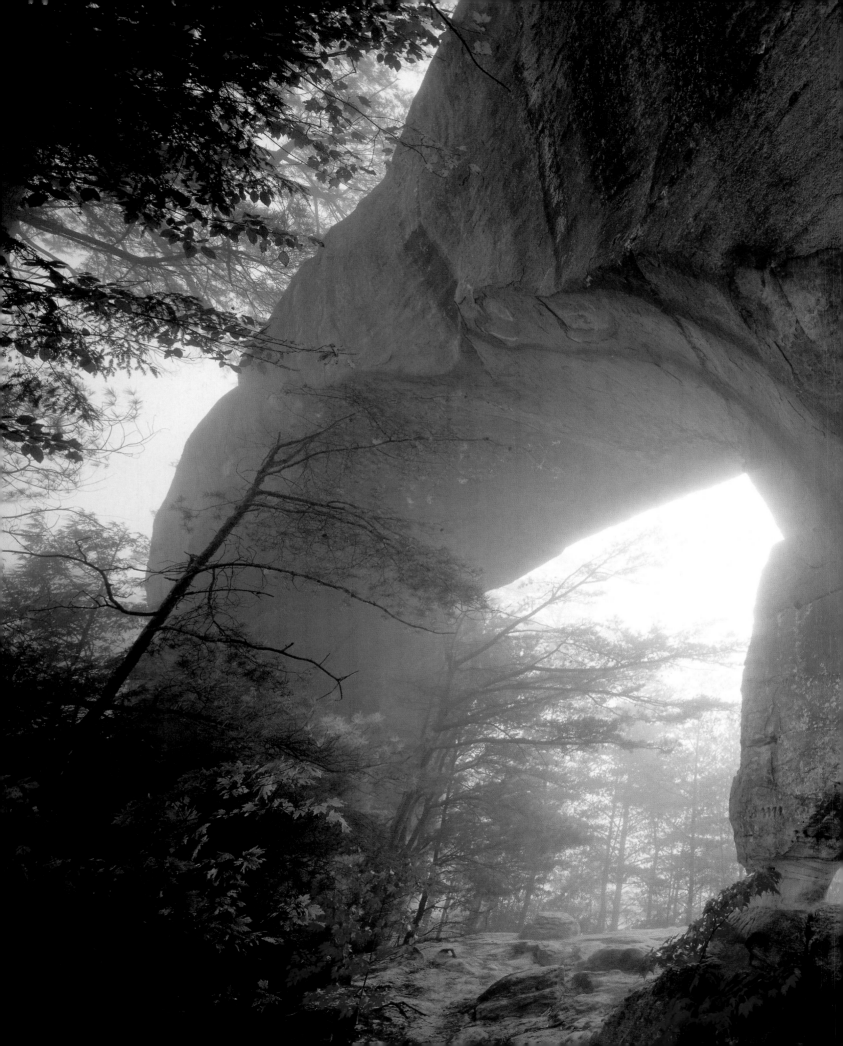

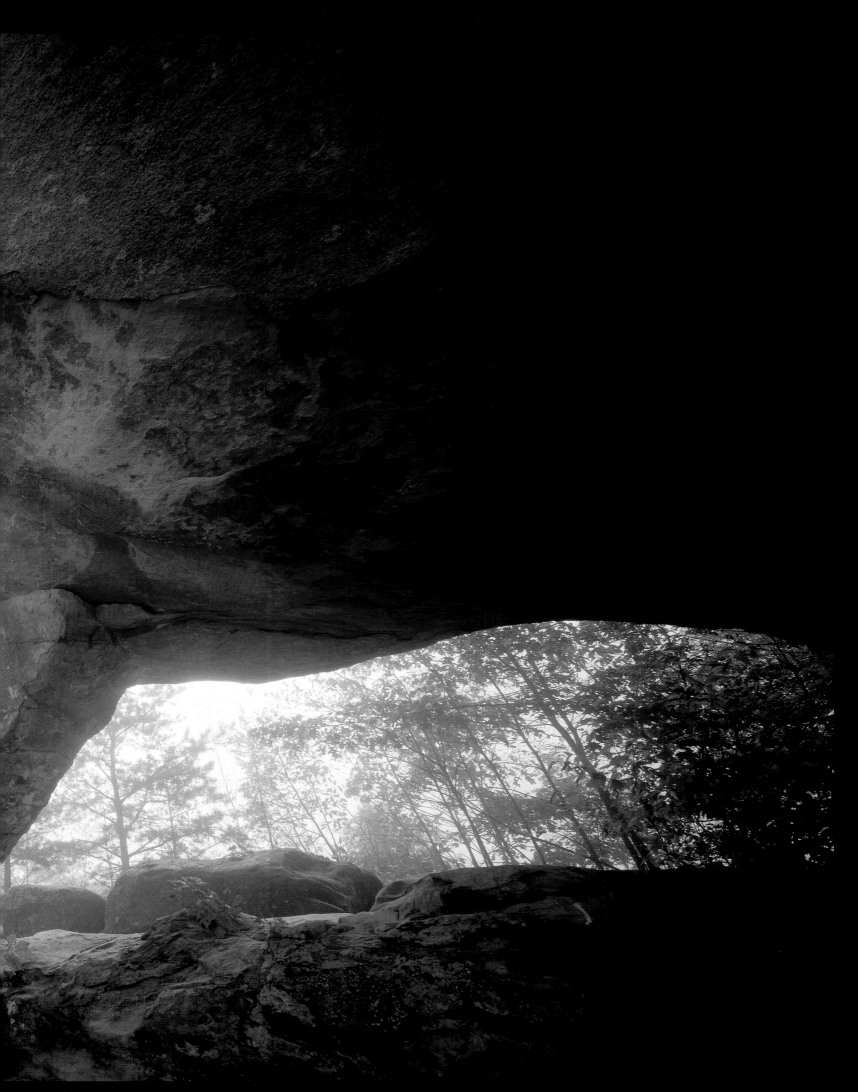

**Sky Bridge**, *Red River Gorge, Kentucky*

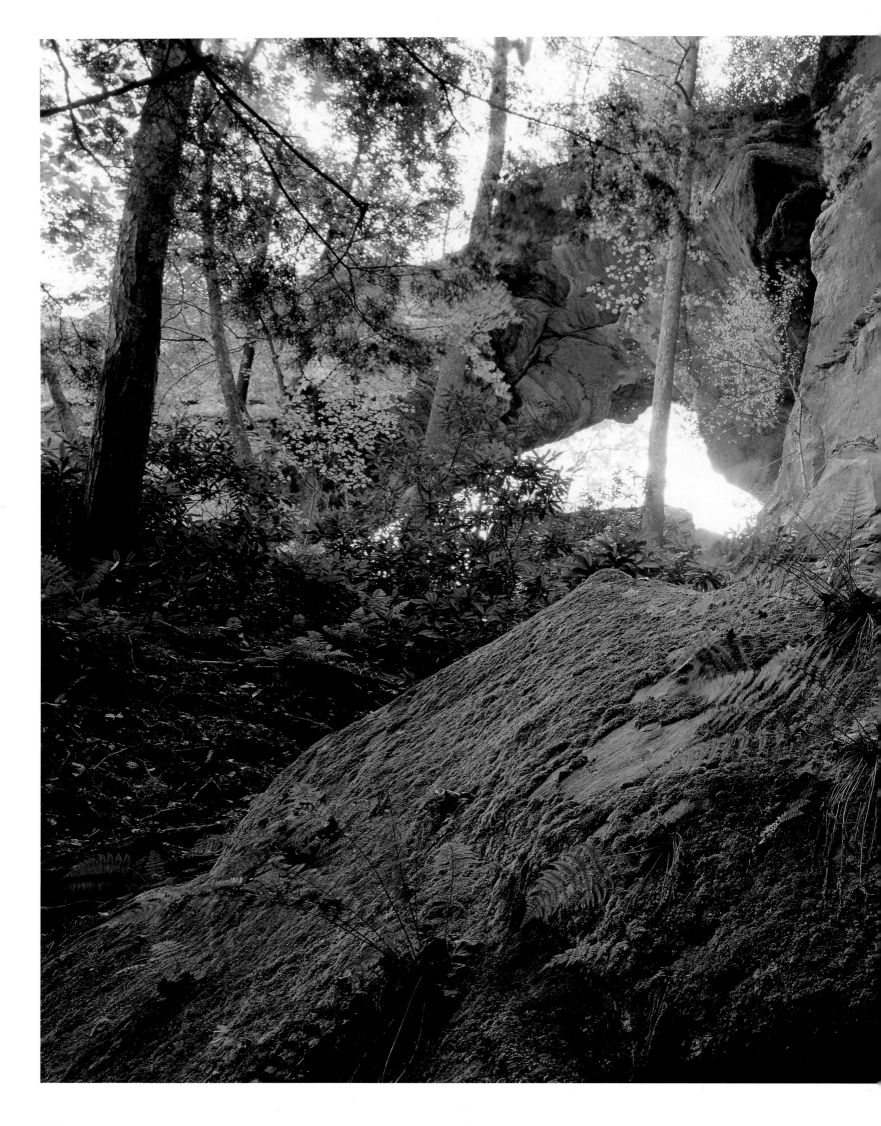

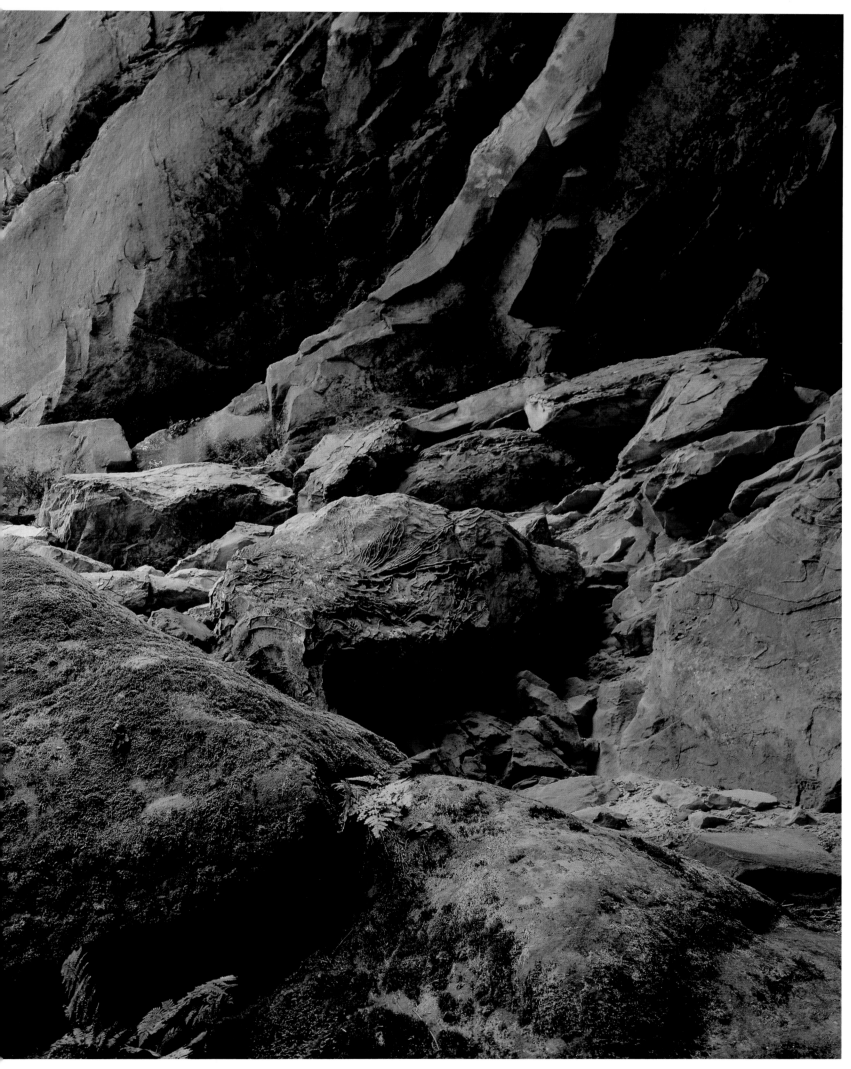

**Grays Arch,** *Red River Gorge, Kentucky*

143

▲ **Double Arch,** *Red River Gorge, Kentucky* ▶ **Natural Arch,** *Daniel Boone National Forest, Kentucky*

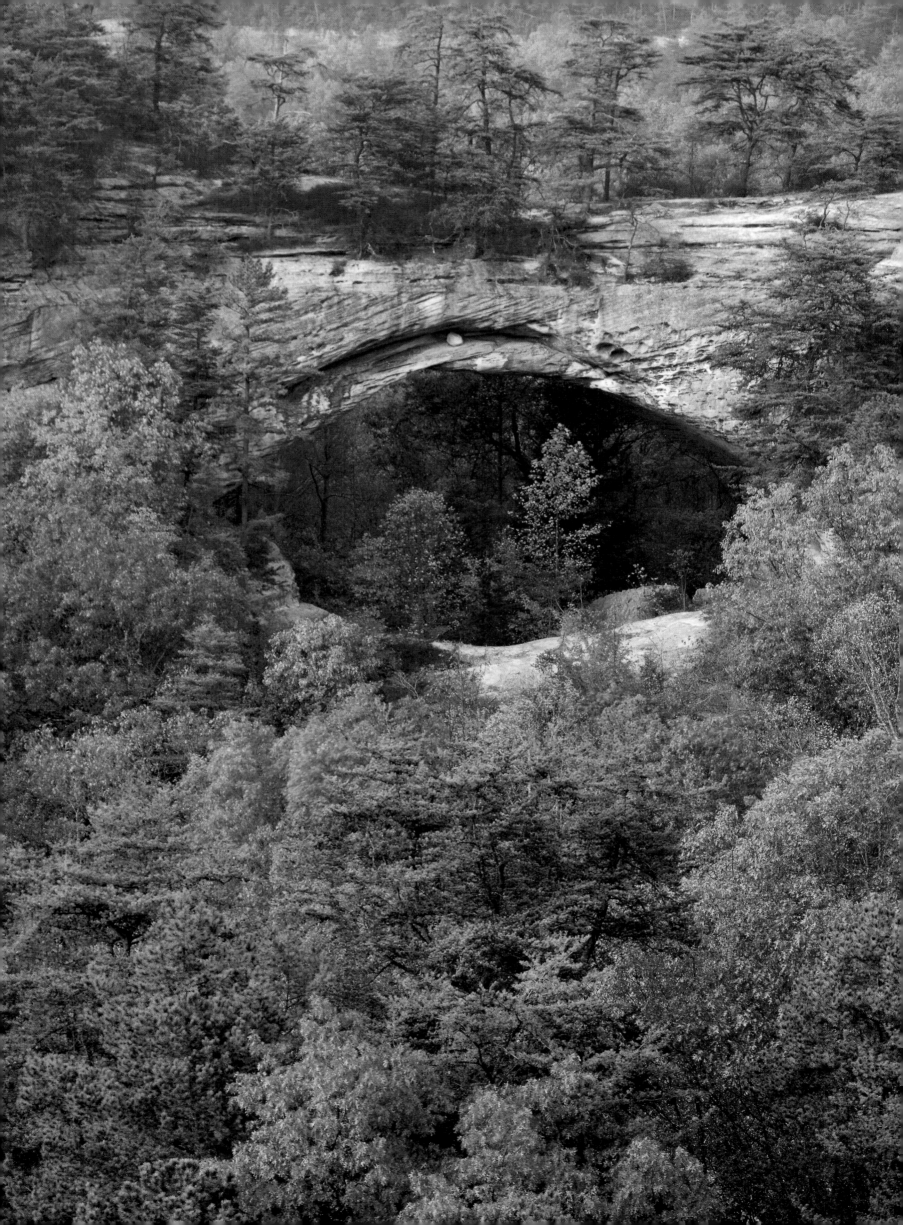

**Needle Arch,** *Big South Fork National River and Recreation Area, Tennessee*

147

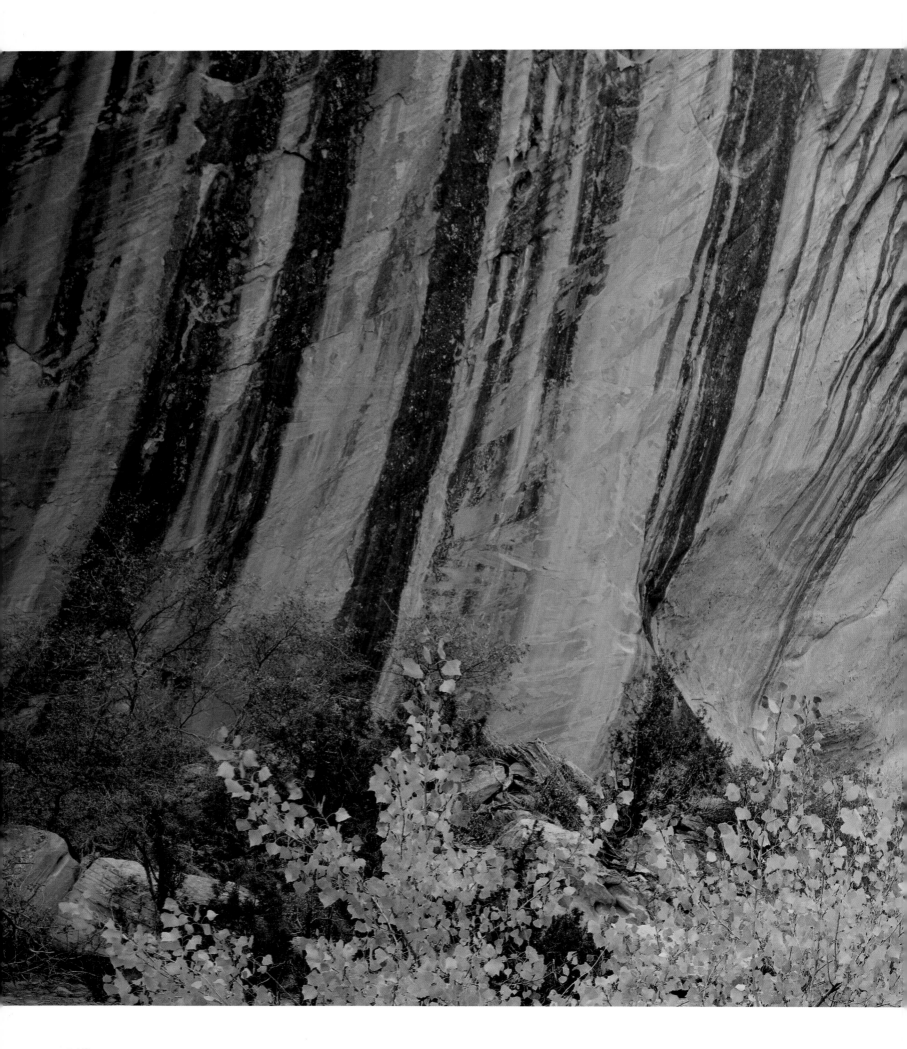

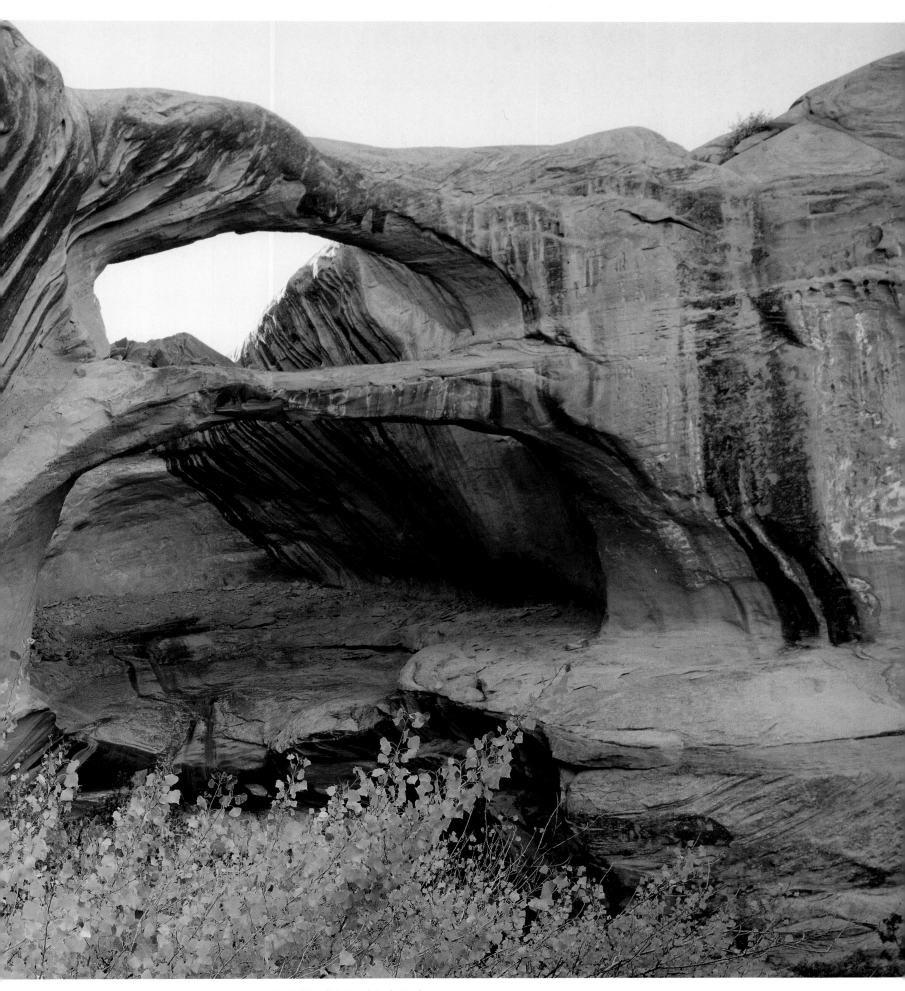

**Brimhall Arch,** *Capitol Reef National Park, Utah*

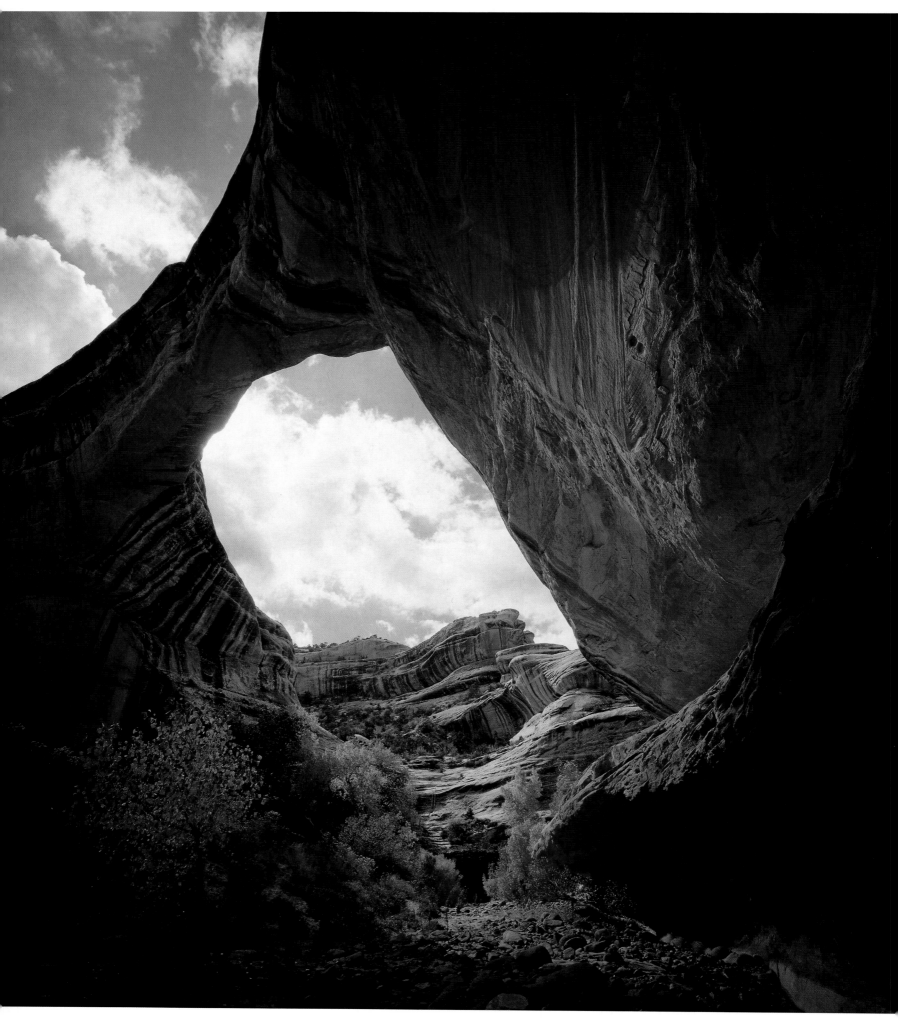

**Sipapu Bridge,** *Natural Bridges National Monument, Utah*

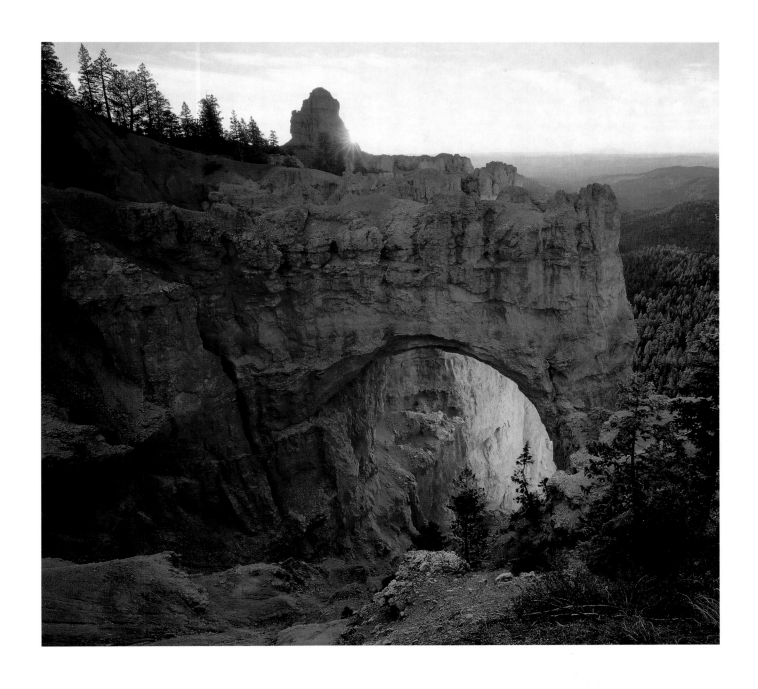

**Bryce Natural Bridge,** *Bryce Canyon National Park, Utah*

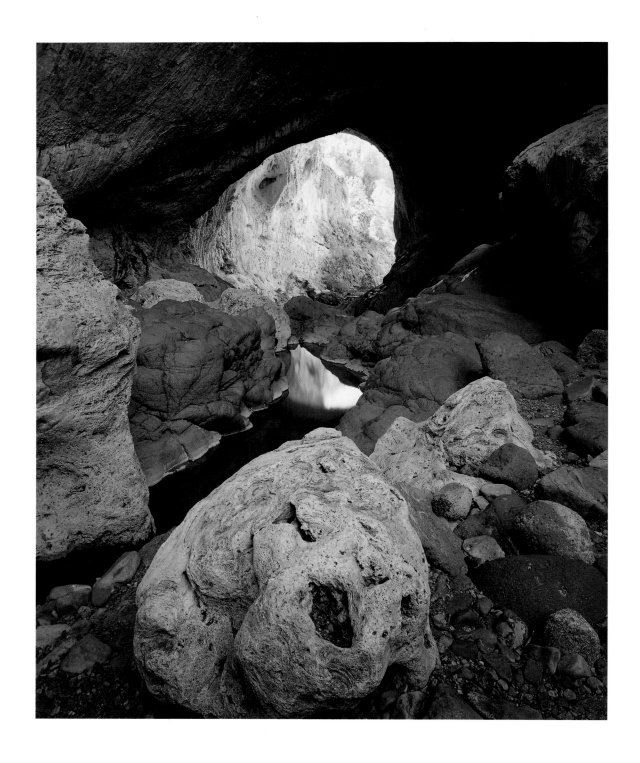

**Tonto Natural Bridge,** *Tonto Natural Bridge State Park, Arizona*

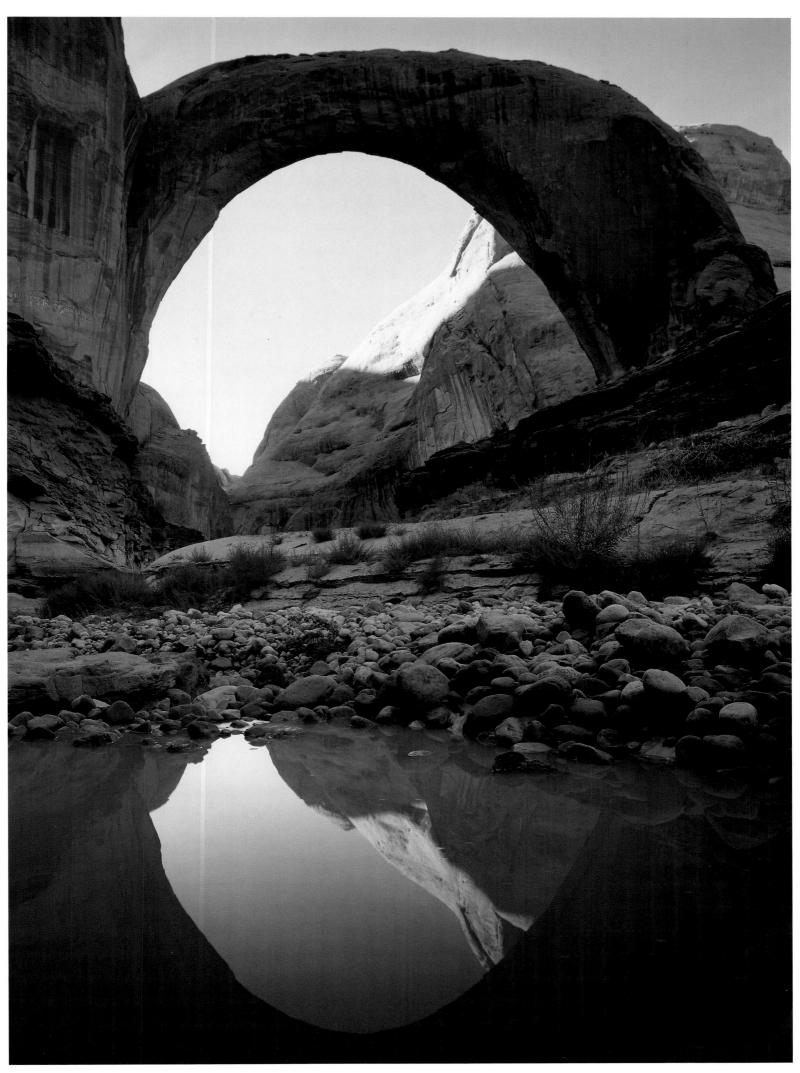

**Rainbow Bridge,** *Rainbow Bridge National Monument, Utah*

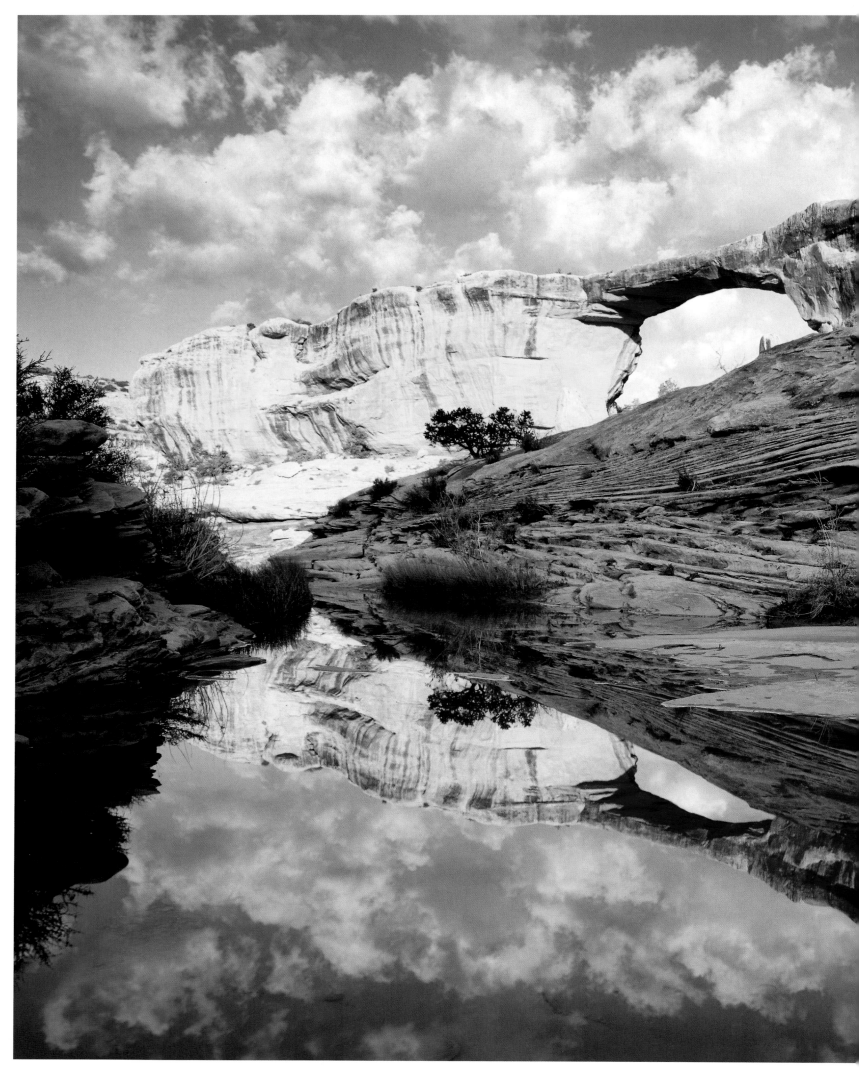

**Owachomo Bridge**, *Natural Bridges National Monument, Utah*

▶ **Aleson Arch,** *Glen Canyon National Recreation Area, Utah*

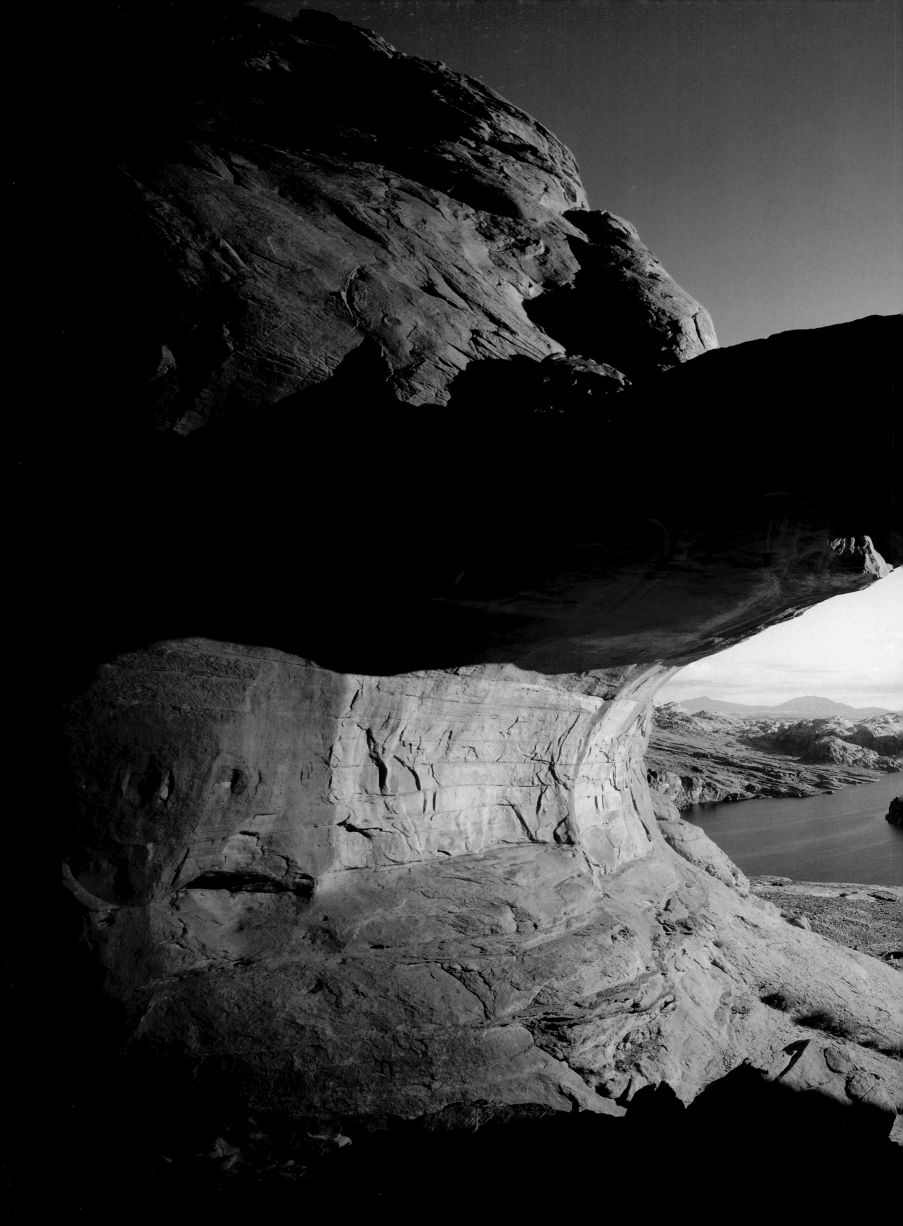

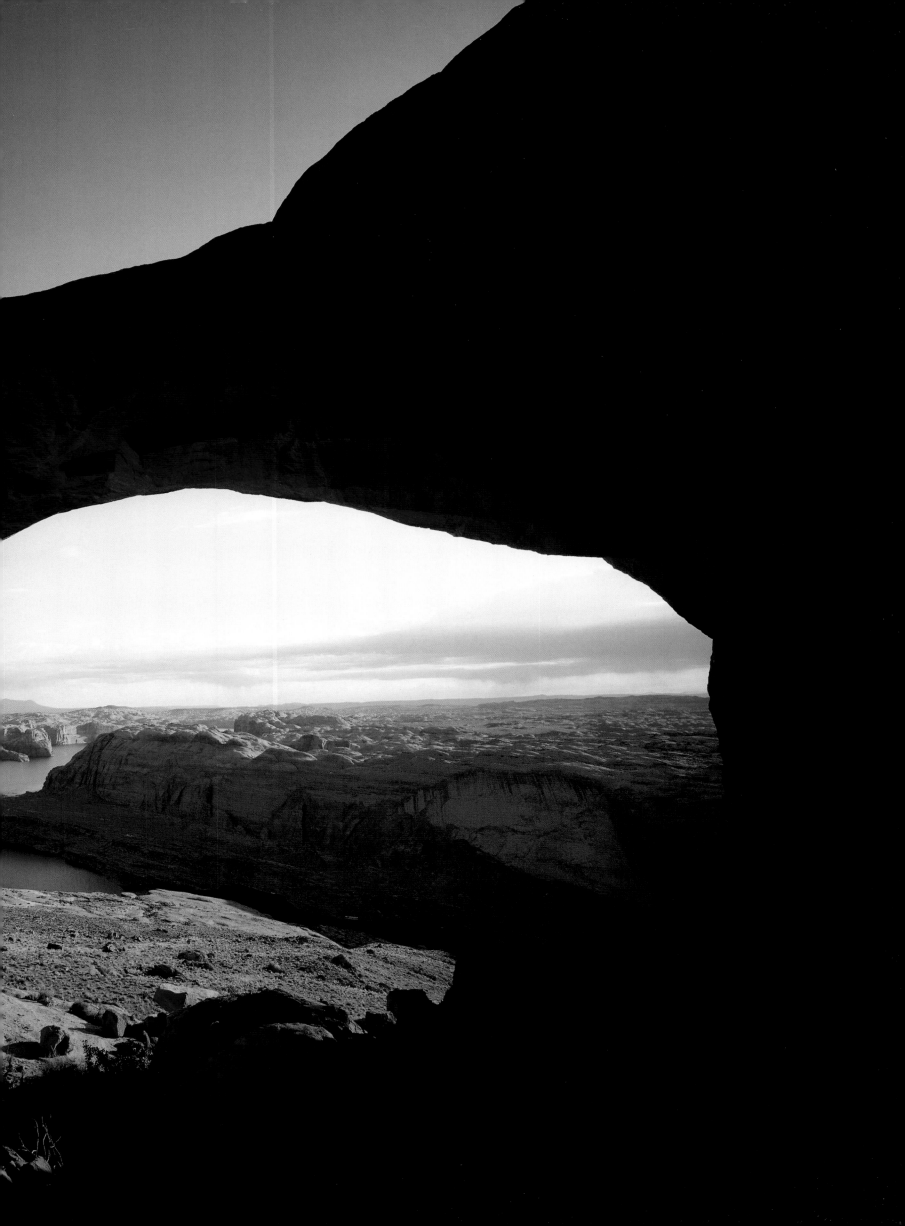

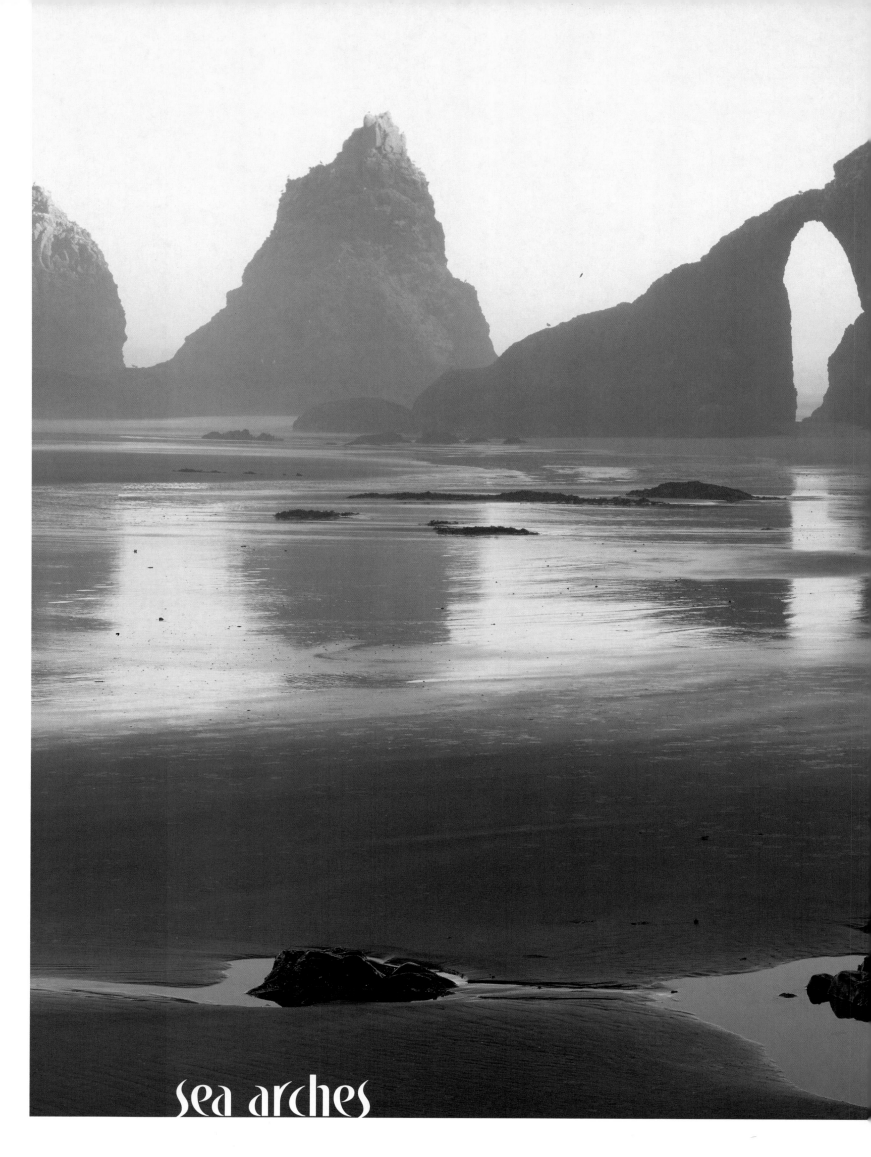

sea arches

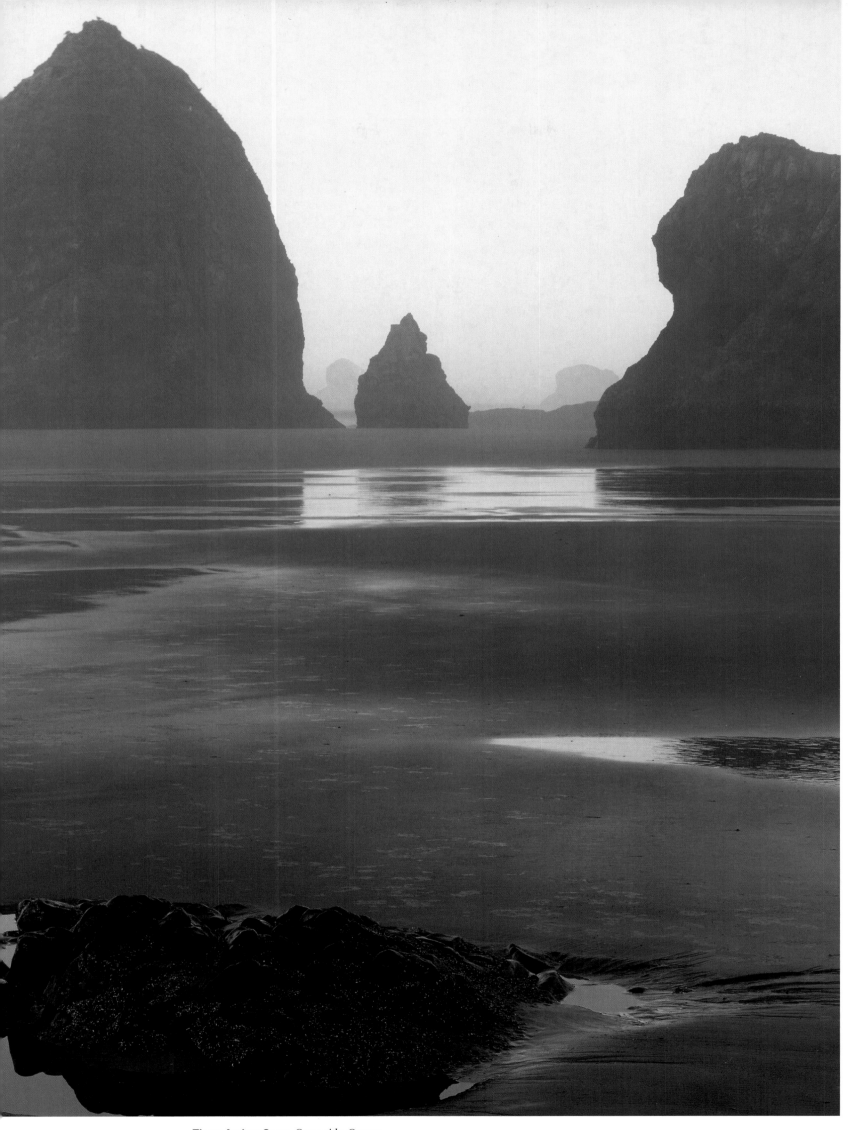

**Three Arches Cape,** *Oceanside, Oregon*

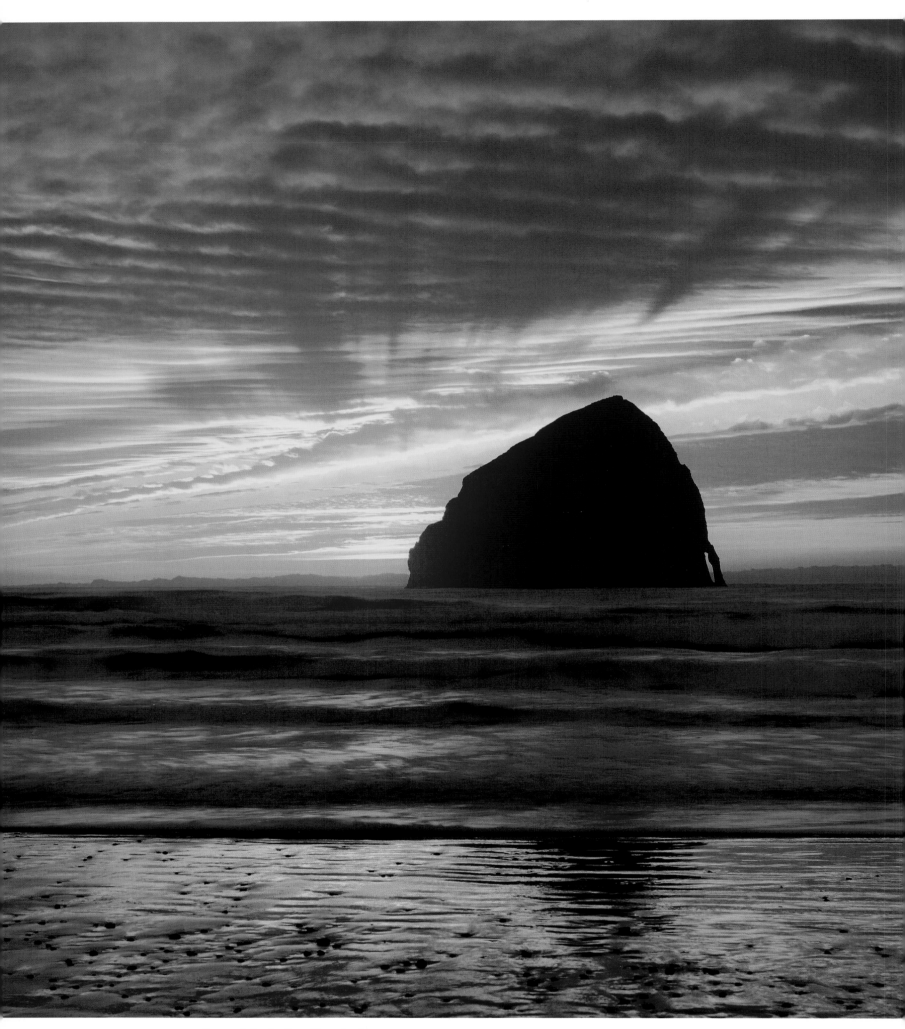

**Haystack Rock,** *Cape Kiwanda, Oregon*

# sea arches

They are referred to everywhere as arches. There is Point of Arches, Arch Cape, Three Arches Cape, Mack Arch, but surely nowhere could any opening have been formed more by water than these marvelous structures off the beaches of the West Coast. Battered by wind-driven waves and fierce tides, they have been hollowed and chiseled by the force of the Pacific. These arches, from Washington to Oregon and California, do not need to wait for centuries to accomplish change. Their aspects change constantly. What at high tide is inaccessible, or completely hidden, stands revealed and inviting when the tide is out.

Before the sea separated these arches and sea stacks—the steep-sided islands left after the roof of an arch collapses—they stood out into the tides as headlands of the continent. Now the sea has isolated them so that each stands like an ancient guardian of the shore, frozen in stone, cloud-shrouded, dark and wet and full of mystery.

OLYMPIC NATIONAL PARK, WASHINGTON. We walked about two miles across Makah Indian land in the northwesternmost corner of Washington State, following a trail through forest, dark in the fog of the day and under the canopy of spruce and hemlock. Huge ferns and salal edging the forest floor deepened its primeval quality and its silence. Just above Shi Shi Beach, we reached the Olympic National Park trail that descends steeply to it.

Point of Arches extends from a headland a few miles south along the beach. Just north of the trail entrance to the beach is a small group of rocks containing another arch. We climbed up the rocks of a headland separating the beach at the end of the trail and the arch to the north, then settled there while David photographed. Fog rolled in deeper, thicker, wrapping itself around us. Drops of mist sprayed my face. The ocean rolled in and in forever. The deep green of the forest slid down to the beach. The sea stacks of Point of Arches to the south receded into fog. Our footsteps trailed across the damp gray sand. Beach, rocks, sea, and sky were all different shades of gray. Only the whitecaps and the green of trees, of ferns, and other plants interrupted the eternity of gray, and a deer, descending from forest to the headland summit.

The trees of these northern forests are so gentle: the drooping flat sprays of the cedars; the soft, flat, lacy needles of the hemlocks, the primeval spread of ferns. Even the spruce seem pliant, as if nature would make up in tender greens for the isolate darkness of the sea stacks, the wildness of the ocean, the indifference of the mist.

A day later, still wanting to actually see Point of Arches, which disappeared entirely in the evening fog, we returned to Shi Shi Beach. While a white mist lingered on the horizon, Point of Arches was perfectly clear. Surf pounded against the sand; white foam crashed against the sea stacks; seabirds cried above the roar of waves.

This beach and this forest are the Makah homeland. One of their primary settlements, a few miles down the coast at Ozette, was buried by mudslides some five hundred years ago. The other four of the original five Makah Village sites lie on their current reservation where the fishing village of Neah Bay is the main settlement. The lives of the Makah have always been connected to the sea. Their great dugout cedar whaling canoes are an example of how the life of the forest provides a way to live by the sea.

These arches, from Washington to Oregon and California, do not need to wait for centuries to accomplish change. Their aspects change constantly.

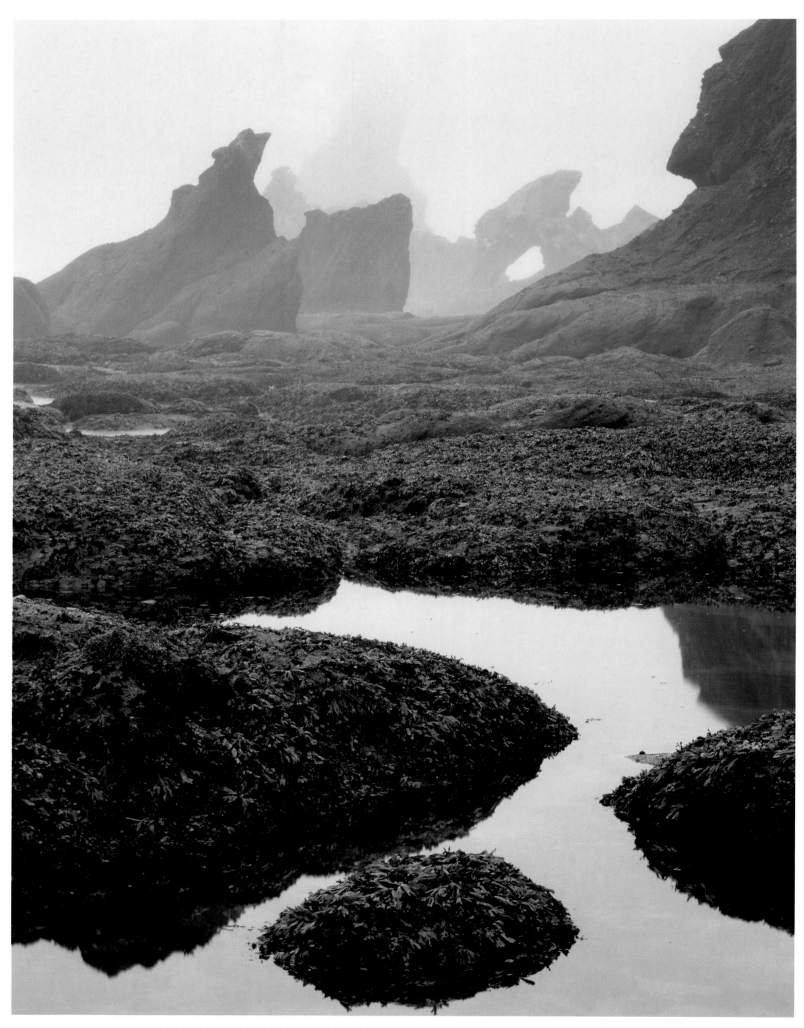

**Point of Arches,** *Olympic National Park, Washington*

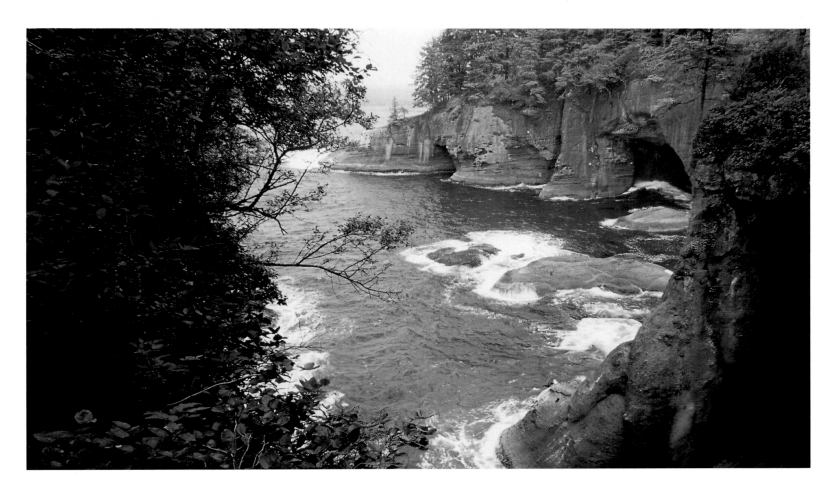

CAPE FLATTERY, WASHINGTON. North along the coast from Shi Shi Beach and accessible from Neah Bay, Cape Flattery is the northwesternmost point of the Lower 48 states. A board-walk leads visitors to the end of the cape where an interpretive sign explains the "Ocean's Siege." It informs us that the cape is slowly retreating under the force of the pounding waves. The Makah formation sandstone beneath us is riddled with sea caves. BY SITTING QUIETLY, the sign says, YOU CAN SOMETIMES FEEL THE WHOLE CAPE SHUDDER FROM THE FORCE OF AN EXPLODING WAVE AS IT FUNNELS INTO THE CAVES BELOW. The ground upon which we stand, it announces, may not even exist in several hundred years.

A wall of sea curves into the cave closest to us. White spumes shot up on the incoming tide crash into the crevices and canyons they have already formed, forming the crevices, pouring over the rock in the inlet fronting the caves. The caves are crowned by thick forest so that from the top you would not know what lies beneath you, except for the constant crashing of the waves; the sweeping, buckling, white-edged movement of the ocean.

TUNNEL ISLAND, QUINAULT RESERVATION, WASHINGTON. The Quinault Indians relinquished their claim to most of the Olympic Peninsula in an 1855 treaty. Now, just south of Olympic National Park, the Quinault Reservation is home to them and an aggregation of other Indian nations forced out of their traditional lands in the nineteenth century.

We drove a dirt track through reservation forest crowning high cliffs that separate the Pacific beach from the rest of the continent. The track ends just above an old, washed-out bridge over an inlet, then continues on the far side of the bridge as if nothing had happened to it. We walked across the inlet on logs, then, past the bridge, headed downslope toward a wild and lonesome beach. Five bald eagles flew over us, which we took as a good sign for our hike toward Tunnel Island. Two miles down the rock-strewn, damp sand, we were turned back by a headland too high and steep to climb over and too late in the tide's rising to go around. We could see Tunnel Island, but we could not get there.

An interpretive sign explains the "Ocean's Siege." It informs us that the cape is slowly retreating under the force of the pounding waves. . . . The ground upon which we stand, it announces, may not even exist in several hundred years.

**Cape Flattery,** *Olympic Peninsula, Washington*

163

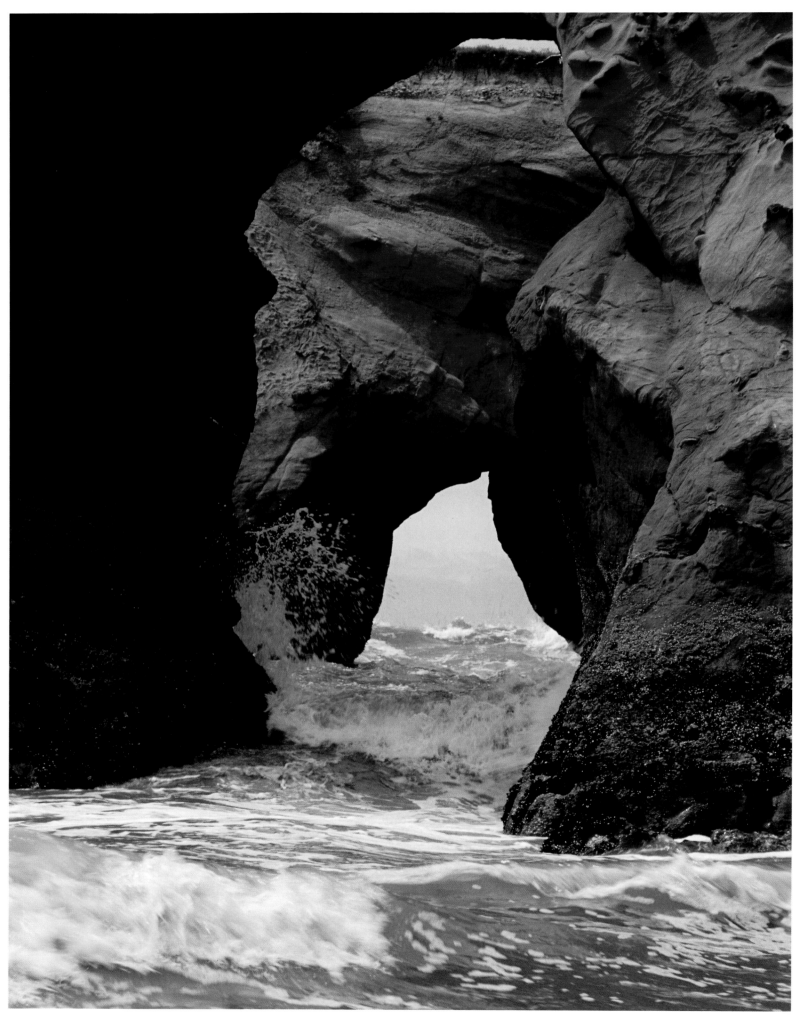

**Tunnel Island,** *Quinault Reservation, Olympic Peninsula, Washington*

The following day we retraced our walk to the old bridge, then followed the road rather than descending to the beach, winding through dark forest until we were beyond the headland that stopped us a day earlier. We descended a steep cliff (someone has attached a rope at the sheerest part) to come out onto the beach south of the headland. Although we were earlier in the tide's cycle, we were later than we had intended and still had to deal with its turning.

To reach the vantage point he wanted for his photographs, David had to wade waist deep across a hundred-yard-wide channel, deepening with the incoming tide. Carrying a long piece of driftwood for a walking stick, he plunged in and crossed, looking quite biblical. I remained at the edge between beach and channel. From here I could easily see forest-topped Tunnel Island, and a string of smaller arches and sea stacks that were once part of the same land.

On Tunnel Island, the ocean, inexorably carving the thick brown rock of the Quinault Formation, has sculpted a large arch framing a second arch. You can see the battering that will one day break through the arches. Their rock will be broken down, pounded into sand, returned to the sea, returned to the beach. Gulls skimmed over the waves. Scanning the island with binoculars, I sighted a bald eagle in each of the two highest trees. The sky alternated clouds with blue sky. The sun shimmered. Everything shimmered—ocean, whitecaps, light, air, David so far distant he seemed a mirage. The beach was littered with small crabs, washed up and abandoned by the tides.

The tide rose enough that when David recrossed the channel, the water was above his chest. I hoped he would remember where the hole he stepped into the first time was. He could not hear my shouts above the sound of the ocean. In that hole, the water would be over his head. He crossed, holding his camera and exposed film in a bag above his head, probing his way with the driftwood walking stick. He emerged from the sea, wet to his chin, but pleased with his photographing.

THREE ARCHES CAPE AT OCEANSIDE, OREGON. The sea stacks at Three Arches Cape clearly once connected to the high headland angling steeply down to the beach. Now they linger in the ocean like some last moment of the earth's insistence on the life of the land itself, a last moment before it is reclaimed by the sea. Along the headland wall, there are caves and inlets carved by the relentless ocean. Crows fly along the steep headland, above grasses and flowers waving like the ocean in the stiff breeze; land and sea mirrors of each other, creators of each other.

The sea stacks teem with life. Gulls swarm over them, then land silhouetted against a paling sky, gulls, pelicans, puffins. The cries of seabirds pour out above the rocks, cries as wild as the sea. I was fascinated by the silhouettes of birds on the steep ridgelines of all these rocks—the gull like an arrow; the S-curve of the pelican; the punctuation mark of the puffin. Hundreds of birds flew on the far side of an arch accessible via the beach in low tide. They rose in slow, circular flight, revolving above the most massive of the sea stacks like some tangible aspect of the wind. In August, the sun sets just south of the arch, falling blindingly in the backwash of the waves lying at the edge of the beach.

At low tide you can walk around the point separating the arch beach from Oceanside Beach. The arch beach (although not the arch) is also accessible during high tide via a tunnel drilled through the headland. When you must use the tunnel, the beach becomes an intimate place hidden from the rest of Oceanside.

When we entered the arch at low tide the following morning, we found it encrusted with green anemones and purple starfish, black mussels, brown kelp, dark barnacles, and bright green sea lettuce. One starfish hung to the rock at the side of the arch by a single ray. We walked through the arch from the morning beach out to the open sea.

SEA LION CAVES, OREGON. Sea Lion Caves, just north of Florence on the Oregon Coast, is similar in its construction to the caves beneath Cape Flattery on Washington's coast. In a way,

> You can see the battering that will one day break through the arches. Their rock will be broken down, pounded into sand, returned to the sea, returned to the beach.

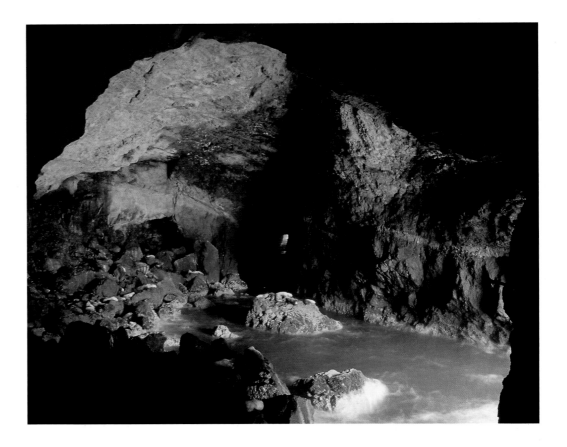

this sea cave is a broad arch (or tunnel) with openings on the west and south providing passage through it. Known as the largest sea cave in the world, it is now a commercial venture but it was formed by nature. Commerce just added an elevator descending 208 feet from the ground level to a cave chamber about 50 feet above the ocean that offers an easy chance to view the resident sea lions, as well as the structure of the cave itself. You are instantly greeted by a smell that is a combination of a commercial fishing wharf and a locker room full of old sneakers. Stay long enough, and you get used to it. In the main room, which is about two acres in size with a vaulted ceiling about 125 feet high, sea lions lie draped across rocks, bulls sprawled in one area, females and pups in another.

The cave is an important mainland breeding area of the endangered Steller sea lion. Deep, hollow sea lion roars echo off the vaulted rock like some kind of subterranean thunder. Once in a while a sea lion slides off its rock into the ocean. To return, the adults simply propel themselves out of the water to leap back onto the rocks; the babies struggle, but they are learning. Pigeon guillemots fly back and forth across the cave, or out into the light from nesting places on ledges near the cave's ceiling. After a while, you become mesmerized by the movement and echoing sounds of the sea lions and the smells and the inexorable pulse of the sea pouring in against the rocks, against the whole structure of the cave itself. It is an intimate experience of geology and wildlife, a glimpse into what forms of the earth offer creatures of the earth.

BANDON, OREGON. The beach at Bandon, south of Coos Bay on the Oregon Coast, may be the most dramatic in America. Monolithic, seaswept rocks spread along the coast here, like some sort of Poseidonic Stonehenge. The ocean crashes against them, explodes up in great spumes between them. They stand sentinel between ocean and land. Dark, forbidding, they seem unapproachable. One morning we walked the beach at low tide. In what seemed solid rocks when the tide was up, we found arches and caves. Winding in and out of the now-exposed monoliths, we entered deep caves where openings on the beach lead to openings on the sea, so that we saw the ocean as if for the first time. Bandon, at low tide, is like an awakening to the earth. ⌇

**Sea Lion Caves,** *Oregon Coast*

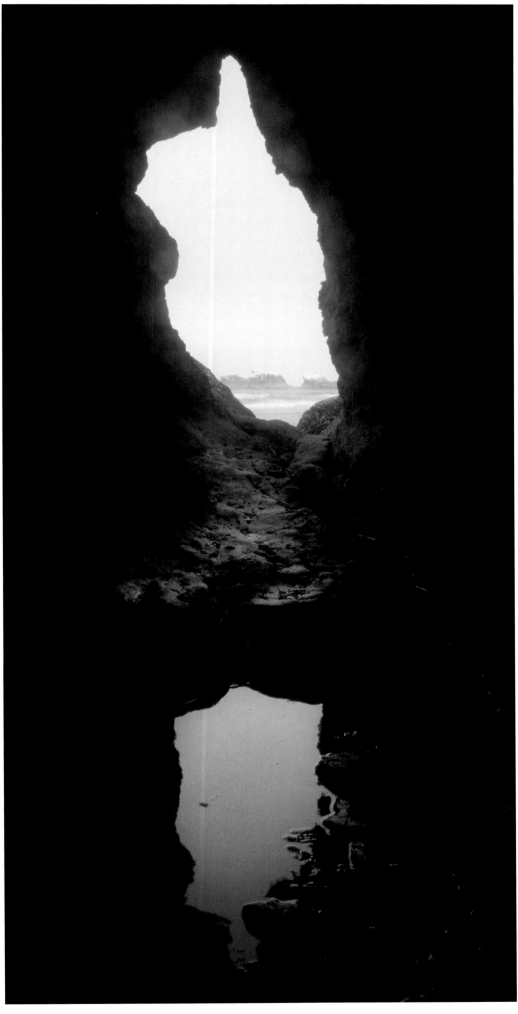

**Rock Opening,** *Bandon Beach, Oregon*

Monolithic, seaswept rocks spread along the coast here, like some sort of Poseidonic Stonehenge. The ocean crashes against them, explodes up in great spumes between them. They stand sentinel between ocean and land. Dark, forbidding, they seem unapproachable.

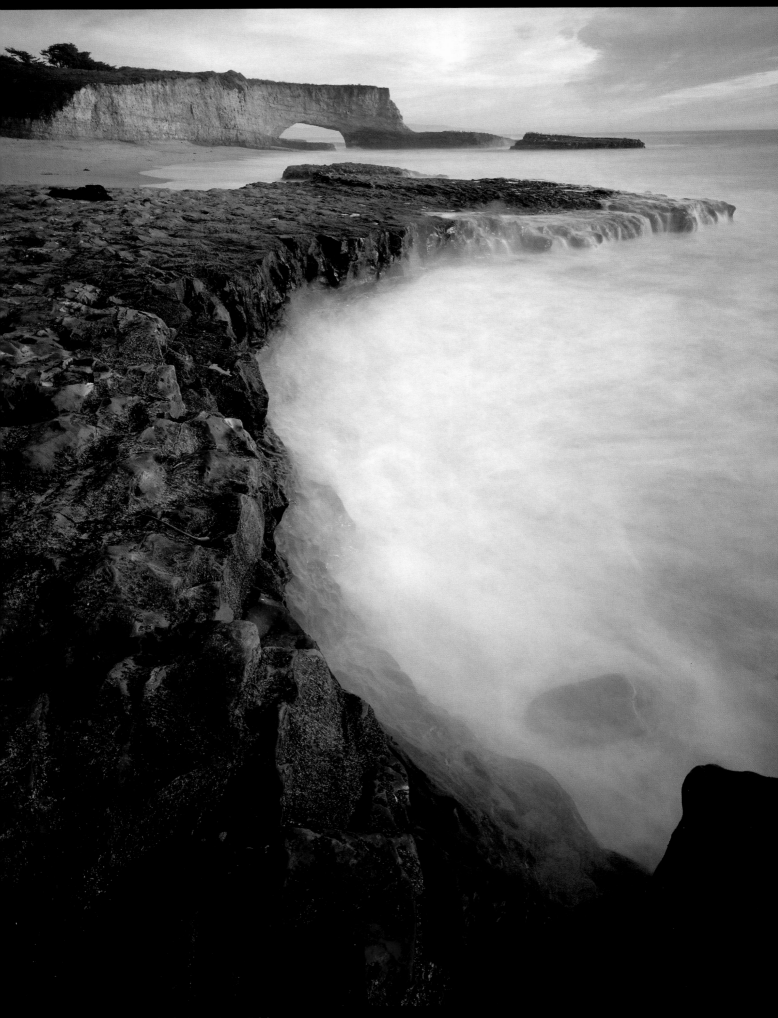

**Sea Arch**, *Santa Cruz, California*

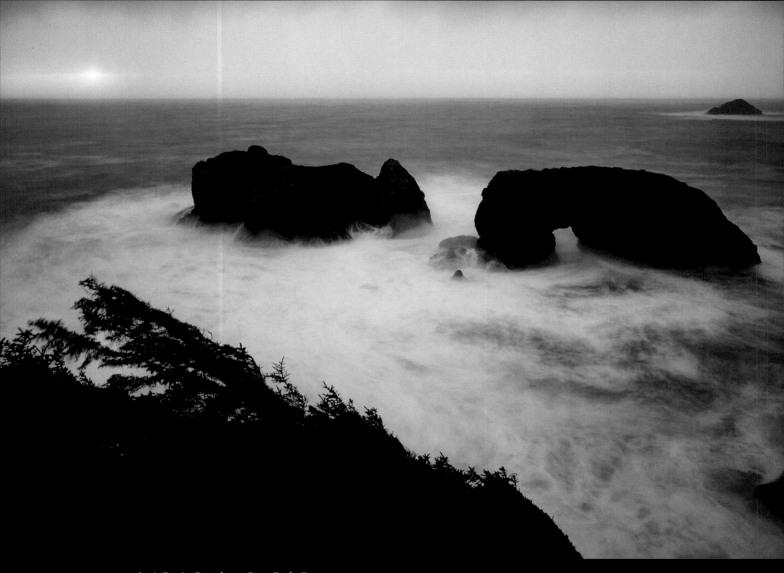

**Arch Rock,** *Boardman State Park, Oregon*

169

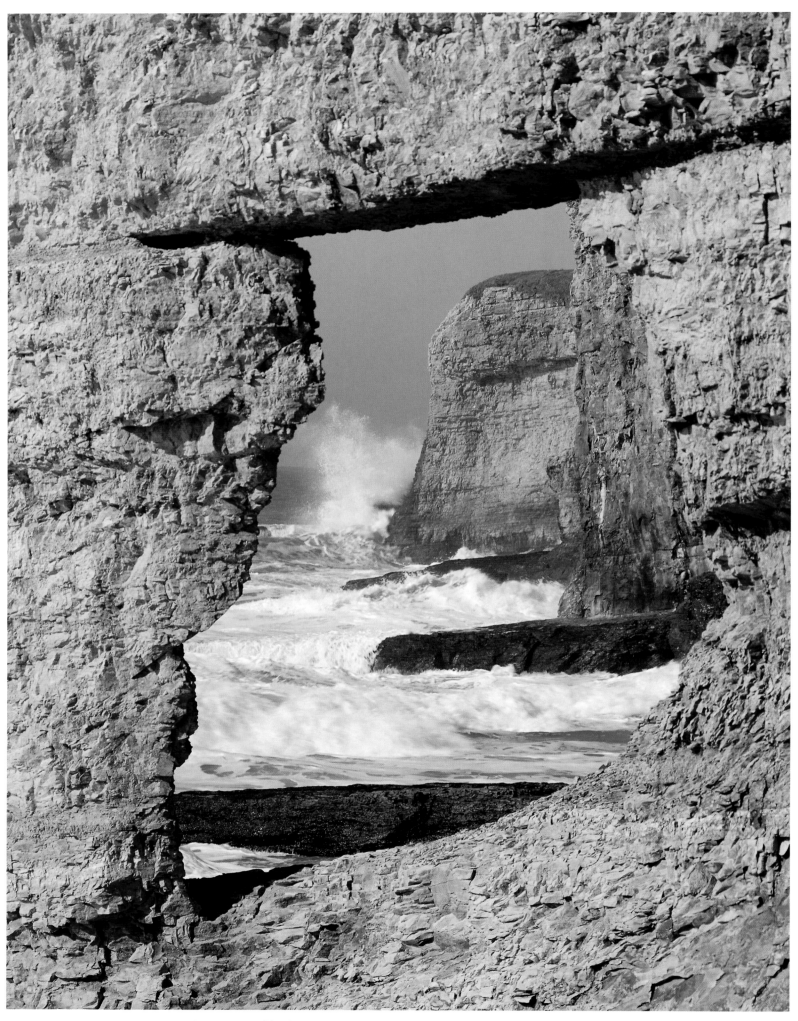

**Window,** *Santa Cruz, California*

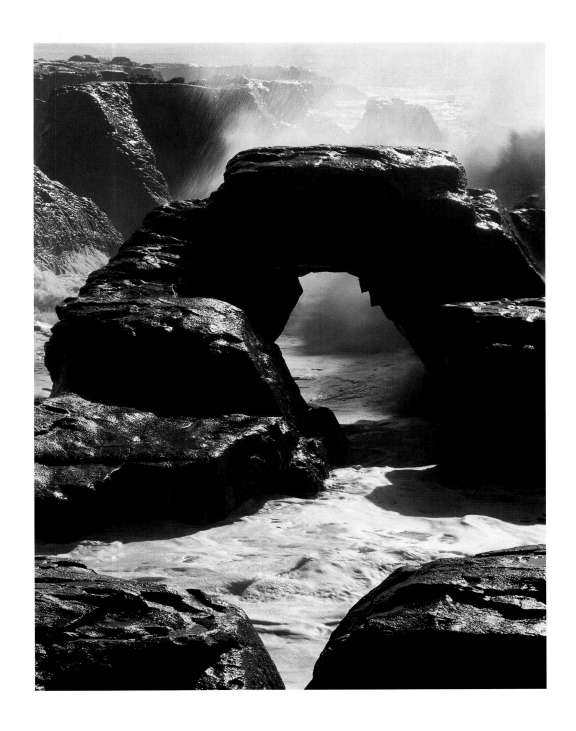

**Sea Arch,** *Santa Cruz, California*

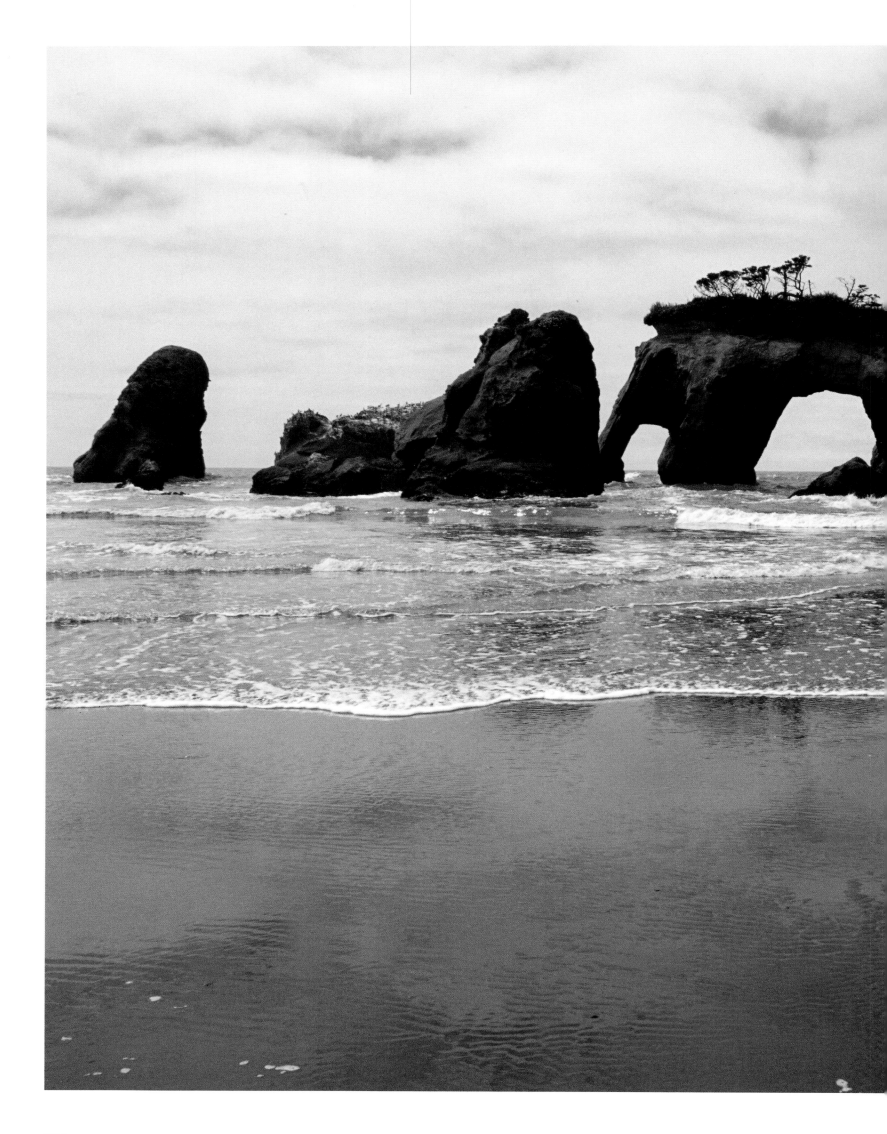

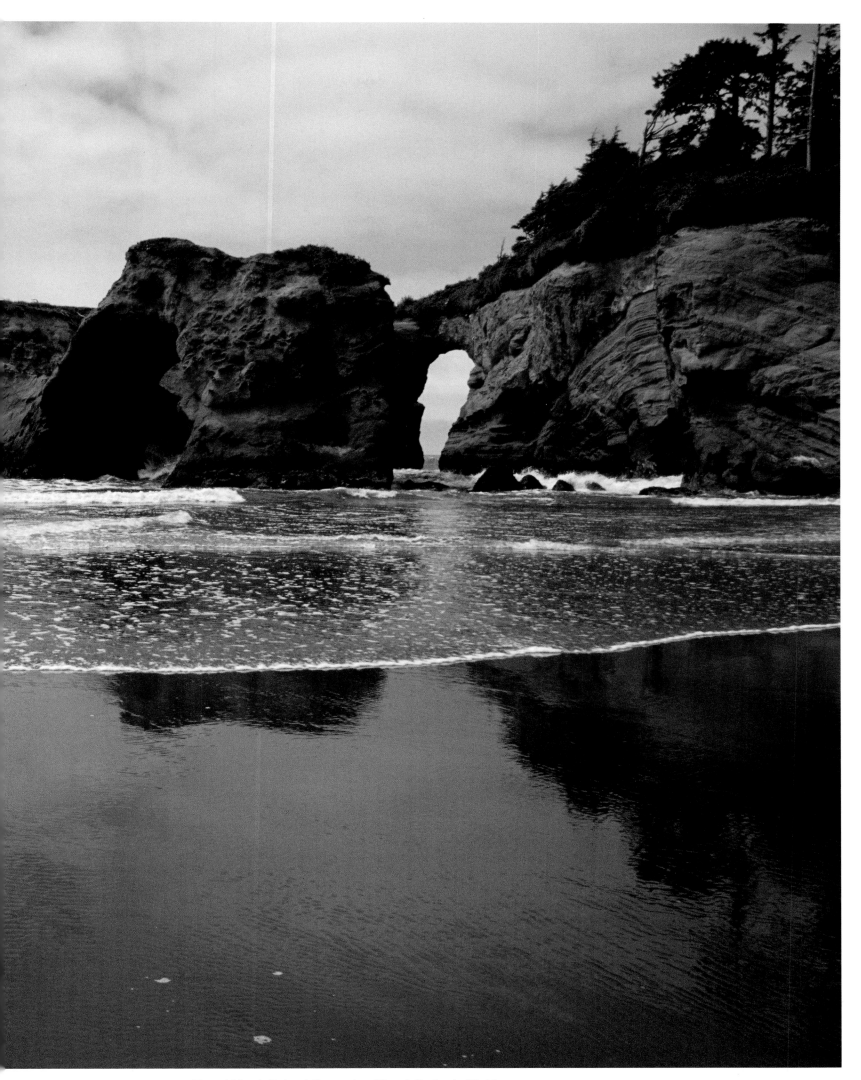

**Tunnel Island,** *Quinault Reservation, Olympic Peninsula, Washington*

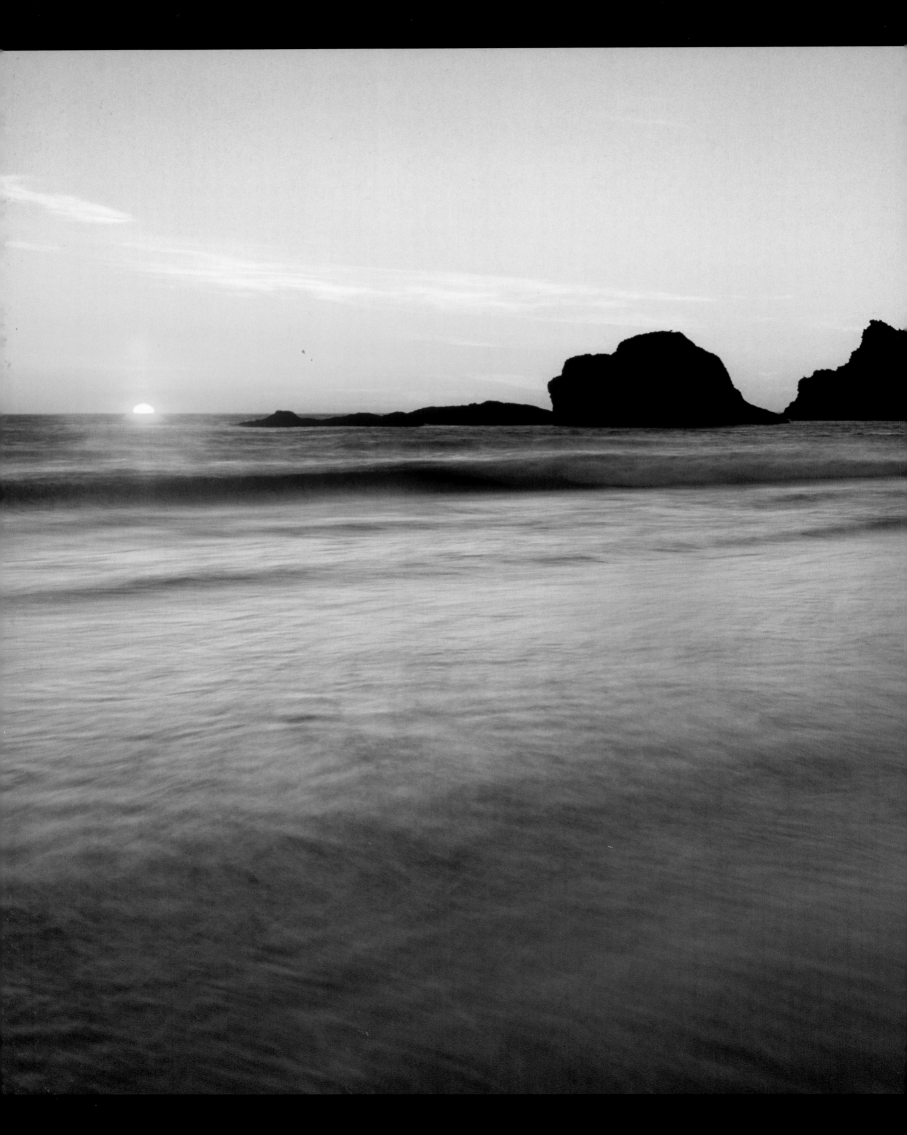

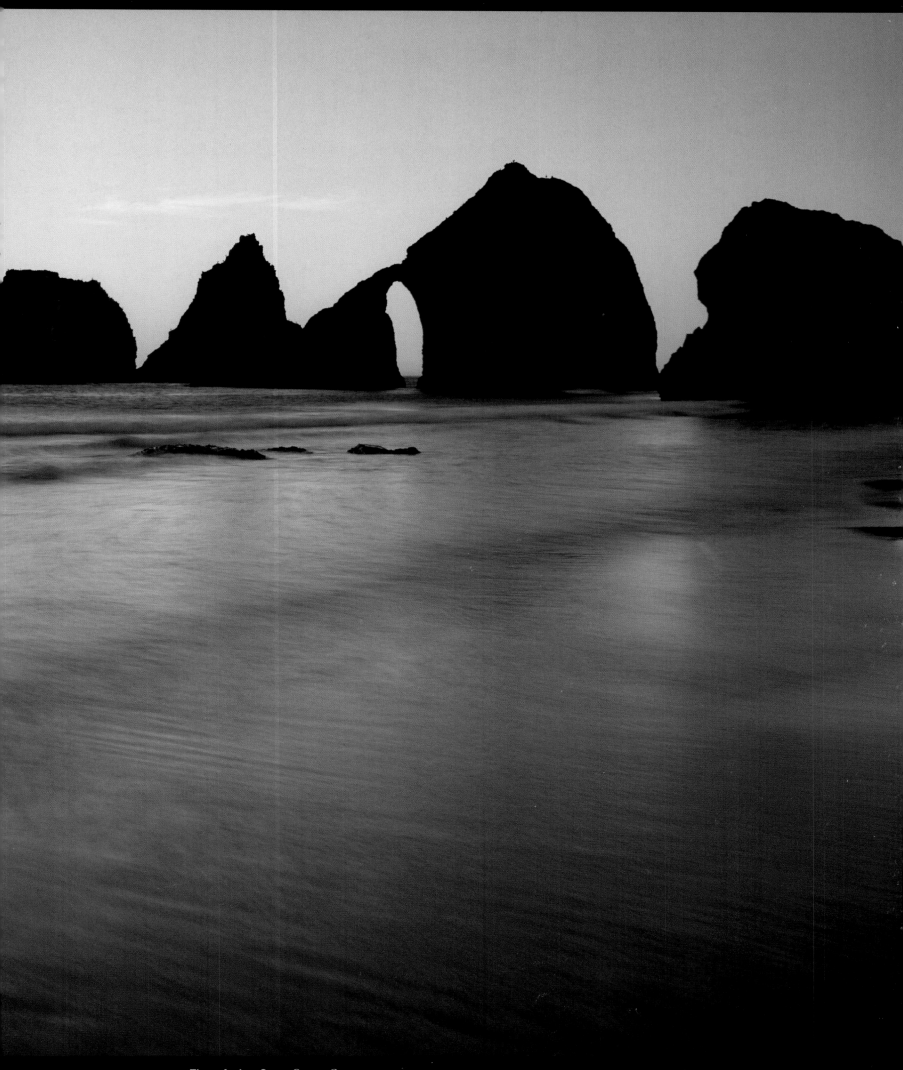

**Three Arches Cape,** *Oregon Coast*

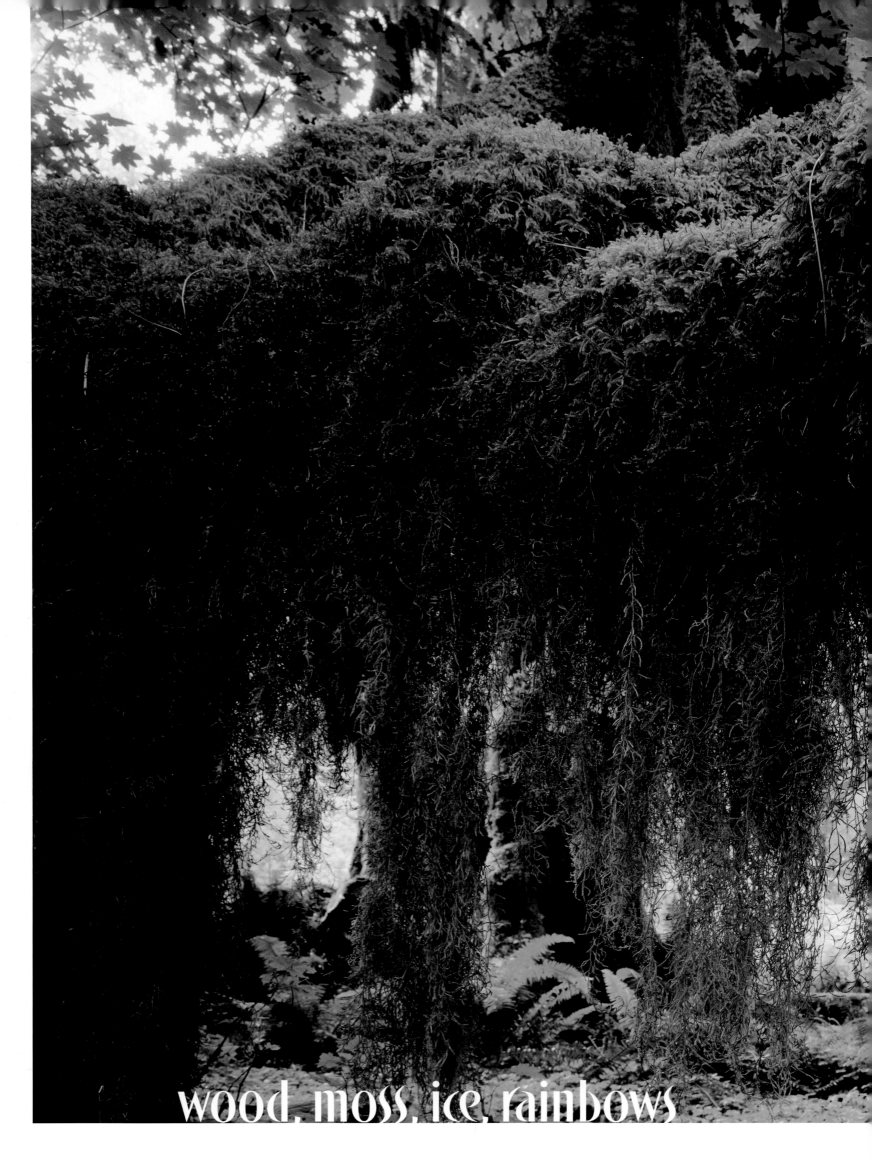

wood, moss, ice, rainbows

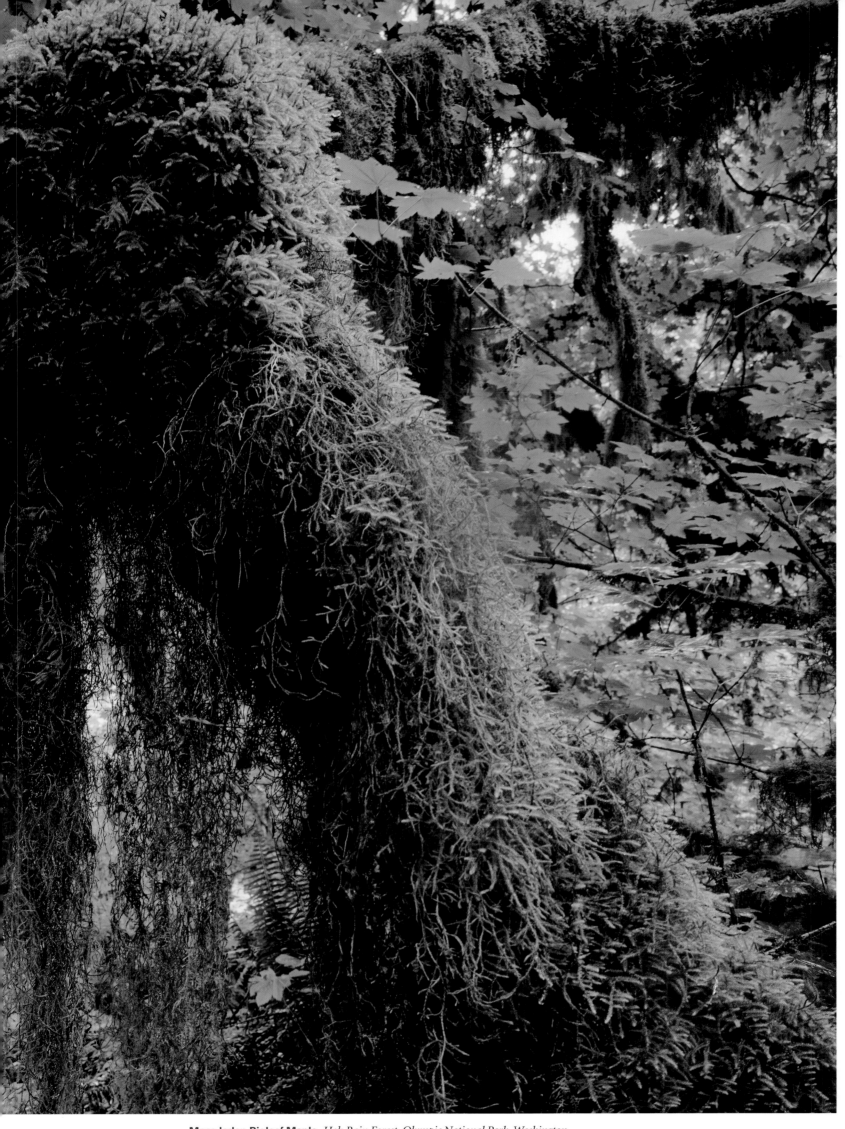

**Moss-laden Bigleaf Maple,** *Hoh Rain Forest, Olympic National Park, Washington*

**Old Tree Root and Mount Rainier,** *Mount Rainier National Park, Washington*

# wood, moss,
# ice, rainbows

The arch form is ubiquitous. What began for us as a deliberate search for the arch form in nature quickly turned to wonder at how omnipresent it is. Now we see it everywhere. Tree limbs bend into arches. Old, long-dead roots, upended when the tree they once nurtured fell in its death, build arching frames for mountains and meadows, flowers and sky. At Mount Rainier National Park in Washington, we find one in a high meadow that perfectly frames the extraordinary volcano. The rest of the tree is long gone. In Grand Teton National Park, Wyoming, near the edge of an old moraine, we find an elaborate arched root in the vast sagebrush flats of Jackson Hole.

In areas like these—meadows or sagebrush flats or deserts or farmland—where no single, remarkable feature stands out, gems like these arching roots become memorable forms. They allow us to relate intimately to places most of us, intent on the spectacular, ignore. Nature is so much more than the spectacular. The spectacular merely points the way while the small things provide intimacy, a sense of deep familiarity: The smooth serendipity of a long-dead root. The feel of moss on the forest floor or softly draped over an arching limb in the green incandescence of the rain forest. The mysterious dark hollows in a living tree that offer a window into the forest and succor to many creatures. The ephemeral window or arch in an iceberg that floats up

What began for us as a deliberate search for the arch form in nature quickly turned to wonder at how omnipresent it is. Now we see it everywhere.

**Ancient Bristlecone Pines,**
*San Francisco Peaks, Arizona*

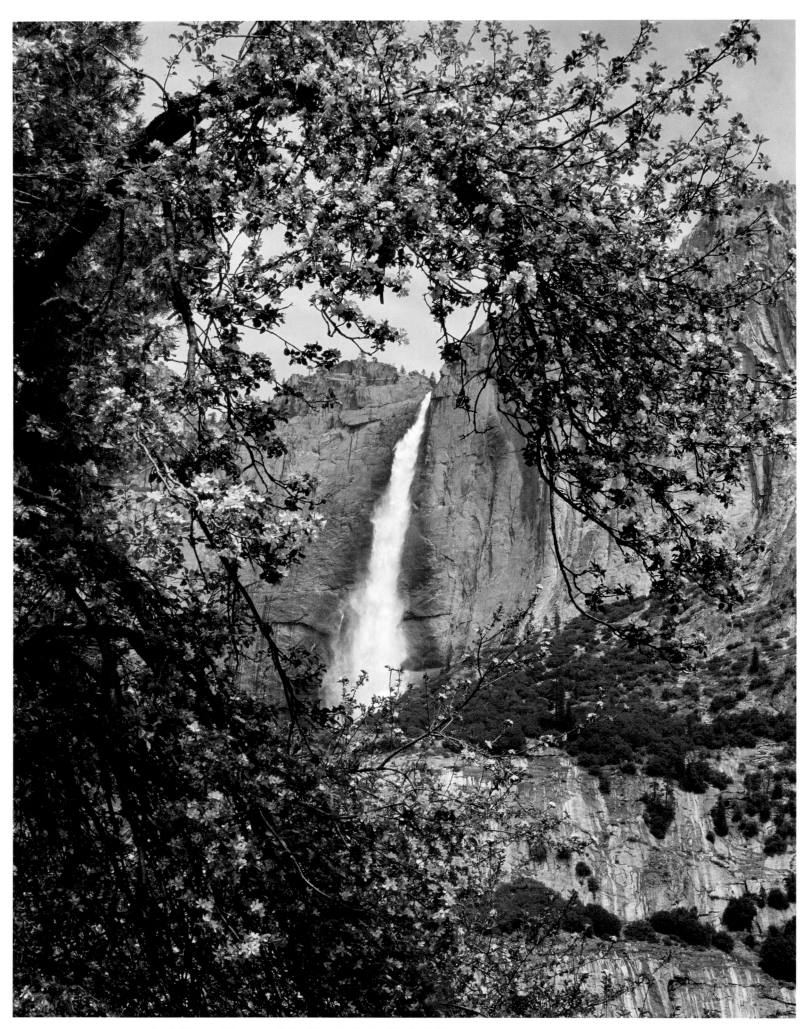

**Apple Tree and Yosemite Falls,** *Yosemite National Park, California*

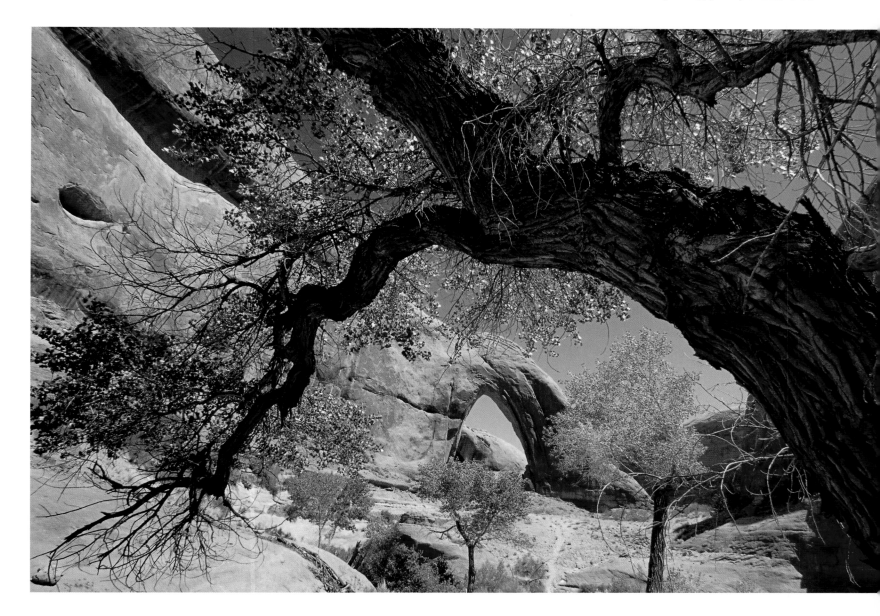

on the beach where you are camped or glides past you on the vast Antarctic seas. The rainbow that arches over the waterfall or the world. Maybe a rainbow arching over the world is not a small thing, but its transitory nature makes it an intimate event. Notice it before it disappears, or it is forever lost.

HOH RAIN FOREST, OLYMPIC NATIONAL PARK, WASHINGTON. Sun filters through the Hoh Rain Forest, where Sitka spruce, western hemlock, western red cedar, and Douglas fir grow huge and tall. Beneath these giants, there are bigleaf maple, vine maple, ferns, shrubs, and mosses. Myriad ferns arch their fronds, mirroring the arch of tree limbs hung with draperies of mosses and lichens. Moss covers the ground and the trunks of trees. Sun filters in with a soft green light. Everything here invites touch that lingers for the pure joy of the thick, green softness. Club moss drapes like buffalo capes from the limbs of bigleaf maples. The limbs are bent in arch after arch; curtains of arch.

Massive living roots of spruce and fir, nurtured by ancient fallen logs moldering into the earth, form low arches where the nurse log has receded. These spaces seem like secret routes into secret places that we, too big to enter, cannot know.

The limbs, the roots, the ferns, the arching dome of heaven. The high canopy of needles and of leaves. The arching strands of spiders' webs backlit by the late sun, gossamer threads of light curving from frond to frond. The arch of silence in the late day. This is the rain forest we have entered.

▲▲ **Cottonwood and Broken Bow Arch/Escalante,** *Glen Canyon National Recreation Area, Utah/Arizona*

▲ **Openings in Bigleaf Maple Trunk,** *Hoh Rain Forest, Olympic National Park, Washington*

181

HARRIMAN FJORD, ALASKA. All night long we listened to the great thundering of icebergs calving off the tidewater glaciers edging Harriman Fjord in Alaska's Prince William Sound. Each morning we found huge chunks of bergs carried by the tide to the dark pebbles of our beach. Carved by the action of waves, their sculpted form changes as they drift across the fjord water. Once deposited on shore and abandoned by the tide that brought them, they are worked on by sun and wind and air, changing shape from moment to moment. An ice window in the glittering crystal sculpture grows and widens, expanding to become the sculpture's core and, ultimately, its demise as, once more, the elements of ice belong to the sea.

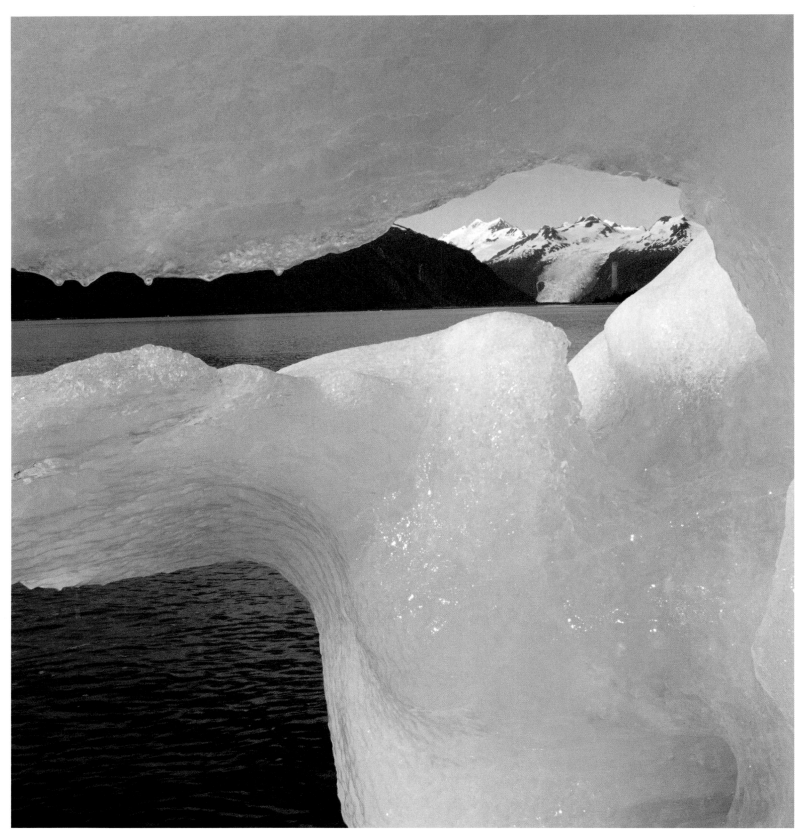

**Ice Window,** *Harriman Fjord, Alaska*

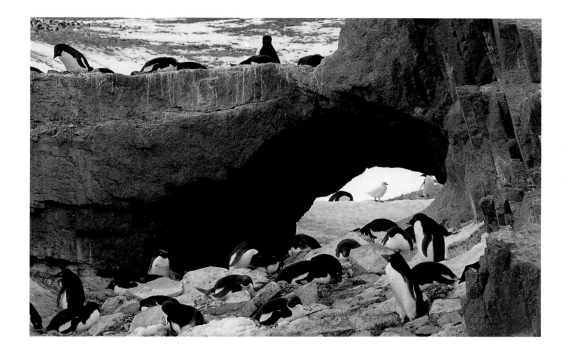

Mazes of icebergs—huge, tabular bergs, glacial calvings, remnants of older bergs carved by sea and warm spring sun into towers, pyramids, arches, into floating beaches for penguins and for seals—form the glittering, evanescent world that is Antarctica.

ANTARCTICA. They rise like crystal cities out of the sea. Icebergs that are miles long and hundreds of feet thick break off ice shelves along the Antarctic coastline. Mazes of icebergs—huge, tabular bergs, glacial calvings, remnants of older bergs carved by sea and warm spring sun into towers, pyramids, arches, into floating beaches for penguins and for seals—form the glittering, evanescent world that is Antarctica.

We visited in November, the Antarctic spring. Arches floated past us daily. White landscapes, white icescapes, blue ocean, blue ice, daylight without end. This is a brilliant dreamscape, unimaginable, even when you are in it.

One morning, when our planned route into Antarctic Sound was blocked by pack ice, the captain delivered us to an island he knew but which the ship's naturalists—veteran Antarctic travelers—had never visited. Or rather, he delivered us to a tabular iceberg, parking the ship into the berg so that one could have stepped from the bow directly onto ice.

In Zodiacs, we twisted through a garden of icebergs to the island inhabited by thousands of gentoo and adelie penguins. They walked along the beach—head forward, flippers out—looking important, as if they all had serious meetings. They climbed up and down the steep, high ridge rising behind the beach. They sat on nests containing recently laid eggs. They stood on snow cliffs at the edge of the ocean, necks bent to look down at the water below, as if jumping into the sea was something to consider seriously. In fact, it was. A leopard seal patrolled the shoreline, waiting. A few days earlier we had watched a leopard seal toy with a gentoo penguin, playing with it as a cat with a bird. The penguin had fallen off its cliff into the ocean as the seal swam by. Although a penguin can outswim a seal, it has a tough time in an ambush.

Walking down the beach, we came upon an outcrop of sharp, black rock, placed like a dividing line between beach and hill. One end of it opened into an arch. We expected ice arches in Antarctica. We did not expect to find a rock arch. Under this one, along its flanks and on the hill behind it, were the carefully built pebble nests of thousands of gentoo penguins. Pebbles are a major currency here, the prize possession of the penguins. They steal pebbles from one another, although, if caught, the thief risks a serious pummeling. Female penguins have been known to do sexual favors for pebbles. So here, in this land of profound ice, we have proof of the value of rock.

YELLOWSTONE NATIONAL PARK, WYOMING. Three hundred twenty-eight metal steps descend the side of the Grand Canyon of the Yellowstone River to the bottom of the 308-foot-high Lower Falls. Near the bottom, we are witness to an urgency of water pouring,

**Adelie Penguins and Rock Arch,** *Antarctica*

183

leaping, dancing over the falls in an irreversible moment. The water blasts down to rise at once in white spray, like clouds against the polychrome canyon walls of 630,000-year-old rhyolite lava.

At the bottom of the falls, a rainbow arches from one side of the canyon to the other. Fleeting, evanescent, it is the perfect arch, a construct of water and of light.

❖ ❖ ❖

Ultimate example of the ephemeral nature of all things, the rainbow can appear anywhere, as much an event in our imaginations as it is a physical manifestation of the refracted, reflected

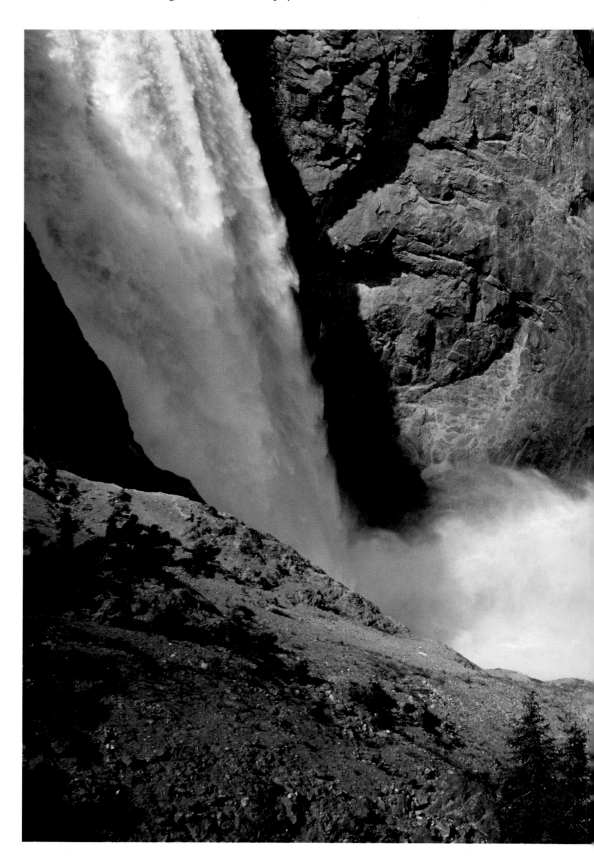

rays of the sun. Whatever their material, all arches are as impermanent as rainbows. All are structures of time and water and whatever carving, forming, building, dissolving, changing agents of the universe come into play. The rainbow we saw at the bottom of Yellowstone Falls is symbol of all these forms.

The ten thousand rainbows we have seen after storms across the earth all required water to form, as did all the various structures in *Windstone*. Like ice, the rainbow is quick to appear and to dissolve. Unlike ice, it is everywhere. Not bound to earth, it hangs in heaven like some spirit of the arch. And all in glorious color. ∿

Whatever their material, all arches are as impermanent as rainbows. All are structures of time and water and whatever carving, forming, building, dissolving, changing agents of the universe come into play.

**Lower Yellowstone Falls and Rainbow,** *Yellowstone National Park, Wyoming*

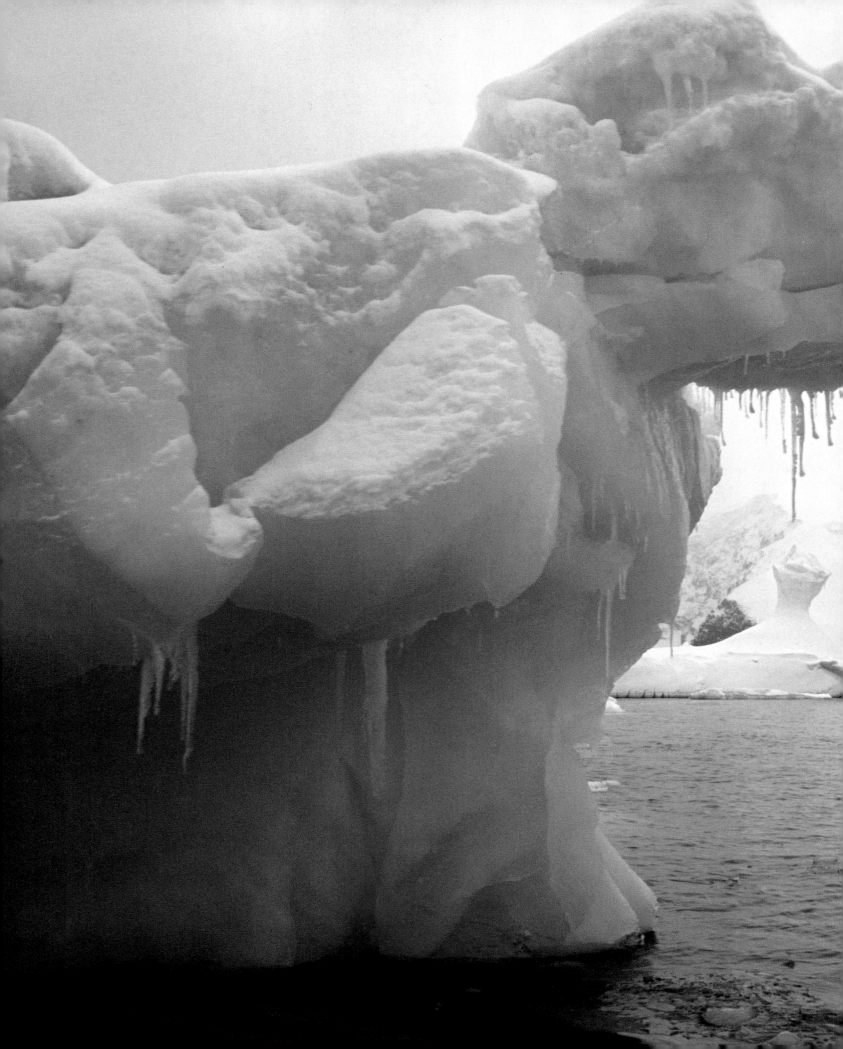

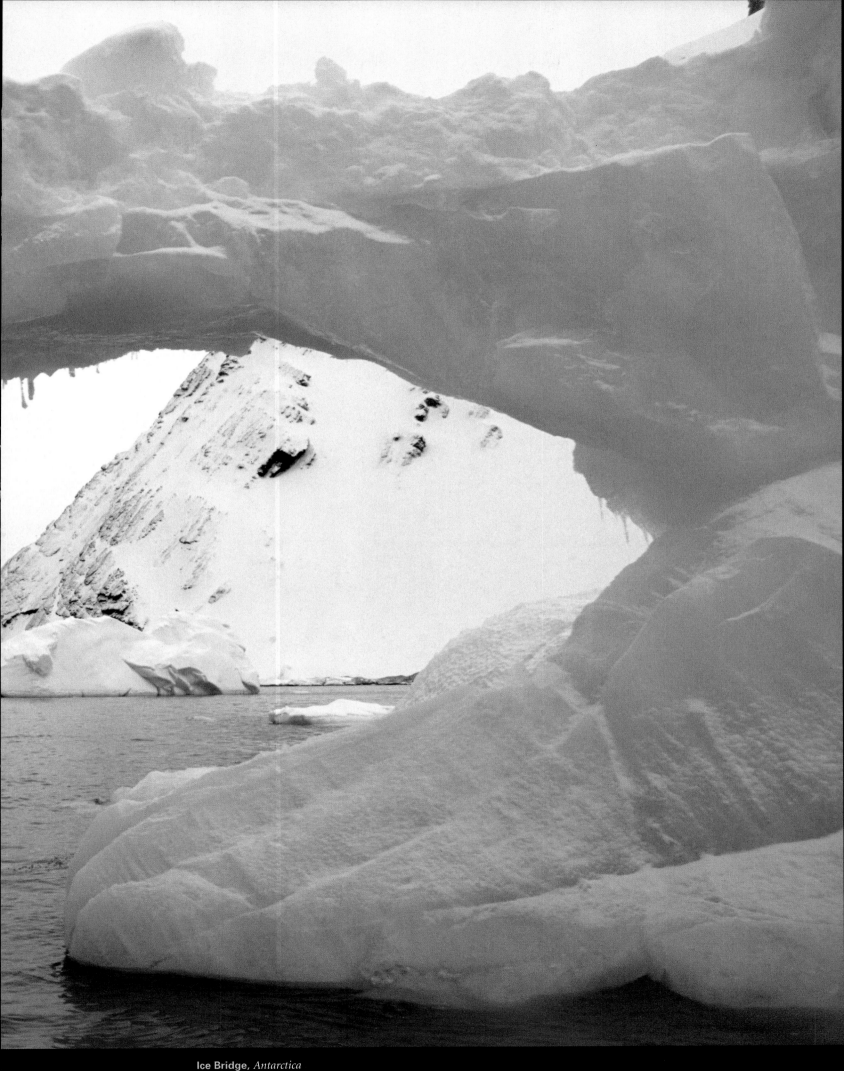

**Ice Bridge,** *Antarctica*

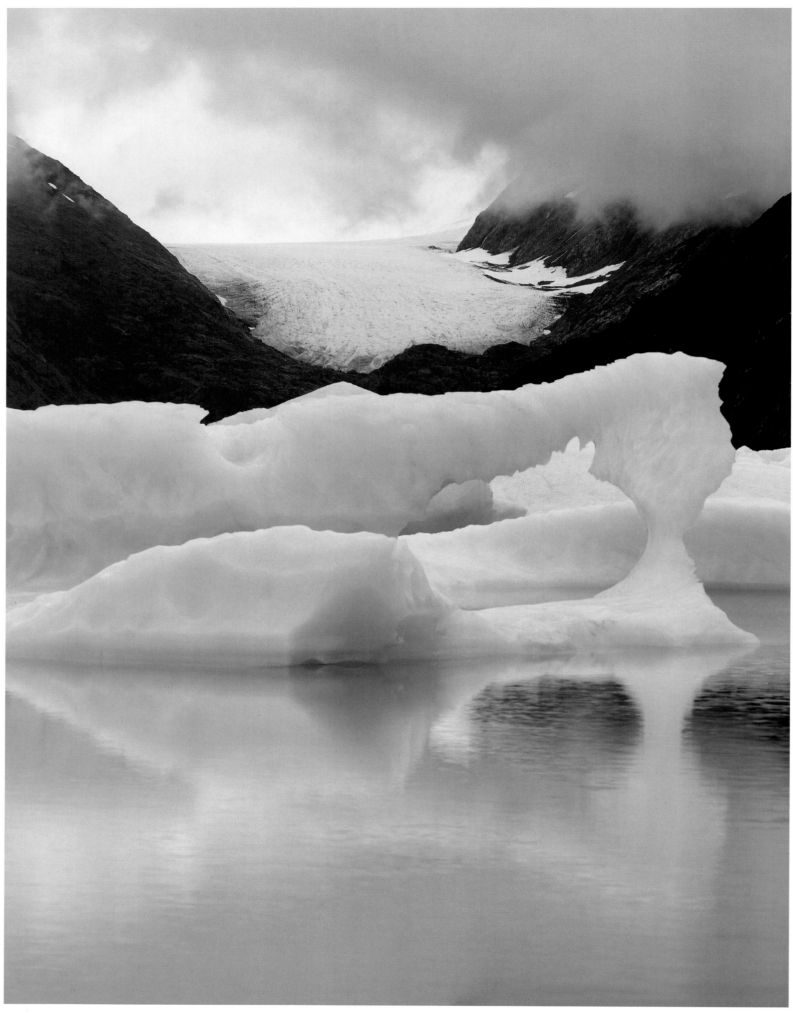

▲ **Ice Window,** *Portage Glacier, Chugach National Forest, Alaska*

▶ **Ice Sculpture and Mount St. Elias,** *Wrangell–St. Elias National Park and Preserve, Alaska*

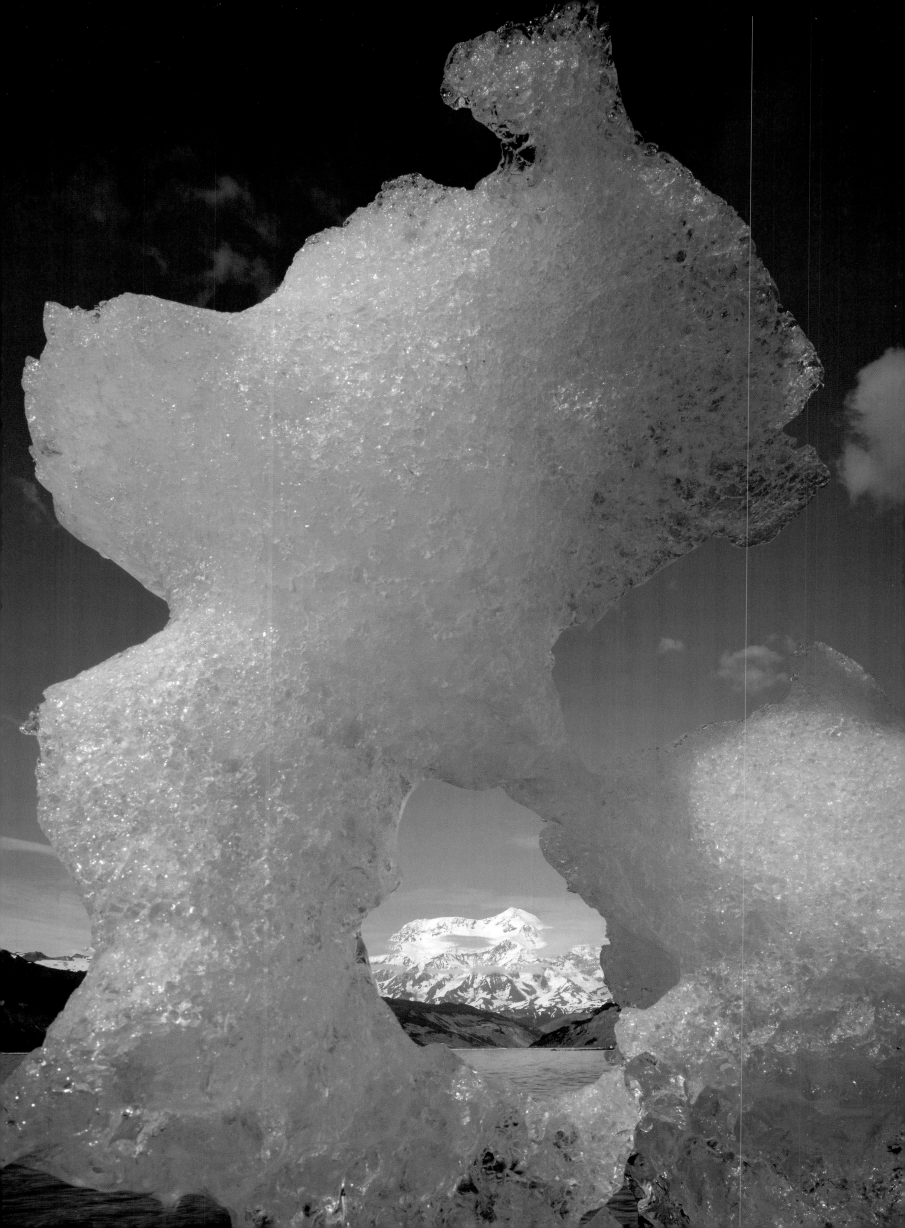

**Window,** *Fire-Scarred Window, Sequoia National Park, California*

# photo notes

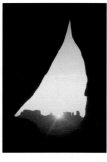

**PAGE 1  Teardrop Arch, Monument Valley Navajo Tribal Park, Arizona/Utah.** Sunrise illuminates a sculpted sandstone landscape window. Temperatures can reach 100°F (38°C) or higher here in the daytime and 32°F (0°C) or lower at night. Moisture penetrates rock cracks and freezes at night; the water expands, forcing cracks wider and breaking the rock into pieces. **June 1979, Linhof 4x5 camera, 210mm medium telephoto lens, Kodak Ektachrome Daylight film.**

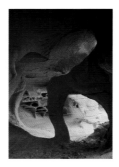

**PAGE 12  Sandstone Cave, Valley of Fire State Park, Nevada.** Numerous arch forms line outcrops of sandstone, some very abstract, some more classical in shape although these are usually more miniscule and delicate. This form appeared to have collapsed in recent years, so it may not exist anymore. **March 1978, Linhof 4x5 camera, 210mm lens, Kodak Ektachrome Daylight film.**

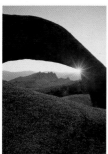

**PAGES 2–3  Sunrise, Granite Arch, Sierra Nevada East Side, California.** Rounded granite forms abound in the ancient Alabama Hills. This boulder arch form is probably more familiar in views from the opposite direction, with dawn light on Mount Whitney and the Sierra Nevada. Here, dawn light etches a landscape to the east. **August 2002, Linhof 4x5 camera, 75mm wide-angle lens, Fujichrome Velvia film.**

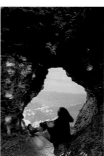

**PAGE 13  Ruth in Window at Storm Castle, Montana.** Author Ruth Rudner contemplates an earlier visit to this spot, when she attended to the care of four baby peregrine falcons at a Peregrine Fund release site just around the corner. This limestone window overlooks the Gallatin National Forest. **July 2002, Canon EOS-1V 35mm camera, 28–135mm zoom lens, Fujichrome Provia 100F film.**

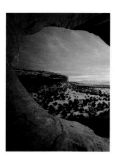

**PAGES 4–5  Sunset, Wilson Arch, Canyonlands Country, Utah.** A winterscape is transformed by awaiting a window of light for the sunset to illuminate a timeless moment of striking beauty. **February 1984, Linhof 4x5 camera, Fujichrome Velvia film.**

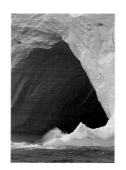

**PAGE 14 TOP  Ice Cave, Antarctica.** Stresses and fractures put pressure on this gigantic floating berg to exfoliate the underside into a large cavelike opening in the ice. **November 2002, Canon EOS-1V 35mm camera, 28-135mm zoom lens, Fujichrome Provia 100F film.**

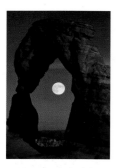

**PAGE 7  Moonrise, Delicate Arch, Arches National Park, Utah.** A half-second exposure captures a balance between evening light, on this most famous of arches, and detail within the glow of the moonrise. **February 1981, Linhof 4x5 camera, 500mm telephoto lens, Fujichrome Velvia film.**

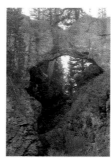

**PAGE 14 BOTTOM  Natural Bridge, Yellowstone National Park, Wyoming.** This volcanic natural bridge is just off Bridge Bay on Yellowstone Lake (see also photo note for pages 124–25). **July 2002, Linhof 4x5 camera, 500mm telephoto lens, Fujichrome Velvia film.**

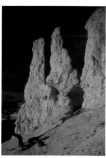

**PAGE 8  Bryce Window, Bryce Canyon National Park, Utah.** An early morning light pours over this well-weathered landscape of ponderosa pine and Wasatch pink limestone along a trail below the rim. **October 2002, Linhof 4x5 camera, 210mm lens, Fujichrome Velvia film.**

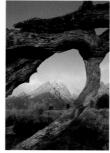

**PAGE 15  The Tetons, Grand Teton National Park, Wyoming.** An upturned root system casually frames the landscape of Jackson Hole and the Tetons at dawn. A low angle was used to create this window in wood against the sky. **July 2002, Linhof 4x5 camera, 75mm wide-angle lens, Fujichrome Velvia film.**

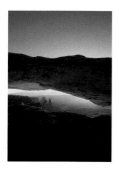

**PAGES 10–11  Mesa Arch, Canyonlands National Park, Utah.** Dawn light pours through a sandstone span along Island in the Sky rim. Sunlight reflects off the cliff below, to illuminate the arch with an incandescent glow. **February 2002, Linhof 4x5 camera, 65mm wide-angle lens, Fujichrome Velvia film; CC05 magenta filter used to enhance the blues of the sky and the reds of morning.**

**PAGE 16  Ear of the Wind, Monument Valley Navajo Tribal Park, Arizona/Utah.** Simple lines of sand and sky find a delicate balance along the way in Navajoland. I was fascinated by the possibilities of sand blowing through the sky window. **November 2000, Linhof 4x5 camera, 75mm wide-angle lens, Fujichrome Velvia film. I used a polarizing filter.**

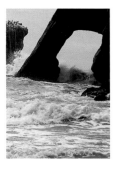

**PAGE 17 TOP Tunnel Island, Quinault Reservation, Olympic Peninsula Coast, Washington.** Cormorants and other sea birds nest just offshore from these prominent island structures that include seaward wave-carved arches and bridge openings. **July 2002, EOS-1V camera, 28–135mm zoom lens, Fujichrome Provia 100F film.**

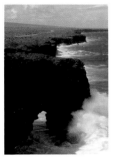

**PAGE 17 BOTTOM Sea Arch, Hawaii Volcanoes National Park, Hawaii.** Waves of the Pacific batter ancient lava flows into a cliffline where a window has formed. **April 1991, Linhof 4x5 camera, 75mm wide-angle lens, Fujichrome Velvia film.**

**PAGE 18 Sandstone Detail, Grays Arch, Red River Gorge, Kentucky.** A panel of sandstone concretion designs form just under the magnificent opening and span of Grays Arch deep in the hardwoods of Daniel Boone National Forest. **October 2002, Linhof 4x5 camera, 210mm lens, Fujichrome Velvia film.**

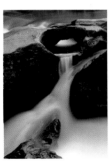

**PAGE 19 Cascade and Bridge, Upper Rogue River, Oregon.** Early spring flow highlights a miniature natural bridge created by the water of the Rogue River near Union Creek. **May 1994, Linhof 4x5 camera, 360mm lens, Fujichrome Velvia film.**

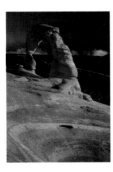

**PAGE 20 Delicate Arch, Arches National Park, Utah.** Sitting out the rain under a rock almost back to the parking lot, I realized the great possibilities of light coming out on the arch before the drama of a stormy sky. I ran back to the sandstone bowl before the arch, arrived breathless, and made four exposures before the lights went out. **March 1987, Linhof 4x5 camera, 210mm lens, Kodak Ektachrome Daylight film.**

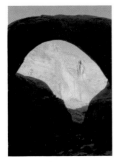

**PAGE 21 TOP Rainbow Bridge, Rainbow Bridge National Monument, Utah.** This magnificent span in Navajo sandstone is the largest and probably the most famous of the natural bridges worldwide (see also the photo note for page 90). **September 2002, Linhof 4x5 camera, 75mm lens, Fujichrome Velvia film.**

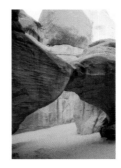

**PAGE 21 BOTTOM Sand Dune Arch, Arches National Park, Utah.** I spent much time sweeping smooth the many footprints in the sand beneath this young and sturdy arch form. My experience was one of matching the primeval impression from a very intimate, tucked-in place. **May 2002, Linhof 4x5 camera, 65mm ultrawide-angle lens, Fujichrome Velvia film.**

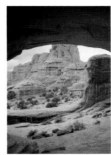

**PAGES 22–23 Tower Arch, Arches National Park, Utah.** A soft, ambient light pervades this quiet and gentle rock stage. The silence was monumental. **March 1986, Linhof 4x5 camera, 65mm wide-angle lens and 81B filtration.**

**PAGE 24 Arch and Ancient Puebloan Granary, Canyonlands National Park, Utah.** An evening light bathes an ancient Indian storehouse sheltered along the rim of Aztec Butte, Island in the Sky. **April 2002, Linhof 4x5 camera, 75mm wide-angle lens, Fujichrome Velvia film, CC10 magenta filter.**

**PAGE 25, TOP Cave Paintings, Mojave Desert, California.** Painted symbols adorn a granite shelter where sacred ceremonies have been held throughout time. I used a PenLight™ to enhance the visibility of the pictographs. **March 2001, Linhof 4x5 camera, 75mm wide-angle lens, Fujichrome Velvia film.**

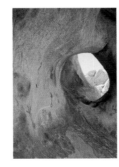

**PAGE 25, BOTTOM Granite Opening and Cave Paintings, Joshua Tree National Park, California.** A ceremonial window looks into the interior of a granite boulder at symbols of the past. **March 2002, Linhof 4x5 camera, 75mm wide-angle lens, Fujichrome Velvia film.**

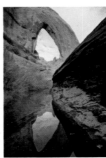

**PAGE 26 Broken Bow Arch/Escalante, Glen Canyon National Recreation Area, Utah/Arizona.** The reflection in Willow Creek doubles this large span's image. The arch was named for a broken bow found nearby. **October 1991, Linhof 4x5 camera, 47mm wide-angle lens, Fujichrome Velvia film.**

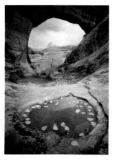

**PAGE 27  Sipapu Bridge and Autumn Pool, Natural Bridges National Monument, Utah.** Fallen cottonwood leaves hint of a change in the season upcanyon from Sipapu Bridge. A diffused gentle light magnifies the silence within the canyon walls surrounding this large sandstone span. **October 1987, Linhof 4x5 camera, 90mm wide-angle lens, Kodak Ektachrome Daylight film.**

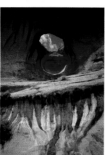

**PAGE 28  Bow Tie Arch, Colorado River Canyon, Utah.** Dried-up water markings give special identity to this portholelike opening. The trail leading to Corona Arch is nearby. **April 2001, Linhof 4x5 camera, 77mm wide-angle lens, Fujichrome Velvia film.**

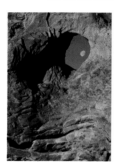

**PAGE 29  Sandstone Opening, Turret Arch, Arches National Park, Utah.** A small arch in Turret Arch holds just briefly a lowering moon at sunrise. **March 1999, Linhof 4x5 camera, 500mm lens, Fujichrome Velvia film.**

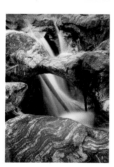

**PAGE 30  Natural Bridge on Roaring Fork River, Aspen, Colorado.** The flow of time brings together cascades of water and a metamorphic blend of Precambrian granite and sedimentary rock. **August 1987, Linhof 4x5 camera, 300mm lens, Kodak Ektachrome Daylight film.** Exposure was 5 seconds to enhance the texture of the waterflow.

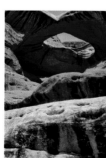

**PAGE 31  Paul Bunyan's Potty, Canyonlands National Park, Utah.** A low-angle view dramatizes layers of the Cedar Mesa formation above Horse Creek in the Needles section of Canyonlands. **February 2001, Canon EOS-1V 35mm camera, 135mm lens, Fujichrome Provia 100F film.**

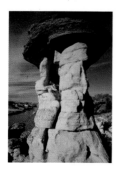

**PAGE 32  Caprock along Missouri River, Missouri Breaks, Montana.** A cap of rock lies tenuously on a pillar of broken rock. Lewis and Clark passed by here on their way to the Pacific in 1805. **May 1972, Linhof 4x5 camera, 75mm wide-angle lens, Kodak Ektachrome Daylight film.**

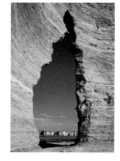

**PAGE 33  Window at Monument Rocks, Monument Rocks National Landmark, Kansas.** Winds, frost, and driving rains slowly erode these Cretaceous layers of rock into many forms. Here a window has opened in a wall that will ultimately break into separate sections and pinnacles to become, finally, level prairie. **August 1978, Linhof 4x5 camera, 90mm lens, Kodak Ektachrome Daylight film.**

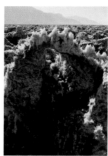

**PAGE 34  Salt Arch, Devils Golf Course, Death Valley National Park, California.** Ancient Lake Manley, which once filled Death Valley, has evaporated away, leaving deep layers of salt. Morning light accentuates a salt-crowned arch form near the lowest point of the lakebed, more than 250 feet below sea level. **March 2003, Canon EOS-1V 35mm camera, approximately 28mm focal length on 28–135mm zoom lens, Fujichrome Provia 100F film.**

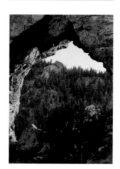

**PAGE 35  Lexington Arch, Great Basin National Park, Nevada.** Tucked away on the east side of the Snake Range is this unusual limestone span. A surprisingly easy trail leads upward to great vantage points, and then directly underneath the arch. **August 2002, Canon EOS-1V 35mm camera, 28mm on 28–135mm zoom lens, Fujichrome Provia 100F film.**

**PAGE 36  Lava Tube Winterscape, El Malpais National Monument and Conservation Area, New Mexico.** Snowmelt lends a temporary design to an opening in a collapsed lava tube. Lava tubes are formed when flowing lava moves through corridors of cooled lava. **March 1985, Linhof 4x5 camera, 75mm wide-angle lens, Kodak Ektachrome Daylight film.**

**PAGE 37, TOP  Lava Tube Interior, Lava Beds National Monument, California.** Lava flows continued through tubes of cooled lava to form another arch expression in volcanics. Extra lighting gives definition to the form. **July 1987, Linhof 4x5 camera, 90mm lens, Kodak Ektachrome Daylight film.**

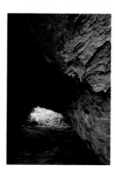

**PAGE 37, BOTTOM  Lava Tube Opening, Lava Beds National Monument, California.** Another arch form happens in volcanics when slower cooling lava flows continue as the surrounding flow cools to solid rock. **July 1987, Linhof 4x5 camera, 90mm wide-angle lens, Kodak Ektachrome Daylight film.**

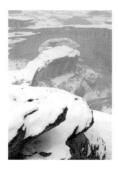

**PAGE 38  Sipapu Bridge Winterscape, Natural Bridges National Monument, Utah.** The silence is exceptional. A gentle snow shrouds this large bridge and surrounding walls of White Canyon, keeping definition to a minimum. I gave extra exposure to compensate for the brightness of the foreground. **February 1991, Linhof 4x5 camera, 75mm wide-angle lens, Fujichrome Velvia film.**

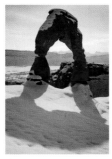

**PAGE 39  Delicate Arch Winterscape, Arches National Park, Utah.** A famous span transforms its image in a winter cloak of snow. Exposure was made from readings in the shadows. **February 1974, Linhof 4x5 camera, 90mm wide-angle lens, Kodak Ektachrome Daylight film.**

**PAGE 40  Gila Cliff Dwellings, Gila Cliff Dwellings National Monument, New Mexico.** The Mogollon Tradition people built their dwellings inside these large caves above a side canyon entering into the Gila River. These ancient ruins hold the memory of their culture. **August 2002, Linhof 4x5 camera, 65mm wide-angle lens, Fujichrome Velvia film.**

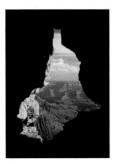

**PAGE 41  Limestone Keyhole, North Rim, Grand Canyon National Park, Arizona.** Summer storms roll across the rims of the Grand Canyon in this view near Point Sublime. **September 1995, Linhof 4x5 camera, 75mm wide-angle lens, Fujichrome Velvia film.**

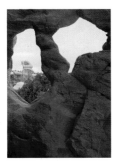

**PAGE 42  Escalante Architecture, Devils Garden, Grand Staircase–Escalante National Monument, Utah.** Windows and hoodoos appear around every corner in the Devils Garden of Escalante Country. **April 1995, Linhof 4x5 camera, 210mm lens, Fujichrome Velvia film.**

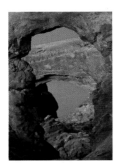

**PAGE 43  Turret Arch and North Window, Arches National Park, Utah.** Major sandstone spans overlap in this land of arches. **March 2002, Canon EOS-1V 35mm camera, 135mm on 28–135mm zoom lens, Fujichrome Provia 100F film.**

**PAGE 44  Fern Grotto, Lava Beds National Monument, California.** Sacred ceremonial cave to the Modoc Nation through historic times, this lava tube opening includes a garden of ferns and a panel of petroglyphs (on far right wall) in a harsh volcanic landscape. There are two arch forms, one a gated opening skyward (just out of view) and the other the oval arch shape to the lava tube. **June 1999, Linhof 4x5 camera, 65mm ultrawide-angle lens, Fujichrome Velvia film.**

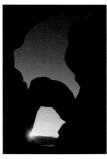

**PAGE 45  Double Arch, Arches National Park, Utah.** Sky windows silhouette against an evening sky. Only a portion of the sun was allowed to show through, giving the extra energy of light in a somber and dark scene. **November 2002, Canon EOS-1V camera, 14mm wide-angle lens, Fujichrome Provia 100F film.**

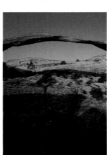

**PAGES 46–47  Landscape Arch, Arches National Park, Utah.** In 1991, this most delicate of all sandstone spans dramatically dropped a slab of rock 60 feet long, 11 feet wide, and 4 feet thick, becoming an even thinner ribbon of rock. **March 2002, Linhof 4x5 camera, 65mm wide-angle lens, Fujichrome Velvia film.**

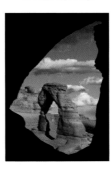

**PAGE 48  Delicate Arch through Frame Arch, Arches National Park, Utah.** The landscape abounds with visual possibilities. A small window begins its journey to maturity, its eroding form framing the delicate form at the other end of the sandstone bowl. **March 2002, Linhof 4x5 camera, 300mm lens, Fujichrome Velvia film.**

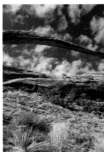

**PAGE 50  Landscape Arch, Arches National Park, Utah.** See also pages 74–75 for a photo note about this image, which was made prior to a large piece falling off the arch in 1991. It is a delicate span 300 feet long and at one point only 6 feet wide. **April 1978, Linhof 4x5 camera, 90mm wide-angle lens, Kodak Ektachrome Daylight film.**

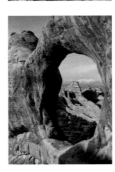

**PAGE 51  Double O Arch and Fins, Arches National Park, Utah.** Late afternoon light accents forms of the upper opening of Double O Arch, with fins of Entrada sandstone throughout. The missing O is at the base, just out of view. **June 1984, Linhof 4x5 camera, 210mm lens, Kodak Ektachrome film.**

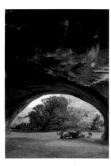

**PAGE 52  Navajo Arch, Arches National Park, Utah.** A pleasant side trip on the trail from Landscape Arch to Double O Arch takes you to Navajo Arch, which frames a pastoral scene. I enjoyed a soft overcast day in which piñon pine, juniper, and lines of the rock were well delineated. **July 1988, Linhof 4x5 camera, 90mm wide-angle lens, Kodak Ektachrome Daylight film.**

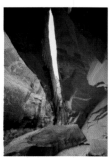

**PAGE 55  Morning Glory Arch, Colorado River Canyon, Utah.** This large span can be awkward to photograph. I approached with a wide-angle lens from directly underneath, which provided a spacious span complex within a tight-walled canyon. An overcast day helped define the different aspects of the arch. **October 1994, Linhof 4x5 camera, 65mm wide-angle lens, Fujichrome Velvia film.**

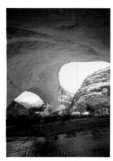

**PAGE 56  Coyote Gulch/Escalante, Glen Canyon National Recreation Area, Utah.** Large arches, bridges, and vaults make up the ins and outs of this serene series of grottos, complete with maidenhair fern and a columbine-lined stream. The waters of the stream in Coyote Gulch flow 3 or 4 miles to the confluence with the Escalante River. **May 2002, 4x5 camera, 36mm ultrawide-angle lens, Fujichrome Velvia film.**

**PAGE 57  Lava Tube, El Malpais National Monument and Conservation Area, New Mexico.** See also photo note for page 36 for discussion of this lava tube structure and opening in volcanics. **February 1995, Linhof 4x5 camera, 75mm wide-angle lens, Fujichrome Velvia film.**

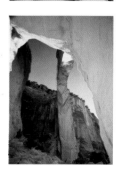

**PAGE 58  La Ventana Arch, El Malpais National Monument and Conservation Area, New Mexico.** This sandstone span located high on a cliffline engages all the senses. I was moved by the niches you can feel almost inside the arch. **April 1992, Linhof 4x5 camera, 65mm wide-angle lens, Fujichrome Velvia film.**

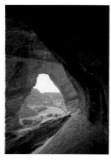

**PAGE 60  The Window, Canyon de Chelly National Monument, Arizona.** Our Navajo guide, Carmen Hunter, gives perspective to this large opening in upper Canyon de Chelly. To make this photograph, I tucked myself into a smaller cave opening adjacent to an ancient Ancestral Puebloan storage granary. **March 2002, Linhof 4x5 camera, 65mm wide-angle lens, Fujichrome Velvia film.**

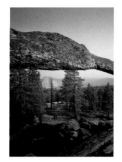

**PAGE 61  Indian Rock, Yosemite National Park, California.** Finding a new arch, especially in an exciting and prominent landscape, is always a thrill. To find two openings together, and just above Half Dome and Yosemite Valley, is a real prize. Indian Rock is along a trail to North Dome. **August 2002, Linhof 4x5 camera, 65mm wide-angle lens, Fujichrome Velvia film.**

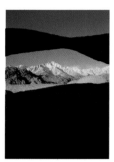

**PAGES 62–63  Alabama Hills, Sierra Nevada East Side, California.** A huge span—holding Sierra peaks Langley, Lone Pine, Corcoran, Whitney, and Russell—must be gigantic! Hardly. A person 6 feet tall reclining inside this granite opening would block most of the view through it. **March 2002, Linhof 4x5 camera, 65mm wide-angle lens, Fujichrome Velvia film.**

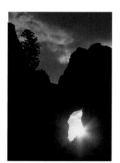

**PAGE 65  Windowlight, Lexington Arch, Great Basin National Park, Nevada.** On the return hike to the camper, I noticed a sun spot approaching a cliffside viewpoint in the shade. Letting the sun pass through the opening, I placed my camera to allow the sun to lower itself into position, obscuring most of the flaring portion. **August 2002, Canon EOS-1V camera, 200mm on 100–400mm zoom lens, Fujichrome Provia 100F film.**

**PAGES 66–67  Limestone Window, Grand Canyon National Park, Arizona.** This opening in Kaibab limestone on the South Rim makes a magnificent frame for one of our great landscapes. Unfortunately, it is no longer accessible because of the danger involved in reaching it. **March 1985, Linhof 4x5 camera, 210mm lens, Kodak Ektachrome Daylight film. I used a polarizing filter.**

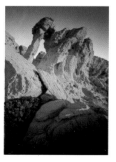

**PAGE 68  Elephant Rock, Valley of Fire State Park, Nevada.** After many visits to photograph through this arch at sunrise, I decided to walk around to find a positioning of the arch in connection with its close environment. A winter sunrise exposure captured a desert warmth. **January 2002, custom-mount camera, 36mm ultrawide-angle lens, Fujichrome Velvia film.**

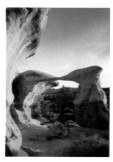

**PAGE 69  Metate Arch, Grand Staircase–Escalante National Monument, Utah.** This place is fascinating for photography, from many viewpoints. Angular forms and shapes in sandstone, including hoodoos, pinnacles, and small windows, hold this delicate span in what's called Devils Garden. **May 2000, Linhof 4x5 camera, 65mm ultrawide-angle lens, Fujichrome Velvia film.**

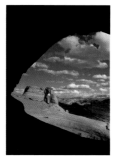

**PAGES 70–71 Delicate Arch and Sierra La Sal, Arches National Park, Utah.** Frame Arch holds in its margins a landscape of beauty and grace. Delicate Arch, with the La Sal Mountains, connects to a cloud-filled panorama sky. **March 2002, Linhof 4x5 camera, 65mm wide-angle lens. I used a Pola screen to accent the clouds.**

**PAGE 72 Boulder Window, Big Bend National Park, Texas.** I was fascinated by the novelty of this rock window, and planned a time of day for unique lighting. Early morning light worked well to bring out this odd formation with its Chihuahuan Desert surroundings. **March 2003, Linhof 4x5 camera, 75mm wide-angle lens, Fujichrome Velvia film.**

**PAGE 73 Blue Mesa Bridge, Petrified Forest National Park, Arizona.** Another oddity is this arch expression of a petrified log spanning a diminutive draw at Blue Mesa. Temporal, this petrified bridge will come tumbling down as have the large fragments in the foreground. **August 1992, Linhof 4x5 camera, 75mm lens, Fujichrome Velvia film.**

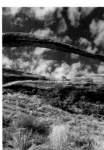

**PAGES 74–75 Landscape Arch, Arches National Park, Utah.** A mackerel sky floats by, with the beauty of a span of rock creating an unusual sky/earthscape. In this image, the 60-foot-long strip of rock that came loose from the narrowest section in 1991 had not yet fallen, as it has in the image on page 50. **April 1978, Linhof 4x5 camera, 90mm wide-angle lens, Kodak Ektachrome Daylight film.**

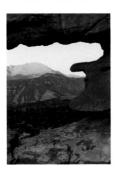

**PAGES 76–77 Pikes Peak through Window, Garden of the Gods, Colorado.** A small rock opening in sandstone frames Pikes Peak at dawn. Sometimes the scene through an arch is more spectacular than the frame. That may be the case here. **September 2001, Linhof 4x5 camera, 210mm lens, Fujichrome Velvia film.**

**PAGE 78 Saguaro and Hewitt Canyon Arch, Sonoran Desert, Arizona.** A chunk of volcanic rock has eroded into a temporary arch form. I chose a sunrise timing with a shaded arch silhouetted against a desert hillside. A saguaro cactus is symbolic of the Sonoran Desert adjacent to the Superstition Wilderness. **February 1987, Linhof 4x5 camera, 300mm lens, Kodak Ektachrome Daylight film.**

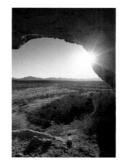

**PAGE 79 El Camino del Diablo, Cabeza Prieta National Wildlife Refuge, Arizona.** An historic gold rush route heads west to California through a searing section of the Sonoran Desert along the United States–Mexico border. This region is dry and hot, with very little water, but it is a hauntingly beautiful place, framed here by a granite cave opening at sunset. **October 1996, Linhof 4x5 camera, 75mm wide-angle lens, Fujichrome Velvia film.**

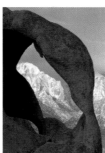

**PAGE 80 Triple Arches, Sierra Nevada East Side, California.** Undulating and muscular, this granite boulder erodes into a mature, sculpted form at the foot of the Sierra Nevada. **April 1997, Linhof 4x5 camera, 500mm telephoto lens, Fujichrome Velvia film.**

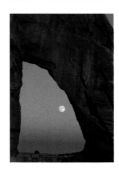

**PAGE 81 Moonrise, White Mesa Arch, White Mesa, Arizona.** An evening moonrise arcs its way skyward through a sandstone window in Navajo Nation country. **November 1997, Linhof 4x5 camera, 300mm lens, Fujichrome Velvia film.**

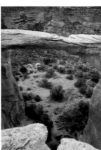

**PAGE 82 Sandstone Span, Rattlesnake Canyon, Colorado.** With the quiet ambient light of an overcast day, a desert pattern develops through a span of sandstone. Rattlesnake is a remote wild country along the northeast side of the Uncompahgre Plateau next to Colorado National Monument. **August 1992, Linhof 4x5 camera, 75mm lens, Fujichrome Velvia film.**

**PAGE 83 Bridge Mountain Arch, Zion National Park, Utah.** I had planned to hike out around Bridge Mountain to photograph at the foot of the arch, but plans to make the strenuous journey were continually delayed. A splendid opportunity presented itself as I drove by on Zion's main road. Sunlight was passing through cloud patterns skimming the arch above. I awaited just the right definition of light and shade to separate the slender arch from its surroundings. **October 2002, Canon EOS-1V 35mm camera, 400mm focal length on 100–400mm zoom lens, Fujichrome Provia 100F film.**

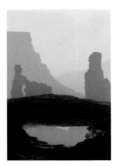

**PAGES 84–85 Mesa and Washerwoman Arches, Canyonlands National Park, Utah.** A special landscape is this Utah mix of rock towers, pillars, buttes, pinnacles, and yes, two arch forms, that make an odd sort of beauty. **February 1998, Linhof 4x5 camera, 500mm telephoto lens, Fujichrome Velvia film.**

197

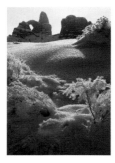

**PAGES 86–87  Turret Arch Winterscape, Arches National Park, Utah.** Winter snow and frost transform a sandstone world into one of magic and subtle beauty. I have not witnessed such an incredible amount of snow in the Canyonlands since this encounter. The temperature that day stayed below freezing, so the beautiful forms remained. **February 1974, Linhof 4x5 camera, 90mm lens, Kodak Ektachrome Daylight film.**

**PAGE 88  The North and South Windows, Arches National Park, Utah.** I was hoping for a different angle on the Windows by wandering around to the east in late afternoon. A silhouette produced a pair of rock glasses. My exposure was taken more in the sky area for silhouetted effect. **Canon EOS-1V 35mm camera, 20mm on 17–35mm zoom lens, Fujichrome Provia 100F film.**

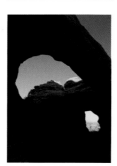

**PAGE 89  Triple Arch, Paria–Vermilion Cliffs Wilderness, Utah.** Deep in a remote part of the Paria Plateau exists this special place of arches and windows in sandstone. August 2002, **Canon EOS-1V 35mm camera, 20mm on 17–35mm lens, Fujichrome Provia 100F film.**

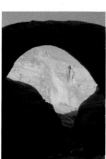

**PAGE 90  Rainbow Bridge, Rainbow Bridge National Monument, Utah.** Rainbow Bridge, the world's largest natural bridge, has inspired people throughout time. Indians have traditionally held the bridge sacred. It is 290 feet high and 275 feet across; the top is 42 feet thick and 33 feet wide. **September 2002, Linhof 4x5 camera, 75mm wide-angle lens, Fujichrome Velvia film.**

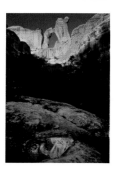

**PAGE 91  Angel Arch, Canyonlands National Park, Utah.** A rain pool reflects the arch in Cedar Mesa sandstone well up Salt Creek Canyon. I find reflections a fascinating connection of earth and sky. **April 1987, Linhof 4x5 camera, 75mm wide-angle lens, Kodak Ektachrome Daylight film.**

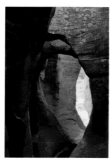

**PAGE 92  Peekaboo Windows, Grand Staircase–Escalante National Monument, Utah.** Intermittent stream pouroff has created this labyrinth of bridgelike openings along Dry Coyote Gulch. **November 1993, Linhof 4x5 camera, 210mm lens, Fujichrome Velvia film.**

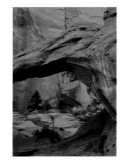

**PAGE 93  Lamanite Arch, Grand Staircase–Escalante National Monument, Utah.** This exquisite arch stands high on a bench at the foot of towering cliffs. A stream runs in dense riparian forest life at the bottom. The area is the Gulch. **November 1996, Linhof 4x5 camera, 500mm telephoto lens, Fujichrome Velvia film.**

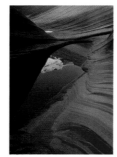

**PAGE 94  Arch Reflection, The Wave, Paria–Vermilion Cliffs Wilderness, Utah.** Looking carefully, one can actually see a small arch on the skyline reflected in the rainpool. **April 2002, Canon EOS-1V 35mm camera, 17–35mm wide-angle lens, Fujichrome Provia 100F film.**

**PAGE 95  Peekaboo Window, Grand Staircase–Escalante National Monument, Utah.** A shallow slot canyon holds this delicate bridgelike opening along Dry Coyote Wash. A PenLight™ was used to highlight the inner sections of this dark corner. **October 1991, large-format 47mm ultrawide-angle camera, Fujichrome Velvia film.**

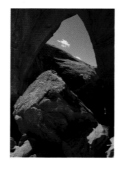

**PAGE 96  Broken Bow Arch/Escalante, Glen Canyon National Recreation Area, Utah/Arizona.** I had visited this massive arch a few times before, with its location along Willow Creek being a good spot to capture water reflections. This time, the approach was to be in close on the opposite side. Massive boulders lie about, some shaped as if they had just fallen directly from the large window. **April 2002, Canon EOS-1V 35mm camera, 28mm on a 28–135mm zoom lens, Fujichrome Provia 100F film.**

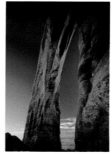

**PAGE 97  White Mesa Arch, White Mesa, Arizona.** There are numerous approaches and vantage points to this arch, high against the mesa. For this angle, I am in very close at the base. The profile is both slender and delicately reaching skyward. **October 1992, Linhof 4x5 camera, 65mm wide-angle lens, Fujichrome Velvia film.**

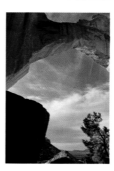

**PAGE 98  La Ventana Arch, El Malpais National Monument and Conservation Area, New Mexico.** Photographing from the right among the fallen boulders gives a powerful expression and poignant experience. **September 2002, Canon EOS-1V 35mm camera, 17mm on a 17–35mm zoom lens, Fujichrome Provia 100F film.**

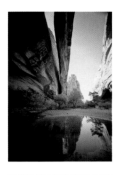

**PAGE 99  Morning Glory Arch, Colorado River Canyon, Utah.** A spring-fed pool reflects the double image of slablike Morning Glory Arch at the head of Negro Bill Canyon. This span can best be appreciated directly from beneath, at the end of the 2-mile hike. **May 2002, 4x5 camera with ultrawide-angle 35mm lens specially mounted, Fujichrome Velvia film.**

**PAGES 100–1  Sunset Arch/Escalante, Glen Canyon National Recreation Area, Utah.** Diversity in arch and bridge locations is equaled only by the diverse qualities in the arches and bridges themselves. Sunset Arch spans a small patch of slickrock surrounded by a huge expanse of open desert on 40 Mile Ridge. The setting is completed with Navajo Mountain far to the south and 50 Mile Mesa to the west. **April 2002, Linhof 4x5 camera, 75mm wide-angle lens, Fujichrome Velvia film.**

**PAGE 102  Royal Arch, Lukachukai Country, Arizona.** A freestanding arch form, this span stands at the eastern edge of the Lukachukai escarpment. A large structure up very close, it is lost to view rapidly in this remote and complex canyon and mesa country. I chose to portray the arch this time from an earthborn dimension. **October 2002, Linhof 4x5 camera, 75mm wide-angle lens, Fujichrome Velvia film.**

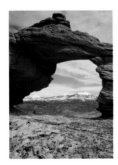

**PAGE 103  Tukanikavista Arch, Canyonlands Country, Utah.** Earth and sky come together in this small double span where the diminutive becomes huge. This arch is small, but the experience of it against the sky is large. Snowcapped Sierra La Sal is on the skyline behind. **February 1995, Linhof 4x5 camera, 210mm lens, Fujichrome Velvia film.**

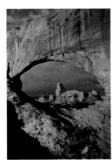

**PAGES 104–5  The Windows and Turret Arch, Arches National Park, Utah.** In the land of arches, this setting is familiar, especially when captured in an early morning mood. Both North and South Windows include the three added openings in the Turret Arch rock complex. **August 2002, Linhof 4x5 camera, 65mm ultrawide-angle lens, Fujichrome Velvia film.**

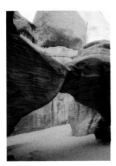

**PAGE 106  Sand Dune Arch, Arches National Park, Utah.** I spent much time sweeping smooth the many footprints in the sand beneath this young and sturdy arch form. My experience was one of matching the primeval impression from a very intimate, tucked-in place. **May 2002, Linhof 4x5 camera, 65mm ultrawide-angle lens, Fujichrome Velvia film.**

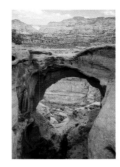

**PAGE 107  Cassidy Arch, Capitol Reef National Park, Utah.** Soft ambient light delineates a span called Cassidy high up on a sandstone rim above Capitol Gorge. Details are pronounced, and the light is subtle with this impression. **March 1994, Linhof 4x5 camera, 75mm wide-angle lens, Fujichrome Velvia film.**

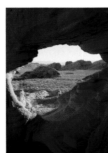

**PAGE 108  Desert Window, Valley of Fire State Park, Nevada.** Islands of redrock sandstone dot an arid desert landscape near Las Vegas. These rock openings and arch forms are relatively small, but they make picturesque frames of the surrounding area. **November 1992, Linhof 4x5 camera, 75mm wide-angle lens, Fujichrome Velvia film.**

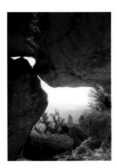

**PAGE 109  Limestone Window, North Rim, Grand Canyon National Park, Arizona.** A favorite rock opening to the world is this limestone window. Slabs of rimrock leaning on each other frame a distinctive view of Mount Hayden and surrounding ridges below Point Imperial. Morning sunlight lends a warm glow. **November 2002, Linhof 4x5 camera, 75mm wide-angle lens, Fujichrome Velvia film.**

**PAGE 110  Wilson Arch Winterscape, Canyonlands National Park, Utah.** A gentle snowstorm silently transforms the landscape around Wilson Arch. It was a delightful experience wandering up and down the slope's new texture, line, and form in the falling snow. **February 2001, Canon EOS-1V 35mm camera, 28mm on 28–135mm zoom lens, Fujichrome Provia 100F film.**

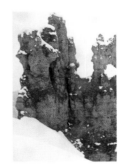

**PAGE 111  Hoodoo Winterscape, Bryce Canyon National Park, Utah.** A masklike wall of rock peers out of a snowstorm along Navajo Trail below the rim. Fragile and delicate, the windows and other openings in Wasatch pink are continually changing in this landscape. **February 2002, Canon EOS-1V 35mm camera, 28mm on 28–135mm lens, Fujichrome Provia 100F film.**

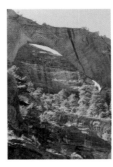

**PAGE 112  Kolob Arch, Zion National Park, Utah.** This massive span stands high up on a ledge of sandstone in upper La Verkin Creek Canyon. Because it was difficult to reach, I approached it with a telephoto lens from a distance. **May 1994, Linhof 4x5 camera, 500mm telephoto lens, Fujichrome Velvia film.**

PAGE 113  Phipps Arch, Grand Staircase–Escalante National Monument, Utah. Soft ambient light enhances the pockets of plant life, including claret cup cactus, Mormon tea, grasses, sage, and a bed of cryptobiotic soil, all making up a spring landscape on slickrock in the Upper Escalante River drainage. April 1993, Linhof 4x5 camera, 75mm wide-angle lens, Fujichrome Velvia film.

PAGES 114–15  Stevens Arch/Escalante, Glen Canyon National Recreation Area, Utah. A massive and young window has made a grand opening high on a sandstone skyline above the Escalante River. I found the sweeping lines of a fallen alluvial boulder to enhance the beauty in this more distant view. July 1985, Linhof 4x5 camera, 75mm wide-angle lens, Fujichrome Velvia film.

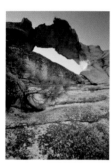

PAGE 116  Granite Arch, Yosemite National Park, California. A young Jeffrey pine takes hold in solid granite atop Indian Rock on Yosemite's north rim. This view is from the east side. August 2002, Linhof 4x5 camera, 75mm lens, Fujichrome Velvia film.

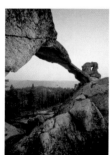

PAGE 117  Indian Rock, Yosemite National Park, California. Two distinctly different arch forms make up the skyline of this rock above the north rim of Yosemite Valley. This viewing is from the northwest. August 2002, Homemade 4x5 camera with a 35mm ultrawide-angle lens, Fujichrome Velvia film.

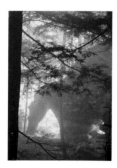

PAGE 118  Angels Windows, Red River Gorge, Kentucky. A gentle morning mist envelops these sandstone openings deep in the hardwood and hemlock Daniel Boone National Forest. October 2002, Linhof 4x5 camera, 500mm telephoto lens, Fujichrome Velvia film.

PAGE 120  Natural Bridge in Autumn, Natural Bridge State Park, Kentucky. This natural bridge is one of the main features of the Red River Gorge Area in Daniel Boone National Forest. Hardwoods display a change of season against this large span of sandstone. October 2002, Linhof 4x5 camera, 65mm ultrawide-angle lens, Fujichrome Velvia film.

PAGE 122  Kachina Bridge and Kiva, Natural Bridges National Monument, Utah. The Kachinas must have danced in this ceremonial kiva at the middle bridges in the White Canyon complex. Kachina Bridge is young and immature. Ancestral Puebloans found it a natural entranceway into their ceremonial place. May 1996, Linhof 4x5 camera, 65mm ultrawide-angle lens, Fujichrome Velvia film.

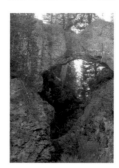

PAGES 124–25  Natural Bridge, Yellowstone National Park, Wyoming. Among the numerous standout volcanic features of Yellowstone is this more obscure natural bridge in rhyolitic rock. I chose the more somber light of evening, with a long exposure, to bring out the mysterious mood I felt when viewing the bridge from below. July 2002, Linhof 4x5 camera, 500mm telephoto lens, Fujichrome Velvia film.

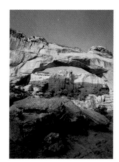

PAGES 126–27  Hickman Bridge, Capitol Reef National Park, Utah. Rock debris has continually fallen from these sandstone walls, as it also breaks off in sizeable chunks from under this bridge opening along a narrow finlike structure. I included the boulders under the bridge in this image, positioned very close, to enhance the feeling of time within the erosion process. April 1999, Linhof 4x5 camera, 65mm ultrawide-angle lens, Fujichrome Velvia film.

PAGE 128  Natural Bridge, Natural Bridge State Park, Kentucky. Autumn leaves contrast with the undersides of this span in sandstone. This bridge is a main feature and part of a collection of sandstone arches and bridges in the Red River Gorge Area of eastern Kentucky. What is fascinating to me is the location of these spans in deep hardwood forests. October 2002, Linhof 4x5 camera, 75mm wide-angle lens, Fujichrome Velvia film.

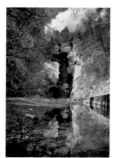

PAGE 129  Natural Bridge, Natural Bridge, Virginia. An autumn reflection sets a certain tone and quality of light on this solid structural bridge that I believe is under private ownership. There is a roadway topside. Octrober 1981, Linhof 4x5 camera, 90mm wide-angle lens, Kodak Ektachrome Daylight film.

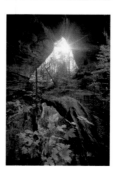

PAGE 130  North Arch Autumn Sunrise, Twin Arches, Big South Fork National River and Recreation Area, Tennessee. Twin Arches are the most impressive natural arches in the Big South Fork area, and probably in the eastern United States. Photographically this image was a challenge because of the variance in the dramatic lighting. Reflective meter reading was made of the middle tone values, and bracketed exposures were made to 1 stop under. Linhof 4x5 camera, 75mm wide-angle lens, Fujichrome Velvia film.

PAGE 131 Natural Bridge, Natural Bridge Park, Alabama. When I made this photograph, the bridge near Hamilton, Alabama, was being administered privately. My response was one of intrigue at finding these forest/sky openings; there was a sense of viewing out of the earth into dense forest. **October 1985, Linhof 4x5 camera, 90mm wide-angle lens, Kodak Ektachrome Daylight film.**

PAGES 132–33 Rock Bridge, Red River Gorge, Kentucky. A natural span crosses over Swift Creek, a rather sizeable stream, in dense forest, its natural location unusual. Most of the arches here are along sandstone ledges high up on the skyline. Photographically, contrast and spotty lighting are an obstacle to work with. I have tried to handle this exposure latitude problem by overexposing the film and underprocessing, or "pulling," the film. **October 2002, Linhof 4x5 camera, 65mm ultrawide-angle lens, Fujichrome Velvia film.**

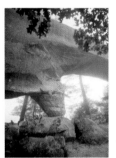

PAGES 134–35 Sky Bridge, Red River Gorge, Kentucky. This span evidently was created originally by a stream at one time, and now it very much appears like an arch high along a ridgeline. From underneath, the span is one and the openings are two. A few maples display their autumn colors on a foggy morning. **October 2002, 4x5 camera body, holding a 35mm ultrawide-angle lens, Fujichrome Velvia film.**

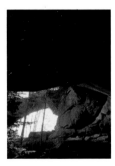

PAGES 136–37 Grays Arch, Red River Gorge, Kentucky. This arch is a most spectacular buttress arch in the Red River Gorge Geologic Area, Daniel Boone National Forest. I made this photograph from inside an alcove beside the arch. **May 1992, Linhof 4x5 camera, 65mm ultrawide-angle lens, Fujichrome Velvia film.**

PAGES 138–39 North Arch, Twin Arches, Big South Fork National River and Recreation Area, Tennessee. The light beams of sunrise capture the spirit of North Arch deep in a pristine forest of hardwoods and pines. Some leaves had fallen; autumn was well along, and morning light poured through hardwood forest to illuminate this magnificent arch. **October 1996, Linhof 4x5 field camera, 65mm ultrawide-angle lens, Fujichrome Velvia film.**

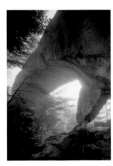

PAGES 140–41 Sky Bridge, Red River Gorge, Kentucky. Actually two arch openings within one at this point in time, the span has smooth and graceful lines and form. This mature arch spans a ridgeline above Swift Creek and Red River Gorge. I waited for an early autumn morning fog to bring a sense of intimacy and the mysterious. **October 2002, large-format camera housing with 35mm ultrawide-angle lens, Fujichrome Velvia film.**

PAGES 142–43 Grays Arch, Red River Gorge, Kentucky. The rock wall of a huge layered alcove extends out onto a ridge and a spectacular buttress arch span. Moss and ferns transform the deep forested alcove with their greens. **October 2002, Linhof 4x5 camera, 75mm wide-angle lens, Fujichrome Velvia film.**

PAGE 144 Double Arch, Red River Gorge, Kentucky. An obscure ridgetop arch includes another opening above. A soft ambient light details the horizontal sandstone layers. **October 1994, Linhof 4x5 camera, 210mm lens, Fujichrome Velvia film.**

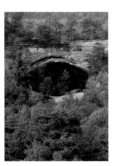

PAGE 145 Natural Arch, Daniel Boone National Forest, Kentucky. Hints of autumn decorate the forest around a sandstone eye viewed from a distant overlook at Natural Arch Scenic Area, Daniel Boone National Forest. Soft light exposes the details of this camouflaged span. **October 1994, Linhof 4x5 camera, 500mm telephoto lens, Fujichrome Velvia film.**

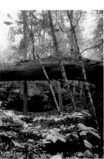

PAGES 146–47 Needle Arch, Big South Fork National River and Recreation Area, Tennessee. Set back in a small alcove, Needle Arch spans through verticals of hardwood forest as if to pretend it is a fallen log of ancient times. A dense layer of clouds lends a brooding mood to this forest landscape. **October 2002, Linhof 4x5 camera, 65mm ultrawide-angle lens, Fujichrome Velvia film.**

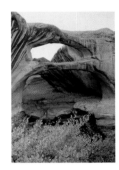

PAGES 148–49 Brimhall Arch, Capitol Reef National Park, Utah. Pronounced water stains, referred to as "desert varnish," pattern an alcove interior holding double arch spans called Brimhall. Bounced light from a canyon wall behind the camera gives all the reflected tones desired. **October 1996, Linhof 4x5 camera, 75mm wide-angle lens, Fujichrome Velvia film.**

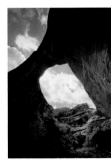

PAGE 150 Sipapu Bridge in Autumn, Natural Bridges National Monument, Utah. Large and magnificent, this natural bridge formed when the main stream in White Canyon broke through its own meander. Autumn cottonwoods line the streambed below the span. **October 1995, Linhof 4x5 camera, 65mm ultrawide-angle lens, Fujichrome Velvia film.**

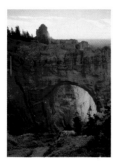

**PAGE 151** Bryce Natural Bridge, Bryce Canyon National Park, **Utah.** Early dawn light reflects off the sunlit wall to define this span in Wasatch limestone along the rim drive at Bryce Canyon. **September 2002, Linhof 4x5 camera, 75mm wide-angle lens, Fujichrome Velvia film.**

**PAGE 152** Tonto Natural Bridge, Tonto Natural Bridge State **Park, Arizona.** This magnificent formation stands almost hidden in a deep gorge in remote Tonto National Forest accessible by a steep trail. Over time, the mineral-rich stream flowing through the canyon created deposits of travertine (calcium carbonate), which were eventually eroded by the stream's flow, leaving this huge travertine bridge. **May 2002, Linhof 4x5 camera, 75mm wide-angle lens, Fujichrome Velvia film.**

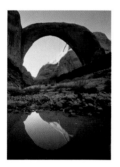

**PAGE 153** Rainbow Bridge Reflections, Rainbow Bridge **National Monument, Utah.** Obscured in a labyrinth of canyons behind Navajo Mountain, this spectacular span is the grand master of them all. A pool in Bridge Creek reflects a double impression as it may have for centuries. Lake Powell provides contemporary access from below the other side. **September 2002, Linhof 4x5 camera, 65mm ultrawide-angle lens, Fujichrome Velvia film.**

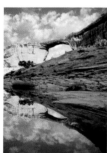

**PAGE 154–55** Owachomo Bridge, Natural Bridges National **Monument, Utah.** Very mature in its old age, the span of Owachomo stands high above Armstrong Canyon against the sky. A rainpool reflects the opening in Cedar Mesa sandstone. **September 1994, Linhof 4x5 camera, 65mm ultrawide-angle lens, Fujichrome Velvia film.**

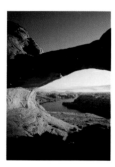

**PAGES 156–57** Aleson Arch, Glen Canyon National Recreation **Area, Utah.** Spanning a tiny alcove high on Wilson Mesa overlooking the Colorado River Canyon in Glen Canyon— now Lake Powell—this arch form was known to me as Flying Eagle Arch before it was renamed in the 1990s. An expansive view awaits you with a cross-country hike up from either the Rincon or Flying Eagle Cove. It is early morning, looking upstream to the Henry Mountains. **September 1978, Linhof 4x5 camera, 65mm ultrawide-angle lens, Kodak Ektachrome Daylight film.**

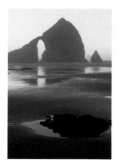

**PAGES 158–59** Three Arches Cape, Oceanside, Oregon. Low tide and early morning light offer a gentle silence to the rugged and active Pacific shore at Oceanside. Within minutes a fog bank rolled in. **July 2002, Linhof 4x5 camera, 210mm lens, Fujichrome Velvia film.**

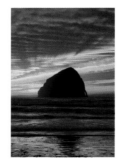

**PAGE 160** Haystack Rock Sunset, Cape Kiwanda, Oregon. Pacific waves have poured through this fracture on Haystack Rock, leaving a vertical opening. The warmth of a sunset lends a timeless quality—a precious moment stopped in time—as ocean waves dissipate onshore. **February 1998, Linhof 4x5 camera, 75mm wide-angle lens, Fujichrome Velvia film.**

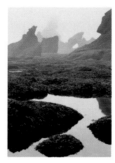

**PAGE 162** Point of Arches, Olympic National Park, Washington. Low tide, foggy wet light, and solitude can only hint at the noisy pounding waves that have created this rugged coastline through time. The mysterious is shrouded for the moment. **July 2002, Linhof 4x5 camera, 300mm telephoto lens, Fujichrome Velvia film.**

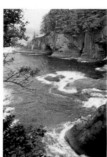

**PAGE 163** Cape Flattery, Olympic Peninsula, Washington. The force of pounding waves lays siege to this northwesternmost point in the Lower 48 states. This photograph was meant to be only a record of coves and caves, crowned by thick forest, on this battered cape close to Neah Bay. **July 2002, Canon EOS-1V 35mm camera, 17mm focal length on 17-35mm wide-angle zoom lens, Fujichrome Provia 100F film.**

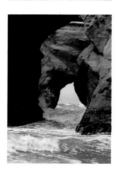

**PAGE 164** Tunnel Island Arches, Quinault Reservation, Olympic **Peninsula, Washington.** Surging waves roll relentlessly through a double opening on this island offshore, soon to be a row of sea stacks, and finally the process will end with open water. I walked hip-deep across an inlet with a rising tidal flow to capture a few hand-held images. A soft ambient light helps to define the complex structure. **July 2002, Canon EOS-1V 35mm camera, 135mm focal length on 28-135mm zoom lens, Fujichrome Velvia film.**

**PAGE 166** Sea Lion Caves, Oregon Coast. This sea cave arch form has openings west and south. An important mainland breeding area of the endangered Steller sea lion, the cave is known as the largest sea cave in the world. **July 2002, Canon EOS-1V 35mm camera, 28mm focal length on 28–135mm zoom lens, Fujichrome Provia 100F film.**

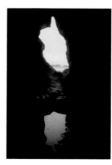

**PAGE 167** Rock Opening, Bandon Beach, Oregon. Rock openings and sea caves expose new vistas to the ocean as the tide lowers. A pool reflects the tunnel opening seaward in this magnificent coastline near Coos Bay. **July 2002, Canon EOS-1V 35mm camera, 28mm focal length on 28–135mm lens, Fujichrome Provia 100F film.**

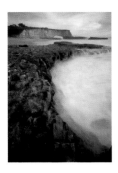

PAGE 168 Ocean Flow and Sea Arch, Santa Cruz Coastline, California. Ebb and flow of a Pacific surf washes along a platform of rock before coming to an opening on a distant peninsula near Santa Cruz. This particular sea arch may have toppled over recently and may not exist anymore. The evening exposure is 3 or 4 seconds long. **March 1994, Linhof 4x5 camera, 75mm wide-angle lens, Fujichrome Velvia film.**

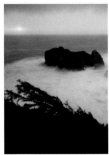

PAGE 169 Arch Rock, Boardman State Park, Oregon. Waves lash rocks offshore along the southern Oregon coast as another winter storm passes by. Companions wind and water have joined forces to create this opening. I used a 5- or 10-second exposure to bring some light to this brooding evening atmosphere. **February 1994, Linhof 4x5 camera, 75mm wide-angle lens, Fujichrome Velvia film.**

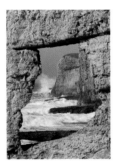

PAGE 170 Splashing Surf and Window, Santa Cruz Coastline, California. Waves from across the Pacific end their journey here along a shale cliffline. A rock window has opened under a fracture in the cliff. The struggle between ocean and shore continues. **January 1985, Linhof 4x5 camera, 500mm telephoto lens, Kodak Ektachrome Daylight film.**

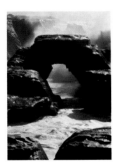

PAGE 171 Winter Surf and Sea Arch, Santa Cruz Coastline, California. Unrelenting wave action splashes a muscular rock span in this dramatic morning view at Santa Cruz. **January 1985, Linhof 4x5 camera, 500mm telephoto lens, Kodak Ektachrome Daylight film.**

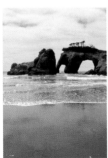

PAGES 172–73 Tunnel Island and Surf, Quinault Reservation, Olympic Peninsula, Washington. A summer surf reflects a string of sea arches off the south end of Tunnel Island. A progression from rock point to sea arch openings to eventual sea stacks is most graphic in this coastal display. **July 2002, Canon EOS-1V, 35mm camera, 28mm on 28–135mm zoom lens, Fujichrome Provia 100F film.**

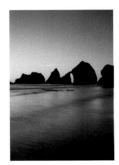

PAGES 174–75 Three Arches Cape at Evening, Oregon Coast. A Pacific surf ebbs and flows around a promenade of sea stacks at sunset, silhouetted forms of a cape giving way to the vagaries of the sea, storm, and tide. I used a 2- to 3-second exposure to capture a more placid feeling. **July 2002, Linhof 4x5 camera, 75mm wide-angle lens, Fujichrome Velvia film.**

PAGES 176–77 Moss-laden Bigleaf Maple, Hoh Rain Forest, Olympic National Park, Washington. Sphagnum moss drapes from a maple in the Hall of Mosses, bringing ends of branches toward the earth under the burden of weight and creating an arch form in wood. With over 100 inches of rain in the Hoh River Valley, plant growth is abundant. The wood span is primarily created by water. **July 2002, Linhof 4x5 camera, 75mm wide-angle lens, Fujichrome Velvia film.**

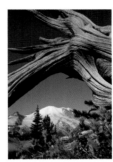

PAGE 178 Old Tree Root and Mount Rainier, Mount Rainier National Park, Washington. Uprooted ancient tree harbors the form of the 14,410-foot volcano in the Cascade Range. This view through the arched roots may be how a marmot would see this landscape. **July 2002, Linhof 4x5 camera, 75mm wide-angle lens, Fujichrome Velvia film.**

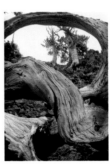

PAGE 179 Ancient Bristlecone Pines, San Francisco Peaks, Arizona. An upturned bristlecone pine torso provides another arch form, this one high on 12,611-foot Humphries Peak. The San Francisco Peaks are sacred to both the Hopi and the Navajo peoples. **June 1985, Linhof 4x5 camera, 75mm wide-angle lens, Kodak Ektachrome Daylight film.**

PAGE 180 Apple Blossom Arch and Yosemite Falls, Yosemite National Park, California. A stray apple tree from historic orchards, plump with spring blossoms, gives an arch frame to Upper Yosemite Falls. **May 2003, Canon EOS-1V 35mm camera, 90mm on 28–135mm zoom lens, Fujichrome Provia 100F film.**

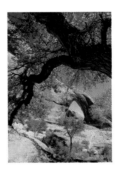

PAGE 181, TOP Cottonwood and Broken Bow Arch/Escalante, Glen Canyon National Recreation Area, Utah/Arizona. A cottonwood branch spans a dry canyon in the Escalante Country, echoing the window made by Broken Bow Arch. This visual form intrigued me during a rest stop for lunch. **April 2002, Canon EOS-1V 35mm camera, 14mm ultrawide-angle lens, Fujichrome Provia 100F film.**

PAGE 181, BOTTOM Openings in Bigleaf Maple Trunk, Hoh Rain Forest, Olympic National Park, Washington. Massive maple trunks in the Hall of Mosses have grown up around branches and fallen logs to leave these windows into the forest. A PenLight™ was used during a 5-second exposure to better illuminate the interior of the trunk. **July 2002, Linhof 4x5 camera, 75mm wide-angle lens, Fujichrome Velvia film.**

PAGE 182 **Ice Window in Harriman Fjord, Chugach National Forest, Alaska.** A window of ice frames a distant tidewater glacier dropping to the sea, one of many lining this fjord in Prince William Sound. **August 2001, Canon EOS-1V 35mm camera, 20mm focal length on 17–35mm lens, Fujichrome Provia film.**

PAGE 183 **Adelie Penguins and Rock Arch, Antarctica.** A colony of nesting penguins surrounded this rock arch, seriously guarding eggs on their rock nests, limiting a closer look at the green ice floe underneath. We expected ice arches here but not rock openings, so this came as a surprise. **November 2002, Canon EOS-1V 35mm camera, 135mm focal length on 28–135mm lens, Fujichrome Velvia film.**

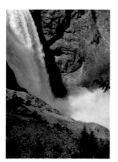

PAGES 184–85 **Lower Yellowstone Falls and Rainbow, Yellowstone National Park, Wyoming.** The dramatic leap of the Lower Falls of the Yellowstone River momentarily displays, just around midday, a rainbow—ephemeral, always changing, perhaps the spirit of an arch. **July 2002, Canon EOS-1V 35mm camera, 28mm focal length on 28–135mm lens, Fujichrome Provia 100F film.**

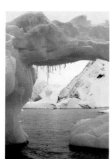

PAGES 186–87 **Ice Bridge, Antarctica.** Spring icicles drape from an arch of ice along the Antarctic Peninsula. Although not quite the arch form I was searching for, it served to excite the imagination for beauty in this ice world of blue. It was snowing lightly. **November 2002, Canon EOS-1V 35mm camera, 20mm focal length on 17–35mm lens, Fujichrome Provia 100F film.**

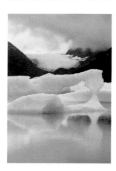

PAGE 188 **Ice Window, Portage Glacier, Chugach National Forest, Alaska.** An ice bridge spans two sections of a large calving from the Portage Glacier, which is just out of sight. The glacier shown is well above calving range into the lake. This window in blue lasted only a few hours. It was melting rapidly. **July 1994, Linhof 4x5 camera, 300mm telephoto lens, Fujichrome Velvia film.**

PAGE 189 **Ice Sculpture and Mount St. Elias, Wrangell–St. Elias National Park and Preserve, Alaska.** A melting ice form, floating on Icy Bay far from a tidewater glacier, gives a brief window framing 18,004-foot Mount St. Elias in Wrangell–St. Elias National Park. **July 1994, Linhof 4x5 camera, 75mm wide-angle lens, Fujichrome Velvia film.**

PAGE 190 **Burned Sequoia Bole, Sequoia National Park, California.** A certain black beauty emanates from the charred remnants of a live Sequoia bole. A recent fire burned much of this prime redwood forest near the Senate and Congress groves. Arch forms were created from this primal force. **May 2003, Canon EOS-1V 35mm camera, 17mm focal length on 17–35mm zoom lens, Fujichrome Provia 100F film.**

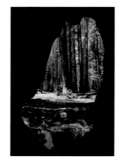

PAGE 191 **Fire-Scarred Window, Sequoia National Park, California.** Snowmelt lingers in a small pool along the base of a large Sequoia bole in this view through an arch space created by a recent fire around Senate and Congress groves. Grotesque in some ways, the phenomenon of fire represents an important event in this forest of giants. **May 2003, Canon EOS-1V 35mm camera, Fujichrome Provia 100F film.**

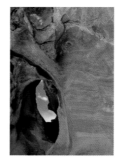

PAGE 205 **Window and Buffalo Rock Painting, Big Bend National Park, Texas.** Ancient people left this painted image—a pictograph—on the north side of a boulder located near a spring; I imagine it was created in much wetter times than at present. This spot is now high Chihuahuan Desert. The window appears to be an integral part of the overall wall design. **April 2003, Canon EOS-1V 35mm camera, 20mm focal length on 17–35mm zoom lens, Fujichrome Provia 100F film.**

PAGE 206 **Granite Boulders and Arch Opening, Sierra Nevada East Side, California.** A landscape of rounded boulders is an ancient foreground to peaks Langley, Lone Pine, Whitney, Russell, Trojan, and Williamson of the Sierra Nevada. **August 2002, Linhof 4x5 camera, 65mm ultrawide-angle lens, Fujichrome Velvia film.**

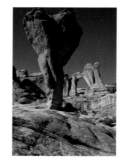

PAGE 207 **Molar Rock and Angel Arch, Canyonlands National Park, Utah.** The prominent features of Molar Rock and Angel Arch break the skyline of a Cedar Mesa sandstone formation well up Salt Creek Canyon in the Needles District. **April 1987, Linhof 4x5 camera, 90mm wide-angle lens, Kodak Ektachrome Daylight film.**

PAGE 208 **Turret Arch through North Window at Sunset, Arches National Park, Utah.** The magic of sunset explodes with a glow, making for a dramatic contrast with deep shadow areas of the North Window. The sun is partially obscured behind rock, to avoid flaring the film. The exposure was made to the left-hand sky area. Also, I was not interested so much in placing detail in the shadow areas. **February 1972, Linhof 4x5 camera, 90mm wide-angle lens, Kodak Ektachrome Daylight film.**

# acknowledgments

I am grateful to Duncan Foley, Ph.D., professor of geosciences at Pacific Lutheran University, for taking time while trying to complete his own book to read my manuscript. Any mistakes that got in anyway are purely mine.

Many, many thanks to our editor, Ellen Wheat, whose thoroughness, patience, availability, enthusiasm and understanding of the artistic process in all its forms brought everything together. I think it comes from skiing.

The Natural Arches and Bridges Society, a nonprofit volunteer organization promoting the study, enjoyment, and preservation of natural rock arches and bridges, is a welcoming organization, generous with their information. Membership, which includes a subscription to their newsletter—that describes more arches than one can imagine on earth—costs $10 a year. Contact NABS, P.O. Box 23025, Glade Park, Colorado 81523 or www.naturalarches.org.

—R. R.

Our deep thanks to Betty Watson for the art of her design that so beautifully melds images and words.

And to my son, Marc, for his stalwart work with the separations and color management, which helped to present my work in its purest form.

Many thanks to my daughter, Zandria, for help way beyond any call of duty in pursuing photographs of Rainbow Bridge and Aleson Arch.

—D. M.

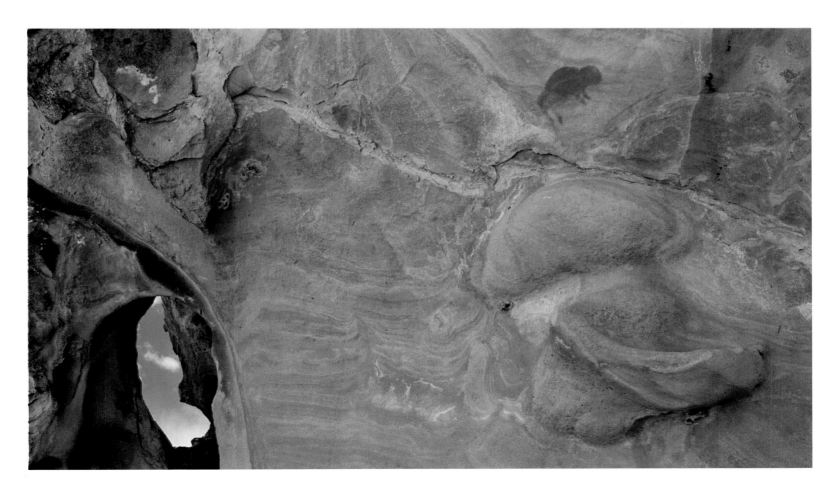

**Window and Buffalo Rock Painting,** *Big Bend National Park, Texas*

# sources

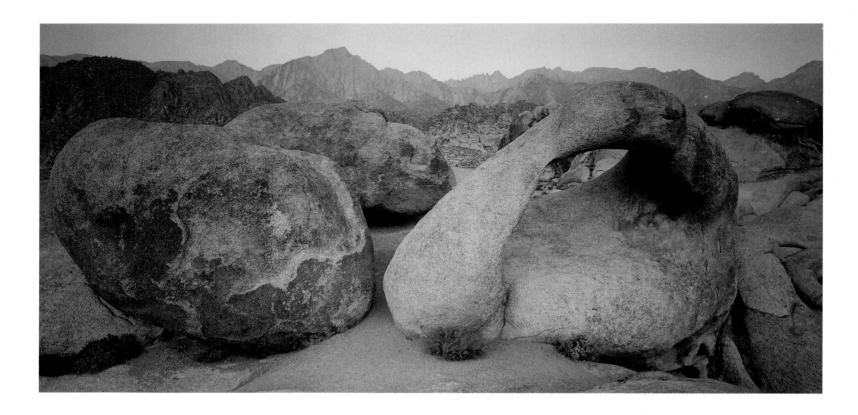

There are many guidebooks and references to most of the areas we include in this book, but there were a few books I returned to over and over:

*Canyon Country Arches and Bridges,* by F. A. Barnes, Arch Hunter Books, Thompson Springs, Utah, 2000. This book, the work of a man who has devoted his life to writing geology so that it is perfectly clear to nongeologists, is one of his many books.

*Cascade-Olympic Natural History,* by Daniel Mathews, Raven Editions, Portland, Oregon, 1999. A well-written and thorough natural history that is, I think, the friendliest guide I've encountered.

*The Colorado Plateau,* by Donald L. Baars, University of New Mexico Press, Albuquerque, 2000. This is a friendly, readable guide to the geology of the region.

*The Field Guide to Geology,* by David Lambert and the Diagram Group, Facts on File, New York, 1998. A gentle way to learn about geology, this book has lots of helpful diagrams and pictures.

*Geology of National Parks,* by Ann G. Harris, Esther Tuttle, and Sherwood D. Tuttle, Kendall/Hunt Publishing Company, Dubuque, Iowa, 1997. An immensely readable book that covers the geographic setting and history of each park and its geologic features,

with wonderfully clear boxes, tables, and charts of information, maps, and photographs. This is a book I would not be without.

*Geology of Utah's Parks and Monuments,* edited by Douglas A. Sprinkel, Thomas C. Chidsey Jr., and Paul B. Anderson, Publishers Press, Salt Lake City, Utah, 2000. This book does more or less the same thing for Utah as the *Geology of National Parks* does for all the parks, but it covers national monuments and recreation areas, state parks, and other parks as well.

*Hiking the Big South Fork,* by Brenda G. Deaver, Jo Anna Smith, and Howard Ray Duncan, University of Tennessee Press, Knoxville, 1999. This is a large and thorough guide to the region's natural history and its related legends.

*Hiking the Escalante,* by Rudi Lambrechtse, Wasatch Publishers, Salt Lake City, Utah, 1985. This is the classic Escalante guide, way predating the National Monument.

*Kentucky's Land of the Arches,* by Robert H. Ruchhoft, The Pucelle Press, Cincinnati, Ohio, 1986. A thorough guide to the geology and trails of the Red River Gorge area; another classic.

*Kentucky's Last Great Places,* by Thomas G. Barnes, University Press of Kentucky, Lexington, 2002. A beautifully photographed, intensely researched coffee-table book about the state's

natural heritage, as well as a heartfully written plea for preservation of its fragile beauty.

*Landscape and Memory,* by Simon Schama, Alfred A. Knopf, New York, 1995. A remarkable history that is an exploration of natural landscapes and their effects on the landscapes of the mind, it presents the story of the formation of Western civilization's traditions of nature. This book has proven to be a kind of bible for me.

*The Natural Arches of the Big South Fork,* by Arthur McDade, University of Tennessee Press, Knoxville, 2000. A good but more limited guide than *Hiking the Big South Fork.* This one is easy to carry.

*Of Wind, Water & Sand,* by David Petersen, Canyonlands Natural History Association, Moab, Utah, 1999. A thin volume that is a wonderful telling of the story of the natural bridges, the geology, and the human history of Canyonlands National Park. It contains a number of photographs, several of them—including the cover—David's.

*Windows into the Earth,* by Robert B. Smith and Lee J. Siegel, Oxford University Press, New York, 2000. This geologic story of Yellowstone and Grand Teton National Parks provides clear insights into how Yellowstone works, and why it is so rare a thing to find an arch there.

**Granite Arch,** *Sierra Nevada East Side, California*

Graphic Arts Center Publishing®
An imprint of Graphic Arts Center Publishing
    Company
P.O. Box 10306, Portland, Oregon 97296-0306
503/226-2402; www.gacpc.com

President: Charles M. Hopkins
Associate Publisher: Douglas A. Pfeiffer
Editorial Staff: Timothy W. Frew, Tricia Brown,
    Jean Andrews, Kathy Howard,
    Jean Bond-Slaughter
Production Staff: Richard L. Owsiany,
    Heather Doornink
Designer: Elizabeth Watson
Editors: Ellen Wheat, Kate Rogers
Digital Pre-Press: Marc Muench
Printer: Haagen Printing
Binding: Lincoln & Allen Co.
Printed and bound in the United States
    of America

Library of Congress Cataloging-in-Publication
    Data

Muench, David.
    Windstone : natural arches, bridges, and other
openings / photography by David Muench ;
text by Ruth Rudner.
        p. cm.
        ISBN 1-55868-745-9
    1. Photography of rocks.  2.  Natural
bridges—Pictorial works.  3.  Muench, David.
I. Rudner, Ruth.  II. Title.
        TR732.M84 2003
        779'.36—dc21

                        2003005486

The desire to present the photographer's work in its purest form could only be fulfilled by understanding the intent of the artist and reinterpreting it, exploiting the finest technologies and materials to meet today's standards.

This book is a combination of old-world craft values and twenty-first-century technology. From traditional thread-sewn binding to state-of-the-art digital management of color and printing, through rigorous testing and meticulous quality control, this collection of artist's images is created for you.

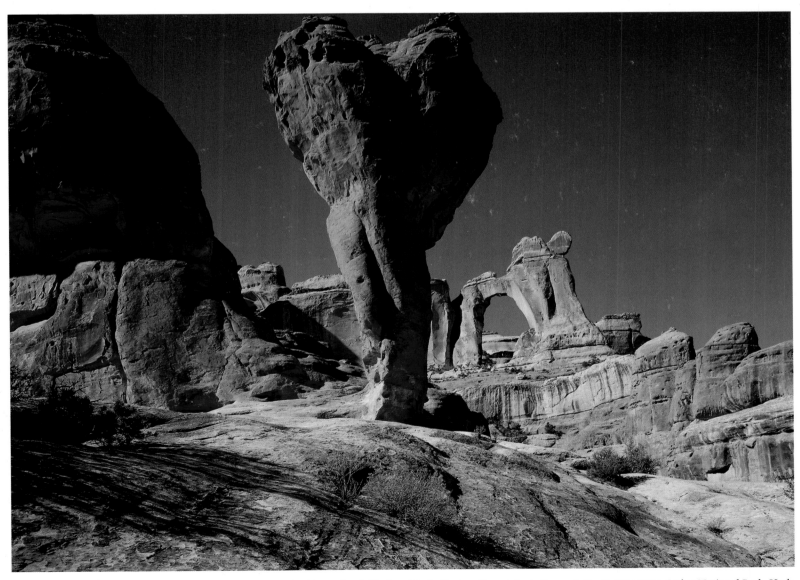

▲ **Molar Rock and Angel Arch,** *Canyonlands National Park, Utah*  ▶ **Turret Arch through North Window,** *Arches National Park, Utah*

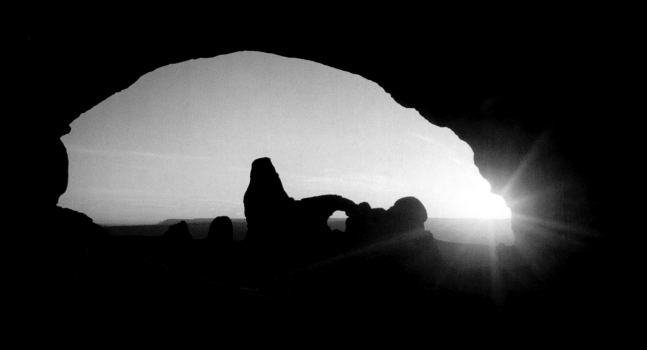